The Heart of Ma Yuan

The Heart of Ma Yuan

The Search for a Southern Song Aesthetic

Richard Edwards

香港大學出版社

HONG KONG UNIVERSITY PRESS

This publication has been generously supported by the Sir Y.K. Pao Publication Fund for publications in Chinese art and architecture.

Hong Kong University Press
14/F Hing Wai Centre
7 Tin Wan Praya Road
Aberdeen
Hong Kong
www.hkupress.org

ISBN 978-988-8028-65-8

British Library Cataloguing-in-Publication Data
A catalogue copy for this book is available from the British Library.

Printed and bound by Kings Time Printing Press Ltd. in Hong Kong, China

Contents

List of Plates

67 Li Gonglin, Chinese, ca. 1041–1106
 The Classic of Filial Piety. Chapter 7, "Filial
 Piety in Relation to the Three Powers (Heaven,
 Earth and Man)"
 Northern Song dynasty (960–1127), ca. 1085
 Handscroll section; ink on silk
 8-5/8 x 187-1/4 in. (21.9 x 475.5 cm)
 The Metropolitan Museum of Art, Ex. coll: C. C.
 Wang Family, from the P. Y. and Kinmay W. Tang
 Family Collection, Gift of the Oscar L. Tang Family,
 1996 (1996.479a–c)
 Photograph by Malcolm Varon
 Image © The Metropolitan Museum of Art

List of Figures

Introduction

Chapter 2

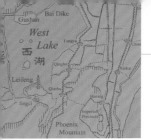

Preface

It simply cannot be
 heard with the ear
But when sound is
 heard with the eye
Then it is understood
—Dongshan (807–869)

I have been drawn, especially in recent years, to the painting of China's Southern Sung, or as it is now written, "Song" (1127–1178). This, in no small part, is because it is the earliest historical period when a sufficient number of works by recognized masters survive to allow belief in their tangible painting history. Earlier times, especially what is so eloquently described of great names in written texts, can only whet the appetite to actually see what is so insufficiently served by the scarcity of object survival. Although texts affirm directions and with the aid of an occasional masterpiece can feed the imagination, the visual world is not the world of words but of forms. The demand is to satisfy the eye, not the ear. This dilemma is succinctly expressed in the encounter between the Tang dynasty scholar-official, Li Ao 李翱 (722–841), and the priest, Yaoshan Weiyan 藥山惟儼 (751–834), an episode re-imagined in a late Song painting by a member of the Ma family, Ma Gongxian 馬公顯. Li Ao, having heard great things about the monk, complained on first confronting him: "Seeing you face to face is not equal to hearing your reputation." Yaoshan's answer was brief: "Why prize the ear but demean the eye?" It was the directness of personal confrontation emphasized by the reduction of verbiage that brought understanding and admitted enlightenment.

Close to the year 1100 the veil begins to lift. Not only are surviving signed works more numerous, there is a growing respect for what might be called the focused eye, a measure of seeing guided by the common word, *yuan* 遠, usually translated as "distance." It is what the painter must do with the tools of brush, ink, and color when faced with the untouched barrier of paper, silk, wall, or other surface in order to realize the magic of presence, a space on or within which the unseen becomes visible in uninterrupted passage from our experience of the world of space and time now flowing into the experience of art. The critic Han Zhuo 韓拙 (act. ca. 1095–1123), writing in 1121, five years before the fall of the northern capital, Kaifeng,

gave this a definition by focusing attention on three such distances, perhaps more accurately described as visual perspectives: broad (*kuo* 闊), hidden (*mi* 迷), and obscure (*you* 幽). Taken together, this trilogy reflects a significant change in aesthetic sensibility. Broad distance defines a spacious sweep extending to the edge of visibility. The hidden distance is quite the opposite in implying the concealing screen of a forward object, including fog or mist, blocking such extension. In turn, obscure distance is a compromise in which objects, though still visible, are reduced to atmospheric suggestiveness. While by no means implying a mathematic single point perspective, the eye becomes an observing eye viewing the passing world from a fixed physical position, watching or gazing upon what is directly present. Both viewer and viewed are joined in a special respect for the eye as it explores the physical world.

Within this time I have selected one of its most famous artists, Ma Yuan 馬遠. While there may yet be a chance for further contemporary accounts to emerge, early verbal descriptions are rare and he has survived, as with so many of his peers, as little more than a name. In fame he is often linked with his fellow artist, Xia Gui 夏珪 (ca. 1180–ca. 1230), equal in contemporary verbal obscurity, but famously further condensed in pairing, as "Ma-Xia," as though searching for a condensed acronym. However limited in quantity, and helped by later hints about style, it is more exactly in the tangible concreteness of painting itself through which one must reach knowledge of "Ma Yuan," anchored hopefully in his own day and offering echoes that reverberate beyond in the succession of dynastic time.

Accordingly, the focus of this book will not be through the gateway of contextual social surroundings. Significant and expected as that may appear, such an approach would be based in large part on what others with greater competence have done. As one such scholar has summarized, ". . . there is a remarkably rich, concentrated body of literature that describes in great detail both the landscape of Hangzhou and West Lake and the cultural activities that took place at the Southern Song capital."[1] Moreover, with the arts, context can only yield partial explanations of the essential mystery locked in creativity. Suffice here to generalize. The city of Hangzhou in the late twelfth and early thirteenth centuries, the socioeconomic world in which so far as we can guess Ma Yuan spent most if not all of his life, was one of the most sophisticated urban/natural environments that has ever been created: the structure, the commerce, the political push and pull, wealth and poverty, philosophy and religion, the din in crowded streets, the garden spaces, grand temples and great palaces, room for quietness and contemplation

[1] Lee, *Exquisite Moments* (2001), p. 20. For an extensive picture of the city close to Ma Yuan's time see Gernet, *Daily Life* (1962).

near city walls or in surrounding hills. It was an unusual urban setting that brought close the urgency of the ocean-directed Zhe, or Qiantang River as it was called in Hangzhou, with its famous tide bore on one side and on the other the calm of West Lake, rimmed by hill and mountain bringing into view their shifting atmospheric effects. One might claim walking distance to "mountain-water" (*shanshui* 山水), the term that defined the traditional Chinese idea of a landscape, and there could draw extension well beyond to prospects rural and wild. The reconstructed Song imperial palace, backed by the river and overlooking city and lake, was now placed to the east on the commanding height of Phoenix Mountain, its majestic gates and soaring roofs partially hidden by enduring green, much of which was known as a Hill of Ten Thousand Pines. Hangzhou itself carried the name Lin'an 臨安, "approaching peace," also to be translated as "temporary peace" ("temporary" for 150 years).

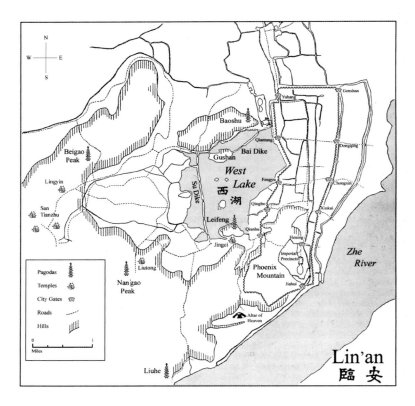

While art never occurs in a vacuum nor need one praise isolation for its own sake, it must be faced directly. Each of the arts comes wrapped in its own medium: the word of the poet, the musician's instrument, the sculptor's chisel, the brush of the painter, the plan and elevation of the architect. With the potter it is clay; the weaver, the loom; the dance,

the body. In turn responses differ. All end in the mind, many directly, others with indirection, some with apparent immediacy, others over time. Whatever the response, the anchor must be the medium itself, respect for the artist's choice. Leo Bronstein, the much-loved elder colleague of my Brandeis days, honed this for me to brevities: We know the "what" and we know the "how." It is the "what-of-the-how" that matters.

In confronting the artist of the past, one enters a different time and, by so doing, enters the world of history. It is not just "art" but now art woven into the complex fabric of times past. As it becomes history, we must accept its dual function, the history of art. As such the non-verbal arts offer a unique contribution — tangibility. In this they differ from words which, however wonderful, generally are about things, not the thing itself. Only when the written word is closely bound to its calligraphy, a one-time creation, does it enter the unique world of visual tangibility, a direct door to the what-of-the how. Long before the written world freed us to a different kind of history, it was what could be seen and touched, the preserved object, including the lived-in cave and architectural foundations, that told of man's creativity and framed an understanding of early human life. This included what was made of stone, of clay, of earth and bone, more rarely of other perishable materials, of fiber, wood, or even paint. When the physical object was supplemented by the discovery that vanishing speech could be captured by a written word, history acquired a far more expanded and flexible channel to the human mind. Still the visual arts remained and in preservation offered in their concrete forms a unique certainty of fact: the fact that can be touched. Running through all historical writing is the essential dialectic presented by the search for factual evidence and the necessity to refine and direct the fact toward the realm of ideas — facts and ideas. Thus the concreteness of visual fact, the enduring presence, can play a special role. Neither fact nor idea can stand alone. It is ideas about facts that anchor truth.

Here in special focus our study is narrowed to painting: in this case the painting of a single artist. Others are drawn in, but it is essentially the work of a single artist, Ma Yuan, that anchors the argument. Its true beginning is a painting. It ends — often after a long journey of comparative exploration — with painting.

Acknowledgments

This work has evolved over many years but I especially thank the following who have helped see the work to its conclusion.

My children Larry in St. Paul, Minnesota, Margo in Birmingham, England and Joan in Williamstown, Massachusetts all provided basic support. However a special thanks to Joan who was closest to the whole operation both in concept and detail.

In Taiwan Tom Smith and Chou Fang-mei have read with expert critical care both the draft and its final versions, giving special attention to Chinese characters.

Wendy Holden provided invaluable and constant help in Ann Arbor, with meticulous attention to details in organizing the many images, preparing digital images for reproduction, thoroughly checking the galley proofs, and finally indexing the text.

In Hong Kong, Michael Duckworth, Colin Day and Dawn Lau all of Hong Kong University Press provided enthusiasm and helped move the book in a timely way as did Cho-Yee To (Du Zhuyi).

Many people contributed to organizing and obtaining the three-hundred-plus images. In addition to photographing original art and images from books, Patrick Young created several digital image composites. Private collectors including Wan-go Weng, Yutaka Takahashi, and John Rosenfield were generous in granting reproduction permissions. Museum curators in this country and in Asia provided time and expertise. In this country they include Maxwell Hearn of the Metropolitan Museum of Art, Hao Sheng of the Boston Museum of Fine Arts, Joseph Chang of the Freer Gallery, Smithsonian Institution in Washington, D.C., Elinor Pearlstein of the Chicago Institute of Art, Hou-mei Sung of the Cincinnati Museum of Arts, and Robert Jacobsen of the Minneapolis Institute of Arts. In Japan they include Hiromitsu Ogawa of the Institute of Oriental Culture at the University of Tokyo, Hideaki Kunigou of Tokyo National Museum,

and Shoko Hasegawa of the Seikadō Bunko Art Museum, Tokyo. In the Nara/Kyoto area Minoru Nishigami of the Kyoto National Museum, Kiyoshi Toyama of the Sumitomo Collection, Sen-Oku Hakuko Kan, Hokuen Yoshida of Nanzen-ji Temple, Kyoto, and Mr. Tsukamoto, curator of Chinese painting at the Museum Yamato Bunkakan in Nara provided valuable assistance with reproductions and permission to publish. In Europe, Giovanni Pagliarulo of the Berenson Collection, Florence is thanked. Behind the scenes were many museum registrars, curatorial assistants and librarians who processed complex orders for photography. Special thanks go to Stacey Sherman of the Kansas City Museum of Art, Kari Smith at the University of Michigan Visual Resources Collections, and Deidre Spencer of the University of Michigan History of Art Library.

Finally, a deep thanks to friends and colleagues too numerous to acknowledge individually. I know they will understand.

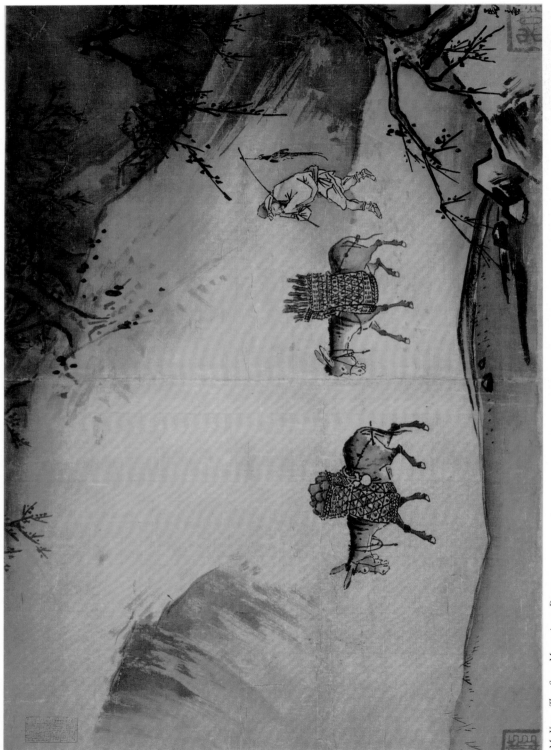

1. Ma Yuan, *Thru Snow Mountains at Dawn*

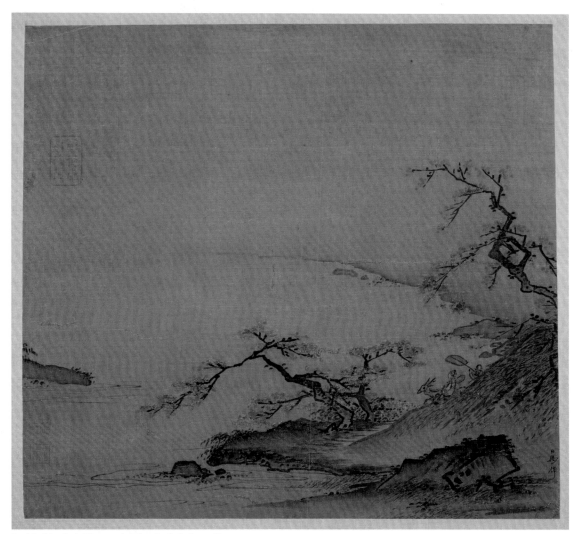

2a. Ma Lin, *Lake View with Palace Lady Riding a Deer*

騎龍重玉過溪頭
紅葉還春碧水流
省得壺中見天地
壺中天地不曾秋

2b. Emperor Lizong, *Calligraphy of a Quatrain in Semi-Cursive and Regular Scripts*

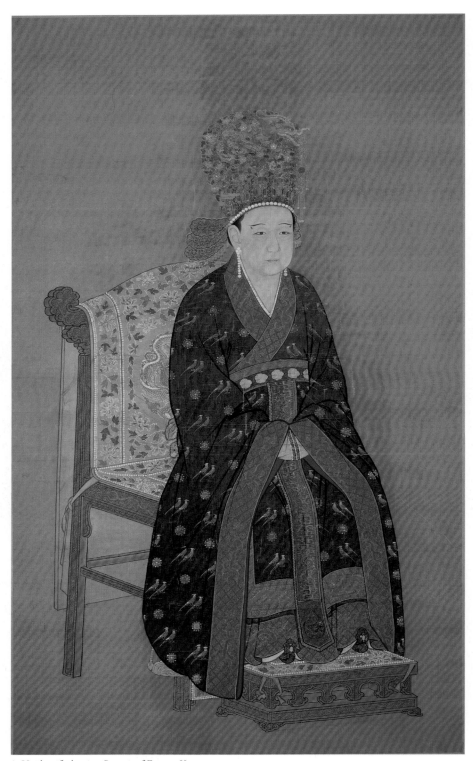

3. Unidentified artist, *Portrait of Empress Yang*

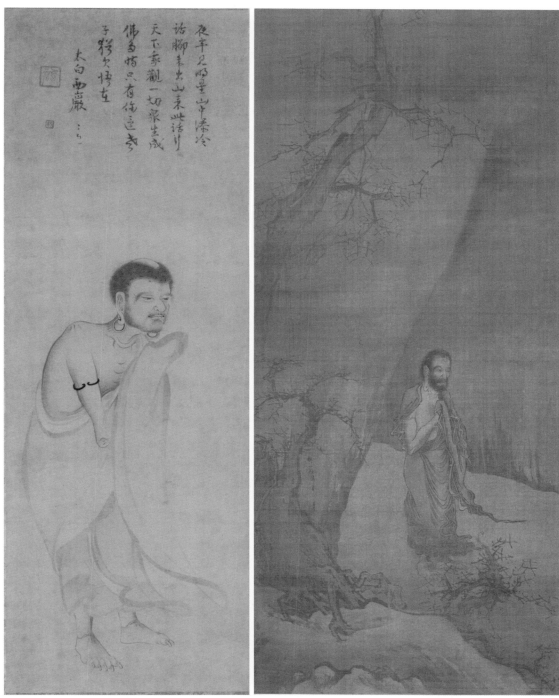

夜半只明星午添冷
诺脚未出山来此活计
天下豪觀一切衆生成
佛多姑只者佐逗考
子彩欠悟了左
太白西巌

4a. Unidentified artist, *Sakyamuni Emerging from the Mountain*

4b. Liang Kai, *Sakyamuni Emerging from the Mountain*

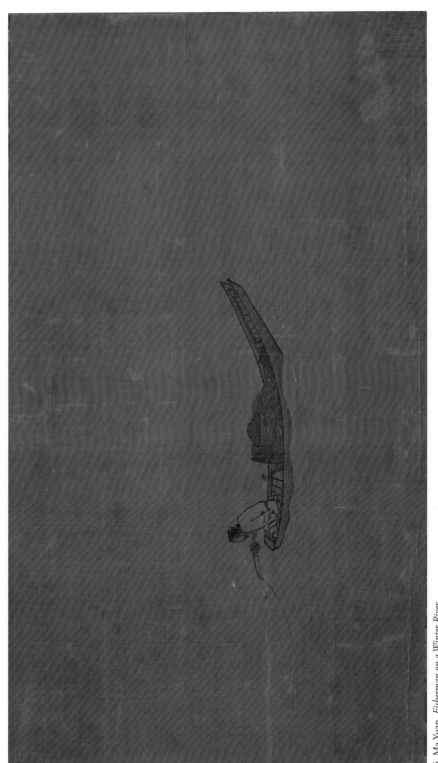

5. Ma Yuan, *Fisherman on a Winter River*

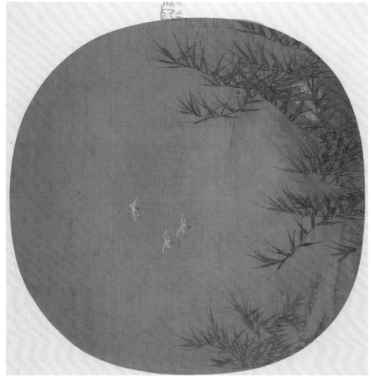

6b. Unidentified artist, *Egrets in Water Reeds*

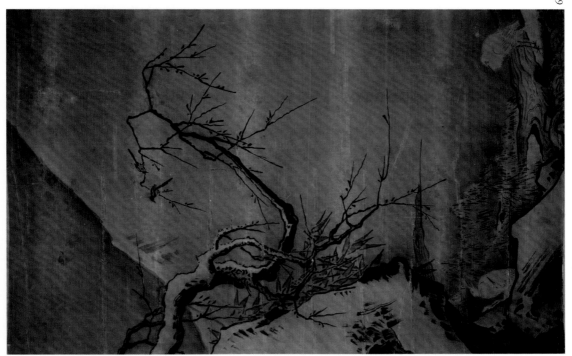

6a. Ma Yuan, *Egrets in Winter*

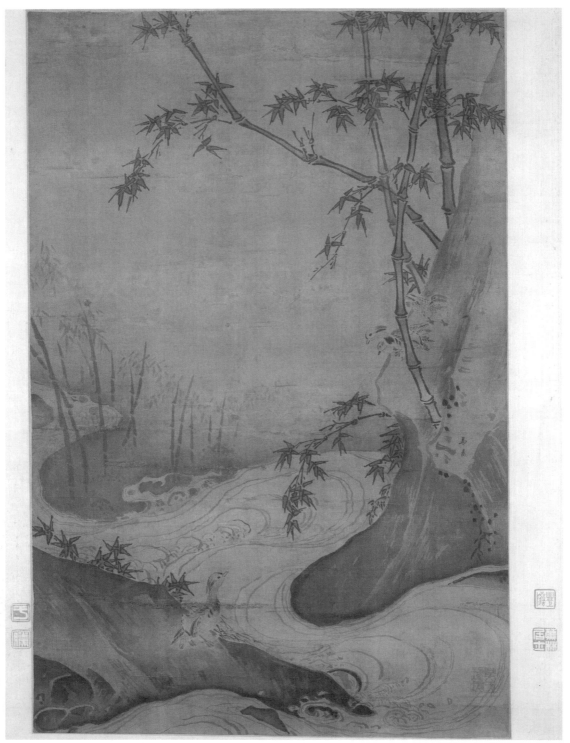

7. Ma Yuan, *Mandarin Ducks by a Bamboo Stream*

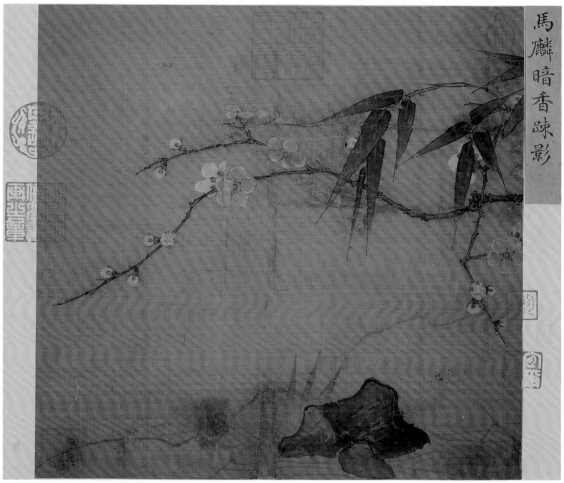

馬麟暗香疎影

10. Ma Lin, attributed, *Sparse Shadows, Hidden Fragrance*

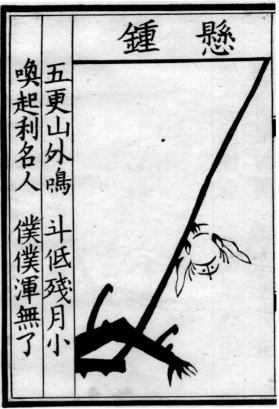
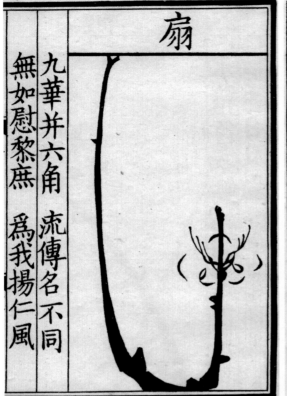

扇

九華并六角　流傳名不同
無如慰黎庶　爲我揚仁風

懸鍾

五更山外鳴　斗低殘月小
喚起利名人　僕僕渾無了

11. Song Boren, *Manual of Plum Blossom Likenesses* (Two leaves: "Suspended Bell" and "Fan")

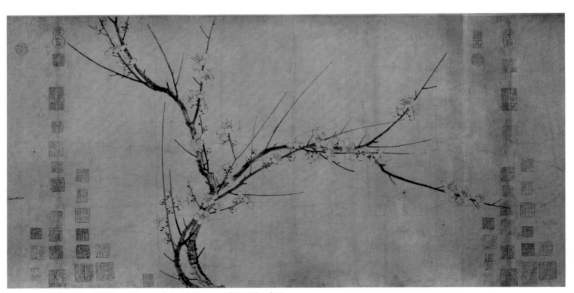

12. Yang Wujiu (Buzhi), *Four Views of the Flowering Plum: Third View*

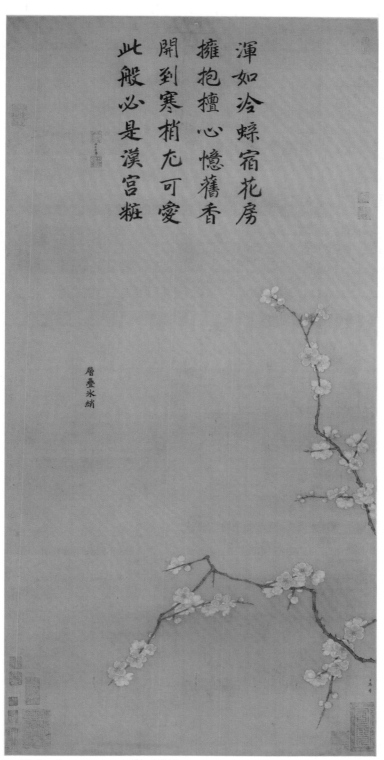

渾如泠蛱宿花房
擁抱檀心憶舊香
開到寒梢尤可愛
此般必是漢宮粧

層疊冰綃

13. Ma Lin, *Layer upon Layer of Icy Silk Tips*

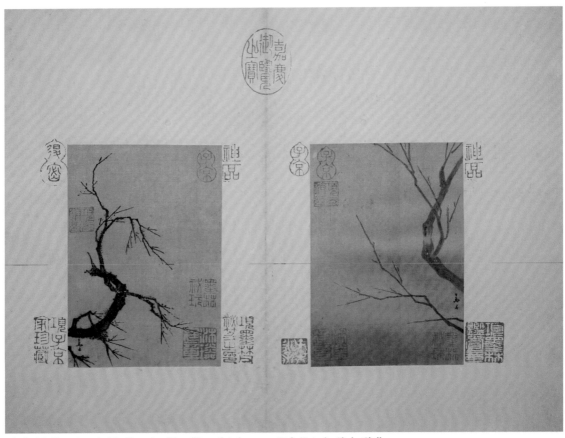

14a, b. Ma Yuan (copy), *The Flowering Plum* (Two of six leaves: a. *Light Rain*; b. *Slight Chill*)

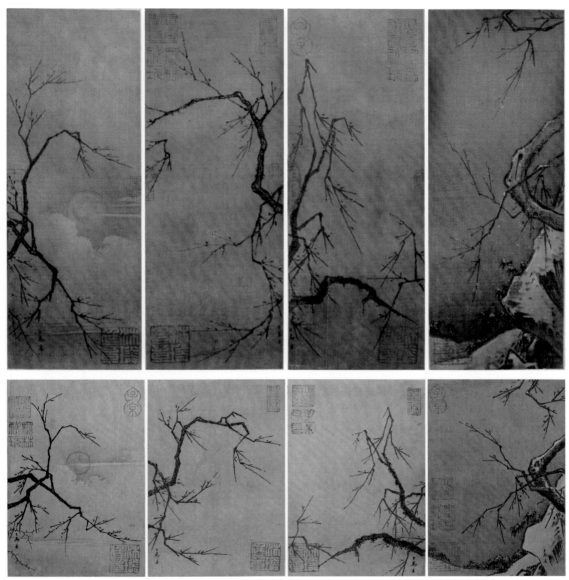

15a, b, c, d. Ma Yuan comparisons: Selection from *Moments of the Flowering Plum* (above); *The Flowering Plum* (below)

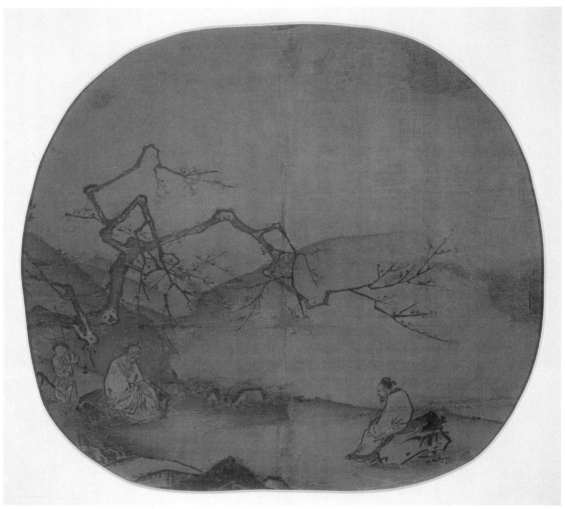

16. Ma Yuan, *Scholars Conversing beneath Blossoming Plum Tree*

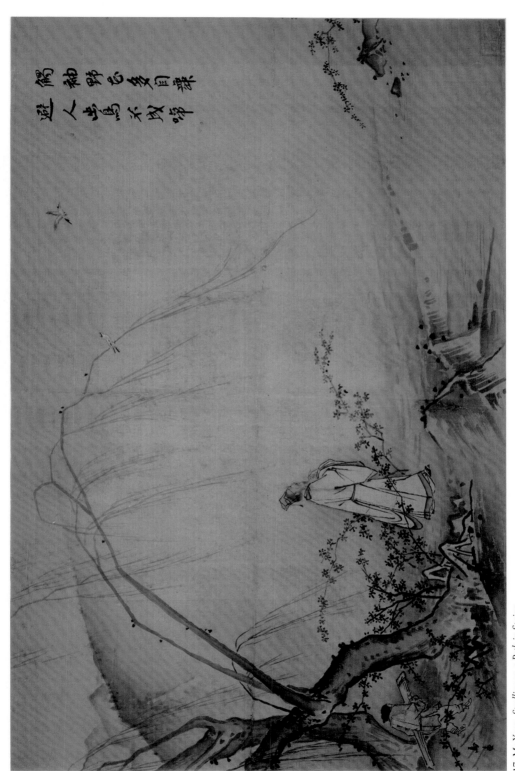

17. Ma Yuan, *Strolling on a Path in Spring*

秋風融日滿東籬萬疊輕紅簇
翠枝若使芳姿同眾色無人知
是小春時

18. Unidentified artist, *Peach Blossom Chrysanthemum*

綠撚依依綠
金垂裊裊黃

19. Unidentified artist, *Golden Catkins of the Weeping Willow*

迎風呈巧媚
浥露逞紅妍

20. Ma Yuan, *Apricot Blossoms*

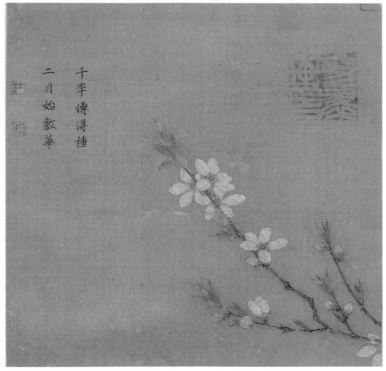

千李傳得種
二月始敷華

21. Ma Yuan, *Peach Blossoms*

22. Ma Yuan, *Water*
Title: Li Dongyang (1477–1516)

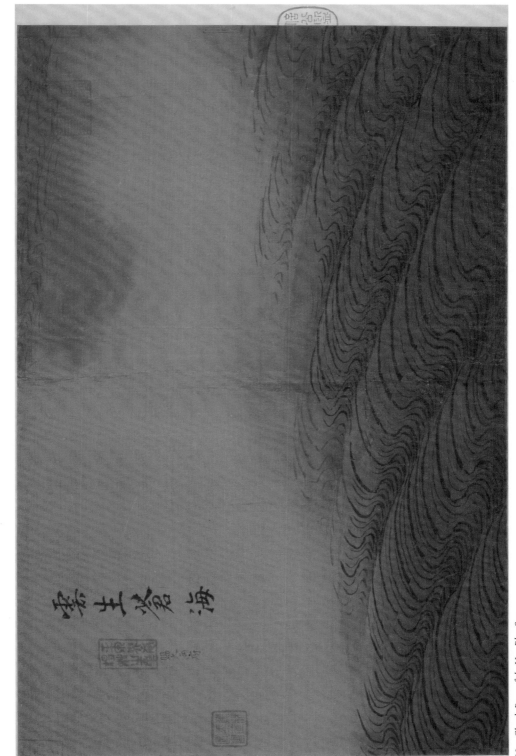

22a: *Clouds Born of the Vast Blue Sea*

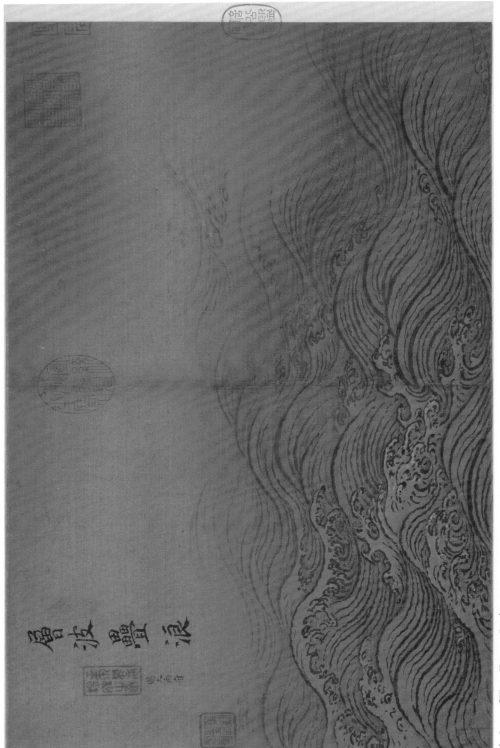

22b: *Layers of Waves, Towering Breakers*

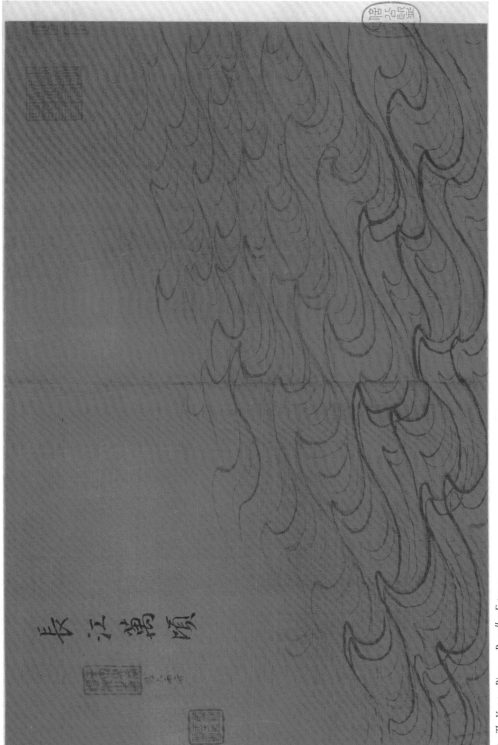

22c: *The Yangtze River — Boundless Expanse*

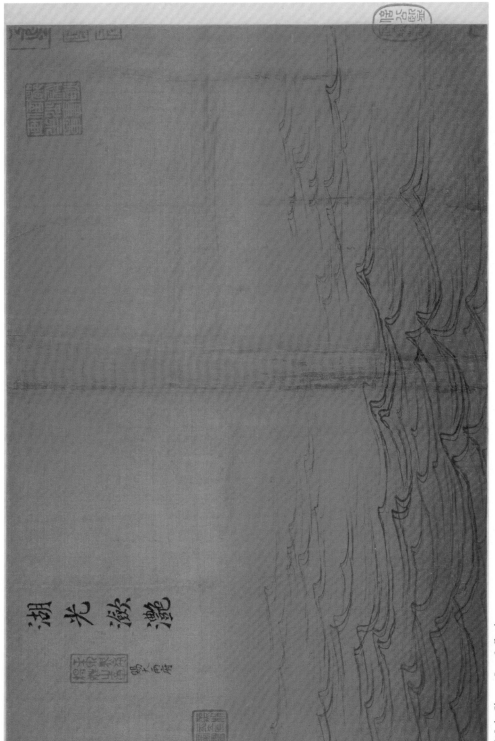

湖光瀲灩

22d: *Lake Glow — Rain Suffused*

22e: *Winter Pool, Clear and Shoal*

22f. *A Rising Sun Warms the Mountains*

22g: *Clouds Unfurling, a Wave Breaking*

22h: *Waves Weave Winds of Gold* (half preserved)

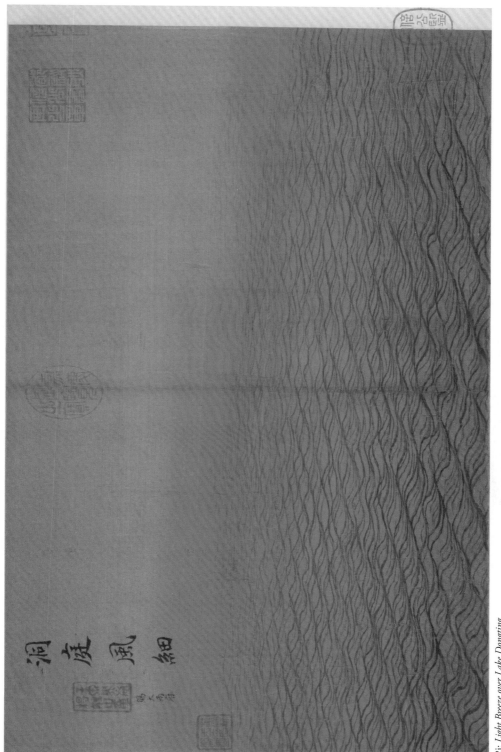

22i: Light Breeze over Lake Dongting

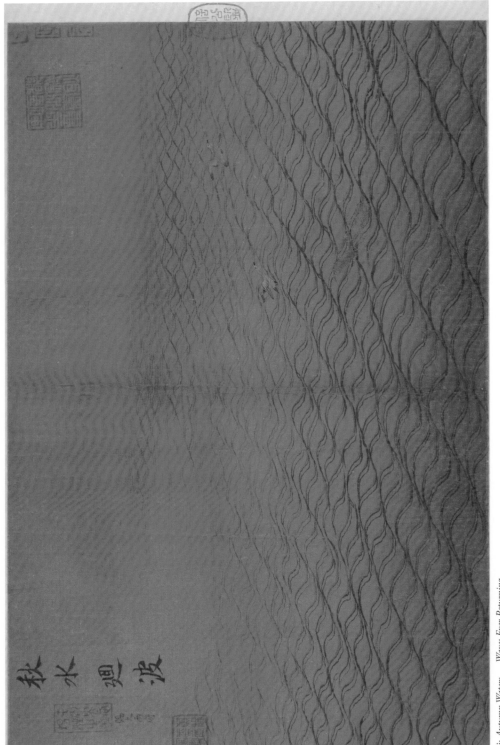

22j: *Autumn Waters — Waves Ever Returning*

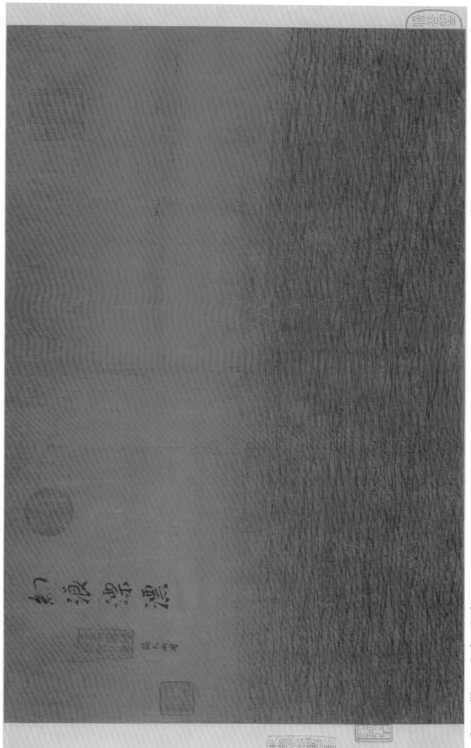

22k: *Gossamer Waves — Drifting, Drifting*

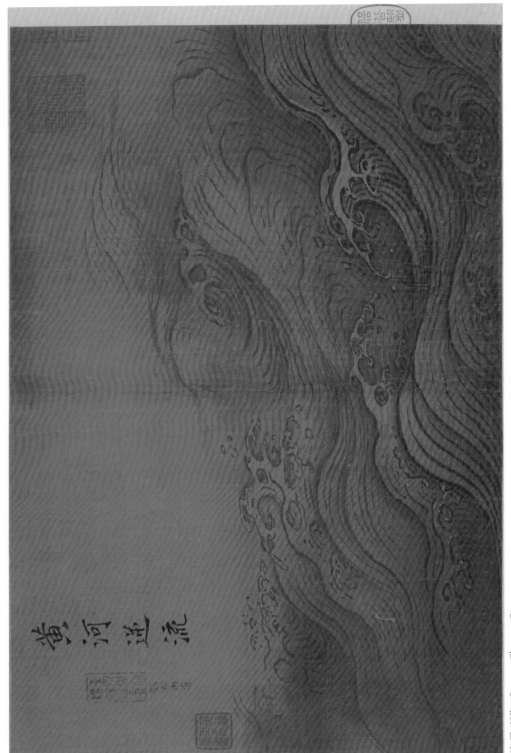

221: *The Yellow River — Churning Currents*

22. Colophons

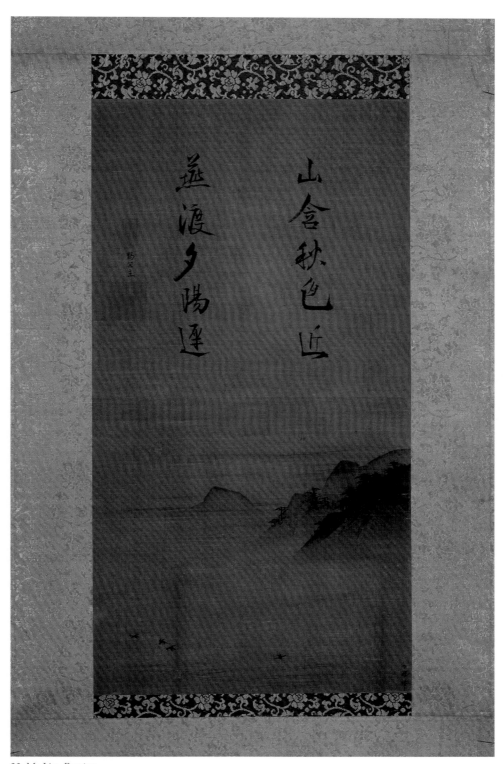

23. Ma Lin, *Evening*

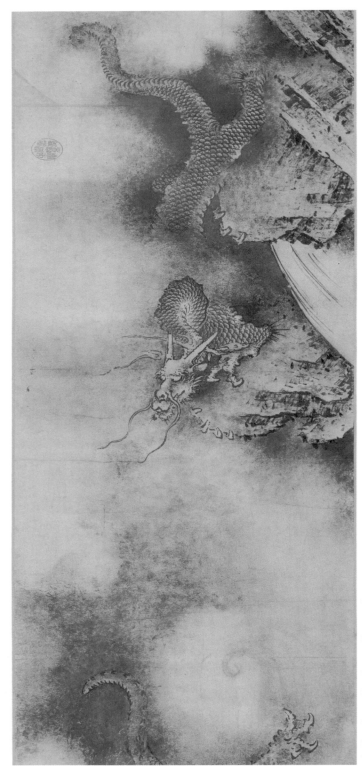

24. Chen Rong, *Nine Dragons* (Section 1)

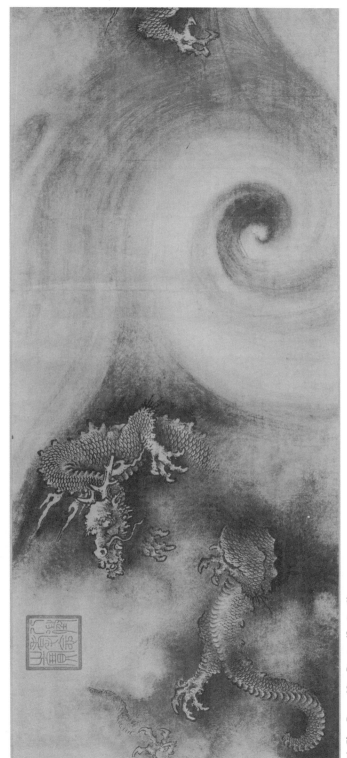

24. Chen Rong, *Nine Dragons* (Section 2)

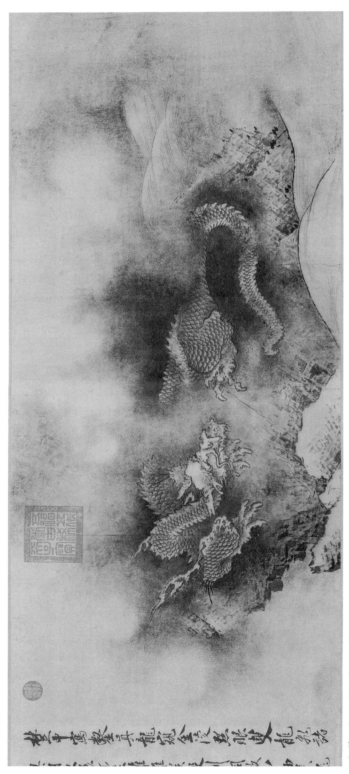

24. Chen Rong, *Nine Dragons* (Section 3)

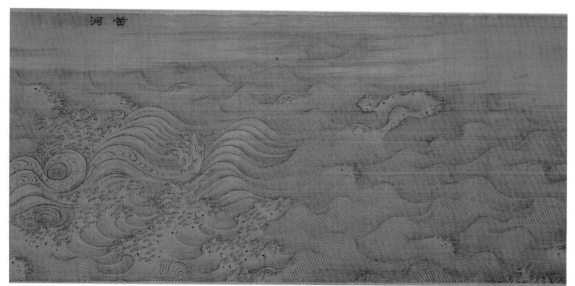

25a. Unidentified artist, *Twenty Views of Water* (Section: *The Yellow River*)

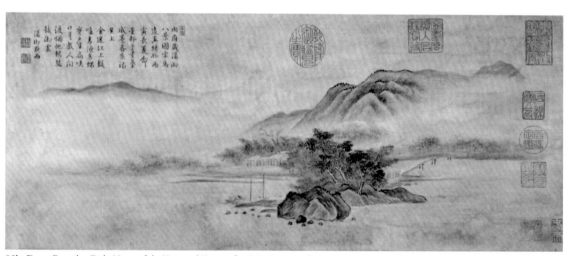

25b. Dong Bangda, *Eight Views of the Xiao and Xiang*, after Ma Yuan: *Night Rain*

攜藤撥草瞻風

未免登山涉水

不知觸處皆渠

一見低頭自喜

26a. Ma Yuan, *Dongshan Liangjie Crossing the Water*

休認空花水月
若了萬法唯心
畢竟是同是別
大地山河自然

26b. Ma Yuan, *Yunmen Wenyan and His Teacher Xuefeng Yicun*

唯有韶陽不畏
擬議�ّ須喪身
出草長噴毒氣
南山深藏鼇鼻

26c. Ma Yuan, *Fayan Wenyi and His Teacher Luohan Guichen*

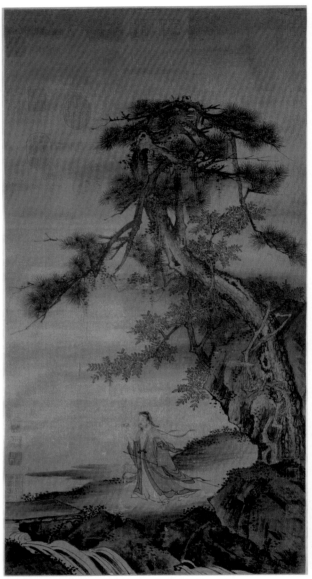

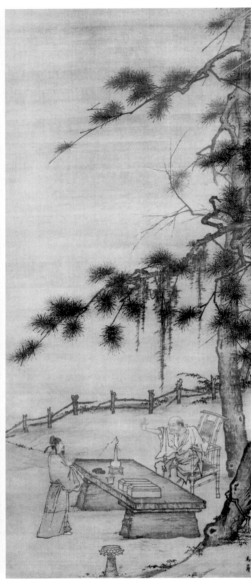

27. Liang Kai, *Scholar of the Eastern Fence: Tao Yuanming*

28. Ma Gongxian, *Li Ao and Yaoshan: Question — Answer*

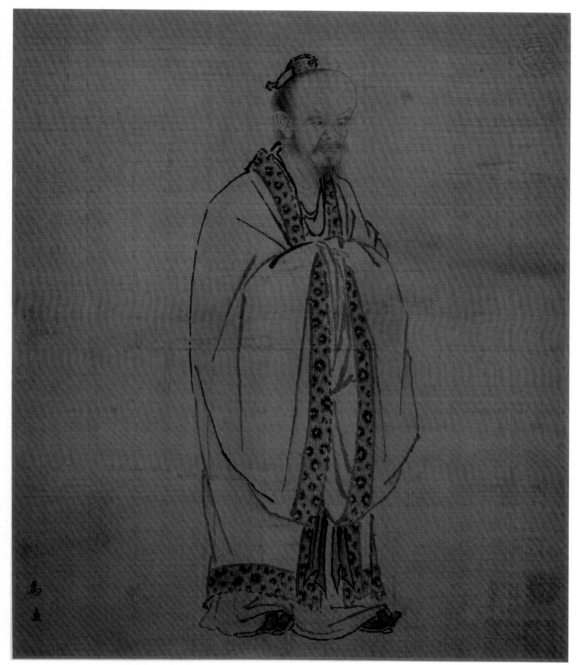

29a. Ma Yuan (genuine or close copy), *Confucius*

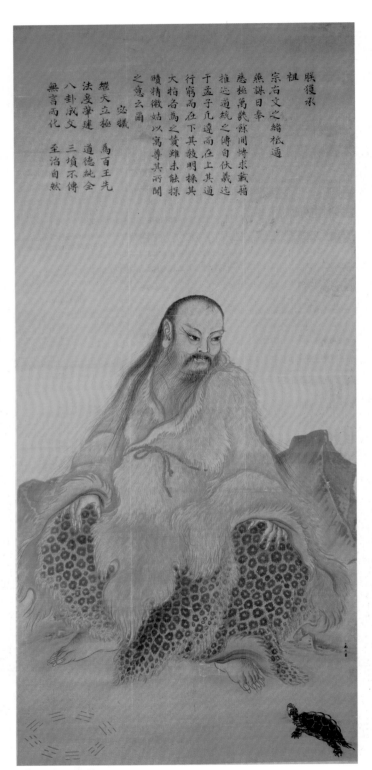

29b. Ma Lin, *Fu Xi*

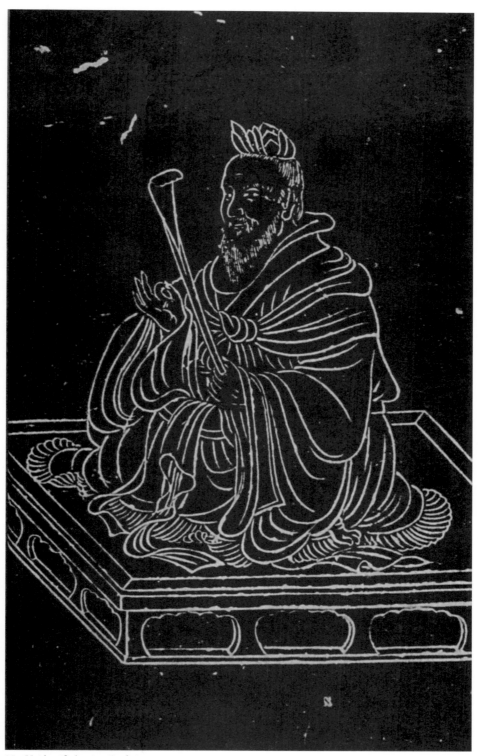

30a. Unidentified artist, *Confucius*

30b. Unidentified artist, *Disciples: Presenting the Human Figure*

31. Ma Yuan, formerly attributed, *Confucius' Encounter with the Hermit Rong Qiqi*

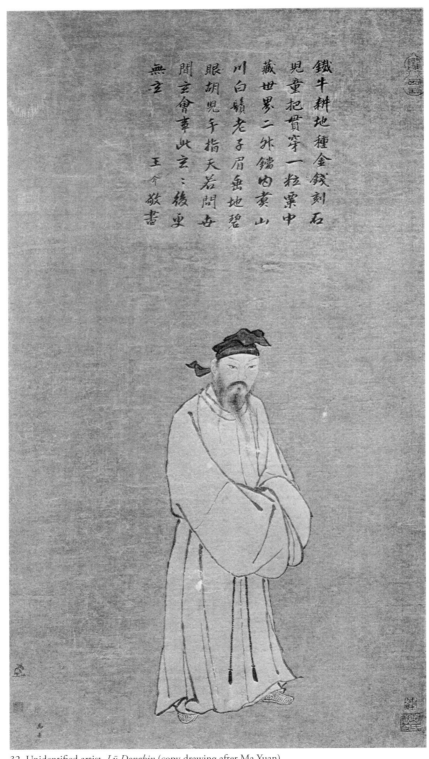

鐵牛耕地種金錢刻石
兒童把貫穿一粒粟中
藏世界二外鑄內黃山
川白嶺老子眉岳地碧
眼胡兒手指天若問岳
間玄會事此玄三後更
無言　　王介敬書

32. Unidentified artist, *Lü Dongbin* (copy drawing after Ma Yuan)

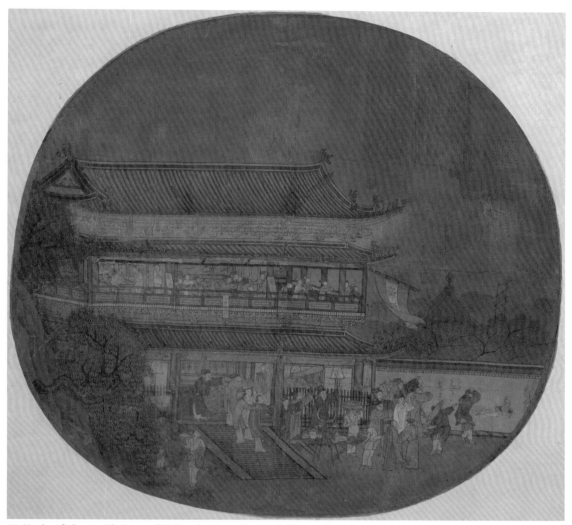

33. Unidentified artist, *The Immortal Lü Dongbin Appearing over the Yueyang Pavilion*

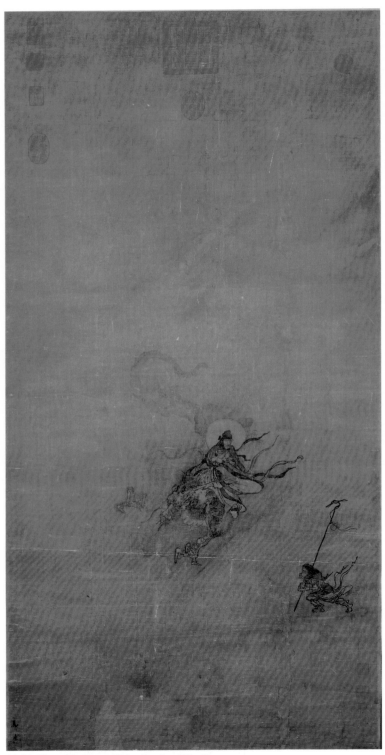

34. Ma Yuan, *The Dragon Rider: Laozi and Yin Xi*

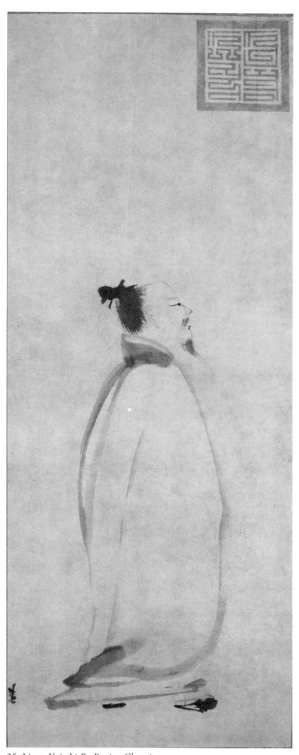

35. Liang Kai, *Li Bo Passing Chanting*

36. Wu Zongyuan, *Homage to the Primordial*

老君在太清境處无為三十六天之尊也在人
世愛化為曆代帝王師自天地初分已後自然
錫歸玄中法師下教經九千九百億萬歲時君
臣皆禀食霓霞諸恩未生之年也
金德任真而已蓋龍漢之先也以上清之道開
度兆人彼在龍漢後為延康劫也時天地將壞
也為一大劫

古先生記
老君在莆三皇時有古先生下教經九千九百
億萬歲時天生甘露地涌醴泉食之長生人壽
六萬歲天地平正無有山河人皆長大慈心一
切盖赤明之劫矣以靈寶法度諸男女經大劫
之周天又壞先以火燒次以洪水蕩除然後
歲凤大起除故就新更立元始歸為開皇之初
也以洞神法化度天人

金闕帝君
老君拎遬人時歸金闕帝君下為師經萬八千
歲敎以改火益新之道人無屋室狌獸客人人
皆巢居冬乃穴處庱生為熟不歸為開皇劫矣

蕊華子
老君拎伏羲氏時歸為蕊華子人壽三萬六千
歲說元陽經教以順性之道伏羲行之制嫁娶
序人倫始畫八卦造書契以代結繩時景昱見
祥靈生兆民悅

大成子
老君拎神農時歸九靈老君六歸六成子說元
精經敎以好生之道神農行之播種百穀以代
烹殺之苦躬嘗萬草敎物理人時得嘉禾生醴
泉涌為歇不妖物無傷害

廣壽子
老君拎祝融時歸廣壽子說按摩道精經敎安
神之道祝融行之重禮樂配陰陽陶鑄彖器以
慶生冷之毒時有慶雲見朱鳳呈祥

廣成子
老君拎軒轅黃帝時在崆峒山歸廣成子說至
道泰生經詣山親聞理國之道戰蚩尤歸九
鼎鼎成而白日上昇

真行子

37. Wang Liyong, *The Transformations of Lord Lao* (sections 1, 2, 3)

真行子
老君於帝堯時歸真行子說靈寶經教以養物
好生之道帝行之闢四門明四目朱草蘖生鳳
凰頻見
玄珪

噄邑子
老君於帝舜時歸噄邑子說太清經教以孝順
仁信之道帝行之獮岑出祺薦見理七十年年
一百一十歲

務成子
老君於夏禹時歸務成子說開天經教以理化
之道帝行之治滔滔之水鑿龍門尊九河手足
胼胝啓呼呱而泣三歲過門不顧功成得天錫
玄珪

傳預子
老君於毅湯時歸傳預子說靈寶經教以順性
養生之道帝行之遇陽九而不屬炎患桑穀生
而自清甘露降醴泉涌丹甈荷秋

胼胝啓呼呱而泣三歲過門不顧功成得天錫
玄珪

37. Wang Liyong, *The Transformations of Lord Lao* (sections 4, 5)

38a. Liang Kai, *Liberating the Soul from the Netherworld*

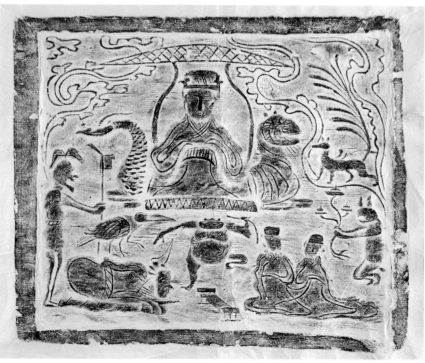

38b. *Tomb Tile with Queen Mother of the West*

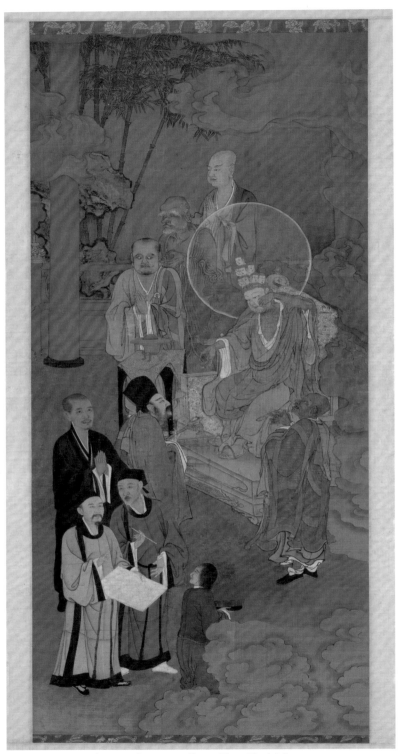

39. Zhou Jichang, *Lohan Manifesting Himself as an Eleven-Headed Guanyin*

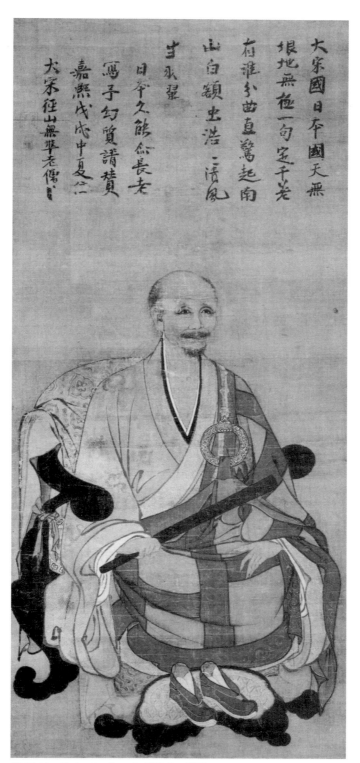

大宋國日本國天無
根地無他一句定千差
右准不曲直鷲起南
山白額虫浩一清風
巾承望
日峯久飫瓜長老
寫子幻質請贊
嘉熙戊戌中夏□
大宋徑山無準老儻

40. Unidentified artist, *Portrait of Wuzhun Shifan*

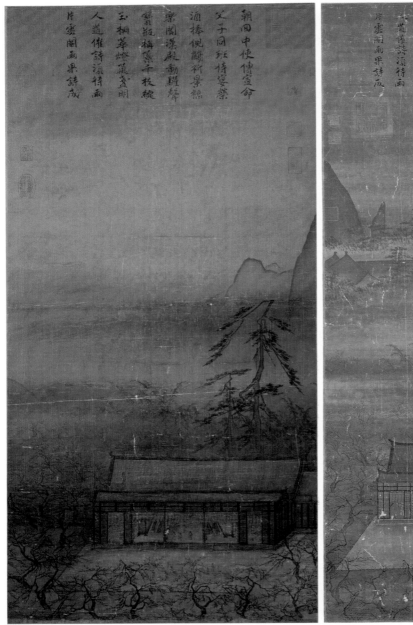

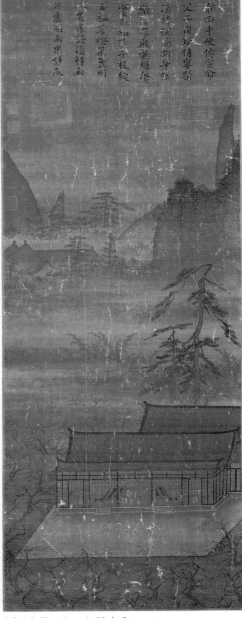

朝回中使傳宣命
父子同班侍宴榮
酒捧倪觴祈景福
樂聞漢殿動鈞韶
綴香飯梅繁千枝綻
玉棚擎燈麗且明
人道催詩須待雨
片雲閣兩果詩成

朝回中使傳宣命
父子同班侍宴榮
酒捧倪觴祈景福
樂聞漢殿動鈞韶
綴香飯梅繁千枝綻
玉棚擎燈麗且明
人道催詩須待雨
片雲閣兩果詩成

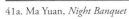

41a. Ma Yuan, *Night Banquet* 41b. Ma Yuan (copy), *Night Banquet*

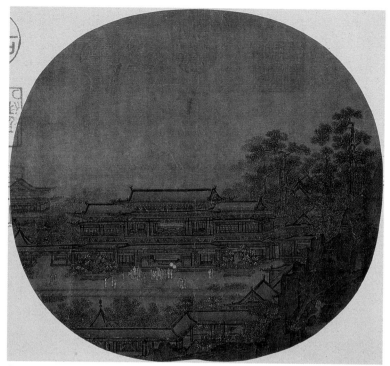

42. Unidentified artist, attributed to Guo Zhongshu, *Emperor Minghuang's Flight to Shu*

43. Ma Yuan, *Bare Willows and Distant Mountains*

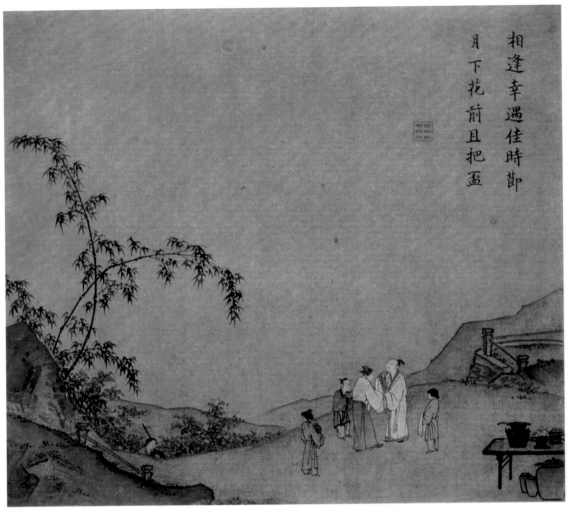

相逢幸遇佳時節
月下花前且把盃

44a. Ma Yuan, attributed, *Grasping the Wine Cup*

涼天佳月即中秋
豈但中秋堪宴賞
萬境相侵一笑休
人能無著便無愁

44b. Empress Yang, Poem: "A Cool Day, a Fine Moon"

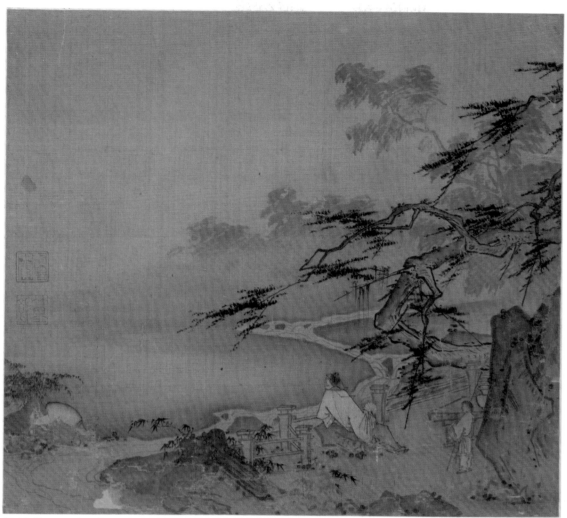

45. Ma Yuan, attributed, *Watching the Deer by a Pine-Shaded Stream*

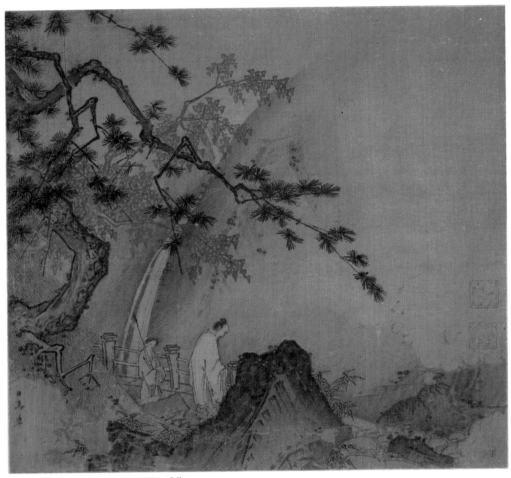

46a. Ma Yuan, *Scholar Viewing a Waterfall*

46b. Ding Yefu, attributed,
Viewing a Waterfall

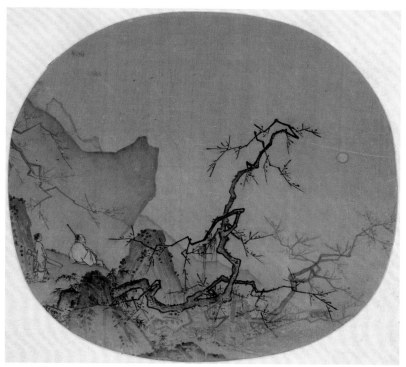

47. Ma Yuan, *Viewing Plum Blossoms by Moonlight*

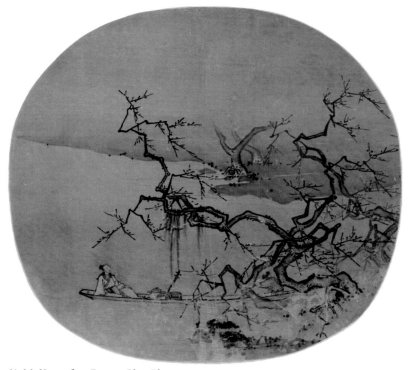

48. Ma Yuan, after, *Enjoying Plum Blossoms*

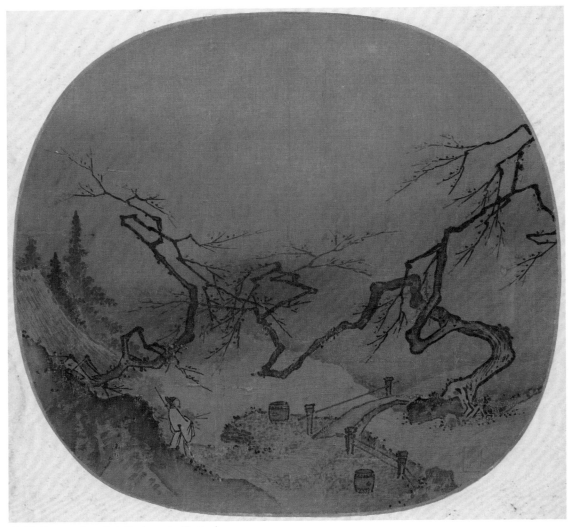

49. Ma Yuan, attributed, *A Gentleman in His Garden*

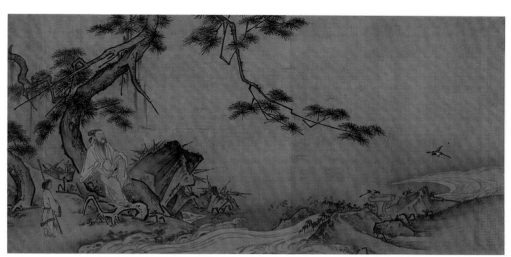

50. Ma Yuan, attributed, *Pine Stream and Paired Birds*

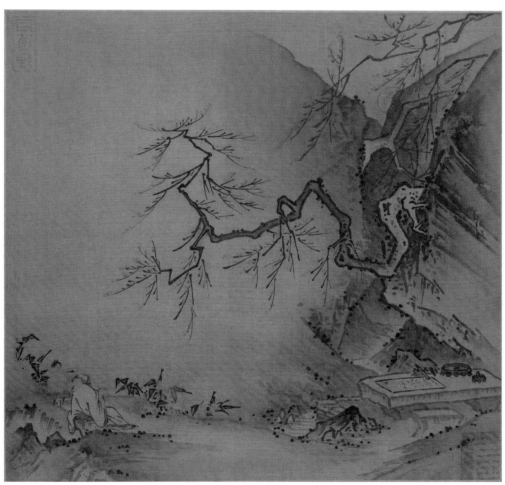

51. Ma Yuan, attributed, *Drinking in the Moonlight*

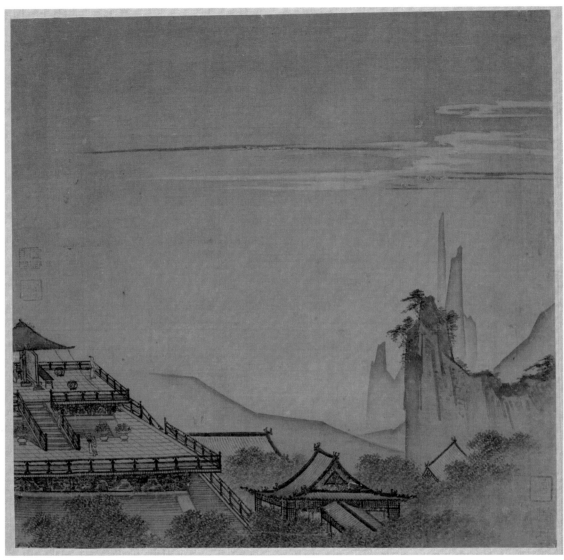

52. Ma Yuan, attributed, *Viewing Sunset from a Palace Terrace*

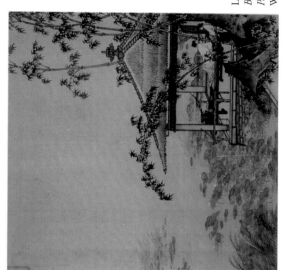

53. Ma Yuan, after
*Landscape Album
Paired with Imperial
Poetry Inscriptions*

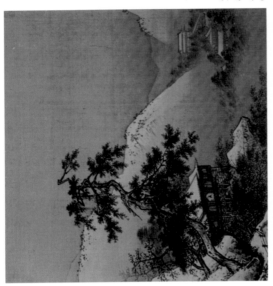

53 Leaf e: *Rosy Clouds over Green Mountains at Dusk*; Poem from Yang Wanli

53 Leaf f: *Spring Gazing from the High Terrace*; Poem from Emperor Huizong

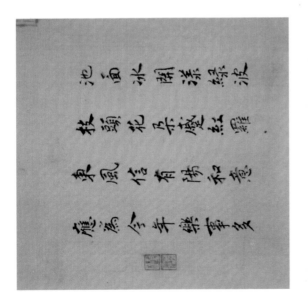

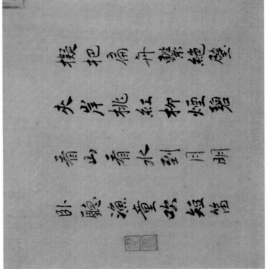

53 Leaf i: *The Long-Lived Locust Tree;*
Poem source not identified

53 Leaf j: *Discussing Dao under the Pines;*
Poem from Shao Yong

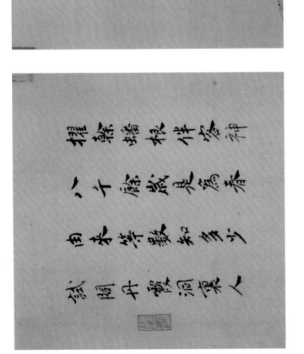

何止千年與萬年
歲寒松桂獨依然
若無橋子天人學
安有群生內外篇

攢攢攢露根春少
八千餘歲是為春
閱井寒霜格知多少
試問寒潭人

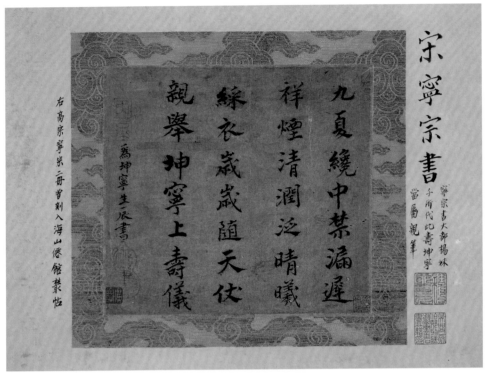

54. Emperor Ningzong, *Celebrating the Birthday of Empress Yang*

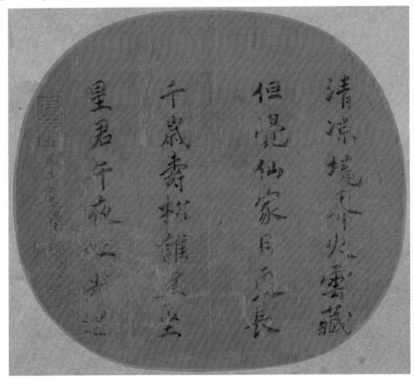

55. Yang Meizi, *Quatrain on Immortality*

56a and b.
After Ma Yuan, *Listening to the Bamboo in the Water Pavilion*, from *Landscape Album Paired with Imperial Poetry Inscriptions*
a: Collection unknown
b: Private Collection (Pl. 53b)

56a

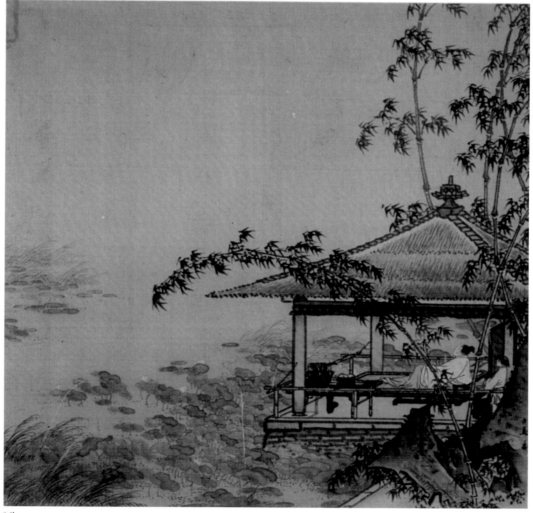

56b

57 Leaf a

57 Leaf i

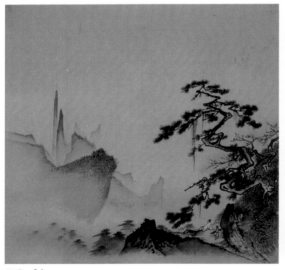

57 Leaf d

好山幸自綠巉巉
須把輕雲護淺嵐
天女似憐山骨瘦
為縫霧縠作春衫

57. Ma Yuan, after, *Landscape Album Paired with Imperial Poetry Inscriptions*

Above: Leaves a: *Whiling Away the Summer by the Lotus Pond* and i: *The Long-Lived Locust Tree*
Below: Leaf d: *Gazing at Spring Mountains*; Poem from Yang Wanli

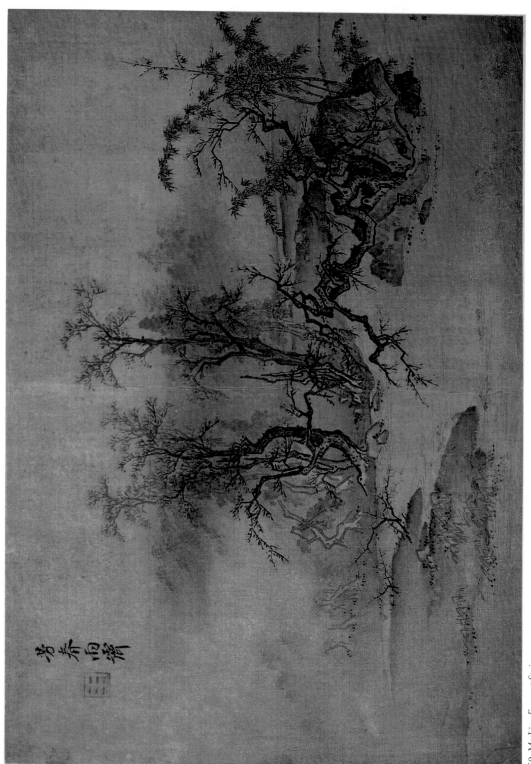

59. Ma Lin, *Fragrant Spring*

60a. Ma Lin, *Sitting to Watch the Time the Clouds Arise*

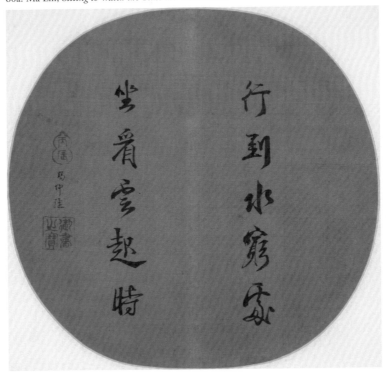

60b. Emperor Lizong, *Couplet from Wang Wei*

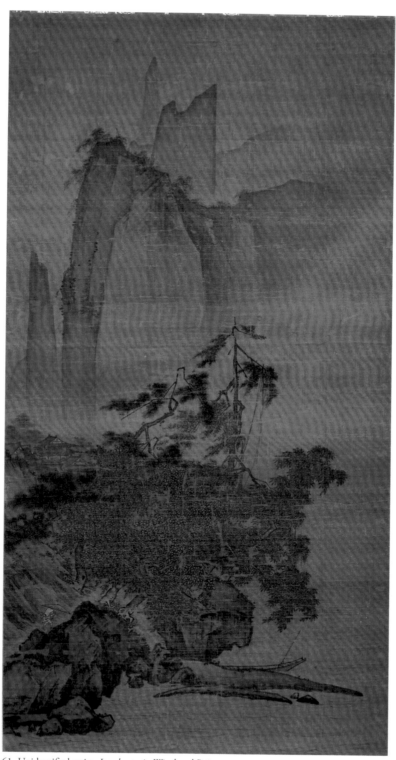

61. Unidentified artist, *Landscape in Wind and Rain*

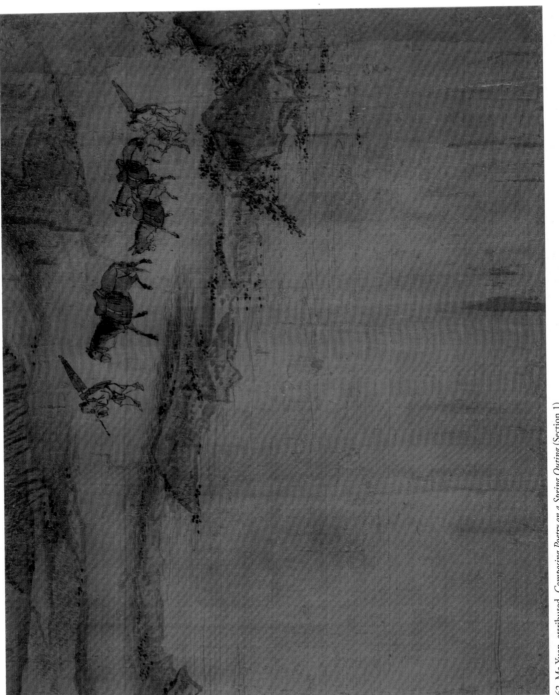

62. Ma Yuan, attributed, *Composing Poetry on a Spring Outing* (Section 1)

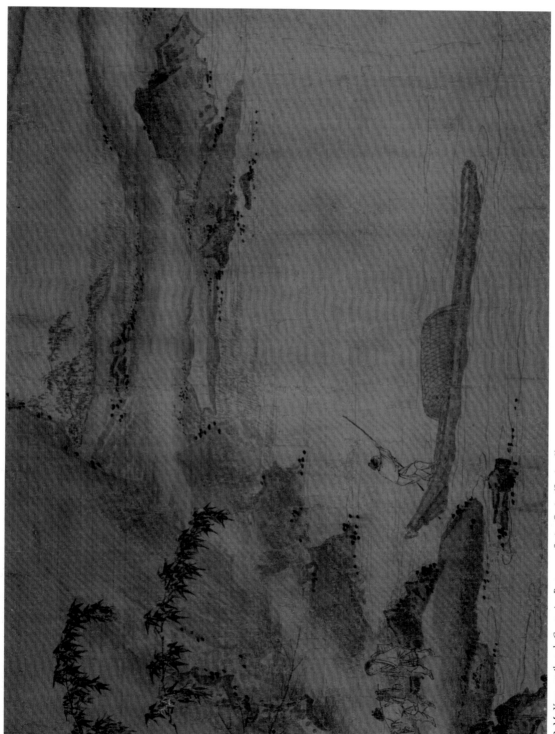

62. Ma Yuan, attributed, *Composing Poetry on a Spring Outing* (Section 2)

62. Ma Yuan, attributed, *Composing Poetry on a Spring Outing* (Section 3)

62. Ma Yuan, attributed, *Composing Poetry on a Spring Outing* (Section 4)

62. Ma Yuan, attributed, *Composing Poetry on a Spring Outing* (Section 5)

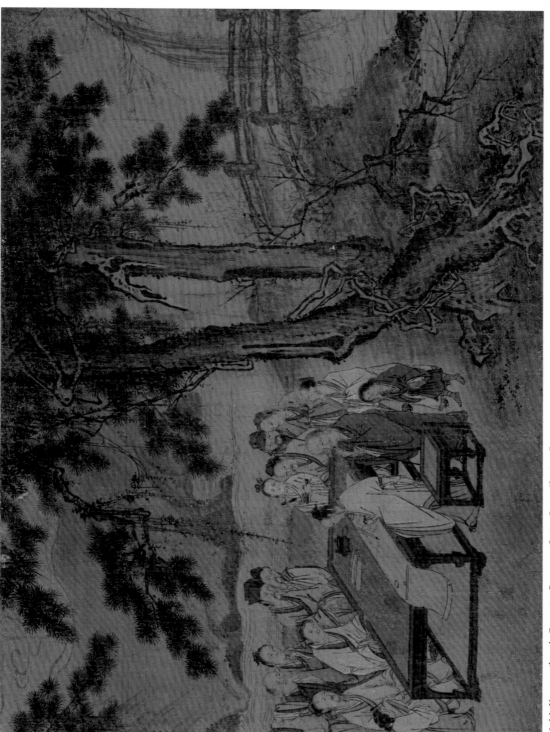

62. Ma Yuan, attributed, *Composing Poetry on a Spring Outing* (Section 6)

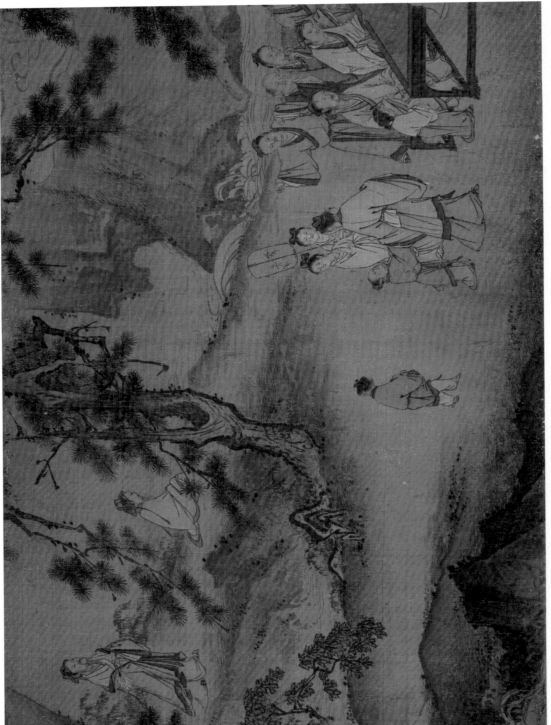

62. Ma Yuan, attributed, *Composing Poetry on a Spring Outing* (Section 7)

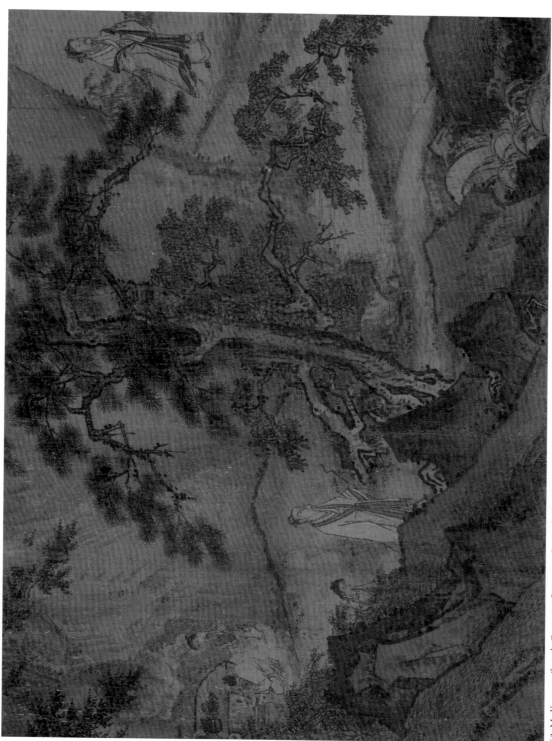

62. Ma Yuan, attributed, *Composing Poetry on a Spring Outing* (Section 8)

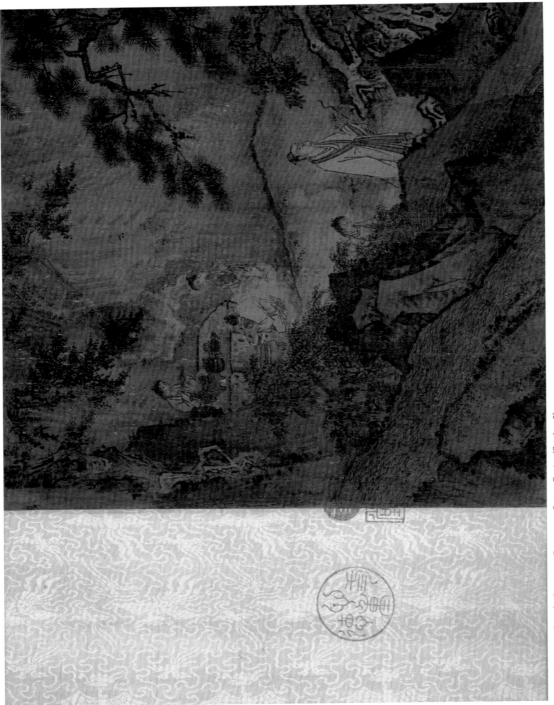

62. Ma Yuan, attributed, *Composing Poetry on a Spring Outing* (Section 9)

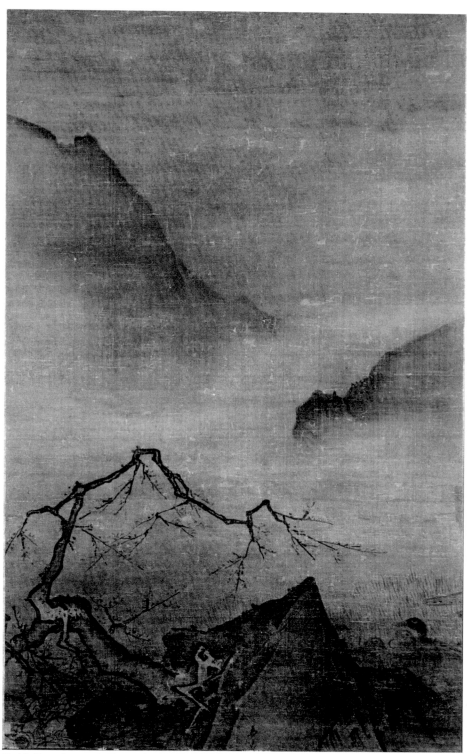

63. Ma Yuan, *Streamside Plum and Wild Ducks*

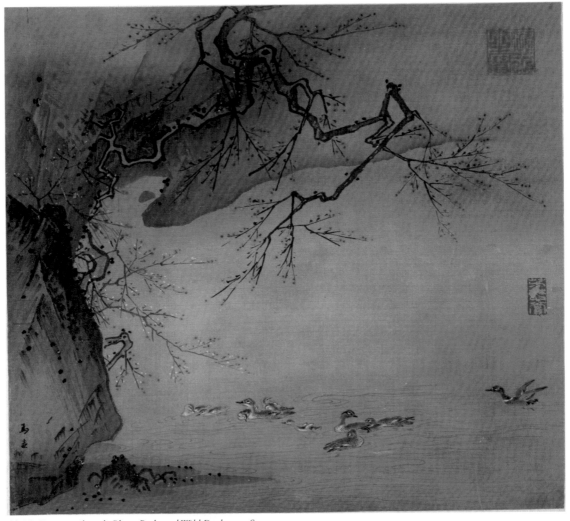

64. Ma Yuan, attributed, *Plum, Rocks and Wild Ducks on a Stream*

宿雨清畿甸

朝陽麗帝城

豐年人樂業

壠上踏歌行

65. Ma Yuan, attributed, *Peasants Dance and Sing: The Stomping Song*

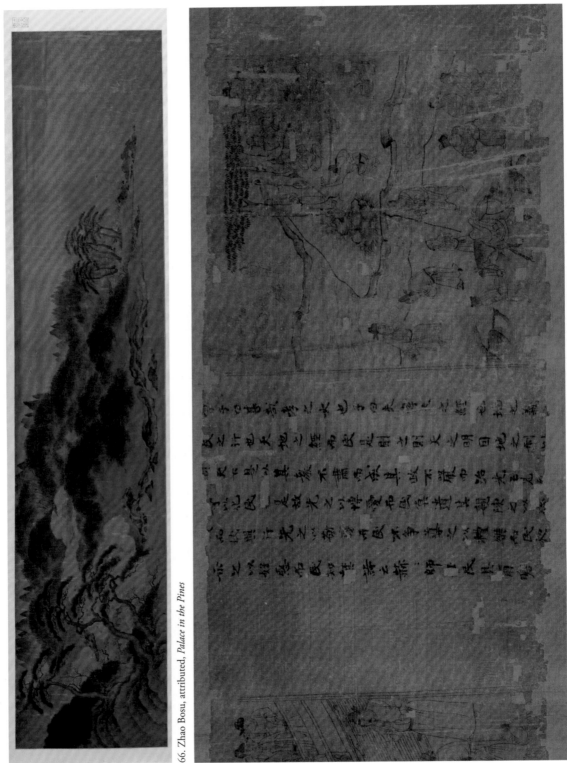

66. Zhao Bosu, attributed, *Palace in the Pines*

67. Li Gonglin, *The Classic of Filial Piety*. Chapter 7, "Filial Piety in Relation to the Three Powers (Heaven, Earth and Man)"

Introduction

Ma Yuan's Family, Patrons, and Style

Ma Yuan is the best known member of a family of artists that laid claim to five, perhaps six, generations of skillful painters. The family offers the most famous example of the refinement of skill under social restraints that prevented Song painters from climbing the ladder of official advancement. As Wai-Kam Ho has pointed out, a decree by the Emperor Renzong in 1056 prevented the transfer of artists into the system of civil service. Artists were required to remain artists and by such careful specialization a focused development of their unique skills was ensured. This often guaranteed transmission from generation to generation.[1] It would appear, at least in part because of such restrictions, that Ma Yuan's career took on special importance. Honing ancestral skills within the Academy and in close association with imperial taste and power, he was able to gain recognition and prestige beyond that of many, if not most, contemporary artists. However, as we shall see, his fame was not restricted to the court alone.

Nevertheless, fame certainly grew from imperial favor and appears responsible for the fact that Ma Yuan, the artist — his style, if not always his precise hand — is preserved for us to a greater degree than any of his contemporaries. A recent study by Lee Hui-shu centering on the personality of Empress Yang has discussed an important group of paintings as proof of this connection.[2] However, no patron can tell an artist how to paint and it must have been Ma Yuan's painting that attracted the patronage. Not unlike Rembrandt for seventeenth-century Holland, Ma Yuan was an artist who carried implications in the art of his time to a differing level of understanding and, in doing so, gave to late twelfth- and thirteenth-century painting in Hangzhou a unique definition. Because of a lack of preserved

[1] Ho et al., *Eight Dynasties* (1980), p. xxviii.
[2] Lee, "The Domain of Empress Yang" (1994).

works it is impossible to judge to what degree his art depended on a family tradition. We do, however, know of his concern for continuity. The late thirteenth-century recorder Zhuang Su 莊肅 wrote in his brief *Supplement to a Record of Painters Continued* (*Huaji buyi* 畫繼補遺): "Yuan loved his son. Often on his own paintings he wrote that they were done by his son Ma Lin."[3]

Ma Yuan belonged to the fourth generation of this uniquely recorded artist-family line dating back to the closing years of the eleventh century: Ma Fen 馬賁 (great-grandfather), Ma Xingzu 馬興祖 (grandfather), Ma Shirong 馬世榮 (father). As no birth and death dates have been preserved for any of the Ma clan, including the final famous masters, Ma Lin 馬麟 (son) and Ma Gongxian 馬公顯 (a likely grandson), one assumes a generational projection, most securely anchored in what can be pieced together from the activity of Ma Yuan joined to that of son and grandson.

Ma Yuan's most certain activity came during the reign of Ningzong who ruled from 1194 to 1224. Specifically, he was a favorite of Ningzong's Empress Yang, who reached that lofty position at the turn of the century, in 1200. We know more about him than other Academy contemporaries in large part because of this empress, whose courtly influence extends from 1225, when she began her reign as the influential Empress Dowager, until her death in 1233. Her patronage extended as well to Ma Lin, apparently during his early developing years. In this imperial connection, two works of Ma Yuan and one by Ma Lin yield specific dates. For the father, a seal on the lower right corner of *Fisherman on a Winter River* (*Hanjiang dudiao tu* 寒江獨釣圖) carries the legend of the empress' palace, Kunning 坤寧, and a date corresponding to the year 1211: "*xinwei Kunning biwan*" 辛未坤寧秘玩 (Fig. I.1a). A more

Fig. I.1a Ma Yuan, Chinese, 1190–1235
Fisherman on a Winter River (detail)
National Museum, Tokyo

Fig. I.1b Ma Yuan
Water
(detail from leaf d: *Lake Glow — Rain Suffused*)
Palace Museum, Beijing

I.1a

I.1b

3 Zhuang Su, *Huaji buyi* (1963), p. 14.

complete seal on the artist's famous *Water: Twelve Views* (*Shui shi'er tu* 水十二圖) with the term "noble consort" (ie. empress): "In the *renwu* year, seal of the noble consort Yang" (壬午貴姜楊姓之章) would in turn conform to the year 1222 (Fig. I.1b). Ma Lin's plum blossom scroll, *Layer upon Layer of Icy Silk Tips* (*Cengdie bingxiao tu* 層疊冰綃圖), carries a seal date corresponding to 1216 (Fig. I.1c).

An anonymous painting of *Orioles on a Cherry Tree* (*Yingtao huangli* 櫻桃黃鸝), the only further dated painting inscription/seal by Empress Yang, conforms to the year 1213 (Fig. I.1d).[4] Skeletal as it is, these dates clearly anchor an important period — just over a decade — of her patronage.

Imperial favor in the arts, however, was not just a matter of pictorial needs. Rather it fitted comfortably into a wider pattern of sophisticated taste, particularly in the realm of calligraphy. This had already been made visible in the early twelfth century, when among other artistic skills the Emperor Huizong (r. 1101–1126) was noted for his "golden wire" writing. Gaozong (r. 1127–1162) in his retreat to the south not only re-established the Painting Academy, but continued as a champion of the writing brush. He practiced continually in a range of historical styles. This passion included, close to his own day, a fondness for the calligraphy of Mi Fu 米芾 (1052–1107/8), whose son Mi Youren 米友仁 (1074–1151) was for a time to hold position in his court. With Gaozong leading the way, a dominant imperial style was established which in turn reverberated through the imperial line. This included the skill of empresses, a tradition going back to the Northern Song. His own Empress Wu appears to have been a mentor for the future Empress Yang when the latter was introduced into the court. There is also little question that the demand for the imperial hand far exceeded the ability to fulfill it, and led to numerous "ghost writers," not excluding using the empresses themselves. Furthermore, calligraphy, by virtue of social class and intellectual accomplishment, was not considered fitting for Academy painters. However, its relevance to the accomplishments of painting was not to be denied. Thus it became common practice for the same aristocracy that supported the Academy to unite its calligraphy to the pictorial accomplishments of others. The verbal, both as classical text and poetry, readily became a prized — to some perhaps the most prized — element in juxtaposition to pictorial expression.[5]

Yet Ma Yuan was not just recognized by the court. Unusual for the painting history of this time are a comment and poem that link him with one of the wealthiest personalities of the late Song, Zhang Zi 張鎡 (1153–

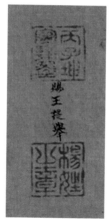

I.1c

I.1d

Fig. I.1c Ma Lin
Layer upon Layer of Icy Silk Tips (detail)
Palace Museum, Beijing

Fig. I.1d Anonymous
Seal of Empress Yang
Orioles on a Cherry Tree (album leaf)
Shanghai Museum

4 Cahill, Index (1980), p. 190, and *Zhongguo gudai shuhua tumu*, vol. II, p. 61. *Zhongguo meishu quanji*, "Painting" (1987), vol. 4, pp. 134–35, text p. 49.
5 Lee, "The Domain of Empress Yang" (1994), p. 10 ff. Murray, *Ma Hezhi* (1993), p. 21 ff.

1211?), a man of position and literary pretension. From Lin Shuen-fu's translation of Zhou Mi's 周密 (1232–1308) account recorded in his *Eastern Qi Jottings* (*Qidong yeyu* 齊東野語), we catch a glimpse of Zhang Zi's extravagant character:

> Chang Tzu (Zhang Zi), who had the courtesy name of Kung-fu and the style of Yueh-chai (Frugality Studio) was a great grandson of King Hsun-chung-lieh (Chang Chun, a favorite general of Emperor Kao-tsung, who gave him the honorific title of "wang" or "king"). Being able to write poetry himself, he was befriended by all the eminent scholars and officials of the time. The elegance of his gardens, ponds, music, singing girls, utensils, and curios excelled in the sub-celestial realm. Once in his South Lake Garden he built Riding-the-mist Pavilion among four ancient pine trees, using big iron ropes to suspend it in the air and to tie it to the trunk of the pines. On nights when the wind and the moon were pure, together with guests he would ascend the pavilion with a ladder. Swaying above the mists made one feel as if he were carrying a flying immortal under the arm and ascending into the skies.

The description goes on to tell of a hall filled with "unusual fragrance," courtesans carrying wine, and musical instruments and various flower decorations including red peony head ornaments. Colorful floral combinations were varied: "In general if they pinned white blossoms in their hair, they wore purple garments, purple blossoms, pale yellow garments, and yellow blossoms, red garments." Most significant in this elegance, which must be thought generally to stand for the high level of material living in Hangzhou of the late twelfth and early thirteenth centuries, was Zhang's own philosophical justification. In these villa-garden splendors was a path to enlightenment. They were accepted in "gratitude for what heaven has given":

> For in the realm of light what is not game? If one can always keep his heart pure, detached from all grasping and clinging, and in the realm of distinction, can always enter the undifferentiated *samadhi*, then for him, to be in the bedroom or a wine shop is no different from going through the places of enlightenment, and sounds of music and the singing voices are nothing but conversations of supreme wisdom (*prajñā*).[6]

[6] For the above and following quotations and evaluation of Zhang Zi (Chang Tzu) see Lin, *The Transformation* (1978), pp. 26–33.

Both a sense of the richness of life and the sadness of its passing gave to Zhang Zi in his time what Western sensibility might describe as an abiding feeling of *fin-de-siècle*. Zhang cited a late Han poem: "To make merry you must seize the moment / How can you wait to the years to come? / Fools are grudging of expenses . . .", mentioning an immortal of Daoist legend (Wangzi Qiao 王子喬) as impossible to match. He further wrote in a 1202 introduction to a collection of his poems that in 1187 he had turned his old residence, located in the northern outskirts of Hangzhou, into a Buddhist temple, carefully naming there the multiple features of his Cassia Retreat, as he called it. His restless search for perfect surroundings led him in 1200 to rearrange the entire villa-garden complex, commenting, "Although my days of public service are many, I will not let them surpass in number my days of leisure."

For Zhang, however, life did not appear to end in contentment, at least in Hangzhou. He was later caught in a plot to get rid of the chief councilor, Shi Miyuan 史彌遠 (1164–1233), and exiled to Guangxi Province where he died close to the year 1211 or 1212. While in terms of material richness Zhang Zi was certainly not "grudging of expenses," his generosity has also been cited by another observer as extending to "entertaining scholars who were living in the mountains and forests or beside the lakes and seas."[7] This, as with his own poetry (which as a whole has not survived), confirms a strong link to the literatus. The love of "things," a dominant feature of Hangzhou life, slipped readily as well into Buddhism, for the "moment" and "things" were not distant from that indescribable *gongan* 公案 (Jp. *kōan*) that stimulated the enlightenment claimed by Chan Buddhists.

Zhang's comments about Ma Yuan are found in a single preserved poem. A brief introduction defines Ma Yuan as having inherited the skills of the craft from his great grandfather, the flower and bird artist Ma Fen at the beginning of the twelfth century, declaring that Ma Yuan was especially skilled at both landscape and figure painting and thus was commissioned by Zhang to paint his garden retreat. Moved by the result, Zhang in turn was inspired to compose a poem to show to him:

The world has true painting	世間有真畫
beginnings established by poets	詩人斡其初
The world has true poetry,	世間有真詩
reverberations defined by skilled painters	畫工綴其餘
High and deep, what moves and grows	飛潛與動植
all are depicted, the Great Mystery defined	模寫極太虛

7 Lin, *The Transformation* (1978), p. 35.

The Creator loathing secrets exposed,	造物惡泄機
no rest in his handiwork	藝成不可居
How the vulgar differ, banality suffused	爭如俗子通身俗
Everywhere piled money, boosting foolish wealth.	到處堆錢助癡福
Surely ghosts and spirits will not weep at their writing	斷無鬼神泣篇章
Nor know mountains and rivers concealed in their scrolls.	豈識山川藏卷軸
For me, and my poetry addiction, hair as fine silk thread	我因耽詩鬢如絲
And you, with your painting addiction, wasting away.	爾緣耽畫病欲羸
Yet even were we to toss brushes to the chamber pot and tear up the silk,	投筆急須將絹裂
True painting, true poetry would never disappear.[8]	真畫真詩未嘗滅

This seemingly bombastic poem is truly rather playful and in that playfulness indicates unmistakable friendship. Grandly asserting the tradition that true art reveals a creativity rivaling nature itself, he contrasts this with the corrupt and useless pursuit of art for material gain. Then turning to Ma Yuan and himself he offers a lighter, more modest stance, seeing what he calls an addiction or devotion to art in the framework of Buddhist teaching. The terms *yin* 因 ("cause") and *yuan* 緣 ("secondary cause") are taken from the Buddhist compound *yinyuan* (*Hetupratyaya*), the "cause" in "cause and effect" on which all existence depends and from which Buddhist teaching sought release. The reward of their addictions was a worn-out old age. Yet in the end he will not admit defeat and asserts, we can assume with a wry smile, the ironic conclusion: despite Buddhist truths, which were we to follow in throwing away the tools of our craft, the creativity of great and true art — poetry and painting — would still not disappear.

It must be added that this ironic touch is characteristic of the writer. How else explain that one of the richest personalities in late twelfth- and early thirteenth-century Hangzhou, noted for his palatial dwellings and gardens, his extravagant festive entertainments, would define himself and his surroundings with the style name, Studio of Frugality (*Yuezhai* 約齋)? It must be remembered, too, that he justified his seemingly extravagant outward life by the more significant truth of a pure heart and thus, as mentioned above, "to be in the bedroom or a wine shop is no different from going through the places of enlightenment." Similarly one is led to think from this poem

8 Zhang Zi, *Nanhu ji* (1983), ch. 2, p. 23. Helped by other translations. See Lee, "The Domain of Empress Yang" (1994), p. 180; Murck, *Poetry and Painting* (2000), pp. 240–41. I am indebted to Murck's discovery of *jixu* as a Song term for a vessel, related to both tea and wine as a warmer, but also for urine. The latter seems the more appropriately destructive. See *Hanyu dacidian*, vol. 7, p. 460.

that in the endurance of art — despite corruption by seekers of wealth — "true painting," "true poetry" rested on a similar reality, far more significant than the outward appearance of the aging of these two friends. After all, we can assume that Ma Yuan, painter of many Buddhist subjects, was surely, as Zhang Zi, much versed in Buddhist teachings.

What, then, of the artistry of the painter Ma Yuan? Even severely limited by the number of surviving paintings either by him or closely following his style, the range of subjects is considerable. They touch on accepted categories of Chinese interest: figure style (Confucian, Daoist, Buddhist); landscapes, including prominent figures, animals and birds in landscape settings, and selected branches of flowers. An unusual scroll details studies of water. An overriding quality associated with many of these subjects can also be defined in compositional terms as they were said to be "leaning on one corner" (*bianjiao* 邊角). In truth, however, this was a quality found among other painters of his time, although the intensity of Ma Yuan's brush may have made his expression of the mode more obvious. In the Ming dynasty it acquired the summation: "one corner Ma" (*Ma yijiao* 馬一角). This also burdened him with pejorative political implications since he was a painter nurtured by a dynasty that only ruled over part of China. A contrary view suggested that he also might paint "complete views" (*quanjing* 全景).

Ultimately, the "one corner" ideal is a positive one. It confirms Ma Yuan's ability to compress formal representation. Ambiguously, less may be more. Contraction becomes a guiding principle. The open hand is closing toward a fist. This is a direction that applies to detail as well as the whole. Thus later efforts to describe his handling of the brush, brush and ink, are precisely consistent: a "squeezed brush" (*jiabi* 夾筆) for defining leaves; "rocks square and hard" (*fangying* 方硬, Fig. I.2a); surface texturing reduced to an

Fig. I.2a Ma Yuan
Scholars Conversing beneath Blossoming Plum Tree (detail)
Museum of Fine Arts, Boston

I.2a

I.2b

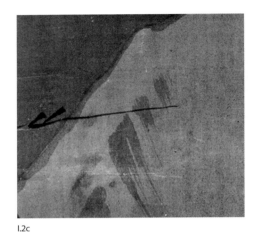

I.2c

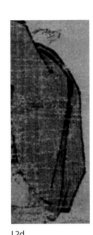

I.2d

Fig. I.2b Ma Yuan
Bare Willows and Distant Mountains
(detail)
Museum of Fine Arts, Boston

Fig. I.2c Ma Yuan
Egrets in Winter (detail)
National Palace Museum, Taiwan,
Republic of China

Fig. I.2d Ma Yuan
*Fayan Wenyi and His Teacher Luohan
Guichen* (detail)
Tenryū-ji, Kyoto

"axe-stroke" convention ("great axe-strokes," *da fupi cun* 大斧劈皴, Figs. I.2b–c), an implied abrupt, chopping angularity from a slanting brush; line might be shaped in a not-unrelated triangular extension, a so-called "nail-head rat-tail" form (*dingtou shuwei* 釘頭鼠尾, Fig. I.2d), the nail referring to a forged nail that we know as well in the West. A differently expressive use of line, a vibrant stroke, acquired the term, *zhanbi*, "trembling brush" (戰筆 or 顫筆, Fig. I.2e); the small significant form of a pine needle cluster might take the precise shape of the "wheel of a cart" (*chelun* 車輪, Fig. I.2f), or more loosely expressive, a "butterfly" (*hudie* 蝴蝶); even the flow of water appears not to

I.2e

I.2f

Fig. I.2e Ma Yuan
Egrets in Winter (detail)
National Palace Museum, Taiwan,
Republic of China

Fig. I.2f Ma Yuan, after
*Landscape Album Paired with Imperial
Poetry Inscriptions*
(detail from leaf j: *Discussing Dao
under the Pines*)
Private Collection

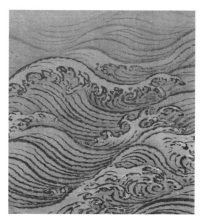

1.2g

Fig. I.2g Ma Yuan
Water (detail from leaf b: *Layers of Waves, Towering Breakers*)
Palace Museum, Beijing

have escaped the possibility of metaphorical definition, in this case outward movement and toughness, in the term "fighting water" (*doushui* 鬥水, Fig. I.2g). All perhaps participated in the generality, "exact severity" (*yanzheng* 嚴整), a description that also fits an alleged fondness for the burnt blackness of his ink — "charcoal ink" (*jiaomo* 焦墨).[9] Surviving examples carry much of this.

Taken as a whole, the terms applied to Ma Yuan's art lead us away from the dangers of over-definition. Expansion is contained. The result is the controlled rather than the casual. We appear to be faced with an inventive and penetrating strength that avoided the superficial, a total effort to express new depths of understanding. With this in mind, what better beginning than to turn to his paintings of winter. Winter's snows reduce the land to the purity of shape. The fallen leaf opens our view. Trees are in skeletal mode, evergreens offering contrasting compactness. With the shortening of day, light and dark take on special qualities, their contrast the more certain. The range of visibility extends from clouded gloom to snow-reflected light. We will see much of this as the seasons and subjects unfold in displaying his finest surviving works.

[9] Edwards, *Ma Yuan* (1976), pp. 113–14.

1

Winter

Thru Snow Mountains at Dawn

In this signed album leaf, less than a foot high (27.6 x 40 cm), Ma Yuan has projected a marvelously condensed view of the season. Here it is winter as travel in the light-gloom of early morning cold. The work itself is untitled but in later publication has been logically called *Thru Snow Mountains at Dawn* (*Xiaoxue shan xing tu* 曉雪山行圖). The painting, in ink on silk with touches of white, is now in Taipei's National Palace Museum (Pl. 1). A single donkey driver follows two heavily laden animals across an abbreviated, pathless stretch of snow that borders on chilled water. Behind them the muted land rises upward defined only by the briefest framing suggestions of contour: the dip of a valley in the upper right, a touch of cliff toward the upper left, and the flat water below. Trees are deliberately cut by the painting's borders. They are reduced to partial trunks, an emerging root, and the sharp tips of branches. None of the latter springs complete except for two brief limbs at the lower right. Washes of ink define dawn's framing dark, down from the upper right, across the lower edge and then in an echoing passage toward the upper left where snow brightness opens the dark. The figures are untouched by this. They float free on the snowy illusion.

Technical mastery is clear. The composition betrays a stronger definition to the right, especially in the lower corner that holds the artist's signature and thus maintains the stereotype of "leaning on one corner." Furthermore, most of the verbal description cited above appears admirably illustrated by a skillful brush: the darkness, the light, the tension of black ink. Line is its frame: blunt, broken, angled, seldom flowing easily without a break, charcoal dark, squeezed tight. Note the broken and sometimes tremulous

outlines for the donkeys (Fig. 1.1), a core statement of their plodding gait. The contrasting line on the driver is in its crackling angles, as drapery, pose, and gesture convey his tense and huddled cold, even to the shivering quality of the trousers to which, apparently, the animals are impervious (Fig. 1.2). Note also the "squaring" of the few selected foreground rocks. Washes fill out the setting and where necessary "flesh" out the travelers. Ma Yuan's legendary axe-stroke movements of the brush appear, however, somewhat disguised as on the loose angled strokes of the cliff-face and the brief daubs of ink above the second donkey. They are darkest, again, at the entering lower right.

Fig. 1.1 Ma Yuan
Thru Snow Mountains at Dawn (detail from Plate 1)
National Palace Museum, Taiwan, Republic of China

Fig. 1.2 Ma Yuan
Thru Snow Mountains at Dawn (detail from Plate 1)
National Palace Museum, Taiwan, Republic of China

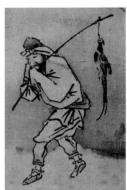

1.1 1.2

What is remarkable is how this selection of brevities is able to draw out the qualities of winter itself — the cold, the gloom, and nature's skeletal strength fused with a reluctant dawning brightness. Similarly, the capturing of physical reality is no less secure for the animals and their driver. The donkeys are precisely alive with a halting forward motion that both their animal nature and the heavy burdens impose. Check the ears. The lead animal's are tipped forward, as is the forward-looking eye, anticipating what is ahead. The ears of the second are laid back (the eye dot repeating the angle). Withdrawn concentration is that of the plodding follower. Nor is there any negligence in describing what controls them or the burdens they bear. The two complete a more certain total portrait, one seen slightly from the rear, the other from the front. Note the counter position of the legs. The near foreleg is forward in the first, the far foreleg in the follower, with a similar reversal for the hind legs. Halters are looped around their necks; the arrangement of their other traces is brief and clear. Similarly we understand the basketry of the containers and the frame that fits them to each animal as well as their hard-packed contents — coke (or coal) and dark sticks of charcoal. A selective precision is no less characteristic of the driver: foot-coverings and bindings, the seemingly bare ankles, the trousers, the cloak cloth-bound at the waist, hands hidden in sleeves raised to the face

confirming the withdrawal of a chilled hunched posture, bearded features, a head-covering pointed cap. Then there are telling additions: the gourd tied to the lead donkey, the pheasant dangling from a pole shouldered by the cloak-wrapped driver, its weight suggested by thin supple bending.

In sum there is no shirking of truth to essential detail linking the images to physical reality. This recognition presses us further. It was noted of the great late Northen Song painter Li Gonglin 李公麟 (1049–1106), that both Li and the Tang poet Du Fu 杜甫 (712–770), to whom he was compared in Emperor Huizong's collection catalogue of 1120, *Xuanhe Catalog of Paintings* (*Xuanhe huapu* 宣和畫譜), were seldom purely descriptive in their art.[1] Should we not expect something similar for an artist as high on the aesthetic scale as Ma Yuan? If so, the chilled fuel gatherer and the small but deliberate inclusion of a gourd and a pheasant may expand our understanding. Both gourd and pheasant are, of course, signs of simple rustic mountain life, its food and drink. Yet given a broader view — Ma Yuan's service to court and wealthy commoners; a painter of subjects consistent with both secular and religious life; connections to empress, priest, and scholar; an artist surrounded by Hangzhou's rich and complex society — may we not expect more?

The gourd, or calabash, begins as a simple container. This in turn extends to being a wine-pot. But even more, it was a clear Daoist symbol. Its name is conjured up as "Penghu" 篷壺 (Tumble-weed Pot), one of the names for Penglai 蓬萊, the well-known sea-girt isle of immortality. The gourd was easily carried. It was famously connected with one of the Eight Immortals, Li Tieguai 李鐵枴, who used it to store his soul, or animus. When desired, he released it to wander wherever through the out-and-beyond. The shape itself represented a miniaturized universe. In his exploration of Daoist lore, Edward Schafer describes its significance: "a double cone, rather like a narrow waisted drum, symbolizing the opposite realms of yin and yang, heaven and earth interacting," and thus able to magically contain the multiplicity of the realms of immortality.[2]

There is no need to doubt that Daoist ideas flourished in late Song Hangzhou, but a specific illustration of the gourd's meaning may be found in a poem by the ninth-century Tang dynasty Daoist, Cao Tang 曹唐. The poem alludes to just this containment of heaven and earth within the wine-pot gourd. It was this earlier poem that the thirteenth-century emperor, Ningzong, was to write out as a quatrain to be placed in juxtaposition to Ma Lin's visual rendition (Pls. 2a–b). Both calligraphy and painting are now in the Boston Museum of Fine Arts:

[1] Edwards, "Li Gonglin's Copy" (1993), p. 176.
[2] Schafer, *Mirages* (1985), pp. 62–63.

Riding a dragon, a double jade
　crossing stream's source
Red leaves return the spring
　blue waters flow
You may in a wine-pot
　see heaven and earth
But heaven and earth in the pot
　no match for autumn[3]

騎龍重玉過溪頭

紅葉還春碧水流

省淂壺中見天地

壺中天地不曾秋

It is the natural world that must be re-established.

Likewise the pheasant may be a sign of something more than the rustic hunter. Turn to the painter Li Di 李迪 (active ca. 1163–1197), apparently an older contemporary of Ma Yuan, and his famous brushing of a similar enigmatic figure carrying a pole-suspended pheasant as he rides on the back of a water buffalo.

The figure is more active but similarly clothed, hatted and bearded, a hunched and ambiguous wintry form, on the back of a water buffalo (Fig. 1.3).

Again, for a suggested verbal parallel turn to the Tang dynasty, this time to a Chan (Zen) Buddhist dialogue of search, here is a dialogue between

Fig 1.3　Li Di
Herder Returning in the Snow
(detail)
Yamato Bunkakan, Nara

1.3

[3]　Wu Tung, *Tales* (1997), p. 183. Schafer has also translated the poem (loc. cit.), but with the "commentary" of Ma Lin's painting, its stress on the landscape, I suggest a somewhat variant version.

Baizhang Huaihai 百丈懷海 (720–814) and his pupil Changqing Da'an 長慶
大安:

"I have been seeking for the Buddha, but do not yet know how to go on with my research."	欲求識佛何者即是。
"It is very much like looking for a buffalo when riding on one."	大似騎牛覓牛。
"What shall a man do after knowing him?"	識得後如何。
"It is like going home on the back of a buffalo."[4]	如人騎牛至家。

It may seem a long jump to the observation that the pheasant found
its way into the highest levels of imperial ceremony as a symbol on the blue
ground of an empress' sacrificial robe, the *wei'i* 褘衣.[5] An official portrait
of Empress Yang, now preserved in Taipei's National Palace Museum,
portrays her in just such dress (Fig. 1.4). Indeed, more and more, studies
of the emperor and empress at this time have indicated closer and closer
connections between them and the images created by artists. This appears to
go beyond simple patronage, Academy interests, or the addition of calligraphy
to a painter's work. Thus we are driven to ponder the notion that sometimes

Fig. 1.4 Unidentified artist
Portrait of Empress Yang
(detail from Plate 3)
National Palace Museum, Taiwan,
Republic of China

1.4

[4] Edwards, *Li Ti* (1967), p. 28. Brinker and Kanazawa, *Zen* (1996), p. 170. From Puji, *Wu deng huiyuan* (Original Assembly of the Five Flames) (1252), *juan* 4, p. 62a. See also Jang, "Ox-Herding" (1992), p. 93.

[5] *Song Shi* (1979), ch. 151, p. 3534 and note 10, p. 3537.

a key figure in a landscape may be an idealized portrait of the emperor himself, an argument convincingly presented for the lordly scholar in Ma Lin's *Listening to the Wind in the Pines* (*Jingting songfeng tu* 靜聽松風圖, Fig. 1.5).[6]

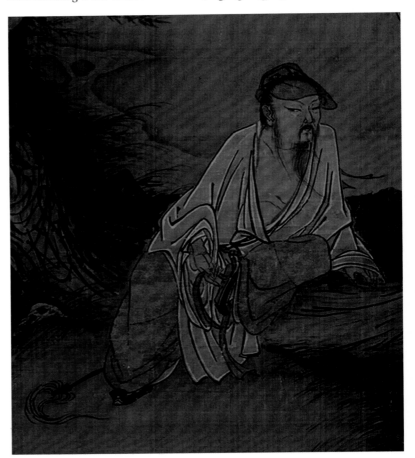

Fig. 1.5 Ma Lin
Listening to the Wind in the Pines
(detail)
National Palace Museum, Taiwan,
Republic of China

1.5

There can be no quarrel with imperial pleasure in the "garden nature" with which Hangzhou was so richly endowed both within and outside the palace. But the appeal of the garden lies in its available controlled representation of a far more extensive "nature," the limitless wild, and the longings for it so prominent in Chinese literature and painting. This included meetings with unpretentious rustics who were the "true" men: the Daoist Zhuangzi's 莊子 sage who "wanders in the realm where things cannot get away from him and all things are preserved," or the poet Wang Wei 王維

6 Wang Yao-t'ing, "'From Spring Fragrance . . .'" (1996), p. 277 ff. For a close look at the emperor and empress in calligraphy see Lee, "The Emperor's Lady Ghostwriters" (2004).

in his Zhongnan Retreat "Meeting by chance an old man of the forest / To chat and laugh: no date to return," or the mysterious rustic who guided Jing Hao's 荊浩 painting at the Stone-Drum Cliffs.[7]

Leave for the moment such carefully selected "signs" as gourd and pheasant and how far the painter may be asking us to extend these natural aspects of rustic life into the realm of ideas, and return rather to the chief protagonist of the chilled scene — the fuel gatherer himself (Fig. 1.2). As already described, the clothed form is withdrawn, huddled and stooped, an angular shape whose trousered legs are set in triangular motion in sympathetic harmony with the plodding gait of the animals that carry his livelihood as well as with the split stretch of the plum branches above and below. While there is no effort to conceal exposed ankles, the rest of the clothing, including simple shoe-bindings and a high-crowned cap, conceals and shelters his body. All combine to convey his chilled withdrawal. It is a pose particularly suited to Ma Yuan's skill in controlling a blunt staccato brush.

As is so often true of the use of drapery in Chinese art, here selective strokes, angles, and sometimes subtly vibrant pressures admirably convey the nature of what is covered. However miniature, it is the face, toward which the upraised arm gesture directs us, that requires special attention. Well framed above and below by cloak and sheltering hat, bearded, long-nosed with downcast eyelids, his concern is not toward an implied market goal somewhere ahead. Rather, psychological inwardness complements the contracted body pose. The head, combining face and hat, is disproportionately elongated. It is not an easy Chinese face.

Expanding into contemporaneous painting history, both the fuel gatherer's portrait and the wintry setting bring us importantly to another figural-landscape image, one of the most famous that has survived, Liang Kai's 梁楷 (ca. 1140–ca. 1210) *Sakyamuni Emerging from the Mountain* (*Chushan shijia tu* 出山釋迦圖) after six years of solitary austerity (Pl. 4b). Much has been written about the historical appearance of this subject. Some years ago, Dietrich Seckel imaginatively placed human withdrawal and its counterpart, emergence, within the long-standing idea of retreat in China as expressed in nature imagery. Thus he plucked two lines from an eighth-century poem by Du Fu, "The Fine Woman" (*Jiaren* 佳人):

[7] Translations found respectively in: Watson, *Complete Works* (1968), p. 81. Yu, *Poetry of Wang Wei* (1980), p. 171, no. 79, Chinese p. 224. Ching Hao (Jing Hao), *Bifa ji*, in Bush and Shih, *Early Chinese Texts* (1985), p. 145.

In mountains the water of springs is pure 在山泉水清，
Emerging, spring water is turbid[8] 出山泉水濁。

Representation of the Buddha in this setting was most importantly a clear break from the formal iconic tradition that spread from India and Central Asia to the Far East from the Han dynasty onward. It appears to have had roots in the expression of Chan ideas flourishing in the late Tang — a time described by one author as "the great Dharma free-for-all"[9] — moving then into the Five Dynasties era and on to the Song. Sakyamuni's fasting and emerging from the cold reflect an essential concentration on a physical individual and the path of awakening centered on the self's efforts. The earliest painter of this theme appears to have been Huang Quan 黃筌 (903–968), as recorded in Huizong's *Catalog of Paintings, Xuanhe huapu*,[10] which puts the subject close to the time of significant historical Chan heroes in China. Huang Quan was noted for his lifelike representations (*xiesheng* 寫生). While the style has been more famously directed toward his bird-and-flower paintings, texts also refer to his skill in depicting the human figure. A continuity into the next generation is suggested in the briefest of notations by Zhou Mi claiming to have seen such a painting attributed to either Wang Duan 王端 (tenth–early eleventh century) or Sun Zhiwei 孫知微, also known as Taigu 太古 (976–1022). It is logical, thus, to speculate that this image of Sakyamuni may have already been removed from traditional iconic formalism.

The earliest surviving record of such a painting in Chan texts, however, appears considerably later, during the Northern Song in poems on painting from the collected sayings (*yulu* 語錄) of the priest Foyan Qingyuan 佛眼清遠 (1067–1120). His list of important subjects begins with *Sakyamuni Emerging from the Mountain*.[11] His was a time roughly contemporaneous with Ma Yuan's great grandfather, Ma Fen, founder, as mentioned earlier, of an unbroken family tradition and who is projected to have been born close to 1080. Evidence for wider popularity of the theme, however, increases as we move into the thirteenth century and beyond with examples of it in images, poetry, and images with poetry, often specifically located in the Hangzhou area. Much of this has been carefully reviewed in Western scholarship, earlier by Dietrich Seckel, and later by Helmut Brinker and Howard Rogers. From these sources, consider thirteenth-century examples

8 Seckel, "Shakyamuni's Rückkehr" (1965), p. 44. Howard Rogers has put the idea neatly: "To be within the mountain was thus . . . to be in a state of grace." Rogers, "Reluctant Messiah" (1983), p. 18. For the full poem see Wang Shijin, *Du shi bianlan* (1986), p. 367.

9 Foster and Shoemaker, *The Roaring Stream* (1996), p. 115.

10 *Xuanhe huapu* (1123), ch. 16 (1964), p. 256. I am indebted to Howard Rogers for calling my attention to this important record. For Huang Quan, see Barnhart, "Huang Ch'uan" (1976), pp. 50–55. For Zhou Mi's notation see Weitz, *Zhou Mi's Record* (2002), p. 134.

11 Brinker and Kanazawa, *Zen* (1996), p. 131.

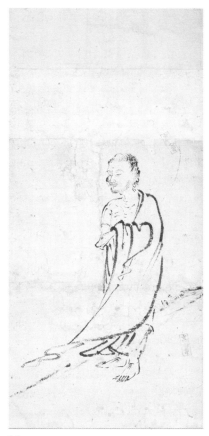

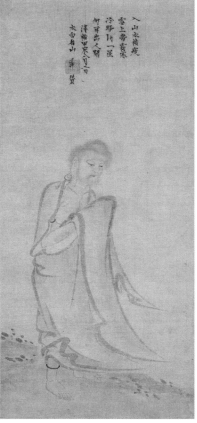

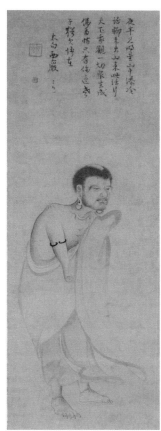

1.6 1.7 1.8

held in American museums. They are among the earliest extant.[12] In differing styles they reflect a common iconographic source.

The first, a brief sketch of the theme, without date or calligraphy, is preserved in a Japanese copy from the Kyoto temple, Kosanji, now in the Seattle Art Museum (Fig. 1.6). It is believed to have been based on an early thirteenth-century Chinese original. A more complete Chinese original, in the Cleveland Museum of Art (Fig. 1.7), offers not only the whole figure but a touch of landscape ground and an inscription dated to 1244 by the priest Chijue Daochong 癡絕道沖 (1171–1251). A later inscription by the same eminent monk is preserved on a painting in Japan. It is dated to 1246 when he was abbot of West Lake's famous Lingyin Temple 靈隱寺.[13] Also close to a mid-century date is another Sakyamuni in ink monochrome on a void of empty paper, now in the Freer Gallery of Art (Fig. 1.8). The inscription is

Fig. 1.6 Unidentified artist
Shaka Coming down from the Mountain
Seattle Art Museum

Fig. 1.7 Unidentified artist
Sakyamuni Emerging from the Mountain (detail)
Cleveland Museum of Art

Fig. 1.8 Anonymous
Sakyamuni Emerging from the Mountain
Colophon by Xiyan Liaohui
Freer Gallery of Art, Smithsonian Institution, Washington D.C.

[12] Seckel, "Shakyamuni's Rückkehr" (1965); Brinker, "Shussan Shaka" (1973), fig. 1 ff, and *Shussan Shaka* (1983); Rogers, "Reluctant Messiah" (1983) and "In Search of Enlightenment" (1999).

[13] Brinker, *Shussan Shaka* (1983).

by Xiyan Liaohui 西巖了慧 (1198–1262), when in residence not far from Hangzhou on Mount Taibo near Ningbo. Xiyan, like his contemporary, the painter Muqi 牧谿, was said to have come from Sichuan to pass maturity in Zhejiang. Also like Muqi, he had studied under the important prelate Wuzhun Shifan 無準師範 (1178–1249). In a further interlocking of personalities, shadowy as it may be, Wuzhun had close enough relations with the court to write, after her death in 1233, the eulogy for Ma Yuan's great patroness, Empress Yang. It is a eulogy which affirms the empress' devotion to Buddhism.[14] Ma Yuan's own relationship to Buddhism is sealed by his painting of such themes, of which three scrolls representing the earlier Chan monks Dongshan Liangjie 洞山良價 (807–869), Yunmen Wenyan 雲門文偃 (864–949), and Fayan Wenyi 法眼文益 (885–958) have survived in Japan and will receive careful later discussion. All are inscribed by the empress[15] (Pls. 26a–c).

Liang Kai's famous image (Figs. 1.9 and 1.10, Pl. 4b), which in its complex definition in ink and color on silk differs markedly from the open, isolated, and repeated representations in ink on paper, is without date. Indeed the same is generally true of his life. By interpretation from sparse and laconic sources, however, we can assume he was a close contemporary of Ma Yuan. He was a pupil or follower of the earlier twelfth-century artist Jia Shigu 賈 師古, an artist trained in the styles of Li Gonglin (who had died in 1106) and active under Emperor Gaozong. Liang attained the position of *Daizhao* 待詔 (painter-in-attendance) in the Imperial Painting Academy some time between 1201 and 1204. His skills were honored by offering him the "golden belt" (*jindai* 金帶), an honor, we are told, he did not accept but "hung" (*gua* 掛) within the Academy. He may also have frequented the less restricted temple environment that surrounded West Lake, presumably there to follow a freer, simplified, and sometimes wine-induced "mad" style of ink representation for which he was noted.[16]

However much his well-filtered "biography" has been refined to fit the stereotype of a rebellious genius, his extraordinary *Sakyamuni Emerging from the Mountain*, while not denying certain freedoms such as the separated criss-crossing of bare twigs and the sweep of broad washes, reveals a clear, rationally controlled content of considerable depth. Although loosely curving rather than rigidly upright (perhaps the result of later remounting), its inscription, in direct translation, defines the work as "painting in the presence of the Emperor" (*yuqian tuhua* 御前圖畫) followed below by a respectively lowered but freely brushed signature (Fig. 1.10). The inscribed

[14] Lee, "The Domain of Empress Yang" (1994), p. 243.

[15] For an important earlier discussion of the three see Fontein and Hickman, *Zen* (1970), pp. 12–15.

[16] For a compact, but incomplete, account of Liang Kai see Xia Wenyan, *Tuhui baojian* (1365), ch. 4.

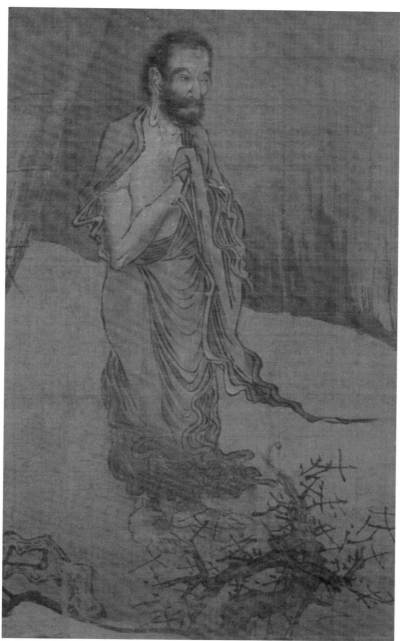

1.9

1.10

Figs. 1.9 and 1.10 Liang Kai
Sakyamuni Emerging from the Mountain
(detail from Plate 4b)
National Museum, Tokyo

mountain, all within easy reach, permitted ready exchange. However, there must be agreement that this Sakyamuni — as with Muqi's great image of *Guanyin* in Kyoto's Daitokuji and I believe as well Ma Yuan's reduced-scale fuel gatherer — is the work of a mature artist.

Despite the towering narrowing of space, the threatening lean and hover of mountain nature, its crackling forms, its ever-present cold to which a human form inevitably reacts, Liang Kai's Sakyamuni retains unmistakable marks of a special tradition. There are traces of his Indian princely past: once jewelled, elongated ear lobes, an upper arm bracelet, the cranial head-swelling of the *usnisa*, as well as other indications of a foreign presence: facial features and robe partially exposing the upper body, then gathered up to reveal bare feet and ankles.

The linear clinging drapery, however swept in motion by some mysterious force of nature or spirit magnetism, can very well suggest one of Buddhism's famous sacred icons, the Udayana image. This image, to which one can trace a rigidly stylized linear drapery convention, however now loosened by Song taste, was originally ordered by the north Indian King Udayana of Kausambi (near present day Allahabad). Its carving was supervised by the early wonder-working disciple Mudgalyayana, who to do so had magically risen to the Heaven of the Thirty-Three Gods. It carried the unique weight of truth because of its direct contact with Sakyamuni Buddha himself, historically the only such image of the living Buddha. Presumably this was not a standard physical likeness (*xingxiang* 形象) but one with marks of spiritual, supra-natural content (not excluding the special embrace of the robe). It must have radiated extra iconic efficacy since it was of Sakyamuni after his enlightenment when he had temporarily disappeared from earth's visibility to preach to his mother.[17] Copies were subsequently brought to China by traveling monks, famously including Xuanzang 玄奘 (602–664) in the seventh century.

However, the image can be traced much earlier. The legend was translated into Chinese in the fourth century (384–385), and surviving dated bronzes perpetuate the continuity of its special forms of stylization. An image of 444 shows the robe lifted above the ankles with clear exposure of the bare feet (Fig. 1.11). Another, more imposing in its dimensions (55¼ in.) is the well-known standing figure now in New York's Metropolitan Museum dated to 477 or 486. The Udayana image continued to be worshipped in China. A famous early surviving replica capturing its original sandalwood medium is preserved in an early Song copy of 984 ordered and brought to Japan by the Buddhist

[17] Rowland, "A Note" (1948), pp. 181–86.

Fig. 1.11 *Sakyamuni*
Museo Nationale dell'Arte Orientale,
Rome

1.11

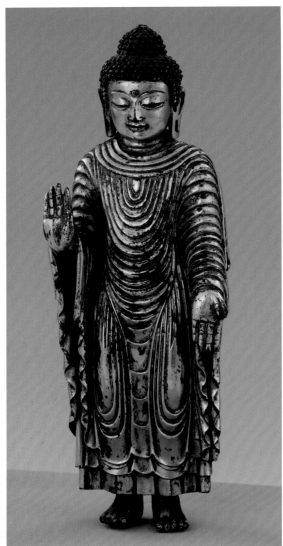

1.12

1.13

Fig. 1.12 *Sakyamuni (Udayana Buddha)*
Seiryōji Temple, Kyoto

Fig. 1.13 *Udayana Buddha*
Minneapolis Institute of Arts

priest Chonin. It now rests in Kyoto's Seiryōji temple (Fig. 1.12). Moving later in time, the Minneapolis Institute of Arts owns a glittering gilt bronze five-inch replica considered to be of the Yuan period (Fig. 1.13). Another takes history to the late Ming and may be seen in a rubbing in Chicago's Field Museum made from an original stone engraving of 1597.[18]

[18] For sources see respectively: Soper, *Literary Evidence* (1959), pp. 259–65; Rowland, *Evolution* (1963), nos. 36 and 39; Henderson and Hurvitz, "Buddha of Seiryōji" (1956), pp. 5–55; Weidner, *Latter Days* (1994), pp. 221–25.

In painting, Xuanzang's seventh-century contemporary from Central Asia, Yuchi (or Weichi) Yiseng 尉遲乙僧, appears to have adopted just this conventional linear drapery mode, turning it often to active purposes (Fig. 1.14).

Fig. 1.14 Unidentified artist
Dancing Girls of Kutcha (detail)
Florence, Berenson Collection

1.14

Thus, as recorded of him in Zhang Yanyuan's 張彥遠 ninth-century *Record of Famous Paintings through the Ages* (*Lidai minghua ji* 歷代名畫記): "In painting foreign subjects or Bodhisattvas, if (the painting) was small then his use of the brush was tight and tense like bent wire and coiled threads; if it was a large (painting) then his strokes were free and abandoned and had resolution of spirit."[19] It is significant that Yuchi's style was recognized as being non-

[19] Acker, *Some Tang and Pre-Tang Texts* (1954 and 1974), II, pt. 1, p. 224.

Chinese, what we might positively describe as a Central Asian style, a clear sign of Western roots and, with Sakyamuni, holding a lingering iconic truth. Of greater importance is the persistence in China of an image, however touched by minor variations, that refused to let go of what was made sacred by direct capturing of the living Buddha. By not yielding completely to the flux of natural time, the strength of all true archaism, the timeless is affirmed. Stamped by this "otherness," it is the more significantly worthy of worship.

Because Liang Kai has not neglected the changeless image, but rather linked it to an immediate personal presence, physical in itself and in its setting, his solitary figure radiates special authority and power — tradition made visible, the immediate strength (or struggle) within, and nature's power without. However, just as implications of original authentic image-truths are compromised by only partial revelation of sacred signs, the Sakyamuni that emerges from the mountain in this Song and Yuan China does not convey an easily grasped message. His is a presence subject to doctrinal doubt. Consider two examples of poetic lines that debate this question close to the time of both Liang Kai and Ma Yuan.

Here are the clipped words of 1244 and 1246 by Chijue Daochong on the two paintings from Cleveland and Japan:

Recluse in the mountain so withered thin	入山太枯瘦
in snow suffering the frosted cold —	雪上帶霜寒
a chilled eye finds the single star	冷眼得一星
Why again emerge among men.	何再出人間

Two years later the enlightenment continues but with less questioning:

In snow mountains six years	雪嶺六年本體成
The body complete — revelation	現絕見明星為物
Exactly seen — bright star.	
By a thing transformed	所轉非物轉略為
not things transforming —	
All causes through a single thread.	群機通一線淳祐
Written in praise by Daochong of	丙午春靈隱道冲贊
Lingyin [Temple] in the spring of	
the year *bingwu* in the era Chunyou.	

However, Xiyan Liaohui of the next generation can disagree (Pl. 4a):

At midnight seeing the bright star	夜半見明星
In the mountain cold words increasing;	山中添冷話
Feet still in that mountain	腳未出山來
these words travelled the world.	此話行天下
I see among all living things	我觀一切眾
buddhas complete, again and again;	生成佛多時
Only you, old man, without *satori*.	只有你這老子猶欠悟在

Now cold austerities for enlightenment (*satori*) continue to be useless.

Such contradictions have their positive side. In presenting ambiguity the image becomes freed from the seeming certainty of an established mold. Indeed, the image becomes a kind of *gongan*, one of those puzzling phrases or situations so important in Chan practice that stressed the pursuit of truth, not as a doctrinal certainty, but rather as experience, a truth more often than not shattering the screen of objective logic: fiercely, such notions as, "If you meet the Buddha, slay him"; or more philosophically, "Seeing to his own nature, man attains Buddhahood."[20]

It was this turning to the individual that opened the prospect of wider means to enlightenment. Return again into the late eleventh and twelfth centuries with Foyan Qingyuan and his poem-painting recordings of collected sayings (*yulu*). The beginning with *Sakyamuni Emerging* is only the first of an expanded list. Wider possibilities exist, even extending beyond the human equation to the broader natural world and its flora and fauna. Thus are brought to life a variety of Chan heroes, priests and sages, monks and arhats (*luohan* 羅漢), not necessarily all with definable names, but to mention some of the more recognizable, consider: Bodhidharma, Fenggan 豐干, Hanshan 寒山, Shide 拾得, and Budai 布袋.[21]

[20] Brinker and Kanazawa, *Zen Masters* (1996), p. 13.
[21] Brinker and Kanazawa, *Zen Masters* (1996), pp. 131–32. Also Brinker, *Zen* (1987), pp. 47–48.

In this group, isolate the enigmatic person of Budai (Jp. Hotei) who, it turns out, had special links to Buddha realization (Fig. 1.15). As with Sakyamuni, he too had historical certainty — a Chinese monk from Zhejiang who lived at one time near Ningbo, not far from Hangzhou. He is said to have died early in the tenth century (between 901–903; a second text lists 916), which places him in history when Chan was establishing strong foundations. He was celebrated as a non-attached soul, wandering from place to place begging and carrying a huge bag full of unspecified treasure, often hung on a staff carried over his shoulder. In begging he would accept meat and wine from wine shops. Apparently impervious to weather, which he could predict, he slept in the cold and snow, yet no snow gathered on his body. According to his earliest biography in the late tenth century he was indeed: "Maitreya, truly Maitreya / But recognized by none."[22] With Budai-

Fig. 1.15 Liang Kai, attributed
Budai (detail)
Shanghai Museum

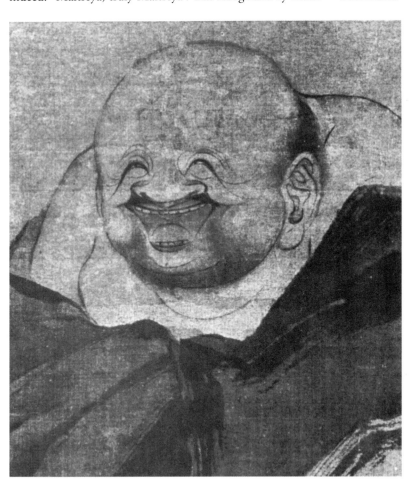

1.15

[22] Edwards, "Pu-tai" (1984), p. 12 ff.

Maitreya, that is, the long-awaited future Buddha, one can understand how buddhahood and enlightenment could then be found for painter, poet, and priest in forms previously unrecognized, or to accept Xiyan Liaohui's lines translated above, ". . . among all living things / buddhas complete . . ."

There is the possibility that both Liang Kai and Ma Yuan created images of Budai — Liang Kai, in the large album leaf now in the Shanghai Museum (Fig. 1.15); Ma Yuan, a Japanese recording of the subject in the *Gyomotsu on-e mokuroku*, Noami's (1397–1471) fifteenth-century inventory of Chinese paintings for the Ashikaga Collection in Kyoto.[23] With this in mind, can we not then return to Liang Kai's Sakyamuni and Ma Yuan's rustic in their chilled winter dawns?

Despite differences in scale and format the two winter paintings show remarkable similarities (Pls. 1 and 4b). A strong foreground definition, tied to a lower corner, sets off a broad path of undefined "snow." Behind is the sharp rise of spare, wash-induced hill or cliff that allows for touches of tree growth, in turn cut by the picture's edge. Each artist in his own way makes use of confident, almost "calligraphic" touches of ink-branch and twig. In each there is a similar play of light and dark, the ink-induced atmosphere of winter gloom. Whether Ma Yuan influenced Liang Kai, or the other way around, or they were both drawing on similar sources, the visual echoes are evident.

Turn to the two protagonists (Figs. 1.16 and 1.17). Although differing stylistically, parallels may be drawn. Both appear to defy gravity. Whether

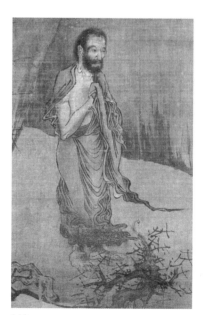

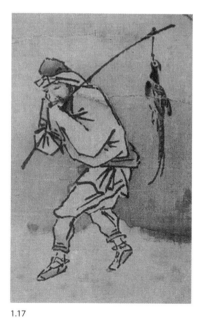

Fig. 1.16 Liang Kai
Sakyamuni Emerging from the Mountain (detail)
National Museum, Tokyo

Fig. 1.17 Ma Yuan
Thru Snow Mountains at Dawn (detail)
National Palace Museum, Taiwan, Republic of China

1.16
1.17

[23] Brinker and Kanazawa, *Zen* (1996), p. 141.

(right)
Fig. 1.18 *Ascetic Buddha*
Central Museum, Lahore

walking or standing, they magically hover above the empty path. Neither sinks into the snow. There are no lingering footprints. Consider again their facial features. Heads are elongated in shape (the rustic with a tall concealing cap). Each offers a dark beard and long prominent nose, both speaking of ethnicity further west. Move to the eyes, always reflections of consciousness. Liang Kai shows them open but the dots of their pupils are usually interpreted as relaying downward and inward concentration. With Ma Yuan's image the prominent lids are heavy, eyes closed to outward concerns. Finally, to arms and hands. Here, with both, gesture is one of tight withdrawal. Much has been said in speculation about Sakyamuni's hands.

Drapery covered, there is no indication of precise positioning, the embracing of a traditional *mudrā* (hand gesture) that in Buddhism was an open sign of physical or psychological action, an urgent guide for the believer. Doctrinal purposes aside, however, in all portraiture a gesture, what hands are doing, active or passive, indicate a subject's character. Here, even in concealment, arms are symmetrically lifted. Hands must be together. In part this is a natural reaction against the cold. However, given the certainty of a god-like presence in one, it is difficult to escape a meaning of reverential withdrawal in both. Action turns into the self.

Rare surviving sculpted images of the ascetic Sakyamuni that were carved for the early Buddhism of India's northwest — three, at least, now in Lahore and Peshawar, the most famous reproduced here (Fig. 1.18) — give early visual meaning to the fixed meditative severity of that tradition.[24]

The verbal counterpart is found in the *Lalitavistara* as disclosed in Nicholas Poppe's translation of a Yuan Mongol text:

> . . . he became lean, became very lean, became extremely lean.
> His eyes sank inwards and were like stars seen on the bottom
> of a deep well. His spine was like twisted rope, the joints of [his]
> arms and legs stuck out and became like ribs of the animal
> called crab or [like] the roof [beams] of a ruined house . . .[25]

Clearly, Liang Kai's figure has moved a long way from such static meditative rigidity, its desiccation of the flesh. It is even further for Ma Yuan. His fuel gatherer is clothed as a commoner (Pls. 1 and 4b). The donkeys and their burdens are also part of that direct human condition, not signals of autocracy or religious hierarchy. This is natural to expect from Ma Yuan. As a painter, whatever he touched with his special vision and the skill of his brush, his style, his art, was closely tied to the physical world and, selectively,

[24] Ingholt, *Gandharan Art* (1957), Pls. nos. 52, 53, 55.
[25] Poppe, *The Twelve Deeds* (1968), p. 139. Text and image also cited by Brinker, *Shussan Shaka* (1983), p. 16 and note 23.

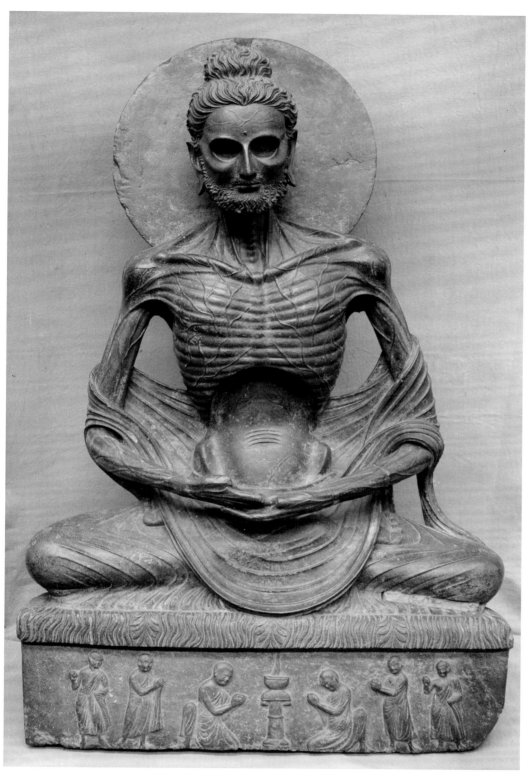

what it contained. In the expanded context of subjects suitable for Chan practice, can we not think of his rustic woodcutter and fuel gatherer, a representation of common humanity, as concealing yet partly revealing a special presence, as with Budai, "recognized by none"? Visual parallels with Liang Kai's hero are difficult to deny. If Sakyamuni spent six years in the mountains, given Chan understanding and the nature of imagery in late Song China, need motionless meditation be the only acceptable activity? What else might have occupied that long stretch of time?

Concentrating on the subject of "The Unity of the Three Creeds" as it is found in Muromachi Japan, John Rosenfield has comprehensively viewed the significance of ink painting in that important period. He sees its presence as no less than part of a vital transformation, even a major "Renaissance" in Japan's unrolling of time. What was previously presented in the form of a "hieratic and strictly logical symbolic system" becomes in the contrasting development of *suibokuga* 水墨畫 ("ink painting") a form of communication in which symbols "are often indirect, understated, or purposely concealed." "Nonetheless," he significantly adds, "the symbolism was meant to be understood."[26]

Since so much in Japan's ink painting tradition, however transformed, can claim ancestry in late Song China, can we not apply this reasoning — including much that the later triumph of a literati aesthetic in China was to overlook and neglect — to China's earlier embrace of such subject, technique, and meaning? Rosenfield's essay is directed to the important theme of the "Three Creeds," the three teachings of Buddhism, Daoism, and Confucianism. This, too, was a vital part of late Song culture, its presence affirming a grasp toward universality. Emperor Xiaozong (r. 1162–1189), who wrote a treatise on them, *Discourse on the Three Doctrines* (*Sanjiao lun* 三教論 also titled *Yuandao bian*), tells that it reached the highest social levels.[27] Inevitably this pursuit was linked to philosophical and religious thought. But it was the painter's task to bring visual tangibility or conversely, by visual forms to create new ideas within this broad conceptual frame.

Consider once more Ma Yuan's modest figural landscape (Pl. 1). As has been suggested, there are signs, specifically selected and placed, that may have meaning for all three modes of thought — Daoist, Confucian, and Buddhist. Indeed, no less than the great thirteenth-century scholar-commentator Zhou Mi wrote of a Ma Yuan painting depicting the subject of the Three Teachings.[28] It is a subject that will be treated later in some

[26] Rosenfield, "The Unity of the Three Creeds" (1977), p. 207.
[27] Lee, "The Domain of Empress Yang" (1994), p. 223.
[28] Zhou Mi, *Qidong yeyu* (1291), ch. 12/8; reprint (1987), p. 249.

detail. But beyond such iconography from Ma Yuan's mind and hand is the wider implication for this album leaf of great nature's importance, of winter's chilled embrace. Ma Yuan's formal unities control the whole most significantly in brief, often broken, movements of the brush, most markedly in varied uses of the angle, its abruptness, its crisp contraction, its triangular implications. In total format such geometry is related to the traditional generalities that claimed his devotion to a one-cornered, hence angled, composition. Here it is more a matter of detail, thus, as mentioned earlier, the gait of the donkey, the stride of the fuel gatherer, the split of the plum branches. But it goes much further: the pitch of the donkey's ears, the sharp twig-end, the brief brush of axe-stroke texturing, dark in the foreground, shadow-like above. It is even found in the tiny staccato ends of protruding river grass or an abbreviated drapery crease. No single shape or line is overwhelming in itself. Each is partial, selective, sure, yet to be sought, not imposed. It even affects the foreground shore line, which is not a simple easy sweep. This is so because of a consistent whole, best described as the meaning of winter. Winter, especially winter in snow, surrounds and conceals. Outward life is closed in. Chill is contraction, not expansion. Yet in this retreat is something new, snow's purity. Ambiguously, through the confining hills and cliffs, there is fresh space. As Ma Yuan's withdrawn, introspective fuel gatherer hovers over and within the open snowy mountain — not unlike Liang Kai's recognizable Sakyamuni — the time is set toward new beginnings.

Fisherman on a Winter River

To move from the subject of a fuel gatherer to a fisherman is a ready transition, and with Ma Yuan this shift can be done in the same cold season. His *Fisherman on a Winter River* (*Hanjiang dudiao tu* 寒江獨釣圖) presents a solitary hunched figure seated, pole in hand at the stern of his fragile skiff (Pl. 5). Now the image is caught in greater isolation but with a parallel clarity of focus. In China both figures stood for a special kind of man who by virtue of a life detached from the "dust-filled" world had a unique potential for wisdom. There, in closeness to great nature, as the eleventh-century landscape painter Guo Xi 郭熙 wrote, one would " . . . come upon the fisherman, the fuel gatherer and the recluse, and know the soaring of the cranes, the crying of the gibbons" 漁樵隱逸所常適也，猿鶴飛鳴所常觀也.[29]

[29] *Linquan gaozhi ji*, Guo Xi, *An Essay on Landscape Painting*, translated by S. Sakanishi, *Essay* (1935), p. 30. Chinese text reprinted in Guo Xi, *Zaochun tu* (1979), p. 9.

Recognized as one of the treasures of the Tokyo National Museum, the painting is again of modest dimensions (26.8 x 50.3 cm) — slightly wider but within a centimeter of the same height as the fuel gatherer scene. Painted in ink on silk with slight color added, the mounting is now that of a hanging scroll. Without the artist's signature, a partly cut-off seal in the lower right offers special significance for it carries the legend: "*xinwei Kunning biwan*" 辛未坤寧秘玩. A seal already mentioned (Fig. I.1a), it designates the Kunning Palace specifically associated with Ma Yuan's royal patron, Empress Yang. A further significance lies in presenting a date, *xinwei*, the cyclical characters of the year 1211, the whole indicating royal approval and presumably collecting. The painting may well have been done close to that time.

The seal has been slightly cut at the right edge. It is thus clear that the entire side of the painting has been trimmed. There are also a good many points of minor damage on the dark, tight early silk. Since there is so much more space to the right of the fisherman than to the left, it is highly likely that the left side was also trimmed, suggesting the possibility that the brief painting might once have been part of a longer handscroll. Scholars in Japan have doubted the painting's personal authenticity. The line is not an exact match to other signed Ma Yuan figures. The seal cannot be found elsewhere. Still, while remaining aware of cautionary faults, the image is so exactly significant in itself that it is difficult not to place it in the closest proximity to Ma Yuan's inventive artistry. The lack of signature reminds us of his water studies that are similarly limited in extension and now similarly unsigned. It is a painting that needs no further addition. Consider the merits.

Against an empty background, darkened by an even, light wash and the wear of time, we look — as so often in the late Song — across and slightly down. There is the fisherman, his rod, reel, his skiff, and the few free-flowing lines that embrace it in the water's movement. Otherwise there is nothing — no land, no trees, no rock, no companion, no horizon. All wiped clean. What we see is characteristic of Ma Yuan's definition of people and things: the reduction of forms to a limited number of selected blunt lines. Without losing strength, they may vary, as in the face, the fishing line or the curving sweep of water.

Alternatively, ink may spread into a stronger dark area, as with hair and beard or boat siding. The severity of ink is only slightly softened or warmed by a light wash of color as on clothing and face. There is little doubt that we are viewing an actual fisherman (Fig. 1.19). He is fishing. The line is in the water. The reel could turn. Complex lines describe its double structure. The boat is properly weighted toward its crouched occupant. We see the drift on the water. Boat planks are structurally lined, the boat covering neatly matted. In the simple selection of gear, there is also no doubt: the crossed pattern of

the fiber-bamboo rain-hat, the grass rain-cape bound and hemmed where it would tie around the neck. There is a brief hole at the bow for a punt pole to anchor the skiff to shoal or shore. Now it is empty, the boat drifting free. The idle oar.

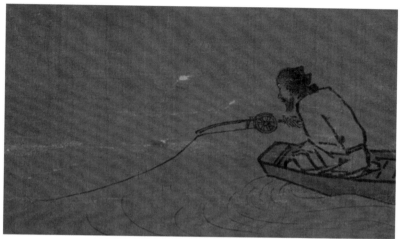

Fig. 1.19 Ma Yuan
Fisherman on a Winter River (detail)
National Museum, Tokyo

1.18

In a wider sense, shape echoes shape thereby stressing the cohesiveness of a tiny world. The upward curve of the bow is caught again in the downward sweep of the fishing line off the stern. The swell of the waves that touch the side of the boat is answered by the curve of rain-cape, hat, and the bending of the fishing pole. The angle of the short oar is repeated in lines that describe the forward lean of the fisherman. Indeed, the unworn empty hat and cape — a shell, a kind of disembodied self — face the same direction as the tense, quiet fisherman (Fig. 1.20).

Fig. 1.20 Ma Yuan
Fisherman on a Winter River (detail)
National Museum, Tokyo

1.20

As definition ties the image to the physical world, one cannot avoid the fact of time. It is no less exact. Contrast defines it. On the one hand are the boat's rigid structure and man's fixed angled pose. On the other are the active rise and fall, the moving lines of water. With that flow is a natural consistency. When it meets the fisherman-weighted stern, easy movement eddies to move around it, later again to be absorbed in the larger flow. The fisherman with rod and reel becomes a counterforce, leaning leftward and gazing further to where the line meets the water. But the line is slack. No fish has yet arrived, nor has there been time for the current to swing the line and hidden bait in its inevitable direction. Action, then, is at a line-thin point — something about to be, something not yet defined. The subject surrenders to the enigmatic moment.

Is not this definition of an anonymous fisherman, as already detailed of the fuel gatherer, a figure suggesting parallels to known Chan sages: to Liang Kai's Huineng 慧能 (638–713), the sixth Chan patriarch, knife raised to chop bamboo, or perhaps the figure of Xianzi 蜆子, attributed to Muqi, discovering a single shrimp? (Figs. 1.21 and 1.22). With Ma Yuan's painted identifiable heroes of Chan Buddhism (Pls. 26 a–c), however fashioned with a sense of restraint similar to this fisherman, none is more accurately aimed at time's moment.

Fig. 1.21 Liang Kai
Huineng Chopping Bamboo (detail)
National Museum, Tokyo

Fig. 1.22 Muqi, attributed
Xianzi and the Shrimp (detail)
Heizandou Collection, Japan

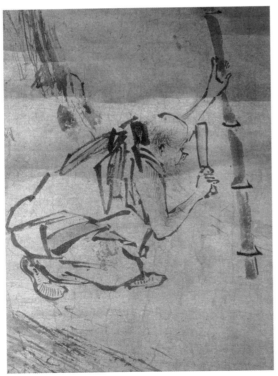

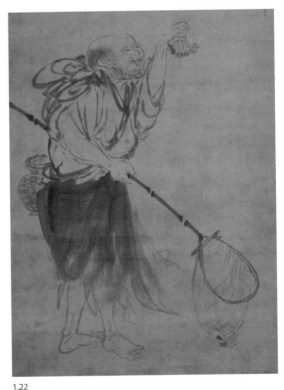

1.21

1.22

Poetry helps seal the subject. In this case it is not because a famous four-line poem by the Tang poet, Liu Zongyuan 柳宗元 (773–819), is actually written beside the painting, but simply that in its brevity of words and elimination of a familiar setting it, too, leaves a similar essential figure:

A thousand mountains – bird's flight cut　　千山鳥飛絕
Ten thousand paths – man's traces gone　　萬徑人蹤滅
Lone boat, straw cape, bamboo hat, old man　孤舟蓑笠翁
Fishing alone the winter river snow.　　　獨釣寒江雪

Egrets in Winter

Ma Yuan's involvement with nature's winter, however, can become all the more direct in eliminating the human element completely, although as will be shown, not devoid of human significance. Such is the hanging scroll, *Egrets in Winter* (*Xuetan shuang lu* 雪灘雙鷺), now in Taipei's National Palace Museum (Pl. 6a). It is birds themselves, not disappearing but present, selected magpies and egrets, that give warm life to chilled, waiting surroundings. Only the bamboo speaks of enduring green, but that touch has withdrawn to the shelter of tree trunk and cliff with subdued leaves directed arrow-down, as do those of last year's river reeds or *lu* 蘆 grass (*Phragmites communis*). Boulders and narrowing land limit the shallow flow of winter water. As has already been shown of the season, it is contraction, not expansion, that sets the mood.

Never is Ma Yuan's leaning to one side or single corner more confidently expressed, an effect enhanced by the liberal use of another mark of his style, charcoal ink, which gives added force both to smooth lines and brief dashes of the brush. With ink there is an inventive range from flat wash-like black to dryer extensions of split brush. Line itself may be brittle and short or given a varied touch to fit the description of a tremulous brush (*zhanbi*).

Although there are touches of light color, the exploitation of a brush loaded with black is the creative means whereby its absence opens much of the silk surface to its opposite, snow's white covering embrace. Yet this is no glaring sunlit day. Rather, vision is consciously tuned to the realities of moisture-laden south central China's water country, where winter may bring a tangible enclosing atmosphere. As with *Thru Snow Mountains at Dawn* (Pl. 1), a brief triangle of dark sky, now in the upper left, sets off the mood of gloom. Elsewhere

lighter washes and aging continue to dull snow's brightness. The background that dims waterside and rising mountain is unfortunately streaked with damage (even-spaced lines of dampness occurring at some early storage time when the scroll was rolled). Otherwise, a surface of silk, with pale touches of wash, is again before us. Ma Yuan continues as the poet of near and selected things.

While the scene is winter *en face*, one can still detect lingering aspects of traditional earlier Song vision, or "distances." One looks down on brief moments of frigid water ("level" distance), and up ("high" distance) toward a rising mountain flank fronted by the extended plum branch, but never truly "high" since the peak is never reached. Otherwise the perspective is direct ("deep" distance). Thus the three huddled birds are partly concealed both by their own bodies and cave-like blocks of boulder and cliff that anchor the lower left. This sets off shallow layers of recession: rock, cliff, and overhanging plum; then birds, water-bordering reeds, and bamboo. Finally, there is an unexpected open-water intrusion into the misted snowy mountain flank rising above it. These are visually separated in space, but never distantly so.

As to the birds' identity, there is a conscious respect for their physical being in a seasonal habitat. While the scale and distance of the magpies can only permit touches of ink, the active poses of their long-tailed silhouette complete with their most prominent patches of white on upper side and underbody define the ever-present Eurasian or Black-billed Magpie (*Pica pica*), China's *xique* 喜鹊, bird of auspicious presence. In turn the species of egrets is more difficult to pin down. However, both because of apparent large size and a common range, including wintering in south China, it would appear to be either the Intermediate Egret, *Zhong bailu* 中白鷺 (*Mesophoyx intermedia*), or the Great White Egret, *Dabailu* 大白鷺 (*Casmerodius albus*, also *Egretta Alba*).

Both are said to be silent but with a rasping croak when disturbed. For both, feet and legs are black. In the end, however, the element of size (compared to the magpies) suggests the identity of the latter. The possible descriptive fact that bare skin extends around the eye, as well as perhaps artistic desire to represent the largest bird, also balance the scale to the great white egret.

Both in composition and selective representation Ma Yuan's creative imagination is certain. The boldness in the leaning to one corner is the more exaggerated by the countering restless outward stretch of the overhanging tree. The same is echoed in the placing of the egrets. The huddled overlapping trio at the left is answered far to the right by the distant isolation of a single complete bird. Shapes also tie varied living things together. For

1.23

1.24

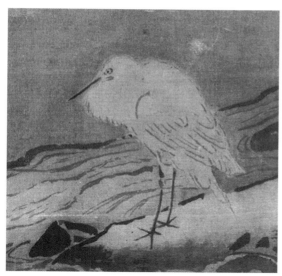

1.25

Figs. 1.23, 1.24 and 1.25
Ma Yuan
Egrets in Winter (detail)
National Palace Museum, Taiwan,
Republic of China

this the egret's form is a special key — simple swelling whiteness as with all snow-covered objects. This is exaggerated in the prominent, apparently male, bird isolated to the right whose withdrawn neck and fluffed-out feathers appear as defense against the cold. In turn, partially black extended beaks may find a sympathetic reply in a sharply pointed texture stroke, the tip of a plum branch, the pointed bamboo leaf and even more, close by, the snow-weighted leaves of last year's water-bordering *lu* grasses. Just above them the

narrow tipped-up intrusion of snowbound water presents not only a beak-shaped "head" but the "eye" of a single small rock.

The traditional meaning of the egret as a prized large bird of the water margins is not quite as easily discovered as that of China's geese or the long-lived crane. However, consistent with other experiences of the natural world, the egret's recorded presence goes back to the early Confucian classic, *The Book of Poetry*. Present in the *Odes of Zhou* is "The Winged Egrets" (*Zhen lu*) 振鷺 which begins:



The winged egrets are flying
now there in the western marsh.
My guests have arrived
with like elegant appearance.

振鷺于飛。
于彼西雝。
我客戾止。
亦有斯容。



Commentary points to egrets as prized both for their white purity and elegance of movement. Here the image is transferred to arriving officials, envoys from two former dynasties arriving at the court to assist in the sacrifices.[30]

Shifting to the Tang dynasty, the flocking bird transfers implications of official dignity to qualities of reclusion. A brief verse, by the Zhejiang poet Zhang Zhihe 張志和 (730?–810?), himself a recluse in China's water country, defines "The Fisherman" (*Yufu* 漁父):

Fronting Xisai Mountain white egrets in flight
Peach blossoms, flowing water, the plump *gui* perch
Fresh bamboo hat
Green reed cloak
A slanting wind and fine rain – no need to return[31]

西塞山前白鷺飛，桃花流水鱖魚肥。青箬笠，綠蓑衣，斜風細雨不
須归。

The fisherman's appearance clearly parallels Ma Yuan's selective linear depiction in the Tokyo Museum painting. Now elements of reclusion direct us to the late fourth- and early fifth-century poet Tao Qian 陶潛 (Tao Yuanming 陶淵明). This is true both of the "peach blossoms" that suggest his account of another fisherman who followed these blossoms along a stream to discover a whole village in utopian withdrawal, and even more directly the poet's earlier famous ode, "The Return" (*Guiqulai xi* 歸去來兮), describing rejection of officialdom for the reclusion of a rustic life. Here the fisherman has already found that life, the flying egrets, as in the Zhou poem, setting the scene.

[30] See Legge, *The Chinese Classics* IV (1970), p. 585. I have slightly altered the translation.
[31] Poem reproduced in Zhongguo shehui kexueyuan wenxue yanjiusuo, *Tang Song cixuan* (1981), p. 11.

Yet another facet of this avian symbol of probity and reclusion may come from snow itself. Edward Schafer quoting a line from a slightly later Tang poet, Li Deyu 李德裕 (787–849), finds the egret "Skimming the wind — flying like the snow." The suggestion is of the whiteness of divinity, not only in the bird but in snow itself. He carries this further to the famous Daoist mountain, Mao Shan in Jiangsu, not far from the river Li and Daoists "who sought total realization of human potentiality and ultimate transition to a more perfect world." Thus the presence of snow evoked a tangible quality of purity, the more to be treasured when unexpectedly found in China's southern regions, and the cold that came with it, the equivalent of divine breath. It can be an effect present as well in Ma Yuan's version of the fuel gatherer.[32]

Other high-quality surviving paintings representing the egret are difficult to find. Thus, all the more important is a rounded fan recently rediscovered by Wen Fong from the collection of New York's Metropolitan Museum (Pl. 6b). No painter is defined, but a general attribution to the twelfth century comes close enough to Ma Yuan's time to offer a striking contrast to his winter representation. Now the season is in the full growth of its water bordering reeds and grasses, blessed with auspicious breezes in unblemished space. The birds themselves are too miniature in scale to offer a search for species identity. Rather, with contrasting black legs and beaks, they become symbols of white feathered purity. Three birds above, with the outspread wings and downward feet of a landing glide, approach an expectant group already settled in the welcoming reed embrace of the lower right corner of the painting.

Another significant suggestion of an early egret painting comes in the form of a poem colophon written by the somewhat obscure Yuan poet Cen Anqing 岑安卿 (1286–1355). Although composed after Ma Yuan's time, it was brushed as a colophon for a painting of undeclared painter or date entitled "Clear Stream" (*Qingchuan tu* 晴川圖), apparently a short handscroll as is implied by the unrolling of a series of suggestive images of what the egret might evoke:

Cloudless — shimmering, gives life to small flowers;	清谿瀰瀰生淺花
The dawn sun, reflected, stirs golden sands.	曉日倒射搖金沙
Swiftly a pair of egrets descends on treacherous rocks,	翩然雙鷺下危石

[32] Schafer, "The Snow of Mao Shan" (1985–1986), p. 110 for the egret; p. 120 ff for Mao Shan and southern snow. While references are drawn from Tang dynasty poets, there can be little doubt that Daoists in sophisticated Song Hangzhou would have been unaware of the importance of Mao Shan. For possible Hangzhou connections with Mao Shan see also Lee, "The Domain of Empress Yang" (1994), p. 265 ff.

Their jade snow lights the shadows — without the slightest blemish.	玉雪照影無纖瑕
The little streamside scene enters the painting	溪邊小景入圖畫
Blue mist, green trees, old fisherman's house.	青烟綠樹漁翁家
The fisherman returns, his song not yet ended,	漁翁歸來歌未終
And the egrets suddenly rise on the reed-flower wind.	鷺絲忽起蘆花風
Eyes turning back, he gazes into the distance, unreachable,	回眸遙望不可極
Sees only white jade flying in blue sky.	但見白玉飛青空
In former years he passed the night on Xiao-Xiang's strand,	昔年夜宿瀟湘浦
No sleeping until dawn, listening to the driving rain.	徹曉不眠聽急雨
With loosened robe, and dragging staff, he stands at the sandy head.	解衣曳杖立沙頭
What is like this morning? Can it be described?	何似今朝得容與
A Chang'an horse: cold, with mud-covered belly.	長安馬寒泥沒腹
Snow-filled court robes: frozen shoulders shrink.[33]	雪滿朝衣凍肩縮
I try lifting the brush to inscribe this painting.	試令援筆題此圖
A long poem — I should offer a "Song of Return".[34]	長篇應賦歸來曲

In part the poem brings images that relate to the Metropolitan fan painting: the idea of a bright arrival in a fresh auspicious dawn; wind stirring the reeds; and the clarity of an open distance. In effect, however, the Yuan poet's description is a mirror reverse of the scene in the Metropolitan painting. Despite a bright dawn, the poet sees arrival in an environment of danger for which the purity of the egrets' embrace can only be affirmed by a breeze-stirred departure into contrasting undefined space.

On the social level, Fong has suggested that the egrets' arrival carries the symbolism of a return to the peaceable kingdom reestablished by Gaozong in the south.[35] Clearly the poet, in his time, turns that around, and despite an auspicious beginning, his world — and that of the unknown painter — embraces a court unworthy of an egret's presence.

The shift to the image of *Night Rain on the Xiao and Xiang Rivers* (*Xiao Xiang yeyu* 瀟湘夜雨), one of the famous series of *Eight Views* that feature so prominently in late Song painting, sets the stage for a traditional lament. As Alfreda Murck has carefully described of that subject, the scene evokes

[33] The image of the Chang'an horse heading into a cold wind derives originally from the story of Wang Zhaojun 王照君, a former Han dynasty palace woman who was sent out from the palace to become the wife of a Xiongnu chieftain in the north. She became a favorite subject for poets.

[34] Cen Anqing, *Kaolao shanren shiji, juan* 2, pp. 3b–4a.

[35] Fong, *Beyond Representation* (1992), p. 259.

sorrow and deprivation, including that of the scholar in exile.[36] Indeed, the Yuan poet Cen Anqing's final lines evoke the incompetence of current rule. Within this, the image of the Chang'an horse heading into the cold is also a long-standing poetic conceit of alienation. It is anchored to the banishment of Wang Zhaojun, the palace beauty of the former Han dynasty, who was unjustly sent to be the wife of a northern Xiongnu chieftain.[37] In its final thrust, the poem directs us again to its only justifiable end, that long-ago famous withdrawal and reclusion, Tao Yuanming's "Return."

With Ma Yuan's egrets, the image shifts understanding to a far more direct and penetrating revelation. By taking a forward position on the stage, the bird is no longer an ornamental metaphor but a natural form with a life of its own. As such the egret is not primarily present to embellish human action, to fly in happy order across mountain flanks or disappear into a far blue distance. While not denying the meanings suggested above, the bird remains, as it were, in the frozen "swamp," the here and now, and with its natural stance meets the cold of winter's gloom, a presence made the more secure by the painter's selective order. Using deliberate space to divide major figures in a composition, either horizontally, vertically, or angled, might well be considered a Ma Yuan trademark (see Pls. 7, 16, and 17, and narrowed but still important, 26b, 26c, and 34). It imbues a special dignity to relationships. With the egrets one should also notice the open bill and tongue of the main bird to the left. This brings the element of sound across the still chilled water margin. It may suggest a parallel to another large bird of sky and fen, the ubiquitous crane. It is an image again that goes back to the *Book of Poetry*, specifically the opening lines of two stanzas from "The Cry of the Crane" (*He ming* 鶴鳴):

The crane cries in the ninth pool of the marsh	鶴鳴于九皋。
and its voice is heard in the wilds	聲聞于野。
The crane cries in the ninth pool of the marsh	鶴鳴于九皋。
and its voice is heard in the sky[38]	聲聞于天。

In the brevity of today's bird guides the egret is usually defined by silence, only mentioning a hoarse cry when alarmed, a meaning here not totally to be discarded.

Whatever Ma Yuan's painting may echo in the more subtle traditions mentioned above, it is at heart a direct temporal occasion when chilling snow blankets cloud-covered winter, most certainly a seasonal experience

[36] Murck, *Poetry and Painting in Song China* (2000), p. 108 ff.
[37] I am indebted to Thomas Smith for this reference, and for providing this previously unpublished translation of Cen Anqing's poem.
[38] Legge, *The Chinese Classics* IV (1960 [1970]), pp. 296–97, "The Decade of Tong Gong," ode 10.

in Hangzhou's often heavy-laden atmosphere. Of no little importance is the pair of China's ubiquitous *xique* magpies actively perched on suspended stretches of the plum tree. One is the feathered equivalent of good fortune, the other, a bare exterior — however its Daoist purity — that brings leafless blossoms, early heralds of a warming season. These cultural symbols blend easily with nature's broad and protective embrace in using dark days of withdrawal as a prelude to the contrasting joy of spring.

Winter into Spring

Ducks in Spring: The Mandarin

One cannot discuss the *Egret* scroll without moving, in a subtle shift, early into the next season, to what appears to have been a painting that, with close similar physical properties and comparable subject matter, must be paired with it: *Mandarin Ducks by a Bamboo Stream* (*Zhuxi yuanyang* 竹溪鴛鴦), now in the collection of the Cleveland Museum of Art (Pl. 7).[1] Give or take two or three centimeters, the dimensions of both hanging scrolls are the same (*Egrets* 59.1 x 40.2 cm; *Ducks* 61 x 31 cm). They are painted on similar tight silk and make like use of active strong passages of ink, of which the burnt or charcoal quality (*jiaomo*) is particularly noteworthy. Furthermore, seal evidence places them together in the sixteenth century with similar seals of An Guo 安國 (1481–1534) and Xiang Yuanbian 項元汴 (1525–1590). That the perfection of both is marred by horizontal bands of mildew indicates they were once stored together, rolled up under similar conditions of dampness.[2]

These two paintings, showing significant closely focused landscapes inhabited only by the unpretentious natural presence of birds, must be viewed in a wider perspective. Following the general truth that art is made from art, it should not be overlooked that Ma Yuan was only the most famous link in a generational chain beginning a century earlier with his great grandfather, Ma Fen. In introducing his unique poem — translated above — it is with Ma Fen that Ma Yuan's patron, Zhang Zi, initiates praise of the great-grandson:

[1] For reasons of clarifying the subject I have altered the common title, "Bamboo and Ducks by a Rushing Stream." The stream and duck species are its defining characteristics.
[2] Sherman Lee, in Ho et al., *Eight Dynasties* (1980), p. 384.

Ma Fen was known for his flower and bamboo painting during the Zhenghe and Xuanhe reigns (1111–1125). Ma Yuan, Fen's (great) grandson has inherited the significance of his brush (*biyi* 筆意), reaching the high point of an ability in both figures and landscape. I once commissioned him to paint the scene of a forest-grove retreat. Much moved, I composed this poem to show to Yuan.[3]

Other writers both before and after Zhang Zi have kept Ma Fen's name alive, but it hovers as little more than a shadow-name against the background of a general time. Even Zhang's dates for his artistic activity are approximate. He was certainly prominent earlier than the beginning of the Zhenghe era (1111). Mi Fu in his *History of Painting* (*Huashi* 畫史, ca. 1103) is moved to discard him together with Cui Bo 崔白 who was involved with the court and Academy beginning around 1070. Mi condemned the paintings of both as only worthy of hanging "in tea houses and wine shops." Others pick up the name, sometimes with further suggestions. Deng Chun's 鄧椿 *Record of Painters Continued* (*Huaji* 畫繼) of 1167 is particularly complete, placing him in the Yuanyou and Shaosheng eras (1086–1097) as a master of "small landscapes" with complex but ordered scrolls of repeated subjects characterized by "a hundred": geese, gibbons, horses, oxen, sheep, deer. He is seen as the originator of the family's Buddhist figures, later on "painting from life (*xiesheng*)." Further in the treatise Deng Chun mentions specific paintings: *A Hundred Geese*, *A Hundred Gibbons*, and *Geese*. Zhuang Su in his "continuation" (*Huaji buyi*) of 1298 cites him only in his account of Ma Xingzu, apparently erroneously making the younger artist Fen's grandson. In the early fourteenth century Ma Fen's name resurfaces as one of a trio of late Northern Song painters grouped with Li Tang 李唐 (1050–after 1130), and Zhou Zeng 周曾 (act. 1086–1097), the latter a recorded painter of small scenes, autumn birds, and extended landscapes. In listing this trio along with Southern Song academicians, the writer, Tang Hou 湯垕, in his *Huajian* (ca. 1320) embraces the literati aesthetic of Mi Fu. All, he claims, are indistinguishable from one another, with only Li Tang "somewhat" appreciated.[4]

3 Zhang Zi, *Nanhu ji* (1983). See my "Introduction," note 8. Translation here based on Lee, "The Domain of Empress Yang" (1994), p. 180.

4 Early notes on Ma Fen can be found successively in Mi Fu (ca. 1103). French translation in Vandier-Nicolas, *Le Houa-che de Mi Fou* (1964), p. 91; Deng Chun, *Hua ji* (1167), ch. 7, p. 96; Zhuang Su, *Huaji buyi* (1298) *xia*, p. 10; Tang Hou, *Huajian* (ca. 1320) (1959), p. 52.

It remained for Xia Wenyan 夏文彥 in his *Precious Mirror for Painting* (*Tuhui baojian* 圖繪寶鑑, 1365) to gather some threads together in a selective, coherent account:

> Ma Fen, from Hezhong (Shenxi Province), was a Painter-in-Attendance (*daizhao*) in the Xuanhe era (1119–1125). He was skilled in painting birds and flowers, Buddhist images, the human figure and the landscape. He excelled in "small landscapes" (*xiaojing* 小景).[5]

In recalling the family line it is important as well to mention the grandfather, Ma Xingzu. Zhuang Su and Xia Wenyan give essentially parallel accounts: that he brought the family skills to the south and Hangzhou with direct service under Emperor Gaozong in the Shaoxing era (1131–1162). They note as well his special importance to the court as authenticator of famous paintings in the imperial collection. As an artist, with a nod to "miscellaneous" subjects, skill at painting the bird-flower theme once again emerges.[6]

In sum, although no actual paintings survive, there is enough subject-matter evidence here to indicate family skills in painting close-up natural scenes: flower and bamboo, a forest grove retreat, bird-and-flower, and small landscapes. A painting, *The Hundred Geese* (*Bai yan tu* 百雁圖), a handscroll now in the Honolulu Academy of Arts, while of considerable quality, probably owes its signed Ma Fen attribution to such traditional early titles as recorded by Deng Chun. On style alone it appears to be no earlier than the very late Song.[7]

If one interprets the idea of "small landscapes" as those scenes that draw us into intimate and close surroundings of stream-banks, birds, grasses, and bamboo rather than great mountains, rivers, and extended spaces, authentic examples by others do survive from the time of Ma Fen. Of highest quality are two relevant handscrolls. One is by the Kaifeng painter Liang Shimin 梁師閔 (late eleventh–early twelfth century), noted for just this kind of subject — a painting, now in the Beijing Palace Museum, bearing its artist's signed title, *Lu-Grass Banks in Deep Snow* (*Luting*

[5] Xia Wenyan, *Tuhui baojian* (1365), ch. 3, p. 66. An alternate translation of "small landscapes" has been offered as "intimate scenery." See Lin Po-ting in *Arts of Sung and Yuan* (1996), p. 87.
[6] Zhuang Su, *Huaji buyi* (1298) *xia*, p. 10 and Xia Wenyan, *Tuhui baojian, juan* 4, p. 78.
[7] Cahill, *Index* (1980), p. 143.

mixue tu 蘆汀密雪圖). It is similarly inscribed by Emperor Huizong (Pl. 8). Two of the five water birds that inhabit this empty, somber low-level winter are Mandarin ducks — male and female (Fig. 2.1).

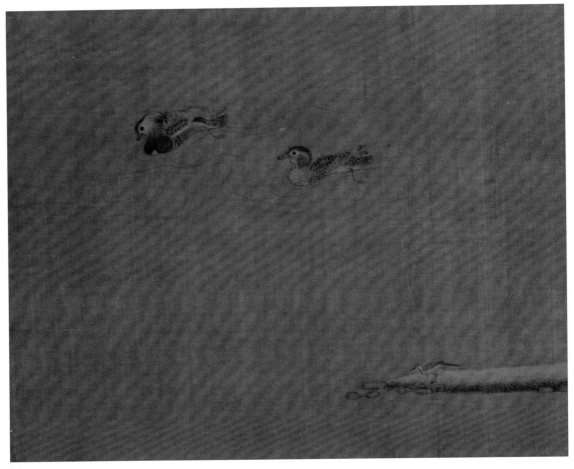

2.1

Fig. 2.1 Liang Shimin
Lu-Grass Banks in Deep Snow (section, detail)
Palace Museum, Beijing

The second sensitive people-less landscape, a handscroll now in the Boston Museum of Fine Arts, is by the royal artist Zhao Lingran 趙令穰 (*zi* Danian 大年, act. late eleventh–early twelfth century). Of Zhao it was said in the imperial catalog, *Xuanhe huapu*, that he "painted nothing more than views of embankments and islets outside the capital."[8] Under the title *River*

8 *Xuanhe huapu* (1123), *juan* 20 (1964), pp. 306–7. See also Maeda, "The Chao Ta-nien Tradition" (1970) and Wu Tung, *Tales* (1997), pp. 138–39.

Village in Clear Summer (*Jiangxiang qingxia tu* 江鄉清夏圖) or *Summer Mist along the Lake Shore* (*Huzhuang qingxia tu* 湖莊清夏圖), the Boston painting clearly fits such a general expectation (Pl. 9 and Figs. 2.2–2.5).

2.2

2.3

Unrolling it is to see an exquisitely refined "small" landscape of retreat with again birds the only fauna. Simple architecture and well-spaced groves are emptied of direct human presence. Now, in what best can be described in conscious absence of linear definition as a "controlled impressionism," the seasons have advanced. Birds on tree-limb and water are many. Over a slightly worn surface they are often too tiny for careful identification, but when, in the beginning, they are high up and in black and white, a flock suggests the stubby Daurian Jackdaw (*Corvus dauuricus*)[9] and the thinner long-tailed bird on the next tree, a willow, are the same Eurasian Magpie (*Pica pica*) that graced the winter plum on the *Egret* scroll. At least one high

Figs. 2.2 and 2.3
Zhao Lingran
Summer Mist along the Lakeshore
Museum of Fine Arts, Boston

[9] MacKinnon and Phillipps, *A Field Guide* (2000), no. 644.

isolated pose indicates song. The ducks with their bright plumage on water and in flight — the only duck with such warm golden color — are likely a more generalized version of the Mandarin (*Aix galericulata*). There are two ghostly waterside egrets. A few others are touched too lightly to withstand the wear of time. In sum, birds are present at the beginning and fly at the end toward what is beyond scroll's limits, carrying with them the unseen.

2.4

2.5

Figs. 2.4 and 2.5
Zhao Lingran
Summer Mist along the Lakeshore
Museum of Fine Arts, Boston

While it is impossible to know Ma Fen's painting style and thereby affirm Ma Yuan's relation to it, it is certainly the transformation of a "small landscape" subject continuing from a previous century that we see in the great-grandson's two hanging scrolls in Taipei and Cleveland. Then, as with Ma Yuan, the seasonal focus, of which birds are nature's reminder, is a major key to its purpose. In the above examples, winter moves well toward summer. In the Ma Yuan examples it is winter into early spring. Also with Ma Yuan, the transformation into a unique style appears complete.

Moving now more exactly from the Taipei *Egret* scroll to the Cleveland painting, the inhabitants shift to one species of ducks (Figs. 2.6, 2.7). Replacing a quiet, static snowbound world is the presence, more accurately an explosion, of a forward-surging mountain freshet. Pinched by a sharp cliff, this time to the right, and an answering rocky intrusion at the left, it becomes a swirling rapid. Only the dancing staccato yet flexible shapes of

open bamboo appear able to survive in this challenging setting. Here they have emerged from a winter of blocking concealment and static cold to reveal separate upright stalks and persistent leafage to help define an early spring. The setting, sometimes tipped, is tense and active in its thrust and counter-thrust of water, rock, and land. Frozen serenity breaks into the excitement of a new season.

2.6

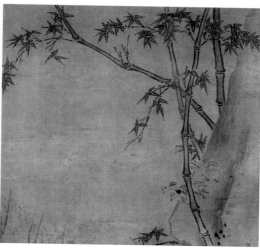

2.7

As with the *Egrets*, this is a conscious artistic performance, but now sharp arrowed points shift to vital curving motion. It is also a view that similarly intensifies and re-presents natural possibilities, a looking anew, which is the business of great painting. Note the empathetic relation between land and water. For example, the dark brush-wash that defines the tipped-up tongue of land at the base of the right-hand cliff is broken enough to allow a line of bright untouched silk to curve upward where it meets the downward arc of a single stalk of bamboo. This touch frames a transparent cave-like area that in turn becomes a variation on the curving lines of water and up-thrust wave — a shape which is again echoed in the mid-distance tongue of land. The rocky shore at the lower left holds another such touch in being pocked with a water-worn hollow that replies to the curved wave-foam at its tip.

In the final analysis, however, what most significantly knits the painting together is its discrete and skillful handling of space. There are, indeed, two view points. The dark tongue of near land on the right as well as the echoing mid-distance promontory and much of the flow of water are tipped to show its level surfaces ("level distance" *pingyuan* 平遠). Yet these are countered by

Figs. 2.6 and 2.7
Ma Yuan
Mandarin Ducks by a Bamboo Stream
(detail)
The Cleveland Museum of Art

the direct eye-level approach to the land at the lower left, the cliff, the birds, and the bamboo ("deep distance" *shenyuan* 深遠). Note the foreshortening for the highest placed duck. There is also a certain daring in the conscious exposure of parts. There is no effort to conceal what might be called the "bones" of the painting — bold forms of land, exact lines of water, stalks of bamboo always single and separate. This "separate" is not only in their plantings but in the way each stalk-segment may be separated from the next. Here it appears deliberate in order to capture the force of detail. In this selective interpretation of nature's growth one is tempted to recall the common phrase applied to the very different art of breaks in free calligraphy: "When the brush breaks off the idea connects" (*biduan yilian* 筆斷意連).

Overall this clarity works because it intensifies qualities in nature as well as our understanding of a season. Anyone who has walked through early spring woods, or for that matter extensive gardens that have not yet fully relinquished their debt to winter, knows of an open world. The contrast comes not only with snow's covering blanket but later with summer's lush concealment. While this division or separation of forms is in part countered by Ma Yuan's sympathy of shape, as we look more deeply the connection is finally secured by a dimming of contrast that creates the illusion of a tangible visible atmosphere. Rather quickly all on this shallow stage fades into an embracing space, an ultimately undifferentiated distance.

Finally, the bird subject, ducks, is a special key to understanding. Their presence gives to the scene a specific narrative focus. The fact that three appear startlingly posed on the steep vertical cliff clearly headed toward a fourth beside the stream below simply adds to the tension of the moment already present in the curving rush of water dancing to instantaneous foam. Their presentation is also a close variation on the winter arrangement of the egrets: one bird separated from three others. Now instead of chilled withdrawal, however, their placement conveys action, thereby complementing the surging rise of spring. We might well think of them with a well-known line from the great Su Shi 蘇軾 (1036–1101):

When spring river water warms 春江水暖鴨先知。
 the duck is first to know.

While Su's verbal image relates to a slightly differing total picture, a painting by the early Song artist Huichong 惠崇 (ca. 965–1017) depicting ducks and, in addition to bamboo, "two or three" branches of the blossoming peach, who is to deny that such an idea was not in Ma Yuan's mind?[10]

[10] Su Shi, *Su Shi lun shuhua shiliao* (1988), p. 99.

Even more, however, small as they may appear in this wildlife drama, the ducks — as in the earlier bird landscapes — are not just any of their kind, but the species clearly identifiable as the Mandarin. Male and female, it is the *yuanyang* 鴛鴦 of common Chinese lore and enduring tradition. Their presence here conveys yet again Ma Yuan's specific concern for the physical world. His setting relates directly to what a modern bird guide succinctly describes of the species' environment: "Wooded ponds and fast flowing rocky streams."[11]

Studies by modern ornithologists have clarified the lives and behavior of these remarkably beautiful birds, for whom the North American counterpart is the Wood Duck — two species in the same genus (*Aix*). The Mandarin, although limited in Asia to its eastern rim, is an extremely wide-ranging bird, all the way from Ussuriland in eastern Russia (as *mandarinka*) to the islands of Japan (as *oshi*) and well down into south China (as *yuanyang*). In modern times the bird has found its way both to Europe and England where it was introduced in the eighteenth century and to North America where it spread in the wild. Winter migrations bring it southward over hundreds, even thousands, of miles. Its association with winter, or living on the edge of winter, accounts for its natural presence in Liang Shimin's *Lu-Grass Banks in Deep Snow*. It is a connection embraced by selected brief words in eighteenth-century Japan — a Yosa Buson 与謝蕪村 (1716–1783) haiku:

> Mandarin ducks
> epitome of beauty
> the winter wood.[12]

While returning to nest in the northern spring, flocks also remained to breed in the south. Careful observations as late as 1990 have reported:

> In China, *Aix galericulata* (Mandarin) is a forest bird, and a bird of small mountain streams, too. According to my records in the last several years, the largest population of wintering Mandarin Duck is in the mountain (hilly) areas of southeast China . . . The number of this species in China is not less than 20,000.[13]

This number can only be a fraction of what may have existed in Ma Yuan's day when large-scale destruction of natural habitat was still centuries away and wooded mountain areas, temple reserves, and extensive gardens pressed so

[11] Meyer de Schauensee, *The Birds of China* (1984), p. 149.
[12] Shurtleff and Savage, *The Wood Duck and the Mandarin* (1996), p. 185.
[13] Shurtleff and Savage, *The Wood Duck and the Mandarin* (1996), p. 139.

closely around the sophisticated city of Hangzhou. Indeed one can suggest a possible parallel with the observed abundance of the comparable Wood Duck in North America before its near hunted extinction in the early twentieth century. Audubon has written of his delight in observing a flock: "Once, twice, three times have they rapidly swept over the stream, and now, having failed to discover any object of alarm, they all alight on its bosom, and sound a note of invitation to others yet distant."[14]

Ma Yuan's depiction clearly parallels scientific observation. Heights appear to be no problem. In Russian forests natural tree nesting cavities are found as high as twenty to sixty feet above ground. Newly hatched downy ducklings are kept well hidden and guarded by the mother in progress that may well stretch considerable distances, even over a mile from the nesting area. In contrast, partially fledgling ducklings are able to dash into the water for protection, skimming downstream. Further, it is noted, Mandarin drakes are among the few ducks that guard their hens and ducklings often until the ducklings are able to fly.[15] It is just this understanding that Ma Yuan is able to relate. The hen, identifiable by her slighter crest and clear white eye-ring extending to the back of the head, guards the precipitous territory above the two offspring. The drake with visibly crested head and more evident touches of color waits below with apparent concern for the inevitable plunge of the two well-formed fledglings. In the late spring, after the young are able to fly, comes the molting season for the adults when the drake sheds his feathered brilliance. Here it is a stage not yet reached.

This special togetherness of drake and hen must certainly relate to centuries of China's familiarity with an abundant species and the semantic linking that identifies them, the inseparable male-female: *yuanyang*. From this appears to have sprung constant auspicious hopes too deeply anchored in tradition to be ever forgotten. In the *Book of Poetry* (*Shijing*) is apparently its earliest recorded recognition.

Yuanyang on the wing	鴛鴦于飛。
caught in nets small nets large	畢之羅之。
for the lord ten thousand years	君子萬年。
great fortune his due	福祿宜之。
Yuanyang at the river-dam	鴛鴦在梁。
gathering the left wing	戢其左翼。
for the lord ten thousand years	君子萬年。
extended fortune his due	宜其遐福。

[14] Shurtleff and Savage, *The Wood Duck and the Mandarin* (1996), pp. 68–69.
[15] Shurtleff and Savage, *The Wood Duck and the Mandarin* (1996), p. 125.

Chariot horses in the stable	乘馬在廄。
fed with fodder fed with grain	摧之秣之。
for the lord ten thousand years	君子萬年。
great fortune his nurture	福祿艾之。

Chariot horses in the stable	乘馬在廄。
fed with grain fed with fodder	秣之摧之。
for the lord ten thousand years	君子萬年。
great fortune his comfort[16]	福祿綏之。

Inseparable from an immediate natural world, this joyous song joins the Mandarin — male-female necessity — to the aristocratic presence of the well-fed horse — wealth and power. The "gathering the left wing," apparently puzzling traditional commentators, is certainly a courting display. From modern observation, the drake "dips his bill, jerks it backward, then preens behind one wing."[17] In sum, sexual fertility graced by constancy parallels the well-fed horse's noble and benign power, twin anchors for "ten thousand years."

Fig. 2.8 *Mating Rituals of the Mandarin Duck*
Reproduced from Shurtleff and Savage, *The Wood Duck and the Mandarin*

2.8

[16] Legge, *The Chinese Classics* (1970), pp. 387–88, with changes.
[17] Shurtleff and Savage, *The Wood Duck and the Mandarin* (1996), p. 159.

The significance of *yuanyang* continues in Chinese tradition with examples too numerous to cite. However, the Tang poet Du Fu who appears to play such a significant part in Song creativity is worthy of mention in sealing understanding of conjugal fidelity. In the poem "The Fine Woman," *Jiaren* (mentioned earlier), comes the heroine's complaint when her husband has acquired "a new wife beautiful as jade" (新人美如玉):

"Yuanyang do not sleep apart."[18] 鴛鴦不獨宿。

Returning once again to Ma Yuan's *Mandarin Ducks by a Bamboo Stream*, if naturalistic, traditional, and poetic purposes are not sufficiently clear, then these lively riverside inhabitants and their setting can simply be seen as declaring a compelling moment — the edge of a swift descent, a splash and away on surging water — the sudden, triumphant, mysterious power of early spring.[19]

[18] Du Fu, *Du shi bianlan* (1986), p. 367.

[19] In closing this analysis of seasonal birds, the well-known hanging scroll of *Swallows and Bamboo* from the Yamato Bunkakan in Nara should not be completely forgotten. It is clear that with its format of swallows, bamboo, and riverside stream it carries out intentions that parallel Ma Yuan's treatment of egrets and Mandarin ducks. Japanese scholars have consistently considered the scroll as a later design crafted on the basis of a now lost original. This conclusion must continue based on what is essentially a looseness of execution that in turn carries a lack of clear seasonal certainty (spring? summer? fall?). On these issues the clarity of the other two scrolls offers a marked contrast. For what it is worth, the clearer seal evidence of the other two scrolls presents a positive history of being kept together in China during the Ming dynasty. Seals of An Guo (1481–1534) and Xiang Yuanbian (1525–1590) as well as similar mildew marks from paired storage all confirm this. In contrast such evidence for the history of the swallows is limited to Japan. A recent brief summary of the painting in Japan, along with references to earlier scholarship, may be found in Nezu Institute of Fine Arts, *Southern Song Paintings* (2004), Pl. 25 and pp. 149–50. See, most significantly, Sherman Lee in Ho et al., *Eight Dynasties* (1980), "Addendum," p. 384.

The Seasons Extended: Flowers

The Flowering Plum

The presence of the plum tree in two winter scenes already discussed (Pls. 1 and 6a) lays a foundation for expanding understanding of Ma Yuan's use of this remarkable flora (*Prunus mume*) so prized in Chinese lore. Often surrounded by winter, it is the first floral manifestation of spring. As with the Mandarin duck, the plum, as the character *mei* 梅, appears on several occasions in the *Book of Poetry*, but its meaning is never clearly defined to include the fragile blossom. The later feminine connotation, however, is not missed in the anthology's only extensive plum poem, "Falling Are the Plums" (*Piao you mei* 摽有梅), which centers on the fruit in the progression of a directly simple folk narrative as the time for action narrows:

Falling are the plums	摽有梅
the fruits are seven	其實七兮
for noble youths who seek	求我庶士
now is your luck	迨其吉兮
Falling are the plums	摽有梅
the fruits are three	其實三兮
for noble youths who seek	求我庶士
now is the time	迨其今兮
Falling are the plums	摽有梅
gathered in shallow baskets	頃筐塈兮
for noble youths who seek	求我庶士
now it's speak up[1]	迨其謂之

[1] Based on Legge, *The Chinese Classics* IV (1970), pp. 30–31; also Bickford, *Bones of Jade* (1985), pp. 152–53. Translations altered.

While importance spreads over centuries, this lack of earliest floral significance in the anthology has led to the interpretation that these songs came from the north and that the flowering plum, whatever its varied forms, only truly flourished in the south.

Thus Maggie Bickford, whose extensive and beautifully researched studies appear to leave no plum blossom uncovered, emphasizes the Southern Dynasties.[2] By the time of Ma Yuan it is not too much to say that the flower had become most significantly a Song Dynasty subject. As it developed, to a great degree it became "Song" because on the one hand, it was part of a direct natural experience and on the other, in that experience, it lent itself to a single probing focus in which the more it was examined, the more it revealed. The flower offered an inexhaustible richness, proof that the most fragile of physical things might become, ambiguously, the most enduring.

Its foundation was exactly seasonal and long recognized as such. Thus, again, the Tang poet Du Fu:

> Just before the winter sacrifice plum buds break 梅蕊臘前破
> Just after the New Year plum blossoms abound.[3] 梅花年後多

It had no floral rival in its defiance of the cold. It thus spoke of life when elsewhere life was dormant. Life was its promise and its beauty. Life was also its reality. It died, as a well-known line by Xiao Gang 蕭綱 (503–551) accepts:

> The spring wind blows plum petals 春風吹梅畏落盡
> The fear is all will fall

With such transiency it was a complete and elegant metaphor for youthful feminine beauty, especially at the court among a sophisticated aristocracy where experience of the flower was the immediacy of its presence in the richly cultivated garden. The Song, however, always exploring, took the imagery further, making it become an established symbol of the recluse. Lin Bu 林逋 (967–1028), while not strictly the first, became the "founder" of this notion of withdrawal, never, we are told, deigning to enter Hangzhou city although he lived close by on Gushan 孤山 ("Solitary Mountain"), an island in the park-like West Lake. In his poem, "Small Plum in a Mountain Garden" (*Shanyuan xiaomei* 山園小梅), Lin captured the flower's essence as "sparse shadows" and "hidden fragrance." In doing so he gave the plum a poetic reference that was never forgotten. Here is an attempt to catch the

[2] Bickford, *Ink Plum* (1996), pp. 28 and 44. For an alternate translation of the poem by Hans Frankel — as well as eighteen more — see Bickford, *Bones of Jade* (1985), p. 153 ff.

[3] For this and the following two quotations, Bickford, *Bones of Jade* (1985), pp. 18, 19, and 24. Some translations slightly altered.

reverberations of each word in two seven-character lines, the shoal waters of winter, the hazed moonlit air of Hangzhou's environs:

Sparse shadows crossing, slanting waters clear and shoal	疏影橫斜水清淺
Hidden fragrance floating, drifting moon yellow and dim	暗香浮動月黃昏

As Bickford tells us, "Poets endlessly invoked the famous couplet, painters gave form to the images it suggested, and colophon writers had only, it seems, to glimpse a painting of a flowering plum for the couplet to spring immediately to mind and brush."[4]

If this vision has not survived in a single work securely given to Ma Yuan himself, it conveys an image easily within his reach, as the quality of his *Egrets and Ducks* implies. Indeed a brief square of painted silk, now in Taipei's National Palace Museum, carries an amended attribution of artist and exact title: "Ma Lin, *Sparse Shadows, Hidden Fragrance*" (*Anxiang shuying tu* 暗香疏影圖). Thus with his son, at least in later commentary, we are brought into the Ma Yuan family (Pl. 10). If sensitive understanding of nature and the inventive handling of its painted forms, often with unexpected outcomes, can be considered to rest at the heart of Ma Yuan's art, this album leaf has found a proper niche. What we see is perhaps the most compelling surviving vision of the famous couplet, the presence of the "small," especially as what is close and intimate, that captures again the essence of very early spring.

From the right edge, too abruptly cut not to suggest some trimming, a single plum-branch with delicately outlined stem and colored circles of blossom and bud extends leftward, interwoven with the contrasting yet sympathetic presence of bamboo. Definition stretches across untouched silk, with a simple split divide toward the end. There is also an additional brittle down-pointing twig that parallels the aim of three arrowed leaves of bamboo. Bamboo presents expected crisp, enduring green. However, worn tips relate that it is not without the wear of time, arrowed endurance contrasting with floral freshness, those fragile beginnings of bud and blossom, white circles of purity dabbed with red and green for heart and sepal. Indeed it is just flowering's beginning. Only three blossoms are fully open — one facing, two turned away. The rest are buds in differing stages of development, offering the suggestiveness of what is "hidden," and its promise of fulfillment, continuing through time.

[4] Bickford, *Bones of Jade* (1985), p. 24.

It is, however, in the water below (perhaps in moonlight's transparency), that uniqueness is compellingly present — a reflected image. Rarely in Chinese art does its imitative nature portray light in such concrete terms. Water is "shoal" by emerging rock. It is "clear" in the calm restraint of only a few lines of movement. Both are a pure touch of lingering winter before spring freshets lift levels and churn stream's flow. The reflected answer is complete in the shadow of branch, a full blossom (badly damaged), three sharp upward-pointing spears of bamboo, and the further upward answer to a down-pointed twig.

The inevitable Song genius, Su Shi, had further set plum blossoms' tone:

Jade and snow comprise their bones ice their soul	玉雪為骨冰為魂
Massed as though of moonlight draped from trees	紛紛初疑月掛樹
Solitary in brightness as Orion at dusk	耿耿獨與參橫昏

Now the flowering plum could be everywhere. For the poet, Zhu Dunru 朱敦儒 (1081–1159):

At the old creek, one branch of plum	古澗一枝梅
Escaping the lock of a garden grove —	免被園林鎖
The road is far, the mountain deep...	路遠山深⋯⋯。

Sumptuous or spare, pretentious or unpretentious, fragile in thin beauty, yet enduring against adversity, close by in the garden or hidden in far distance, a single living thing became a fitting symbol for the age.[5]

Wrapped in the sophistication of the late Song, there was a seemingly unending effort to define the blossom's significance. Lin Hong 林洪 (act. thirteenth century), a descendant of Lin Bu, claimed like retirement on the same Solitary Mountain island. There he created an artistic substitution in a plum blossom paper tent over his bed. It was complete with black lacquer posts, each supporting a vase of the flower as well as other "natural" aids such as a pillow stuffed with dried chrysanthemums and a bulrush mattress.[6] Perhaps more telling in the transference of nature into the metaphors of art was an ambitious quantitative approach. The mid-thirteenth century artist-poet Song Boren 宋伯仁 (act. ca. 1240) printed a still preserved *Manual of Plum Blossom Likenesses* (*Meihua xishen pu* 梅花喜神譜). It was published in 1238 and an early edition of 1261 is still extant in the Shanghai Museum. It

[5] For the two poems see Bickford, *Bones of Jade* (1985), pp. 168 and 173. Translations altered.
[6] See Bickford, *Bones of Jade* (1985), pp. 31–32.

consisted of a neat numerical series of a hundred clean, brief prints detailing moments of the life of the flower starting with bare-branched buds and extending through elaborate stylized manipulations of a single blossom to the final falling of petals (Fig. 3.1 and Pl. 11). Poems accompanied the illustrations, extending ideas not without political implications of loyalty and protest. But the lyric focus, the poetry-painting connection, and above all, the persistence of a living, growing, and dying image carry throughout the book's artistic stylization.[7]

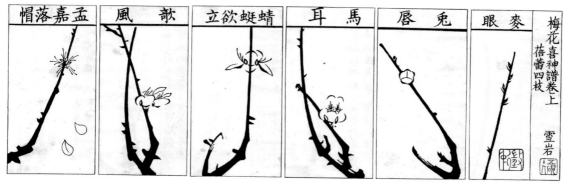

3.1

Fig. 3.1 Song Boren
Manual of Plum Blossom Likenesses
(composite of six selections)
Zhonghua shuju, Shanghai

It is the painting of the plum blossom in its numerous possibilities that further links Ma Yuan to his wealthy friend, poet, and sometime patron, Zhang Zi, who, never sparing of this wealth and long before Song Boren, created controlled multiplicity in the form of a garden grove of three hundred such trees. He then proceeded to characterize the flowers themslves into fifty-eight different types: twenty-six "Fitting blossoms" (*Hua yicheng* 花宜稱); fourteen "Hateful abominations" (*Hua zengji* 花憎嫉); six "Glory-favored" (*Hua rongchong* 花榮寵); and twelve "Abusive mortifications" (*Hua quru* 花屈辱).[8]

However, the genesis of the theme in painting had still earlier shifted to a more individually spontaneous source. It is generally established that the Zhejiang monk Zhongren 仲仁 (d. 1123) was the true creator of the painting genre as a worthy subject for brush and ink. Zhongren's significance is highlighted in the literature by a meeting between the monk and the famous calligrapher-poet Huang Tingjian 黃庭堅 (1045–1105). This well-recorded occasion occurred in 1104 at the monk's Huaguang Monastery 華光寺 in the province of Hunan. At this time Zhongren spontaneously brushed such

7 See Bickford, *Bones of Jade* (1985), pp. 28–31 and 273–74. Also Bickford, *Ink Plum* (1996), pp. 45–47. For the entire manual see Song Boren, *Meihua xishen pu* (ca. 1238), reprint (1928).
8 Bickford, *Bones of Jade* (1985), pp. 34–35.

an ink painting.[9] Concentration on the theme was continued well beyond mid-century by the southern painter from Nanchang, Yang Buzhi 揚補之, or Yang Wujiu 揚無咎 (1097–1169). His work is better known today since a handscroll, *Four Views of the Flowering Plum* (*Simei tu* 四梅圖), dated to 1165, is preserved in the Beijing Palace Museum (Pl. 12). While Zhongren favored a style of soft washes surrounding the negative lightness of fragile petal, Yang's important contribution appears to have been a reliance on outlining the flower-form as "circled petal" (*quanban* 圈瓣). While such developments may be seen as securing the theme's significance within a variety of ink-brush possibilities and thus increasing the importance of the plum blossom for what was fast becoming an aesthetic mainstream, scholarly, or literati painting, the shift from the non-linear wash of Zhongren to Yang Wujiu's crisp outlines may also be seen as bringing the art within range of the Song Academy's own love of outline visible in many of its floral themes.

Indeed it was a floral definition favored by both Ma Yuan and his son, Ma Lin. However, no major painting by Ma Yuan of the plum blossom itself appears to have survived. What has survived is his typical fascination for structure as in the tree itself, its endlessly shifting angled limbs. In these, flowers are simply an added touch of color. The linear, however — as will be later shown — may be found in other of the father's floral forms, but is made specifically "plum-blossom" clear by turning to his son, Ma Lin, in a beautiful masterpiece now in Beijing's Palace Museum. The painting, a hanging scroll, *Layer upon Layer of Icy Silk Tips* (*Cengdie bingxiao tu* 層疊冰綃圖) is a complete expression of imperial elegance (Pl. 13). Both calligraphy and seals give this verbal certainty. The title hangs in the air at the middle left. Bold calligraphy high in the center sky is "signed," also to the left, with seals of Empress Yang. They carry the date — equivalent to the year 1216 — and the name of the empress' palace, Kunning. Between seals is a brief dedication to an unidentified "Supervisor Wang" (Wang tiju 王提舉). Far below, Ma Lin's signature clings modestly to the lower right corner.

The blossoms themselves also carry imperial implications. These are special blooms that can be associated with "Palace Plums" (*Gongmei* 宮梅), the significant statesman and literatus Fan Chengda's 范成大 (1126–1193) earlier species designation as well as the empress' use of this term in other poetry. The flower was the result of horticultural intervention, the grafting of a more luxuriant variety to nature's wild plum. This carried as well the distinction between natural spontaneity and splendor sheltered by the garden wall, more exactly the palace. In scientific terms it is the green-calyx

[9] For sources on Zhongren's life see Bickford, *Bones of Jade* (1985), p. 286.

plum (*lü'e mei* 綠萼梅 or *viridicalyx*). The flower is described by the botanist Hui-lin Li: "Branchlets dark green; flowers white, simple or double; calix green."[10]

My expanded translation of the painting's title to "silk tips" is supported by the interchangeability of *xiao* or *shao* in parallel versions with differing radicals (綃 and 梢). On the painting, the former is used for the title and the latter in the empress' inscription. But this double intention is even more exactly supported by the painting itself. With a sensitive feeling for selected purity, Ma Lin's corner composition cuts floral support to the brief separated tips of an imagined branch. The empress in her poem, no longer young — she is fifty-four — surrenders memories of rose-tinted youth to a white enduring purity, in effect a fixed iconic symbol, which is also exactly Ma Lin's reduction of form:

Like frigid butterflies dwelling in flower chambers	渾如冷蝶宿花房
Embrace of rouge hearts is memory of past fragrance,	擁抱檀心憶舊香
Opening now to chilled tips the more to be cherished —	開到寒梢尤可愛
A species indeed for the Palaces of Han.	此般必是漢宮妝

Can we not also think of Su Shi's image of solitary brightness, "Orion at dusk"? In turn, the "Palaces of Han" take us beyond a specific imperial center to wherever the noble palace of central rule may be found.

The date of 1216, although applied to Ma Lin, is also significant for his father, Ma Yuan, and his place in historical time. The year falls directly into what we can piece together of Ma Yuan's full artistic maturity. Here is the consistency of a Ma family format that appears for Ma Yuan in his own similar hanging scrolls. As will presently be discussed, a detailed recording of the exact same scroll — missing only the dedication to "Supervisor Wang" — attributes it to Ma Yuan himself. Does this mean that with this masterpiece we can go so far as to accept Zhuang Su's 1298 claim that the father out of love for his son, "Often wrote on his own paintings that they were done by Ma Lin"?[11] Judging from what has survived, in 1216 Ma Lin was still to have some forty more years of painterly creativity. Although the scroll is thus comparatively early in that career, its quality, when compared

[10] Hui-lin Li in Bickford, *Bones of Jade* (1985), p. 247. Fan Chengda, *Fancun meipu* (1965), pp. 1b, 3b–4b. See also Lee, "The Domain of Empress Yang" (1994), p. 261. She continues with a full analysis of the scroll suggesting that the recipient was of Daoist origin. Bickford, *Ink Plum* (1996), pp. 162–63 stresses visual relationships between Ma Lin and Yang Wujiu.

[11] Zhuang Su, *Huaji buyi*, reprint (1963), *xia*, p. 14.

to other accepted paintings, need not be considered beyond his own skillful brush.

The recording is especially significant for another reason. Its claim is to place the Beijing scroll — or one exactly like it — as the final painting of a set of four such plum blossom hanging scrolls. In numerical consistency, one cannot help thinking back to Yang Wujiu's 1165 handscroll, *Four Views of the Flowering Plum*. With this later set of four, attributed to Ma Yuan himself, each is inscribed by Empress Yang with both a title and a poem. Such consistency is far too precise to ignore, and the whole emerges as an enriching narrative that reaches a significant climax in the final painting and verse. It is a climax all the more convincing because of the concrete skill and beauty of the only existing image, the scroll signed "Ma Lin." The others must have matched it. Consider the progression, first in the titles:

Red Fragrance in Bright Snow (*Qingxue hongxiang* 晴雪烘香)
Rouge Face Powder Adorned (*Zhuyan fufen* 朱顏傅粉)
Rose Tinted Veil of Mist (*Xiaxiao yan biao* 霞綃煙表)
Layer Upon Layer of Icy Silk Tips (*Cengdie bingxiao* 層疊冰綃)

Then the poems (repeating the final verse, from both the recording and the surviving scroll):

Again and again layer on layer yellow tinted plum	重重疊疊染緗黃
Now in the light of spring already fragrance halved	此際春光已半芳
Opening they cannot bear the wind the warming sun	開處不禁風日暖
Wildly spinning bright snow showers my robe	亂飛晴雪點衣裳
With beaded dress and blue-green robe reflecting ruby face	銖衣翠蓋映朱顏
Who knows what year she entered the Emperor's domain	未悉何年入帝關
Silently with painter's skill an image handed down	默被畫工傳寫得
Till now as though the time were still Heng Shan[12]	至今猶似在衡山

[12] It is worth mentioning, at least in the reverberation of words, that *Hengshan* is also a mythical reference to the North Pole. While not appropriate to this verse, it fits the final conclusion that the only true plum is the one that survives the cold. See *Hanyu dacidian* (1986), v. 3, p. 1100.

Tender peach seductive apricot
 what match is that?

天桃豔杏豈相同

The blush of red allure
 surrounded by pale chill

紅潤姿容冷淡中

Waves of light mist
 what use is that ⌊what is it like?⌉

披拂輕煙何所似

Moving us in springtime
 to coverings of gauze

動人春色碧紗籠

Like frigid butterflies
 dwelling in flower chambers

渾如冷蝶宿花房

Embrace of rouge hearts is
 memory of past fragrance,

擁抱檀心憶舊香

Opening now to chilled tips
 the more to be cherished —

開到寒梢尤可愛

A species indeed
 for the Palaces of Han.

此般必是漢宮妝

The sequence in each of the now lost paintings suggests the illusion of a fragile passing beauty that now betrays the true strength of the empress. Fragrance is halved by swiftly falling petals (the snow of the poem); a falseness of allure perpetuated by the make-up artist or painter (who now knows me when I first arrived at the palace), a time linked to my youth in Hengshan; the fickleness of suggestive peach and plum, whose blossoms

Fig. 3.2 Ma Lin
Layer upon Layer of Icy Silk Tips (detail)
Palace Museum, Beijing

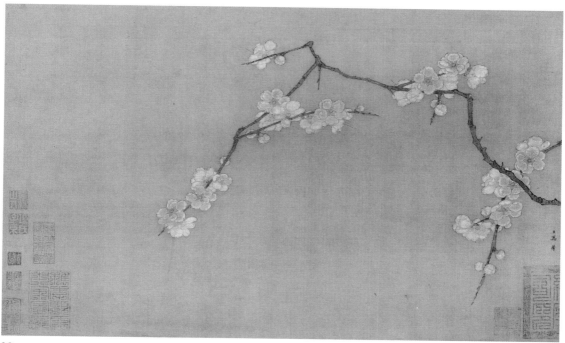

3.2

cannot even stand spring chill. Only icy silk tips can express the present. Remember her age of fifty-four, far removed from youthful courtesan delights, a ruler adorning the universal summit of imperial power, the enduring timeless Palaces of Han.

Turn more precisely to Ma Yuan's interest as it is preserved today, not specifically in plum flowers, but in the branches themselves. While they crown many of his fuller compositions, his description of them is reduced to its essence in a series of ten miniature album leaves, *Moments of the Flowering Plum*, no more than a few inches of silk (7 7/8 × 2 7/8 in.; 20 x 7.3 cm — Figs. 3.3-3.7). Each is signed with a tight dark brush, "Chen 臣 Ma Yuan" ("Servitor" — or "Your Majesty's subject — Ma Yuan"). While the album has escaped early recognition, collector's seals are to be dated in the fifteenth and sixteenth centuries and it was a personal treasure of the eighteenth-century emperor, Qianlong, who kept it together with a matching album of calligraphy by the late Ming artist, Dong Qichang 董其昌 (1555–1636).

Fig. 3.3 Ma Yuan
Moments of the Flowering Plum (two views from an album of ten leaves)
Private Collection, Taipei

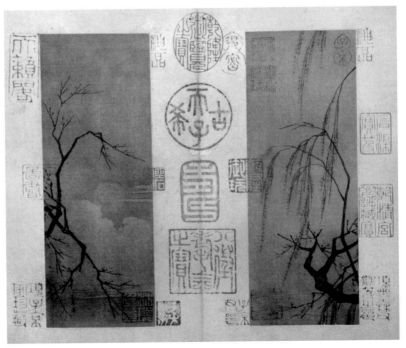

3.3

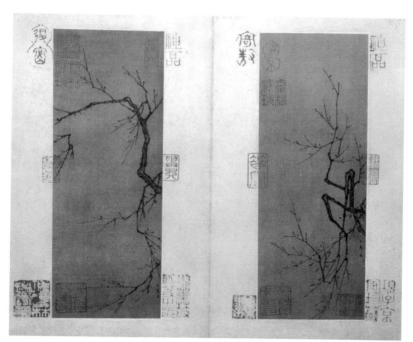

3.4

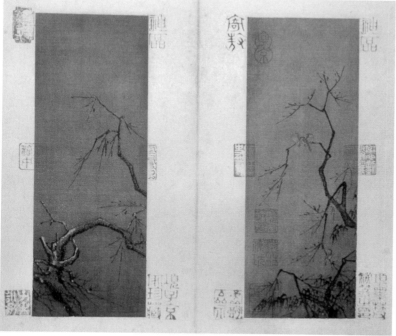

3.5

Figs. 3.4 and 3.5
Ma Yuan
Moments of the Flowering Plum (four views from an album of ten leaves)
Private Collection, Taipei

Figs. 3.6 and 3.7
Ma Yuan
Moments of the Flowering Plum (four views from an album of ten leaves)
Private Collection, Taipei

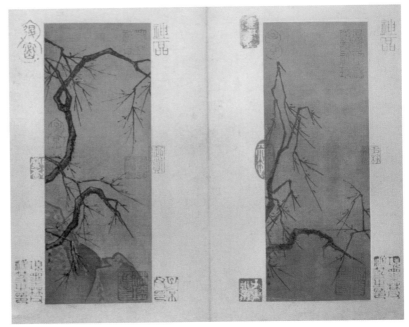

3.6

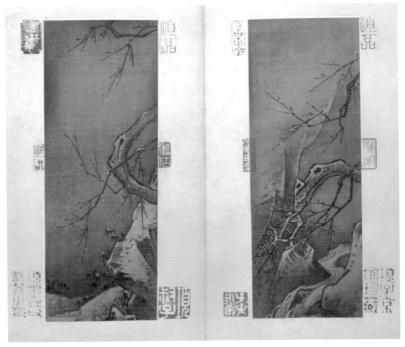

3.7

It is valid, following Richard Barnhart's suggestion, to assume that the album is now incomplete, and thus possible to relate to the multiple aspects of the flower so carefully defined by Ma Yuan's friend Zhang Zi. The section of the fifty-eight choices — mentioned above — that appears to offer the most likely parallels is that of the twenty-six "Fitting" views. The literature records such a twenty-six-leaf album as being in the collection of Xiang Yuanbian (1525–1590) in the year 1595, five years after his death. Xiang's seals on the current work are added confirmation. In addition, seals of an earlier collector, Mu Lin 沐璘 (d. 1457) take recorded history back to the fifteenth century.

The greater published number is supported by six additional leaves now in the collection of the National Palace Museum in Taipei (Pls. 14a–b and 15a–d). Although also of miniature size, they are of different dimensions. Four of the Taipei designs are of closely similar, or mirror reverse compositions of the original set. Two new designs in the Taipei Palace Museum set (Pls. 14a–b), however, inch forward our knowledge of the "Fitting" twenty-six.[13] In this group it is possible to match many, but not all, of the extant paintings with Zhang's list, datable to 1194. More often than not it is the addition of a landscape clue that directs meaning. Working with such hints, I emerge with a list differing in part from earlier publication, some still remaining undefined. Moving from left to right (Pls. 15a–d): *A Fine Moon* (*Jiayue* 佳月); *Gentle Shade* (*Danyin* 澹陰, the screening of willow fronds only at the beginning of full leafage, suggesting such a hint of covering); two branches whose identity is unclear; *Light Snow* (*Weixue* 微雪); *Rare Birds* (*Zhenqin* 珍禽); *Hoary Cliff* (*Cangyai* 蒼崖); perhaps *Light Mist* (*Qingyan* 輕煙); *By a Sparse Wattle Fence* (*Suli* 疏籬, the fence-top intruding from the lower right edge); and *A Clear Stream* (*Qingxi* 清溪). Of the two differing compositions from the Taipei set, one with touches of cloud and darker atmosphere (Pl. 14a) may be *Light Rain* (*Xiyu* 細雨). For the other (Pl. 14b), there seems no clear identification — possibly *Slight Chill* (*Bohan* 簿寒) by virtue of its crisp left-sided withdrawal? If all cannot be clearly identified, recorded titles alone must serve to complete a sense of the richness of the entire "fitting" twenty-six among them: *Beneath Pines* (*Songxia* 松下), *A Bronze Vase* (*Tongping* 銅瓶), *Playing Chess on a Stone "Board"* (*Shiping xiaqi* 石枰下棋), *Sweeping Snow and Making Tea* (*Saoxue jiancha* 掃雪剪茶).

[13] Barnhart in Bickford, *Bones of Jade* (1985), pp. 251–52. Illustrated, pp. 37–42. Zhang's original listings in translation are found on pp. 34–35.

Possible missing paintings are important for indicating the incredible scope that a single subject might embrace, an intensity of aesthetic sensibility helping to define the age itself. Zhang Zi foretells in turn the idea-stylization of the plum blossom to be realized by Song Boren some four decades later. Fragmentary as it is, however, Ma Yuan's acceptance of the aesthetic varies markedly from that of the later printed text, a text that embraces a differing visual manipulation, one with only three branches with dormant buds, described as "eyes" (*yan* 眼), before shifting them to hold a bewildering variety focused on blossom-shapes themselves (Fig. 3.7 and Pl. 11). In often expanding the verbal suggestions of his patron into hints of miniature landscapes Ma Yuan once again offers proof that his art will not let go of a constant devotion to nature. His signature also directs the paintings toward the court.

The existence of closely similar versions — the album of ten and four repeated leaves — is important in another way. The corpus of works attributed to Ma Yuan is, for this period, rather large, and if we are to understand the painter, it is important to establish distinctions among the many. Comparing the two sets, there can be little doubt, as Barnhart has also noted, that the Taipei National Palace Museum version is a copy. While two leaves (Pls. 15b and c) reproduce mirror-reverse compositional effects and thereby alert one to look for subtle distinctions of brush and ink, with two other pair where compositions are echoed (Pls. 15a and d), flaws can be directly detected. In *A Fine Moon*: the copy moon circle is poorly drawn, the right side flattened; a horizontal cloud becomes a rigid streak and other cloud edges are excessively mannered; expanded dimensions have the effect of relaxing the sure tense crispness of Ma Yuan's original relationships between moon, cloud, and side-framing branches. *By a Sparse Wattle Fence*: the rustic fence is eliminated. More broadly, the copy structure goes flat because of rigid outlines to the rock-cliff, heavy shading to the tree trunk, and sharp jagged axe-strokes for texturing.

Such close looking is necessary as it highlights the set of ten as revealing aspects that closely parallel the excellence of Ma Yuan's paintings already examined. As the images unfold in each slit-like glimpse, it is clear, as mentioned earlier, that flowering itself is not the major purpose. They are not far removed in seasonal time from Du Fu's line: "Just before the winter sacrifice plum buds break." The abstractions of minute dots of color are all that is allowed to warm tiny dabs of ink and those wiry black limbs that stretch and rise, dip and fall, thinning to sharp tips where posturing

silhouettes end against the atmospheric silk. The only other flora present in what has survived are arrowed leaves of bamboo that endure, and the slender falling strands of early willow catkins, also dotted with spring — life's beginnings.

Ever-present is a sense of reduction, a clinging to the bone-strength of limb, and with it a feeling for the validity of ink-abstraction. Yet it is Ma Yuan's gift, especially in this theme of calculated formality, to join the conscious forms of his art to the reality of nature's ambient, thereby intensifying perception of nature's own claim to the art of life. While the shapes may well have been influenced by careful pruning of the genre in Hangzhou's numerous gardens, in a wider sense Ma Yuan's insistence is on clinging to physical nature. That nature, by definition, is always in flux and thus his work continues to rest on the edge of time. Key here is a season's beginning, but this is further refined through day and weather and into night. Strange that an art so miniature should carry us so far.

Having already absorbed the style in two winter scenes that were partially framed by the plum-tree, there is no need to point in detail to each of these added ten. Whether rock or cliff, snow or water, or even a golden moon are present or absent, all is embraced by the shapes of winter holding a brittle past that was seemingly dead. Life comes, however, not only in dots of color — which here are merely a symptom — but more exactly to be observed is the life of the seemingly inert. While immediately evident are the off-balance compositions and then the varied dance of the branch-shapes, one needs to look further and grasp their structure. Evident is the presence of a special individual touch, in part defined in terms already mentioned: the "squeezed" quality of "burnt" ink, the axe-stroke texturing, a broken or "trembling" line. Most significant is the absence of repetitive monotony. Thus, the outline of a tree-trunk may be rich and strong, but it also will be broken and varied in width, and there is a conscious effort through varied touches of texturing to create a meaningful relation between it and what is contained within. When the axe-stroke convention is used for rock surfaces, if multiple, that multiplication usually takes on a variety of forms. It is thus through varied brevities and accents that the normal illusion of solidity has special meaning. Old trees and ancient rock are not just described but become alive.

In listing his twenty-six fitting matches for the plum, Zhang Zi included one which seems to demand the human figure: *Playing Chess on a Stone Board*. The chess part of this human theme, although featuring a pine tree

and only minimally a plum is caught in a lively handscroll in ink on paper now in the Cincinnati Museum (fig. 3.8). This painting, *The Four Sages of Shang Shan* (*Shang shan sihao tu* 商山四皓圖) — to be discussed more fully in a later chapter — is a puzzling work, partly because it is on paper with considerable wear and apparent retouching. It must, on the basis of present knowledge, be considered a later interpretation. But the recluse scholarly graybeards that comprise the subject are indeed playing chess — a traditional Daoist theme — on a flat-topped rock. However, the subject of reclusive scholars without chess, yet placed under a plum, is realized with a more secure Ma Yuan touch in a circular fan now in the Boston Museum, a painting that bears convincing marks of personal authenticity: *Scholars Conversing beneath Blossoming Plum Tree* (*Meixia duizuo tu* 梅下對坐圖; Pl. 16).

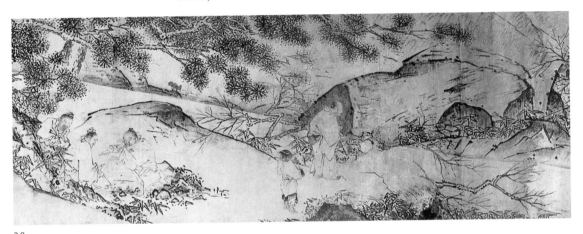

3.8

Fig. 3.8　Ma Yuan, attributed
The Four Sages of Shang Shan (detail)
Cincinnati Art Museum

Two rock-seated gown-wrapped figures and a youthful standing attendant are presented in the rarefied world of a mountain plateau. A knotty horizontal extension of the familiar flowering plum is their only shade as hillcrests and a mountain peak curtain human presence with a background wash of misted form. Above them is the simple silk of a still higher sky. Although there are many spots of damage, particularly toward the lower left, and the spots of color that would have warmed the plum tree have eroded away, original intentions remain. Clearly this is not the garden plum. The composition, now filling a contrasting wider, more expansive circular format, is however an echo of the composition in Ma's painting of winter plum and egrets with its stretch of plum across that more frigidly enclosing setting. Now scholars have replaced the birds, and join Ma Yuan's depictions of fuel gatherer and fisherman as recognizable portrayers of reclusion. Here spring has risen into

liberating heights. Again the composition, featuring one of the scholars, is anchored in what is currently a somewhat damaged lower left corner. A bit higher is a partially cut signature, not comfortable in its sky-edge placement (a possible later addition to counter damage?). The off-balance accent of the second scholar is spread far to the right. The tree, tempting the pull of gravity, extends with its knotty, angled, persistent progress from left to right, moving across the center of the painting. It presents again an unmistakable statement about its life here directly related to the wisdom that is seated below — now instead of gracing a bird's patient endurance is the tough core of age, the flowering of its truth.

In this replacement of birds by man, the anchoring definition of the plum's growth at the left is similarly shaped to sympathize with what is below. For the contained three-quarters pose of the scholar, two main branches offer crowning angles of growth rising higher and higher in inescapable symbolic reference. Another branch helps frame the attendant. Similarly the ever-thinning drawn-out rightward stretch of the tree caps the more extended deliberate profile of the second scholar (Fig. 3.9). Not only is he placed closer to the void, he is more precariously seated at the edge of his rock and is thus partially "split" from it, creating an open "V," a variant to the open-angled plum-tips.

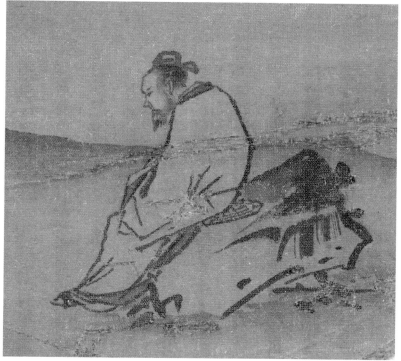

Fig. 3.9 Ma Yuan
Scholars Conversing beneath Blossoming Plum Tree
Museum of Fine Arts, Boston

3.9

Throughout this small fan one can find technical touches similar to what has already been defined in other works. Focus particularly on the profiled sage and his convincing relation to the crisply brushed rock — a bit precarious, yet ambiguously secure (as the sliding ducks on a steep hillside) — momentary yet enduring. Small as it is, do not fail to see the mat, both a cushion for old bones and a comforting aristocratic touch, yet another example of Ma Yuan's selective detail.

It is a painting, too, in which what is open and undefined takes on equal importance to the objects defined. As such, space becomes an eloquent statement of release — the heights, the sage's mind, the mountain's spring season. Although only one figure is undamaged, within this setting it is on those sages that we must finally focus. Again we meet the significance of restraint. Their careful placement controls an open distance that separates and yet ultimately unites. James Cahill has pointed out how curving backs harmonize with the fan's shape, concluding that the sages are placed "like a pair of parentheses enclosing nothing, but expressing a perfect accord."[14]

Spring: The Second Month

Among the ten views of the plum, one included willow catkins, and by this touch created a more advanced sign of spring. A poem in the collected poetry of the Empress Yang begins defining such a setting:

> Gentle and soothing: the light breeze 剪剪輕風二月天
> of the second month
> Willow tendrils, windblown . . .[15] 柳絲飄揚……

Another album leaf by Ma Yuan has caught this later spring. Rectangular, but horizontally so, it has an added title on the mounting, *Walking on a Mountain Path in Spring* (*Shanjing chunxing* 山徑春行). The "mountain," however, is mist screened, its peaks distant. The painter's main figure, an elegant long-gowned aristocrat, is deliberately posed on comfortable water-level land. The whole thus embraces an aura of gentility far more in keeping with a stroll by West Lake's park-like waters where mountains can be readily viewed as far presences to stir the mind rather than challenges to be traversed. A more appropriate shortened title can be: *Strolling on a Path in Spring* (Pl. 17).

[14] Cahill, *The Art of Southern Sung China* (1962), p. 48.
[15] Lee, "The Domain of Empress Yang" (1994), p. 188.

Presented with the familiar corner-angled composition, the whole painting becomes one of contemplation. Now two sturdy willow trunks replace the plum. Leaning leftward they challenge the limits of the format, but by implying extension beyond its borders, they establish through forms unseen an even stronger anchor for the freedoms extending far to the right. Near the ground at the left, their solid crossed shapes create a triangular cave-like opening through which the familiar boy-attendant, active and hunched, walks into the scene — active because he is moving, hunched because he is carrying. The youth contrasts with his towering master's detached pose of contemplation which, despite the general aura of naturalness, introduces the significance of an iconic scale (Fig. 3.10). The diminished servant is carrying the master's musical instrument, the cloth wrapped zither-like *qin* 琴, in turn a symbol of retreat and solitude. Its presence anticipates the low vibrant plucking notes of its music, not unlike

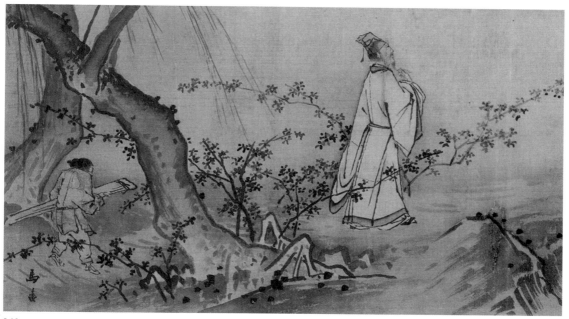

3.10

Fig. 3.10 Ma Yuan
Strolling on a Path in Spring (detail)
National Palace Museum, Taiwan,
Republic of China

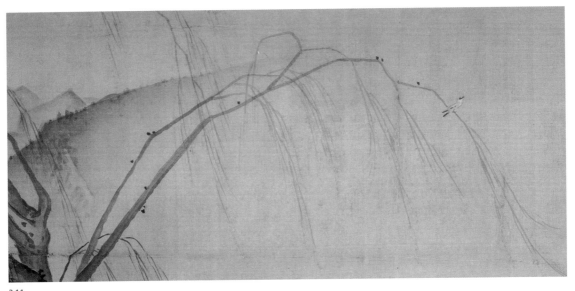

3.11

Fig. 3.11 Ma Yuan
Strolling on a Path in Spring (detail)
National Palace Museum, Taiwan,
Republic of China

the visual presence of the pale, yet carefully separated strands of weeping willow fronds and their gentle certain motion in a spring breeze (Fig. 3.11).

More than any of the previous paintings, here it is movement into space that gives direct meaning to it. Once the objects are established — trees, leafing undergrowth, figures, land, even the mountain peaks — it is what is open that makes them alive. It is openness that demands the artist's lightening touch: wash for the land with the emptiness of an implied path, the pale strokes of the water-bordering bank, the shadowed calm water.

In this brief scene are many echoes of familiar forms and conventions. The cave-like entrance shaped by the willow trunks for the *qin*-bearing attendant is a variant of the rock opening that embraces winter egrets (Pl. 6a). It is of importance similar to the eroded hollows in the introductory rock of *Mandarin Ducks by a Bamboo Stream* (Pl. 7) that lead to the most prominent of the four ducks and the stream's swirling water, and is even closer to the form-surrounding space that allows the presence of a patient, if now damaged, boy-attendant waiting on *Scholars Conversing beneath Blossoming Plum Tree* (Pl. 16). The background washes of hill-crests and far mountains, although now much more open, are not unrelated to the Boston painting. While by their nature the willow branches have lost the crisp angularity of the plum, they still retain an echo of Ma Yuan's love of the angular. While they are found here in a scene of more distance, the willow fronds are related to the close-up of them in one of the *Ten Views of the Plum* (Fig. 3.3). Despite a crack of wear that mars the face and upper garment of the

tall strolling sage-aristocrat, ink lines that define his figure are both varied and certain. Important are nail-head and rat-tail strokes. Present, too, is the vibrancy of a tremulous touch. A few dark dots ("moss-dots"), as in the fuel gatherer scene (Pl. 1), add their playful accents. Axe-strokes are muted and found only by the low waterside bank and then more faintly on the rising hillside, again similar to their placement on the winter scene.

Returning to the whole, strong definition at the left is muted throughout as we follow the gaze of the main actor and with him absorb the open gentle harmonies of a southern spring. Here for the first time calligraphy plays a significant role. Begin with the painter's signature. Its placement is similar to that on other convincing paintings as it hugs a lower entering corner. (The exception is the Boston scholar painting where the name appears something of a forced intrusion on the empty sky.) With *Strolling On a Path in Spring* the modest signature at the lower left is answered firmly in the clear space of the upper right by two lines of seven characters each. However they lack any seal or other outward recognition of authorship. A strong possibility, suggested from style alone, would attribute the writing to the Emperor Ningzong (r. 1195–1224).[16] If so the writing becomes an especially suitable match for the painting's aristocratic figure and its almost iconic nobility. It is an ideal representation even to be considered as suggesting the emperor himself, an imperial claim that has been made for important figures in other contemporary paintings. It is doubtful, however, that it was done specifically *for* the emperor since the painter's signature is not preceded by the defining "servitor" character (*chen*) as found on the intimate plum blossom album. The poetic couplet may be translated:

Sleeves graze the wildflowers
 and many dance themselves 觸袖野花多自舞
Spurning man reclusive birds
 cut short a song 避人幽鳥不成啼

Man's presence stirs a self-sustaining world. Within the brevities of a few selected words, the poet directs us to a powerful self-life, something out there which is at once a challenge and an embrace. In turn, with elegant, selective restraint, image harmonizes with word. A gown brushes low undergrowth. The "dance," however, appears transferred to hovering willow fronds. A perched bird is about to fly, song interrupted. Another is already on the wing, leading us further on. Thus painter, as well as poet, secures nature's spontaneous life.

[16] Chu, "Imperial Calligraphy in the Southern Sung," in Murck and Fong, *Words and Images* (1991), pp. 305–6.

The vision extends rightward in Ma Yuan's composition to spaces and meaning beyond visibility. In turn the stroller's pose reinforces a mind drawn out of itself to follow the wind, bird's silenced flight. Even the incomplete repeat of earlier land at the far lower right edge suggests its necessary continuity. An aristocrat's immediate, incidental physical act, his "strolling," his gaze, finds reality in a far greater continuous existence. Indeed, is this not the grasp of a kind of "otherness" in which our surroundings are no longer "other"? Can we not sense a spontaneous moment of revelation, not unlike, it must be said, the understanding of a Chan Buddhist *gongan* (Jap. *kōan*)?

Flower Portraits

The lunar second month and its blossoming willow, a month we should more closely associate with the solar March, were not only for a solitary stroll in thoughtful withdrawal. It was by the mid-month halfway through the spring season, more publicly a time for the Festival of Flowers (*Huachao jie* 花朝節), to absorb fragrance and colorful fragile beauty, even to look closely at a selected branch or blossom, in a southern world that was coming to life with Hangzhou's spring splendor. The fifteenth was a day for visiting famous gardens and temples, even including imperial temples, now open to commoners. It was through the fragile flower that the natural world often came closest to human existence, not just in gardens, but even more intimately within, entering palace, hall, and inner room, where roof and column and wall both protected and shaped the social order.

Nothing reflects this more grandly than the imperial display of flowers. Again one must turn to Zhou Mi's reflections of Hangzhou life:

> It started with the appreciation of plum blossoms at Mei (Plum Blossom) Pavilion, then moved to Fangchun (Fragrant Spring) Hall for the apricots, to Taoyuan (Peach Blossom) Spring for the peach blossoms, to Canjin (Radiant Brocade) Pavilion for the *haitang* crabapples, to Lanting (Orchid) Pavilion for a literary gathering, and finally the highlight with a viewing of the grand flowers at the Zhongmei (Favored Beauty) Pavilion. In front of this pavilion were flower beds in three layers built with colored marble and planted with famous blooms . . .[17]

[17] Zhou Mi, *Wulin jiushi* (1962), ch. 2, p. 374. For this translation and repeated Chinese text see Lee, "The Domain of Empress Yang," pp. 55–56.

Adding further significance, such a display could not escape reference to deeply established historical tradition. Thus the Peach Blossom Spring recalled the peach blossoms of which the famous Six Dynasties poet Tao Yuanming had written in describing an errant fisherman who followed their flowering into a mysterious grotto beyond which a hidden community lived in timeless perfection. Similarly the Orchid Pavilion celebrated the by now immortal literary gathering held in 353 during a far-off spring in the expansive garden of the famed calligrapher, Wang Xizhi 王羲之 (ca. 303–ca. 361).

According to Lee Hui-shu these arrangements were accompanied by all manner of high decorative art: emerald green drapes, carved balustrades, peony cloth spread as a red carpet, jade, crystal and golden pots, Persian glass, *Guan* ceramics, *Xiang* bamboo which was used for hanging flower containers placed high over windows and beneath the ceiling beams. Once again artistic splendors crowd our view of late Song Hangzhou, in this case revealed by arrangements in the hands of domestic servants, eunuchs of the Rear Garden, who not only carried out the decoration but also "prepared silk embroidered tents, cushions, toys, gifts of painted headdresses and flower fans," even "delicacies for the table which were designed to look like the scenery of West Lake."[18]

Flowers in nature's offerings, however, are not stable icons. The contemporary poet Yang Wanli 楊萬里 (1127–1206), in the piquant imagery of a poem, brief as an album leaf, tells of flowers' fate behind walls:

Afraid that wind and rain might be jealous of the peonies,	只愁風雨妒花枝
I cut a branch and put it in a porcelain vase.	翦入瓷瓶養卻伊
The heavy curtains are drawn, the doors are closed –	更下重簾深閉閣
why do the petals keep falling off?[19]	忽然花落又關誰

Surrounded by obsession with floral beauty, including social implications both contemporary and traditional, it is not surprising that major artists should seek to rival nature with images less evanescent, yet similarly focused on retaining qualities of the living object, implications of life, a life without which they could have no significant purpose. Although only a handful survives, some of the finest of such works are particularly noteworthy, both in themselves and as evidence of direct imperial patronage. Two are

[18] Lee, "The Domain of Empress Yang" (1994).
[19] Yang Wanli, *Chengzhai shiji* (1927–1936), *juan* 41, p. 5b. Translation, Chaves, *Heaven My Blanket* (1975), p. 51. First line altered but kept the effectiveness of the last, which literally might read: "Immediately the petals fall — what more to be done?"

now in Beijing's Palace Museum. One is a circular fan mounted as an album leaf displaying a flower in a vase, and is a rarity in reflecting Yang Wanli's protective intentions (Pl. 18). The theme itself, however, must have been popular. Recall Lin Hong's black lacquer bed posts each supporting a vase of plum blossoms and that Zhang Zi's fitting matches included *In a Bronze Vase*. While the flower here is different, a chrysanthemum, it is carefully arranged in a rounded, high-stem celadon vase further secured in the cube-like shape of a wood or lacquered stand. To the right the upright image is balanced by a strong vertical block of calligraphy. The captured flower, six consciously placed stems, is however far from static. The implication of growth is shown in painting both bud and full flower as well as a variety of blooms placed, forward and back, revealed and partly concealed. They are most often in profile with petals actively spread, partly fading, but not faded, the repetition of green leaves themselves subtly varied.

The writing is a poem most recently identified as brushed by Gaozong's Empress Wu. The flower, already known in many more common species, is the prized Peach Blossom Chrysanthemum. The poem, of the so-called *yongwu* 詠物 variety, "in praise of an object," expands the nature of that object:

Autumn breezes under warm sun, filling the eastern hedge	秋風融日滿東蘺
Ten thousand layers of light red, encircling branches emerald green	萬疊輕紅簇翠枝
If fragrant grace were as all common colors,	若使芳姿同眾色
Who then would know the time called "little spring".[20]	無人知是小春時

For this painterly act of preservation, meaning expands. The eastern hedge is an automatic reference to Tao Yuanming not only in his love of chrysanthemums there but in this case carrying the further implications of the peach whose blossoms led to a world that time had passed by. But here the most important proof of outlasting time is the visible evidence that the tender peach of spring may indeed flower in fading autumn. Given the writer, it is an empress' self-expression, presumably directed toward her emperor. The assurance that the fragrance of her early beauty is not lost in late seasons.

The second anonymous painting, a squared album leaf, *Golden Catkins of the Weeping Willow* (*Chuiliu feixu tu* 垂柳飛絮圖), is more characteristic of an artist's approach to the flower or flowering branch (Pl. 19). Not trapped

[20] Translation after Lee, "The Domain of Empress Yang" (1994), p. 144.

in a vase or basket, nor plucked for an elegant headdress, the illusion is simply that of bringing the eye close, and in doing so shutting from view all distracting surroundings. Thus in an image that endures we can examine and be drawn into the ambiguities and the ultimate mystery of a fragile yet incomparable beauty. Here, caught in mid-air, leaf and tiny light blossoms hang, sway, indeed dance in repetitive yet constantly varied movements that can only tell of a fresh spring breeze. We need not be shown trunk or roots or sturdy branch, nor cloud or moon or sun, nor the spring blue sky. The empty silk leaves that to shifting yet enduring images of the mind.

Leading from the lower right there is a progressive placement of three fronds, all cut by the painting's edge, each successively longer. Thus the composition itself is of growth, growth defined on the freedom of open silk. By this we subtly, but unmistakably come to the modest clean block of calligraphy. The writing, carefully spaced, floats free on the empty silk, creating verbal form and meaning harmoniously as spare — and rich — as the artist's painting:

| Thread-like tendrils gently so green | 線撚依依綠 |
| Golden they hang, rhythms of yellow | 金垂嫋嫋黃 |

The two line-ending characters that in each instance define the words "green" and "yellow" are in reality not static definitions at all, but rather their suggestively repeated modifiers (in standard modern pronunciation, *yi yi* "gently," *niao niao* "rhythms") create a progressive force. They are auditory sounds, perhaps in their day onomatopoetic, to open one's feelings rather than to exactly trap them. *Niao*, for example is a homonym for "bird." Blossoms being rather invisible — here as tiny daubs of Chinese white though perhaps once touched with a brighter hue — the couplet's emphasis is on tendrils. This must ultimately come from the natural observation that while still in the dormant stage of winter, as spring advances, tendrils of the weeping willow shine yellow and golden fresh among other trees. By this time such color was an accepted convention that the painter need not literally repeat, any more than bamboo needed always to be painted green. Here the tendrils were first carefully outlined before applying umber wash.

Further, as so often with flowers, the painting and its words tell also of youthful feminine beauty. In Lee's description: "Her dainty figure and gently moving waist are equated with the graceful willow tendrils, while the uncertainty of her social position, dependent in part on the fleeting beauty of youth, is reflected in the image of the light, wind-blown catkins."[21]

[21] Lee, "The Domain of Empress Yang" (1994), p. 188. The author also notes that the outlining is not usually visible in reproductions. I have followed Lee's translations for the inscription as well as with the following *Apricot*.

The woman here, the writer of its word-meaning and the hand that impressed the single seal beside it, was Emperor Ningzong's Empress Yang. Again, as with *Peach Blossom Chrysanthemum*, it appears that an empress is addressing her emperor. Yet here it is difficult not to be aware of a far greater aesthetic subtlety.

The contrasting bold harshness of Empress Wu's calligraphy overwhelms the modest flower, now reduced to a symbol trapped in vase and stand. Empress Yang's writing, carefully precise and modestly withdrawn into its own corner, more justly answers with its forms what leaf, blossom, and tendril present with theirs.

Apricot

Just as the wealthy Zhang Zi was, with the flowering plum, to lead us to Ma Yuan, the even higher-placed Empress Yang brings us to him in other flowers, and with even greater authority. Certainly at the level of sensitivity to a subject, *Weeping Willow*, with its corner composition and the acceptance of the empress, might speculatively not have been beyond him, were it not that in its painting touch it lacks Ma Yuan's love of the angular. However, Ma Yuan's hand at the close examination of flowers — in addition to his skill in the plum branch — is precisely confirmed by the signed album leaf, *Apricot Blossoms* (*Xinghua tu* 杏花圖), now in Taipei's National Palace Museum. Dimensions are closely comparable to those of the willow catkins. Empress Yang's calligraphy is likewise a discretely placed couplet, this time in the upper right in answer to the floral composition that springs from the lower left just above the artist's signature (Pl. 20). The signature is unusually complete, not just the name but, as with his miniature album leaves of *Plum Blossoms*: "Servitor Ma Yuan painted" (*Chen Ma Yuan hua* 臣馬遠畫). In turn, Empress Yang's couplet reads:

Receiving the wind, boasts artful seduction	迎風呈巧媚
Moistened with dew, presuming rose charms[22]	浥露逞紅妍

The later more extensive title currently given the painting extends the imagery: *Apricot Blossoms Leaning against the Clouds* (*Yiyun xianxing* 倚雲仙杏). Characteristically, however, there is no such setting, only the single flowering branch against flat silk. There are as yet no leaves. In the imagination of its ample space, blossom and knotted twig must speak for themselves. Somewhat in contrast to Empress Yang's verbally seductive expression of

[22] Lee, "The Domain of Empress Yang" (1994), p. 194 (some changes).

easy charms, an expression which both Song Hangzhou and our own post-Freudian world should have little difficulty in expanding, Ma Yuan offers a more complex vision of interrupted progression. As has been shown of other subjects, his is an art anchored to physical truth but one to which he consciously brings a personal order and skill, a focus and intensity that links special meaning to that truth. With *Apricot Blossoms* and his defining signature below the left-edge entry comes recognition of the single corner approach. There is also the stubborn angularity of movement that suddenly shifts to go up or down or across as, for example, with the plum branches in Boston's *Scholars*. Here the contrast between the darker more distinctly outlined craggy progress of the branch and the circular white purity of blossoms touched by red must rely on a physical nature specific to the species, but it is also a painting marked by visible refinement of technique. The artist-scholar Chiang Chao-shen's intimate knowledge of the painting has allowed him to explain an approach he associates both with Ma Yuan and his son Ma Lin:

> Ma Lin (in a similar painting) first used dilute ink to paint five round petals. A pentagonal shape was naturally formed in the center of the petals. Within the pentagonal shape Ma Lin added a small circle. He used a blend of sepia and green — without any opaque white to fill in the pentagon. Later (he) again used sepia to outline the points of the five corners and completed the sepals. Ma Yuan's apricot blossoms were painted in the same way. Ma Yuan's brush is more firm and definite than Ma Lin's.[23]

In turn, the technique that defines the branch itself is worthy of note. It is carefully outlined with a brush tip followed by a brown wash within. Despite areas of repair, enough of the original line remains to grasp the subtle uniqueness of a movement that flows no more easily than does the progress of the entire composition. The brush-tip's movement is based on detectable staccato variations, at once continuous but sympathetic to a halting natural growth. In turn, stem and blossom combine to reinforce this quality of tense awkwardness — stretching out, holding back and then presenting a final major divide, one twig-tip falling down as though weighted by the very fullness of its crowded blossoms. The other shoots directly upward into its clear space narrowing from blossom to bud to a brittle unfulfilled ending of on-reaching potential.

[23] Chiang, "The Identity of Yang Mei-tzu," *National Palace Museum Bulletin*, vol. II, no. 2 (May 1967), pp. 5–7. See also Ma Lin's *Icy Silk Tips*, Pl. 13 and Fig. 3.2.

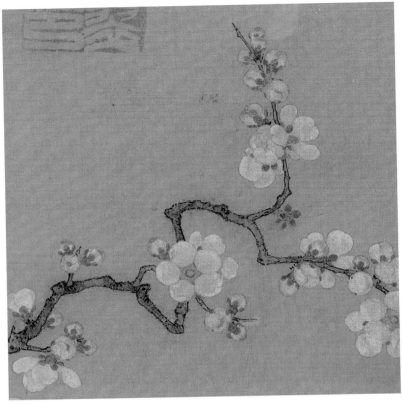

3.12

Bud and flower are throughout in varied positions — front, back, profile, fully exposed, partly hidden. There are only two full-face blossoms. The first, as one moves rightward, becomes a kind of target center — which is off-center — at the branch's sharpest angle. At this point of strongest hesitancy it becomes an anchor and prophecy to a full completed statement of lyric blossoming. There is a section of vertical branch above its five petals, and a brief downward sprig below. It thus foretells the full branch-end divide, both high above and down to the right where there is the only other full-face bloom, now placed within the richness of other bursting buds and petals. Angularity that is the strength of this knotty branch — a kind of trademark in much of Ma's style — creates the pure circularity of the open blossom with a targeted center holding forever the five spheroid circles of its petals. It is a moment of perfection, however, that leans on the arc of natural time: bud to flower and perhaps beyond. Near the tip of the vertical branch is a tiny swelling (a bud or leaf yet to be?), and there is also one dark view of open sepals from which all petals are absent. Inconspicuous as it is, the latter occupies a central point in the composition.

Peach

The *Apricot Blossoms* is usually paired with another selected branch-end, *Peach Blossoms* (*Taohua tu* 桃花圖), now in the same Taipei National Palace Museum collection (Pl. 21). The latter painting presents a contrasting bloom in a strikingly similar format. This time the branch enters a square of like dimensions not from the left, but from the lower right corner in a carefully aimed rising diagonal of three brief twigs and one long extended tip. As with the apricot, time has also brought spots of damage, unfortunately most notably at the key tip of the main branch. There is, in addition, no artist's signature, but the total composition is similarly enriched by a sensitive couplet in the opposite upper corner. There it discretely completes the aim of the blossoms. The hand is again that of Empress Yang:

A thousand years, so widely sown	千年傳得種
Two months, the blooms begin	二月使敷華

Notable is the contrast in the parallel lines between "thousand" and "two" (ie. the second month) — the fragile present and the enduring past. Fragile as is its spring presence, the flower is anchored to the wonder of enduring time, nature's repetitive cyclical gift. The moment is not lost.

Once again, as with the Mandarin duck, Ma Yuan — and in this case the empress — may take us back to the classic *Book of Poetry*, and as with that earlier cited poem confirm auspicious promise. Now it is a gentle song of youthful marriage:

The peach tree young and tender bright its flowers	桃之夭夭 灼灼其華
This girl is being married Fit for a new home	之子于歸 宜其室家
The peach tree young and tender plentiful its fruit	桃之夭夭 有蕡其實
This girl is being married fit for her new house	之子于歸 宜其家室
The peach tree young and tender its leaves are lush	桃之夭夭 其葉蓁蓁
This girl is being married fit for her new family.[24]	之子于歸 宜其家人

[24] For the poem's translation I have followed Frankel, *The Flowering Plum* (1976), pp. 18–19. He uses it to point to the poet's need for "placing" emotion in a concrete object. See also Legge, *The Chinese Classics, Vol. 4: The She King* (1970), pp. 12–13.

Paralleling the *Apricot* one does not escape the significance of a direct relation to the person of the inscriber, the persistence in a courtly world of her enduring femininity. But the floral appearance of the two five-petal blossoming branches can also bring a botanical focus. According to Hui-lin Li, among the complexities of some two hundred plum species both can be classified as subgenera in the *Genus Prunus*: Apricots (*Armeniaca*); Peach (*Amygadalus: P. persica*). Can we not then relate these images to the sequence of plum poems connected to *Icy Silk Tips*? At that time her disparagement of the blossoms in the third verse — beginning with, "Tender peach seductive apricot / what match is that?" — offers a far different focus. This gives credence to a date for the album paintings well before that time of 1216 and, indeed, much closer to 1200 when she first became Honored Consort (*Guifei* 貴妃) and then in 1202, Empress.[25]

Again with Ma Yuan the visual image is anchored to understanding the object. Within its broad classification the blossom of the peach is not the blossom of the plum (Fig. 3.13). Note particularly in the peach a parallel to

Fig. 3.13 Ma Yuan
Peach Blossoms (detail)
National Palace Museum, Taiwan,
Republic of China

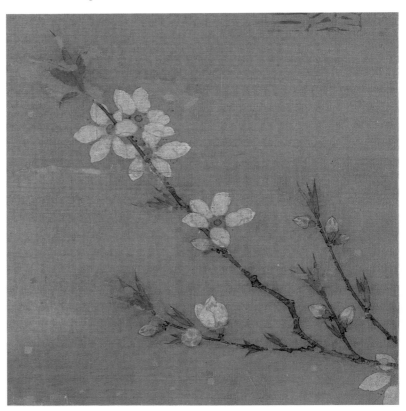

3.13

[25] Li, in Bickford, *Bones of Jade* (1985), pp. 248–49. For the empress' advancement see Lee, "The Domain of Empress Yang" (1994), p. 89 ff.

the early folk poem's significance of tender, lush leaves. For the painter the knotted apricot now gives way to a contrastingly easy upward thrust of the peach, its opening blossoms and leaves. The white petals have a differing separating pointed shape, not the tightly enclosed, stable circles of the apricot. Blossoms are now openly relaxed and momentary. So it is now with the complementary appearance of rose-tipped green leaves, a richness just beginning to spread from the branch. Left behind are those flowers that bloom on branch or twig alone. Yet their spear-tipped infant openings are tensely consistent with the sure upward thrust of woody stems. They are also of the moment, the moment before full leafage will mark blossom's end, a promise already being realized at the tip of the main branch.

Backed by similar royal calligraphy and parallel compositional sensitivity, there is no compelling evidence to deny Ma Yuan's hand in both paintings. While now kept in separate albums, they have similar dimensions (25 x 27 cm — give or take fractional differences in trimming). Along with the empress' calligraphy both carry the same prominent, though unidentified collector's seal, *Jiaocui xuanyin* 交翠軒印. Further, there is an unmistakable answering harmony when the two paintings are placed side by side. The "signature," not written on the peach, is in the image itself. Both flowerings reveal like technical attention to detail and blossom's colors of sepia, green and white. There are subtle touches to reinforce that judgment. Except at tender tips, the line that borders the branches continues to betray a knotty hesitancy. It is more apparent on the apricot, but it lingers with the peach where its presence, along with the dark brown interior wash, remains true to the nature of woody stems. Note as well, in both, such a minute detail as the turned scalloped edges of a petal. One painting remains deliberately contained in protective constancy, withstanding "wind" and "dew"; the other, scattered over a "thousand years," need not fear its apparent fragility, offering enhanced delight of easy return and openness in that brief second month — about to scatter again.

4

Water

As has been shown, it was Zhang Zi who claimed that Ma Yuan inherited the skills of flower painting from his great-grandfather, Ma Fen. But currently no other surviving works in the genre appear to capture the excellence, along with the supporting evidence of imperial patronage, found in the two album leaves just discussed as well as in his miniature plum paintings. Because of Empress Yang's poetry dealing with other flowers, poems that easily might have been paired with painted versions, we can speculate that the skills of her much patronized painter, Ma Yuan, were not limited to three floral types. However, from surviving evidence, one must continue to acclaim him as a master of other close selected subjects. Most notable was his pursuit of the seemingly impossible illusory subject of water. The painting, or rather series of paintings, *Water: Twelve Views* (*Shi'er shui tu* 十二水圖) are found in the form of a dozen rectangular album leaves, in ink and some color on silk, now mounted as a handscroll and kept in Beijing's Palace Museum. The central fold of each early album leaf is still clearly visible and confirms the book-like opening of each scene (Pls. 22a–l).

The views were much praised in the Ming dynasty and colophons from leading connoisseurs and painters from the fifteenth and sixteenth centuries attest to its importance, particularly those from the cultural center of Suzhou. Surviving are comments in order of mounting: Li Dongyang 李東陽 of Changsha (1447–1526; colophon undated); Shen Zhou's 沈周 (1427–1509) close friend Wu Kuan 吳寬 (1435–1504; colophon 1488); another friend, Wang Ao 王鏊 (1450–1524; colophon 1488); Chen Yu 陳玉, on separate paper with Liang Zi 梁孜, or The Man of Mount Luofu (*Luofu Shanren* 羅浮山人, dated to 1572); Yu Yunwen 俞允文 (1512–1579; *Yanguan Jushi* 掩關居士; colophon 1568); Chen Yongnian 陳永年 — also named Chen

Yunwen[1] 陳允文 (1531 or 1591; colophon of *xinmao* 辛卯); Wen Jia 文嘉 (1501–1583; colophon 1577); Zhang Fengyi 張鳳翼 (1527–1613; colophon undated); Wen Boren 文伯仁 (1502–1575; colophon 1568); Wang Shizhen 王世貞 (1526–1590; colophon 1570 plus second undated colophon).

The initial writer, Li Dongyang, sets the stage for the subsequent Ming viewers. His comment is brief, yet in that brevity indicating that, as painting, importance for him extended to a related art, an art inseparable from literati taste.

> To the right is Ma Yuan's Twelve Views of Water, each presented differently, with rivers passing strange, well beyond the standard paths of brush and ink – true living water. Not familiar with the rules of painting, I simply judge this by methods of calligraphy.
>
> 右馬遠畫水十二幅　狀態各不同　而江水尤奇絕　出筆墨蹊徑之外
> 真活水也 予不識畫格　直以書法斷之

Wu Kuan, writing at an unidentified but appropriate "Sea-Moon Hut," appears familiar with stereotypical remarks about the artist, and understood these paintings as not fitting that mold. He suggests as well a physical reality for those who could claim direct experience of it:

> Ma Yuan was not famous for painting water. However looking at these twelve paintings with such intricate aspects of water he is to be considered as one of many talents. All those living among rivers and lakes, and thus truly knowing water, must be drawn to them.
>
> 馬遠不以畫水名　觀此十二幅曲盡水態　可謂多能者矣
> 全卿家江湖間　蓋真知水者　宜其有取於此

However it was Wang Ao, writing in the same year (1488), who expanded on both history and meaning:

> Mountains and forests, great buildings, figures, flowers and trees, birds and animals, insects and fish – all have fixed forms. Only the transformations of water are not as one. All painters are faced with its difficulties. Thus, Dongpo ⌈Su Shi⌉ said that only the two Suns of Shu ⌈Sun Wei and Sun Zhiwei – Five Dynasties to Early Song⌉ exhausted the variations of water. With their deaths, their methods were cut short. Now I have seen Ma Yuan's paintings of water: Water twisting and turning over level distances, coiling and counter coiling in clear depths, in billowing and dashing waves, rapidly flowing in skips and leaps, wind rippled, in moon-reflected

[1] For confusion of names see *Zhongguo meishu* (1987), p. 991. Ming artist but no published dates of life-span.

waves and in running waves under the sun — all transcending a foot of space with the appearance of a thousand *li*. Why should the two Suns be the only painters said to have exhausted the variations of water?[2]

山林　樓觀　人物　花木　鳥獸　蟲魚　皆有定形　獨水之變不一
畫者每難之　故東坡以為畫水之變　蜀兩孫　兩孫死　其法中絕
今觀遠所畫水　紆餘平遠　盤廻澄深　洶湧激撞　輸瀉跳躍
風之漣漪　月之激灩　日之潰洞　皆超然有咫尺千里之勢
所謂畫水之變　豈獨兩孫哉

These three earliest colophons, apparently written in Beijing or its environs, set a special tone for appreciation in the late fifteenth century. While the first, by Li Dongyang, is not dated, it is highly likely that its brevities were brushed close to the time of the other two. All were from the south but at the time were important figures in the capital. In 1488, Li was senior expositor in the Hanlin Academy; Wu Kuan became chief secretary of the new heir apparent; Wang Ao was appointed to the commission in charge of the emperor's classical studies. Of special interest are their specific connections to the southern "water country," home of all three. While Li Dongyang turns the painting toward calligraphy he does prefix his signature with his southern origins, Changsha. Wu Kuan is specific about "waters and lakes," while Wang Ao's eloquence speaks for itself.[3]

Thus, in the understanding of a water environment, Ma Yuan's talents — the talents of a precise academic professional — were recognized, and recognized as transcending a narrow craft-oriented focus: a brush suggesting qualities of calligraphy, skills of varied richness, and a painter to be equated with the meritorious commentary of one of China's greatest literati. It was a painting that through stylistic transformation continued a recognized tradition.

Su Shi's own writings, as mentioned by Wang Ao and Lee Hui-shu has continued to expand, carry us further into an ideal, a difference between stylized "dead water" and "living water" where "natural disposition and painting meet" — Li Dongyang's "true living water." Then a generation later the writer Dong You 董逌 (fl. ca. 1120), focusing more exactly on the specific object, defined "true water" (*zhenshui* 真水) as water not depending on a setting through which it might flow, but that which was valid in its own unique presence. While the hyperbole of exhausting the qualities of water may continue unrealized, a viewing of these scenes gives little doubt but that

[2] Maeda, "The 'Water' Theme in Chinese Painting," p. 256; Lee, "The Domain of Empress Yang" (1994), p. 276 — both with slight changes. The term *qingjia*, in Wu Kuan's colophon might be given the direct translation of "Your household" if he is specifically addressing the owner of the unidentified Sea-Moon Hut (*Haiyue an*) where the album is seen.

[3] For general biographies of these three see Goodrich, *Dictionary of Ming Biography* (1976), pp. 877, 1343, 1487.

the variety of water's magic has been captured here in a manner unique in the history of Chinese painting, at least as it has currently survived. With the exceptions of two leaves showing only the briefest of rock or mountain, and another enlivened by two ducks in flight, the paintings are, indeed, of this "true water." One cannot help but think of Leonardo's scientific awakening to such mysteries in Italy some three centuries later. Again for Ma Yuan the painter, it is the physical world that continues to guide his vision. It is a matter of place, of season, of time. No view of water exists in the purity of abstraction.

It is doubtful, however, that Ma Yuan actually visited all the geographically inscribed sites. The presentation, thus, is one sifted through the mind. Yet it is in turn *re*-presented as the experience of actually seeing that water. Of this the painter will not let go. In each, the depiction is brought close to the immediate entering edge of the view. There, each movement of water is caught in inevitable atmospheric effects — the "hidden" (*mi* 迷) qualities of Han Zhuo's late Song painting perspective — and we are pressed to look into and beyond definition. Who is to deny that, in nature, living water establishes the quality of its presence which in turn defines a setting and in the constant movement of its flow ultimately carries echoes of meaning far beyond its visible presence?

The implication of water's physical nature became deeply embedded in Chinese thought, particularly in the ideals of philosophical Daoism. In recording Ma Yuan's intentions, Yu Yunwen's mid-sixteenth century colophon insists that his representations carry us to the very heart of this meaning — established in pliability, able to move or halt, rooted in quietude, able to grow and diminish with time, calm and bland, empty and yielding, soft and weak, clear and pure . . . "the virtue of ultimate benevolence, venerated under heaven" (具靈長之德　為天下之尊).[4]
And he concludes:

> In examining Yuan's painting and with the help of my words, one should grasp Yuan's meaning. Yuanmei's ﹝Wang Shizhen﹞ venerable family home is sea-bordering and thus his basic nature is of responding brilliance. My verbal understanding of water must harmonize with it.
>
> 是以覽遠之畫者　以余言參之　而遠之旨可得矣
> 元美世家海壖　而性復通明　知水於余言必有合者。

4　In these terms I have followed Lee, "The Domain of Empress Yang" (1994), p. 280.

Turn to the Daoist source itself, the *Classic of the Power of the Way* (*Daode jing* 道德經):

> Because water excels in benefiting the myriad creatures without contending with them and settles where none would like to be it comes close to the way.

Or even more tellingly:

> In the world there is nothing more submissive and weak than water. Yet for attacking that which is hard and strong nothing can surpass it. This is because there is nothing that can take its place.[5]

In the early text, *Guanzi* 管子, water is given a more concrete significance. It is "the blood of the Earth" and thus stored up "in the various things." This brings it to human significance:

> Man is water and when the producing elements of male and female unite, liquid flows into forms … what is it, then, that has complete faculties? It is water. Hence the solution for the Sage who would transform the world lies in water . . . (He) does not teach men one by one, or house by house, but takes water as his key.[6]

Thus, it is not just incidental politeness that in closing his account of the album Yu Yunwen notes the special suitability of Ma Yuan's painting for harmonizing with the nature of its then owner, Wang Shizhen, and his "venerable house."

Following water's suitability as personal metaphor back to Ma Yuan's own time, the album-scroll not only supplies a firm date but with it enters the political world. The title of each scene is inscribed on the upper left corner in what is generally recognized as the hand of Empress Yang. Her writing is authenticated on each leaf by an elaborate eight-character seal carved in archaic script and carefully placed beside it: "In the renwu year, seal of the noble consort Yang" (壬午貴妾楊姓之章). The time, mentioned earlier as giving a rare date, translates to the Western calendar as the year 1222 (Fig. 4.1).

Below each seal is the standard modest-scale script notation: "Bestowed upon the elder of the two administrators" (賜大兩府). The specific high official recipient can be further identified. Empress Yang, whose origins are clouded in obscurity, apparently for greater family legitimacy had early

4.1

Fig. 4.1 Seal and signature of Empress Yang from Ma Yuan, *Water* (detail) Palace Museum, Beijing

5 Lau, trans., *Tao Te Ching*, Book 1, viii (1963), pp. 64 and 140.
6 Feng Yu-lan, *A History of Chinese Philosophy* (1937), p. 166 ff.

adopted an "elder brother," Yang Cishan 楊次山 (1139–1219). Yang Cishan, her senior by twenty-four years, was himself an established civil servant but more importantly offered family traditions of recognized official and military significance going back to an honored patriot, Yang Quan 楊全, who had died in defense of Kaifeng during the invasions of 1126–1127.[7] Yang Cishan in turn had two sons, the empress' "nephews," Yang Gu 楊谷 and Yang Shi 楊石.

These are the "two administrators" of the inscription, authorities in charge of military and civilian administration, or perhaps at this time in the late Song simply commissioners of the Bureau of Military Affairs. The "elder," Yang Gu, was the recipient of the *Water* album. It is one of two significant surviving Ma Yuan paintings directly related to the empress' family. The second, to be discussed later, is a hanging scroll, *Night Banquet* (*Huadeng shiyan tu* 華燈侍宴圖), now in Taipei's National Palace Museum, memorializing an imperial feast in their honor (Pls. 41a–b).

Water carries its significance both for the patron and her recipient. For the empress, now a powerful figure, it is the embodiment of *yin*, the ultimate female image, clearly a positive force in handling her position, but also to be transferred as a gift of political wisdom — a necessary grasp of flexible adjustment — for a high official, in this case offered to her declared elder nephew, Yang Gu.

In sum, the painting series must be placed within the loftiest official circles at a time when the empress was at the height of both political and cultural power, a power that appears not to have significantly diminished when she became Empress Dowager two years later (1224). She continued to be honored and respected under Lizong until her death in 1233. It was also a time, if we can assume the general projection of his life span, when Ma Yuan, likely of similar age, must have been equally established in artistic eminence, aging but with a hand still continuing in confident and consistent creativity.[8]

[7] Lee, "The Domain of Empress Yang," p. 92.

[8] For the above assessment also see Lee, "The Domain of Empress Yang," pp. 281 ff and back to pp. 125–27.

The Paintings

The following sequence lists the titles of each water-subject, as defined by the Empress and found in the present handscroll mounting. An earlier sequence, preserved in the original 1568 colophon by Yu Yunwen, presents, I believe, a more meaningful order, an order which will be discussed below, but is here indicated by an alternate place-number after each title:

Waves Weave Winds of Gold (*Bocu jinfeng* 波縠金風) ⁂8

Light Breeze over Lake Dongting (*Dongting fengxi* 洞庭風細) ⁂9

Layers of Waves, Towering Breakers (*Cengbo dielang* 層波疊浪) ⁂2

Winter Pool, Clear and Shoal (*Hantang qingqian* 寒塘清淺) ⁂5

The Yangtze River — Boundless Expanse (*Changjiang wanqing* 長江
萬頃) ⁂3

The Yellow River — Churning Currents (*Huanghe niliu* 黃河
逆流) ⁂12

Autumn Waters — Waves Ever Returning (*Qiushui huibo* 秋水
迴波) ⁂10

Clouds Born of the Vast Blue Sea (*Yunsheng canghai* 雲生蒼海) ⁂1

Lake Glow, Rain Suffused (*Huguang lianyan* 湖光潋灧) ⁂4

Clouds Unfurling, a Wave Breaking (*Yunshu langjuan* 雲舒浪卷) ⁂7

A Rising Sun Warms the Mountains (*Xiaori hongshan* 曉日烘山) ⁂6

Gossamer Waves — Drifting, Drifting (*Huanlang piaopiao* 幻浪
漂漂) ⁂11

Like the miniature ten leaves preserved in the album of the *Flowering Plum*, this sequential series of more imposing dimensions (each leaf 26.8 x 41.6 cm; 10 1/2 x 16 3/8 in) has much of the same implications — a single subject carefully observed extends far beyond apparent limitation. Here Empress Yang's calligraphy helps extend that meaning, titles only, but titles as with her poems for other paintings that carry even in their brevity reverberations of extending poetic imagery, fitting supplements to the deliberate focus of painted representation. With this in mind, the translations above are attempts to turn into English not only the characters themselves but a meaningful relation to what has been painted — word-idea linked to visual fact. Damage has resulted in preserving only half of the current first leaf. However its title comes from the complete list by Yu Yunwen (1512–1579). Yu was a calligrapher from Kunshan, not far from Suzhou,[9] again confirming the album's significance in that Ming environment.

[9] For Yu Yunwen see Yu Jianhua, *Zhongguo meishujia renming cidian* (1981), p. 570.

Consider the poetic implications. For *Winter Pool*, the water term "clear and shoal" (*qingqian* 清淺) is the same as that used for water by Lin Bu in his famous poem on winter's flowering plum; for the title *Lake Glow, Rain Suffused*, the last two characters *lianyan* 瀲灩 belie an exact definition, but are clearly atmospheric in quality. The same term is used by Wang Ao to describe the effect of "moon-reflected waves," and is also found in a poem by the Southern Song scholar-poet Lu You (1125–1210) in a more complete mountain-water imagery: "Clouds splitting the mountain heights / Rain completing lake's plenitude" (雲破山燐峋　雨足湖瀲灩).[10] Just as clouds may suggest the greater height of the mountains, so rain expands the meaning of lake waters. Here Ma Yuan's painted quality of light on the water also suggests an atmospheric "suffusion" of misted rain — the waves low-pointed, active, yet subdued, expanding into the damp air, the fullness of lake's hazed obscurities (Pl. 22e).

In many ways the entire series is a contradictory tour-de-force. The main artistic choice is line. At first thought, of all of the most evident physical aspects of nature, water appears most without line's illusion. Line contains form. How thus contain water's mercurial essence? We are asked to suspend belief. By what means, then, do these paintings return us to nature's understanding? Is it not that water's life is present because line, not being a static point, requires movement in its creation and thus, to follow Li Dongyang's suggestion, is consciously allied to the art of China's calligraphy?

Toward the close of the eleventh century the great Mi Fu, much admired in the Southern Song, had used the movements of calligraphy not only for verbal narrative or poetic purposes but to present an expressive brush-style. In these, as suggested by some famous calligraphy titles, the movement of water in tide and wind or river's flow was inevitably linked: *Watching the Tidal Bore*; *Sailing on the Wu River*. Furthermore, poetry and its visible manifestation in the ink-flow of calligraphy were ever joined to the person. Thus, as Peter Sturman has described of Mi, ". . . life out of office promises a return to the scholar's original nature, represented by landscape. Clouds and water boundless, and ever-changing symbolize the expansiveness of his heart." It was an idea sealed at this time by Mi's brushed line, "This heart forever entwined with clouds and water."[11] It is not out of place to suggest comparison between Ma Yuan — *Wave Breaking* — and Mi Fu — *Wind Shifts* (Figs. 4.2 and 4.3). Shapes differ but the distinctive brush of each holds qualities of surging freedom and wind-blown action, a parallel "heart" embracing "clouds and water."

4.2

Fig. 4.2 Mi Fu
Poem Written in a Boat on the Wu River, "Wind Shifts" (detail)
The Metropolitan Museum of Art

[10] *Cihai* (1962), p. 1811.
[11] Sturman, *Mi Fu* (1997), pp. 109–11.

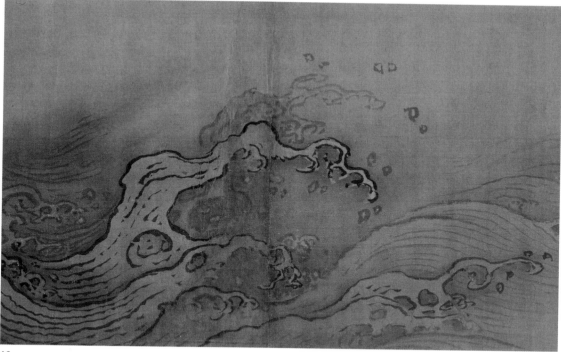

4.3

Fig. 4.3 Ma Yuan
Water (detail from leaf g: *Clouds Unfurling, a Wave Breaking*)
Palace Museum, Beijing

In contemplating Ma Yuan's views, technical mastery of the flexible brush — calligraphy — cannot be ignored. To use a well-established aesthetic term, "life-motion" (*shengdong* 生動) is present even when repetition is the theme. Consider *Autumn Waters — Waves Ever Returning* (Pl. 22j). Vibrancy to each line creates ribbons of repetition that vary in width and enliven the mounds of their rising returnings. They may be seen as variants of the heavier rolling swells of *Clouds Born of the Vast Blue Sea* (Pl. 22a). They curve toward a distance where strip-like continuity is muted by invading mist and eventual dissolution. Ma's noted "trembling" brush is clearest for the powerful *Layers of Waves* (Pl. 22b) and their breaking crests. We are asked to see the Yangtze (Pl. 22c) as ink-heavy unbroken points of hovering, overhanging rise that fall smoothly to muted threads of receding trough.

Contrast in turn a thin extending brush, the horizontal calm, that brings cold stillness to the shoals of *Winter Pool* (Pl. 22e) — more active here but of intent similar to the shoal water in the album leaf attributed to Ma Lin, *Sparse Shadows, Hidden Fragrance* (Pl. 10). Easy thin linear waves from *A Rising Sun Warms the Mountains* (Pl. 22f) show adjustment to an open view including brief distant mountain peaks and again suggesting a relation to

Ma Lin, this time his famous *Evening* 夕陽山水圖 in Tokyo's Nezu Institute of Fine Arts (Pl. 23). This is especially so if, as is now the case, the lower half of that hanging scroll is considered to have once been a separate album leaf. When small net-like units repeat themselves (*Winds of Gold, Lake Dongting*, Pls. 22h and i) the painter's brush continues to deny print-like monotony. In the rather damaged *Gossamer Waves* (Pl. 22k) the scattering of brief rising ribbons of foam becomes not so much imposed convention as easy touches affirming the dancing quality of light and lightness. In contrast, the churning waves of the *Yellow River* (Pl. 22l), their claws of foam, their eyes of openness cannot help but suggest the play of mythical dragons that tradition always found lurking in China's waters.

Move closer. Contemplate details. Turn to the central image of the isolated breaking wave in *Clouds Unfurling, a Wave Breaking* (Pl. 22g and Fig. 4.3), not just to accept its surging claw-like shapes but to understand the way the brush is handled as a mind-brush intention: broken, curling strokes, surging rightward from a single corner, strong dense black, highlighted by touches of Chinese white, echoed in muted grays for repeated shapes behind, as well as in the scattering angled drops of lesser force that carry spray into the surrounding air. Here certainly is the brush-expression for which Ma Yuan has been praised: the richness of black "charcoal ink," lines of a "trembling brush," evidence of "nail-head" beginnings. The whole is repeatedly active, no long even strokes in its thickening and thinning, its variations of touch. In the imbalance of its left corner composition, angularity and the abruptness of a moment extend to drops of spray that seldom admit to the common stereotype of being round. Here, and in other active representations the idea of "fighting water" is self-evident.

Just as convincing are water's quieter moods. Contemplate a detail from the lower left corner of *Lake Glow — Rain Suffused* (Fig. 4.4). Here definition is in easy repeated motion, wave peaks rising, falling to sweep across troughs to pointed crests, and then to sweep again. Movement is enhanced by a subtle variety of thick and thin, dark and light. A general looseness pervades. Line is not a binding limitation. There are hair-like doublings and tonal variants. The brush of one stroke passes easily across another, thereby suggesting the waves' transparencies. Enhancing this "calligraphy," however, is line's amorphous counterpart, the controlled wash. There is, accordingly, the direct imagery of water's other aspect: mist, cloud, and atmospheric rain returning brush-movement to the physical certainty of the "view."

Yet despite praise of exhausting all of water's manifestations, in a somewhat contradictory result, Ma Yuan's comprehension becomes significant not through expansion but rather limitation. Each view is a selection. Each contains the pictorial focus, a continuing sign of this artist's vision. It is a

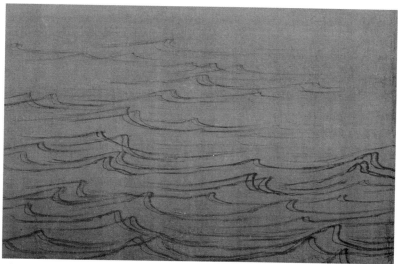

4.4

limitation that is also true of Empress Yang's calligraphy, her condensed titles that are both brief and suggestive — limitation in visual focus, limitation in verbal commentary. Whether the patron supplied the subjects, or drew them from some as yet unknown source, or simply added them later to harmonize with the painter's vision is not certain, but one cannot escape the link, the just joining of media, a connection implying conscious choice.

The range throughout these twelve leaves is that of a creative hand, one that avoids the stereotype, not dependent on others. Because no signature has survived, no statement from the empress beyond her calligraphy and seal, no evidence of another contemporary admirer, this unique touch must speak alone of its master — that and the known relation between painter and empress followed by acceptance among Ming connoisseurs that Ma Yuan was indeed the artist.

The Order

The scroll now opens with a seal character title, "Ma Yuan's Water" (*Ma Yuan Shui* 馬遠水) signed "Xiya" 西涯 or "West Bank" (Pl. 22 colophons). It is the sobriquet of Li Dongyang, the famous calligrapher, poet, and grand secretary, presented earlier as the writer of the first of the scroll's many colophons. However, this title does not secure the present order of the paintings as having been established during his lifetime.

Significantly the present first painting is only partially preserved and is missing Empress Yang's title. That calligraphy, and accordingly the completed picture, comes only from earlier recordings where the painting is placed in a far different position, well within the body of the album. It was, however, also missing as early as 1744 when the painting was entered in Qianlong's catalog. There the whole is meticulously recorded as a similar handscroll. Not until the second leaf do the calligraphy titles appear, the first leaf one being limited to the careful notation of its seals, all presently preserved. Thus for Qianlong the present mounting was intact, carefully framed by Li Dongyang's opening seal-style calligraphy and his writing of its first colophon. In turn, the actual time of the current mounting appears to be indicated by a seal of the well-known collector, Geng Zhaozhong 耿昭忠 (1640–1686), making use of his style name, Xingong 信公. It is placed at the right edge of each painting, where it overlaps the junction of painting, calligraphy and mount (Fig. 4.5). It is curious that an earlier order, known in the sixteenth century, was ignored.

Fig. 4.5　Seal of Geng Zhaozhong from Ma Yuan, *Water* (detail from leaf d: *Lake Glow — Rain Suffused*) Palace Museum, Beijing

4.5

Li Dongyang wrote only of "twelve paintings (*fu* 幅) to the right by Ma Yuan." His remarks are without date, but its position in the mounting indicates a time no later than the two colophons that follow (by Wu Kuan and Wang Ao), both dated to 1488. More certain, however, is the listing found in the long original 1568 colophon essay by Yu Yunwen. Yu Yunwen saw and studied the album in the collection of Wang Shizhen, whose two

colophons, one dated to 1570 and a second without date, appear placed at the end of the scroll. Wang mentions "twelve leaves" (*fu*), again with no indication of a scroll, but he does mention two titles, apparently to identify the whole. They are the same two that begin Yu's account. The first leaf suggests water's great extension: *Clouds Born of the Vast Blue Sea*. The second continues with a stated focus on water's power: *Layers of Waves, Towering Breakers*. The sense of magnitude continues by depicting the *Yangtze River — Boundless Expanse*.

Only at this point do the subjects relax to more limited calmer aspects: *Lake Glow, Winter Pool, A Rising Sun*. After these three is an abrupt return to the original theme of power: the cloud-wind and the driven force of a single central towering *Wave Breaking*, the detail analyzed previously (Fig. 4.3), its majesty made more evident by the contrasting gentleness that follows: *Winds of Gold, Light Breeze, Autumn Waters, Gossamer Waves*, until the end reasserts water's, and nature's, undeniable power, moving north to the uncontrolled Yellow River and its angry *Churning Currents*. In one's mind that great river inevitably suggests what lies surging beyond the painting's borders, its return to the Vast Blue Sea that began this remarkable sequence.

One must admit, in addition, one slightly earlier sequential recording. In it Li Dongyang's initial colophon was published with others, but adds as well another complete list of painting titles. It is found in Li Rihua's 李日華 (1565–1635) printed diary notes, written somewhat randomly from 1624 to the end of his life.[12] Li Rihua's sequence is both remarkably different from the present mounting and remarkably close to that presented by Yu Yunwen. As with Yu, this earliest order begins with the *Vast Blue Sea* and ends with *The Yellow River*. The only difference comes in placing *Lake Glow* before *Yangtze River*. Reverse this order and the sequence is the same. Preference must go to Yu Yunwen's version, partially because it suggests a more meaningful relation, but also because we see it in the original written hand. Printed versions are prone to error. In fact there is one such error in Li Rihua's transcription. The sixth painting, *Rising Sun* (*xiao* 曉) of Empress Yang's writing becomes *Evening Sun* (*wan* 晚) when printed.

Although in album form with its inevitable separate views, the work as a whole suggests the order of an integrated composition embracing the continuity of an implied narrative. After all, water does flow. This implied unity takes on added credence when compared to a related theme in certain handscroll format, Chen Rong's 陳容 (act. 1235–1262) *Nine Dragons* scroll dated to 1244, now in the Boston Museum. Slightly later in time, and

[12] Li Rihua, *Liuyan zhai biji, sanbi* (1935–36), *juan* 2, p. 41. For an account of the text see Lovell, *Annotated Bibliography* (1973), no. 38.

moving right to left, the latter still falls within the historical range of Ma family ascendancy. It is also, of course, water immersed, now presented in a surging ideal mythical context. Each visionary animal is separately conceived and yet part of an interconnected whole (Pl. 24). Beginning with a meaningful entrance, movement rises and falls. It surges toward a significant mid-point marked by a large tipped-up whirlpool of Daoist meaning, for it is a painterly version of the *Supreme Ultimate River Diagram* 太極河圖 (Figs. 4.6 and 4.7).

Fig. 4.6 *Diagram of the Supreme Ultimate*, from *Tu shu bian*, by Huang Zhang
East Asian Collection, The University of Chicago Library

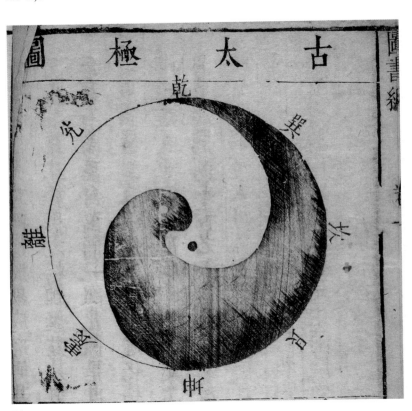

4.6

Furthermore, this mid-point image is analogous to Ma Yuan's surging, breaking wave in his *Cloud Unfurling, a Wave Breaking*, the seventh leaf (Pl. 22g) which is also near the center of his twelve views. As Chen Rong boasts of his own work: "one feels that the clouds and waves were flying and moving." There the scroll surges on to a final reclining dragon who looks back in an enclosing rightward gesture to indicate from whence he came.[13] This last is comparable to Ma Yuan's final separate moment, *The Yellow River*,

[13] Wu Tung, *Tales* (1997), pp. 198–99.

where major crests fly leftward, but the ending horizon holds a counter movement back to the right.

Robert Maeda in his discussion of varied representations of such water has called attention to clear narrative purpose in a slightly later scroll, *Twenty Views of Water*. Very likely of the fourteenth century, in an almost spaceless linear stylization of forms (Pl. 25a), it links specific water sites as well as more general expression with a beginning that depicts Daoist implications of

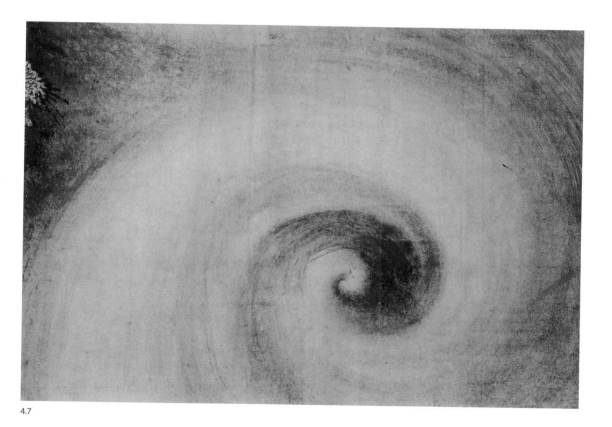

4.7

Su Shi's famous "Red Cliff" and ends with Li Bo 李白 (705–762) ascending to heaven on a giant fish.[14] The more subtle Ma Yuan lets water's Daoist meanings speak for themselves.

The realization of such views, separate and yet connected is, of course, found elsewhere in existing masterpieces of the late Song. One need only recall Xia Gui's (act. first half of thirteenth century) *Twelve Views of Landscape* (*Shanshui shi'er jing* 山水十二景) partially preserved in Kansas

Fig. 4.7 Chen Rong
Nine Dragons (section 2, detail)
Museum of Fine Arts, Boston

[14] Maeda, "The 'Water' Theme in Chinese Painting," 33, p. 261.

City or those *Eight Views of the Xiao and Xiang* (*Xiao Xiang bajing* 瀟湘八景) originating with the literatus, Song Di 宋迪 (ca. 1015–1080) and surviving in paintings by or attributed to Muqi and Yujian 玉澗 (act. late thirteenth century) now in Japan.[15] As with Ma Yuan's brush, they too involved an interweaving of place, of season, of light and atmosphere, time and distance beyond time. Of special significance is the association of Ma Yuan with these same *Eight Views*. The painting, now lost, was in Qianlong's collection along with the *Water* studies. Although carefully screening out what must have been Ma Yuan's original authority, his selective interest in both near and far and his compositional intention of separate yet handscroll-connected views can still be viewed in an existing tight copy dated to 1746 by the court artist, Dong Bangda 董邦達 (1699–1769) (Pl. 25b).[16]

In sum, while the album format demands attention to Ma Yuan's comfort in the separate view — each to be opened book-like, as the scar of its central fold makes clear — Yu Yunwen's mid-sixteenth-century sequence offers the special prospect of continuity. It is no less than an interrupted but connected journey, a journey now expanding Ma Yuan's characteristic focus on an individual scene into a comprehensive vision over sea, river, and lake. An essentially linear form surpasses static limitation to become a living progression or, even more appropriately, a "flow" and thereby all the more consistent with Dong You's conception of "true water." Entry into water's limitless creative source as clouds from the sea, great breakers, and the grandeur of the "Long River" (Yangtze), it continues to spread — usually side-leaning in composition — over areas of varied quietude, returns near mid-point (leaf g, no. 7) to a deliberately isolated image of power, followed again by relaxation, until reaching a concluding vision of exploding force, the "Yellow River," that as in nature, must return us to those beginnings in the vast sea. Perhaps it is hindsight, but is it not a vision that conveys a powerful message not only to a highly placed official, but to the human order of a too narrowly wealthy, sophisticated Hangzhou only a few decades from political collapse?

As such, it is worth repeating again what Empress Yang brushed for Ma Yuan, each a strong line of calligraphy, each four characters in the upper left, announcing what is painted below and "to the right." This time follow the arrangement of their earliest directly recorded alignment — beginning, central focus, and an end with its implied return. It is verbally a kind of

[15] Wai-Kam Ho et al., *Eight Dynasties* (1980) and for broader references to Xia Gui and Mu Qi see Cahill, *Index* (1980), pp. 169–70 and 196–97.

[16] Barnhart et al., *Jade Studio* (1994), pp. 228–31. Murck, *Poetry and Painting in Song China* (2000), pp. 233–37.

broken circular poem. The word "Clouds" (*yun* 雲) repeats near the center the opening of the first line. There it offers a logical break and renewal:

Clouds Born of the Vast Blue Sea
Layers of Waves, Towering Breakers
The Yangtze River — Boundless Expanse
Lake Glow — Rain Suffused
Winter Pool, Clear and Shoal
A Rising Sun Warms the Mountains

Clouds Unfurling, a Wave Breaking
Waves Weave Winds of Gold
Light Breeze over Lake Dongting
Autumn Waters — Waves Ever Returning
Gossamer Waves — Drifting, Drifting
The Yellow River — Churning Currents

The flow is from sea to sea.

5

Portraits:
Buddhist

While the implications of water may carry us toward the human condition, Ma Yuan brings us directly there in another aspect of his focused skills — representation of the human figure. In what has survived this is never the mirror of a living image, exact portraiture. Rather he offers us what the mind draws out of history and a hand that recreates it in the immediacy of a close realized presence. Surviving images carry with them the iconography of religious definition, but not so narrowly as to suggest religious preference. Attributed to him are: Chan Buddhist sages (Tokyo National Museum and Kyoto's Tenryū-ji Temple); an image of Confucius (Beijing Palace Museum); a Daoist sage riding a dragon (Taipei National Palace Museum); a curious painting of some quality of the Daoist sage Lü Dongbin 呂洞賓 (Chongqing Museum). This latter is unusual in the watery lightness of its touch, suggesting a later imitation. While the presence of such single or paired isolated figures is unusual among Ma Yuan attributions, they certainly fall within a wider Ma family interest as shown by the large hanging scrolls of *Thirteen Sages and Worthies* (*Shengxian shisan* 聖賢十三; also described as *Daotong wangxiang* 道統王像) commissioned by Emperor Lizong in 1230, carried out by Ma Lin and still partially preserved (Taipei National Palace Museum).[1]

Ma Yuan's most reliable extant paintings of historical sages survive at their most complete in three hanging scrolls of individual or paired Chan monks. As mentioned above, they are now preserved in Japan, one in the Tokyo National Museum, the other two in Kyoto's Tenryū-ji temple (Pls. 26a–c). As with Ma Yuan's water studies, the paintings are unsigned and thus his hand must be recognized on the basis of a painting style in logical combination with Empress Yang's calligraphy. The three also take their special place as hanging scrolls painted on silk in dark ink and added color

[1] Fong and Watt et al., *Possessing the Past* (1996), pp. 256–59; Shih Shou-chien, *Yishu xue*, no. 1 (1987), pp. 7–29.

along with a select few of other such famous Chan icons of the period, most notably the single tight Buddha image that is Liang Kai's enigmatic *Sakyamuni* emerging from his winter mountain (compared earlier with Ma Yuan's *Fuel Gatherer*) and the explosive confrontation between the hermit Yaoshan Weiyan and the official Li Ao (to be discussed presently, Pl. 28). The latter is signed with the name Ma Gongxian, an obscure personality who has been claimed as both the uncle and grandson of Ma Yuan.[2] Or to mention an image, not strictly Chan but of related intention, consider Liang Kai's painting of a strolling *Tao Yuanming* (Pl. 27, Taipei National Palace Museum). Paintings in this mode and medium embrace a special quality of force and dignity that sets them apart from variant representations found with the immediacy of touch that so often energizes surviving Chan sages painted in ink on paper. Those images are usually associated with the following generation, masters such as Li Que 李確 (late thirteenth century), Muqi, and of course, also the presumed later Liang Kai.

At any rate, the three scrolls attributed to Ma Yuan present their figures in limited open landscapes with differing approaches to enlightenment. One, representing Dongshan Liangjie 洞山良價, presents only the single image, but like the others, it is modestly confrontational. Dongshan is meeting the non-sentient aspects of nature. Each of the other monks confronts a human teacher. But is not nature also a teacher? It should be realized initially, however, that while each of the other monks confronts a human teacher, "nature" is not forgotten. For Yunmen Wenyan 雲門文偃 the mountain is important, hence the steep peak behind his teacher, Xuefeng Yicun 雪峰義存 (822–908). With Fayan Wenyi 法眼文益 it is the pine tree — green constancy in contrast to implied deciduous change.

Nevertheless, non-sentient nature offered a direct challenge with which Dongshan was intimately concerned. It is thus no accident that with this single monk Ma Yuan presents the most visually complete "portrait" of nature. The specifics of the other portraits, with narrative aspects not readily apparent, are at least initially, less directly understood. Identity for all, however, is assured by prominent inscriptions that cap their empty skies. The calligraphy is generally accepted as that of Empress Yang. Each carries an empress' palace seal: "Kunning Palace" (Fig. 5.1). Since she became empress in 1202, the acceptance of her hand thus indicates an early thirteenth century date and certainly no later than 1225 when as Empress Dowager, according to both chronicler Zhou Mi and the official Song history, she moved to the Ciming Palace 慈明殿.[3] Since the style of that calligraphy appears close to the bold strength of the

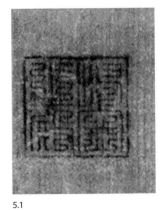

5.1

Fig. 5.1 Kunning Palace seal of Empress Yang National Museum, Tokyo

2 Cahill, *Index* (1980), p. 149; also Brinker and Kanazawa, *Zen Masters* (1996), p. 167.
3 Lee, "The Domain of Empress Yang" (1994), p. 241. She refutes claims, especially in Japanese scholarship, that have sought to make use of the Kunning seal as a sign of late, not early, residency for the empress.

hand revealed in the *Water* album of 1222, it suggests a further refinement of that date into her late maturity. Meaning for all three scrolls is not to be separated from this writing. Accordingly, one must assume the closest possible collaboration between empress and artist. It is the verbal that now most clearly leads us to specify the visual. Yet the writing above and the figures far below balance each other in the ordering of vertical formats that leave a meaningful central emptiness between. Just as Ma Yuan's representation of water had roots in antiquity, so now he plucks monks from a similar period, late Tang to Five Dynasties, definable as the "onset of the classical age of Chan,"[4] to make them visible for the thirteenth century. Translations of the inscriptions follow, in order of historical seniority:

Dongshan Liangjie (807–869):

He carried a staff pushing aside grass, gazing into the wind	攜藤撥草瞻風
He could not but climb mountains, cross waters	未免登山涉水
Unaware that everywhere is he	不知觸處皆渠
One glance, head lowered – self-joy.	一見低頭自喜

Yunmen Wenyan (864–949):

Hidden deep in the Southern Mountains, a "turtle-nose"	南山深藏鼈鼻
Through grass long spurted poison air	出草長噴毒氣
Most believed it must bring loss of life;	擬議捻須喪身
Only Shaoyang ⌈Yunmen⌉ was unafraid.	唯有韶陽不畏

Fayan Wenyi (885–958):

The great earth – mountain, water, nature.	大地山河自然
In the end is sameness? Is difference?	畢竟是同是別
Believing all truth as mind alone	若了萬法唯心
He ceased to see air-flowers, water-moon.	休認空花水月

The terms "air-flowers" (*konghua* 空花) and "water-moon" (*shuiyue* 水月) are standard Buddhist terms for illusion. They may be likened to spots before one's eyes and are found in Sanskrit vocabulary respectively as *khapuspa* and *udakacandra* or *jalacandra*. It is thus that the famous subject of water-moon Guanyin carries connotations of phenomenal unreality.[5]

[4] App, *Master Yunmen* (1994), p. 9 ff. The final character of the third line of the first poem below (*qu*) is consistently used as a personal pronoun in Chan texts.

[5] Soothill and Houdous, *Dictionary* (1904/1937), pp. 278, 159. Brinker and Kanazawa, *Zen* (1996), p. 162 cites a similar apparent evil creature at South Mountain, in this case a *bai'e hui* ("worm without forehead"). It comes from the inscription on the portrait of Wuzhun Shifan 無準師範 (1177–1249) given to his pupil Enni Ben'en 圓爾辯圓 (1202–1280). There it is considered a pejorative for the self, and the Southern Mountain is the site next to Hangzhou. However one cannot help but see a parallel with Yunmen's experience written by an empress who had close connections to Wuzhun. See Foulk and Sharf, "Ch'an Portraiture" (1993–94), p. 206.

These brief, clipped tales take on clearer meaning in the context which formed them. Each monk became a founder of one of five "houses" (*jia* 家) of Chan Buddhism, a distinction consistent with a traditional Chinese passion for order, which grew up after their lifetime but was certainly current in Ma Yuan's day. All of these sages, along with others, partook of what has been also eloquently described as "the great Dharma free-for-all of the late Tang period."[6] A set of four unspecified Chan encounters by Ma Yuan were recorded in Japan in the well-known fifteenth-century listing, *Catalog of Paintings in the Ashikaga Collection* (*Gyomotsu on'e mokuroku*). Whether or not from that set, the three houses surviving here are: 1) Caodong 曹洞 (Jap. Sōtō), associated with Dongshan; 2) Yunmen 雲門 (Jap. Ummon); 3) Fayan 法眼 (Jap. Hogen). The two missing are: 4) Linji 臨濟 (Jap. Rinzai) and 5) Guiyang 溈仰 (Jap. Igyō). If we can postulate their inclusion, Ma Yuan would have presented a full set of five. Lee Hui-shu has suggested the very plausible idea that it was a set commissioned to hang in Empress Yang's own Kunning Palace, a supposition supported by their identical seals, "*Kunning zhi dian*" 坤寧之殿 (Fig. 5.1). At any rate they reflect her knowledge of Chan Buddhism as well as Ma Yuan's own understanding. The empress' ardent support of that Buddhism is further confirmed in lines from a eulogy after her death in 1233 written by the prominent Wuzhun Shifan 無準師範 (1178–1249), known also as a teacher of the famous painter Muqi:

> Reverently she believed in the teachings of the Buddha 崇信佛教
> Profoundly comprehending its principles[7] 深悟教理

Chan's roots were personal, practice and knowledge being passed from monk to monk rather than relying on the more abstract intellectuality of traditional holy books, a rejection most graphically illustrated in the painting attributed to Liang Kai depicting the *Sixth Patriarch Tearing the Sutras* (Fig. 5.2).

Enlightenment, however, was not sealed by a single episode. Historically it involved a general progress, a pilgrimage leading to many teachers, repeated confrontations, and constant questioning. These extended over time in the course of which teaching skills were honed and experience gained. Pupils themselves became masters. Somewhat ambiguously, in the recording of these encounters Chan itself grew to accumulate an extensive personal literature with its own complexities, a knowledge of which is reflected in these three hanging scrolls.

6 Foster and Shoemaker, *The Roaring Stream* (1996), p. 115.
7 Lee, "The Domain of Empress Yang" (1994), pp. 241 and 243, citing *Fuojian chanshi yulu, juan* 6 in *Xu zangjing* 續藏經, v. 121, p. 483b.

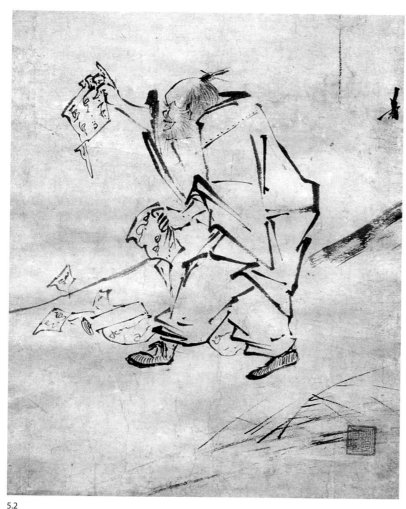

5.2

Fig. 5.2 Liang Kai, attributed
Sixth Patriarch Tearing the Sutras
(detail)
Mitsui Memorial Museum, Tokyo

To view the lives of Ma Yuan's three Chan heroes — Dongshan, Yunmen, and Fayan — is thus to see them on extended journeys. They moved from place to place involved in a series of master-pupil relationships for which revelation was never a static closed experience. Eventually they themselves were to settle at a special site, a kind of magnet where they in turn were considered masters, the focus for others searching enlightenment.

Perhaps the written statements appear more ambiguous than the paintings, but however startling or contradictory the tales, close looking reveals a consistency in both. What links them is an emphasis on freeing the mind from popular distinctions, strivings, and fears: water everywhere negating the need to search, fear from poisoned air that is illusory, and the ultimate contradiction — neither "sameness" nor "difference." Despite meeting with others, it was a resolution to be reached only by oneself.

Dongshan (807–869)

The narrative in the Dongshan encounter (Pl. 26a) is the easiest to understand visually since confrontation is with a broadly accepted idea of nature as opposed to the more concealed personalities of specific monks. The bending grass and wading in water is simple, low-level, unspectacular, as are the fading mountains, a contrast to the frantic search implied by the first two lines of calligraphy.

Dongshan came from Kuaiji in eastern China. His early movements took him to Zhejiang's Mt. Wuxie, not far from Hangzhou. At twenty-one he was at China's traditional central sacred peak, Mt. Song in Henan, for ordination, thence to Mt. Nanquan in Anhui. He was then in pursuit of the notion as to how non-sentient being could expound the Dharma, or Buddha Law. This took him to Hunan and Mt. Gui near what is modern Changsha to study with Guishan Lingyou 潙山靈祐 (771–853), who advised him to search out — also near Changsha — the cave-dwelling master Yunyan Tansheng 雲巖曇晟 (780–841), rather picturesquely describing the prospect with:

| If you are able to "push aside the grass and gaze into the wind" then you will find him worthy.[8] | 若能撥草瞻風
必為子之所重 |

The quotation here makes use of a phrase from Confucius:

| The superior man's virtue is as the wind, the inferior man's virtue is the grass; when the wind blows, it must bend.[9] | 君子之德風
小人之德草
草上之風必偃 |

It is this instruction to which Empress Yang refers in her inscription. Revelation came in part as Dongshan expressed it in a brief poem, or *gāthā*, the last lines affirming:

It simply cannot be heard with the ear,
But when sound is heard with the eye, then it is understood.[10]

若將耳聽終南會，眼處聞聲方得知。

It was only after leaving Yunyan that his wanderings brought him to the experience painted by Ma Yuan, which not only confirmed the importance of non-sentient being — water — but added the element of joy. The water sent back his image and he later wrote of it, again in song-poem or *gāthā*:

8 *Yunzhou Dongshan wuben chanshi yulu*, T. 47 (no. 1986 A), p. 507b.
9 *Lun Yu*, Book XII, chapter 19. Legge, *Chinese Classics*, Vol. 1, p. 259.
10 *Ruizhou Dongshan Liangjie chanshi yulu*, T. 47 (no. 1986B), p. 520a.

Earnestly avoid seeking without,	切忌從他覓
Lest it recede from me	迢迢與我疏
Now I am walking alone,	我今獨自往
Yet everywhere I meet him.	處處得逢渠
Now he is exactly me	渠今正是我
And I now am not him.	我今不是渠
It must be understood this way	應須恁麼會
In order to merge with suchness.[11]	方得契如如

Both his relationship to Yunyan and later wanderings help explain Empress Yang's writing above Ma Yuan's painting. Yunyan had earlier raised the question, "Are you joyful yet?" using the word *huan* 歡 (Sanskrit *nanda*), the first of the bodhisattva's ten stages (*bhūmi*).[12] It is joy with appropriate Chan emphasis on the person, "self-joy" (*zixi* 自喜), that is the empress' condensed conclusion of Dongshan's experience. Still, this is only a beginning. There is more to be explored. Dongshan goes on. Exchanges continue. In Dongshan's *Record*, total episodes reach over a hundred. There is no clear point of finality. Clearly, however, he was a recognized master when established at Dongshan, the mountain that gave him his name.[13] Dongshan was in yet another province, Jiangsu.

Yunmen (864–949)

Yunmen was born in Jiaxing midway between the present Shanghai and Hangzhou, five years before the death of Dongshan. After first receiving study in his hometown, he went some seventy miles upriver from Hangzhou to study from the crusty Muzhou Daoming 睦州道明 (780–877). He remained there apparently for some years before Muzhou passed him on to the more distant region of Fujian, the Kingdom of Min, where he traveled to Mount Elephant Bone (Xianggushan 象骨山), which because of its appearance was also known as Snow Peak (Xuefeng 雪峰). The latter became the mountain name for the famous recluse there, Xuefeng Yicun, who is depicted in Ma Yuan's Yunmen confrontation (Pl. 26b). Yunmen was then about thirty, already having shown great ability. He needed more, however, and was to continue with Xuefeng and then on to numerous subsequent pilgrimages of learning for some seventeen years. Or, as one

[11] *Ruizhou Dongshan Liangjie chanshi yulu*, T. 47 (no. 1986B), p. 520a. For quotations see also Powell, *The Record of Tung-shan* (1986), pp. 25–28. I have made small changes. The word, *qu*, a personal pronoun, as in the empress' inscription, occurs here three times.

[12] Soothill and Houdos, *Dictionary*, p. 487a.

[13] The episode depicted by Ma Yuan is no. 9 in Powell, *The Record of Tung-shan* (1986), p. 27; *Yunzhou Dongshan wuben chanshi yulu*, T. 47 (no. 1986A), p. 507a. For mobility see Powell, ibid., p. 16.

of the most reliable early records, a stone tablet inscribed shortly after his death, succinctly describes, "For many cold and hot seasons, Yunmen went to question at dusk and dawn." Many of these encounters, according to Urs App, involved followers of Dongshan. It was not until the venerable age of sixty-four that, still further south and west in the Kingdom of Han, in what is now the northwest corner of Guangdong Province, he established his own mountain fastness on Yunmen Mountain, the site from which he gained his name.[14]

Just as Dongshan's stream crossing was a positive happening along the way, so too with Yunmen, who had numerous encounters that were better preserved, according to App, than for any of his contemporaries. One of the most famous, recorded in another stone-tablet inscription, took place in the early days with Muzhou. Unhappy with his pupil's persistence Muzhou asked: "Why do you keep coming?" Yunmen replied, "I am not clear about myself." Muzhou replied: "Absolutely useless stuff!" and pushed Yunmen out the door. The problem rooted in "self" could not be answered by another. Yunmen must go on. Later elaborations added drama and pain to this tale, insisting that the door damaged or broke his leg.

Empress Yang's calligraphy brevities carry us directly to one of these further confrontations, the one recorded as no. 22 in the Song text of one hundred such meetings, or *gongan* (Jap. *kōan*), compiled in the *The Blue Cliff Record* (*Biyan lu* 碧巖錄), the preface of which dates to 1128 (curiously close to the fall of Kaifeng two years earlier). Yunmen now faces Xuefeng. Xuefeng had once addressed an audience suggesting they should all look at the poison-breathing creature — "turtle-nose" — deep within Southern Mountain. The opening line of the empress' inscription briefly parallels the opening of the case: "Hidden deep in Southern Mountain, a 'turtle nose'." When a pupil suggested loss of life even here in the temple the question arose, "Why make use of South Mountain?" With this episode in mind Yunmen confronted his teacher with even more immediacy by taking a staff and throwing it toward him with a gesture of fright. The shift is then from the Southern Mountains (or South Mountain), to the temple, and to direct personal confrontation. As with Dongshan's water, the illusion of something distant, in this case a semi-mythical threat, is transferred to the here and now, and in that direct presence Empress Yang gives a brief final summation: "unafraid" (*buwei* 不畏). This latter comes from an appended note to the main case — "Why be afraid of it?" A lengthy commentary expands each episode in *The Blue Cliff Record*, first by the compiler Xuedou Chongxian 雪竇重顯 (980–1052) and then by another Song commentator, Yuanwu

[14] App, *Master Yunmen* (1994). This and much of the further account below have been from this source, especially, pp. 14–15, 19–20, 23–24, 38.

Keqin 圓悟克勤 (1063–1135), all of which literature, of course, was available to both the empress and Ma Yuan. Indeed it might be called necessary since, according to App, the direct Yunmen line disappeared after the end of the Song. From this expanded account one is able to extract phrases that are suggestive in explaining the joint effort of word and image. Lines in Xuedou's own verse are especially significant:

Elephant Bone Cliff is so high no one goes there.	象骨巖高人不到
Those who do must be master snake handlers . . .	到者須是弄蛇手
Who knows how many have lost their lives?	喪身失命有多少
Shaoyang ⌐Yunmen⌐ knows,	韶陽知
repeatedly pushing through grass	重撥草
South, north, east, west nowhere to search.	南北東西無處討
Suddenly he thrusts out the head of his staff.	忽然突出拄仗頭
And throws it down before Xuefeng; it opens wide its mouth.	拋對雪峰大張口
Opening wide its mouth is like a lightening flash . . .	大張口兮同閃電
Right now hidden here on Ru Peak . . .	如今藏在乳峰前
The master with a loud shout:	師高聲喝云
'Look under your feet!" [15]	看腳下

Fayan (885–958)

Fayan Wenyi, born twenty-one years after Yunmen, lived a shorter life by a dozen years and was thus essentially Yunmen's younger contemporary during the first half of the tenth century. As another originator among the five Chan houses, he was especially noted for his learning, a knowledge not restricted to Chan. As with other Chan heroes, the road to wisdom was a pilgrimage. His birth place was Yuhang, near Hangzhou. He was ordained in Shaoxing at the age of twenty, then moved to Ningbo, again not far from Hangzhou, before traveling further south to Fujian, which was then the Kingdom of Min.

In the complexity of relationships that characterized these monks in the late Tang and Five Dynasties periods he may be said to have had connection with Xuefeng, for his next teacher was one of Xuefeng's followers in Chan study, Changqing Huileng 長慶慧稜 (854–932). However, his real progress is said to have come in meeting with Luohan Guichen 羅漢桂琛 (867–928) — Luohan from the name of his temple. It is this priest with whom he is

[15] Translation from Cleary, *The Blue Cliff Record* (1977; reprint 1992), pp. 130–32, with small changes. See also original text, reprint edition, *Taipei T'ien-hua ch'u-pan shih-yeh* (1979). "Opening wide its mouth" suggests that the staff had a dragon head. See discussion of the staff in later Daoist chapter.

pictured in Ma Yuan's painting. Again the road leads back to Xuefeng since Luohan's teacher was Xuansha Shibei 玄沙師備 (835–908), who had been so close to Xuefeng that it was said the two could communicate wordlessly — an idea, incidentally, to which with a different subject, Ma Yuan appears to have given visual expression in Boston Museum's *Scholars Conversing beneath Blossoming Plum Tree* (Pl. 16).

Fayan was later to become most influential in spreading his ideals from the Qingliang Temple 清凉寺 (Jap. Seiryō-ji) in Nanjing, the seat of the Southern Tang kingdom (937–975), and was patronized by its ruler, Li Yu 李煜 (r. 961–975), known as well for the arts that flourished in his court as he pursued the fading glories of the Tang. In that Nanjing locale, Fayan may also be recognized as a contemporary of the painter Dong Yuan 董源 (d. 962) who, although obscure at the time, was to become in later criticism the southern landscapist of enduring fame.

His encounters reflect a pursuit to overcome the notion of duality, the "sameness" and "difference" locked in Empress Yang's four lines of calligraphy. In Ma Yuan's painting (Pl. 26c), Fayan, younger by eighteen years, confronts his teacher, Luohan Guichen, with a lesson on the denial of distinctions, especially in the questioning brevity: "The same, different?" — Empress Yang's: "Is there sameness? Is there difference?" (*shitong, shibie* 是同 是別). It is made clearer, however, by an expanded knowledge of the teacher-pupil confrontation known certainly to both the writer and the painter. The discussion concerns an early Buddhist text, *Treatises of Zhao* (*Zhaolun* 肇論) by the monk Sengzhao 僧肇 (374–414), a pupil of the famous translator, Kumarajiva (350–ca. 409).

Reaching the point where the text asserts: "Heaven and earth and I are of the same root," Luohan's questioning proceeds:

> Luohan (here using a temple name, *Dizang*): Mountains and rivers, the great earth, and yourself, are they the same? Are they different?
> Fayan: Different.
> Luohan raised two fingers.
> Fayan: The same.
> Luohan again raised two fingers, got up and walked away.[16]

> 地藏云，山河大地，與上座自己，是同是別？師云，別。地藏豎起兩
> 指。師云，同。地藏又豎起兩指，便起去。

[16] *Jinling Qingliangyuan Wenyi chanshu yulu*, T. 47 (no. 1991), p. 588b. For Sengzhao see Feng Yu-lan, *History* II (1953), p. 258 ff. and Sharf, *Coming to Terms* (2002), pp. 31–33. Cleary, *Blue Cliff* (1992), "Biographies," p. 575 also describes the Ma Yuan episode.

Parenthetically, and not without interest in connection with Fayan's reputation for wide learning, it is important that this episode is based on such an early text.

Ma Yuan's Interpretation

What is Ma Yuan's explanation of these wandering heroes? One can assume a certain awareness of history and an understanding of the time of these three monks and their teachers whose lives spanned a period from the late Tang into the early Song. There were major Buddhist persecutions from 842 to 845 when Dongshan was in his thirties. Thousands of established religious institutions were destroyed or secularized. Against this background, the wandering monk searching for individual wisdom in mountain retreats distant from northern authority is the more readily understood. Their major activity was centered south of the Yangtze reaching, in the case of Yunmen and Fayan, into the Kingdom of Min (Fujian) and beyond. However seemingly distant, there was already in these regions a tradition of Buddhist support, now to be extended with the development of Chan.[17]

More importantly, the idea of such wandering after cataclysmic political upheaval was not far from Ma Yuan's generation — wandering after the fall of Kaifeng and seeking refuge in the south. Despite the acceptance of time and treaty creating a stabilized Hangzhou, there was the lingering reminder of continuing northern occupation. Although not specifically recorded, the Ma family, along with others that are so recorded such as Li Tang, Xiao Zhao 蕭照, and Mi Youren, could not have avoided this experience. In any case, Dongshan's gentle glance as he still moves forward, Yunmen's high mountain encounter with Xuefeng, and Fayan's brief level earth confrontation with Luohan Guichen, the only painting without the suggestion of a mountain, and from which his teacher is said to have quietly walked away, all indicate an ongoing search — more certain than any single moment. Ma Yuan's apparent rejection of dramatic finality helps account for his control in depicting them.

Indeed, why emphasize the drama of difference if the purpose is to eliminate common distinctions? Understatement may be the positive clue to understanding. It is evident both in the calmness of the figures and the brevities of their surroundings. Yet there remains the ambiguity of deliberate contrast. There is emptiness — for at least half of each painting is well below

[17] Cf. Gernet, *A History* (1982), pp. 294–96. Schafer, *Empire of Min* (1985), pp. 91–96.

the calligraphy. There is definition — concentrated in the immediacy of the lower part of the scroll. There is landscape and no landscape. Ma Yuan's conscious restraint and selective certainty are here. The painted world shows its forceful presence. Two monks are placed forward and parallel to the picture plane. The solitary Dongshan slants toward us. At the same time surroundings may eliminate physical presence: brief disappearing mountain wash or simple background emptiness.

As always with Ma Yuan, selection reinforces the message. In Fayan's representation the enduring pine is securely anchored in the lower right corner. It then disappears beyond the borders of the picture, reappearing in an isolated limb above, angled and split, a single branch becoming two, imbalanced yet balancing, a double benediction to the human pair, the conundrum of "different" and "same." Fayan's open mouth denotes speech. With Yunmen there is also a right-hand composition where the brief wash of the Southern Mountains defines place, but also its visionary nature. There is in addition behind the teacher, Xuefeng, a magic mushroom, its symbolic immortality backing the stable seated triangle of a lofty pose. It becomes also a touch of seeming certainty to parallel and contrast the distant illusory mind evil of the inscription's mythical "turtle-nose." The wilderness austerity and endurance of the craggy iconic teacher are further maintained by a seat cushioned only by a rustic mat of leaves, while the undercutting of its rocky shelf and mists obscuring all but the highest peak help confirm that "Elephant Bone Cliff is so high no one goes there." Fayan's teacher, the most elaborately robed of all, suggests his temple-dwelling authority, a sharp contrast to the far simpler garments of mountain-dwelling Xuefeng.

All three paintings have indeed suffered significant surface damage, and we are unable to see them in their direct fresh immediacy. Still, this does not hide major intent. Looking back over the skeleton of what history has preserved of Ma Yuan, one cannot help but see how much at home he was with a calm, stable figure, whether it be the plodding of a donkey-slowed fuel gatherer, the frigid postures of winter egrets, plum tree seated sages, or the elegant strolling contemplation of an aristocrat in early spring. Nature, however, may be active as in the angled impossible stretch of a plum branch, the splitting axe-stroke of a rock, the knotty tension of a flowering apricot, or water surging to an explosive crest. But with the painting of flesh and blood, stability appears to be the norm.

This is clear with all three of the Chan heroes (Figs. 5.3, 5.4, 5.5). However, there is a special relaxed ease with the image of Dongshan, who is the only one presented in clear physical movement. It is movement, however, marked by the gentleness of his action. He had the reputation in his teaching of

avoiding the blows and shouts found in others.[18] In the painting he ventures into ankle-deep water not far from a low undramatic bank, feeling his way supported by a probing too-thin staff. Easy shoals continue as we are told by the emerging grasses before him. Nature conforms to what is written above. Wind is in the rightward bending grasses. There is the wash presence of mountains. But now mountain climbing is a distant illusion, the wind a sympathetic breeze behind him or just touching the foreground. Water

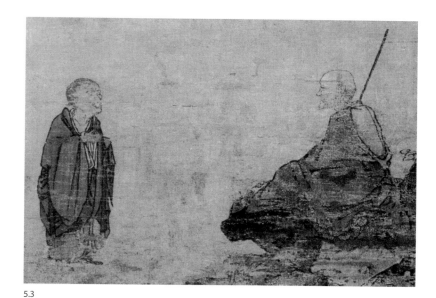

Fig. 5.3 Ma Yuan
Yunmen Wenyan and His Teacher Xuefeng Yicun (detail)
Tenryū-ji, Kyoto

5.3

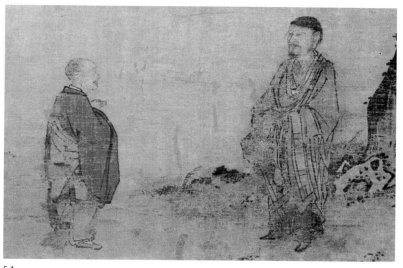

Fig. 5.4 Ma Yuan
Fayan Wenyi and His Teacher Luohan Guichen (detail)
Tenryū-ji, Kyoto

5.4

[18] Powell, *Record* (1986), p. 18.

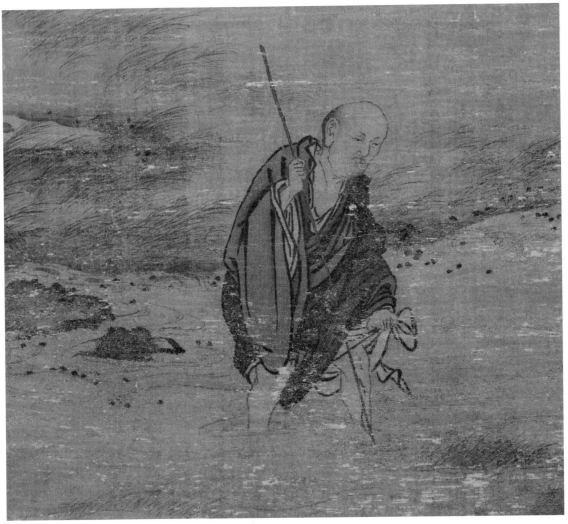

5.5

Fig. 5.5 Ma Yuan
Dongshan Liangjie Crossing the Water
(detail)
National Museum, Tokyo

opening toward us in a typical late Song perspective offers an unassuming lowland flow, a movement defined by spare lines encircling rock and ankle, recalling the water in Ma Yuan's album leaf *Winter Pool, Clear and Shoal* (Pl. 22e). The jagged touch of the garment hem he holds above the water is a single sharp angle that by contrast emphasizes the dark and heavy vertical weight of his ample robe. With an enlarged cranium, the head offers features narrowly gathered on a wide open face. The lowered eyelids touching the jet black pupils seal the expression of his tightly pursed lips. All "self-joy" — *zixi* of the inscription — is held within.

Can we not repeat the claim of Ma Yuan's friend, Zhang Zi, at least so far as the inner rules over the outer:

> If one can always keep his heart pure, detached from all grasping and clinging, and in the realm of distinction, can always enter the undifferentiated *samādhi*, then for him to be in the bedroom or a wine shop is no different from going through the places of enlightenment, and sounds of music and the singing voices are nothing but conversations of supreme wisdom (*prajñā*).

Such ideas gain authority from the consistent technical mastery that permeates representation in all three scrolls. Drapery, always in Chinese art a major element for characterization and here so all-embracing, is of special significance. Strong black lines outline slate-grey surfaces with occasional interruptions of color depending on which part of the robing is exposed. Sleeves hang with unmistakable stability of linear intent — brushstrokes within, pointing downward, some with nail-head beginnings, others simply starting thick and then tapering to thin endings. In turn, however, this weight may be altered by deliberate angles (Ma Yuan's characteristic love) for a shoulder, a collar, or with the active Dongshan a touch of sharp rising lower hem.

Color, despite damage and aging, also carries meaning. Toda Teisuke's sharp eyes have even discovered the use of gold.[19] Color is simple and subdued for the mountain-dwelling Xuefeng. Gold is, however, on the magic mushroom, a special touch of unique power. The wrap-around robe is an even violet. For the back-exposed garment the tone is olive. In contrast, color is especially prominent with Fayan and his teacher. Here robes are the most visually apparent of the three scrolls. The much repaired wrap-around on Fayan suggests subdued color, while the extensive sleeves of his temple-prominent teacher feature an elegant pattern of red and lighter rectangles that recall Sakyamuni's original patched robe, adding as well the weight of authority. Appropriately, to this was added another touch of gold, this time for the disk to which the surplice is tied. Both robings are significant for the confrontational play of "difference" and "sameness," as is the benediction of a single split-branch pine, a setting here contrasting with wide and gentle water or the severity of overhanging cliff and peak of the other two scenes.

Only necks, hands, and heads directly reveal the physical person. These demand a thinner line and the miniature of more detail that portraiture requires. Yet even here Ma Yuan's brush only makes marginal concession. Miniature as it is, there is continuing dark firmness. Still, they are portraits

[19] Murck and Fong, *Words and Images* (1991), p. 318.

and faces add thin sensitive touches for eyes, eyebrows, beards, red lips or white teeth. With the hands damage takes its toll. Thus it is only on Fayan and Dongshan that the depiction of heads and hands is essentially clear. With Fayan open hands are pressed together in a gesture (*mudrā*) of reverence complementing the open mouth of speech. Luohan's hands are so damaged as to reveal nothing about his two-finger gesture. It is difficult, however, to think of fingers raised very high. Dongshan's hands are engaged — holding the robe, grasping the staff. The latter "action" offers a special Ma Yuan quality with the strength of its angularity. With Yunmen only the thumbs are preserved.

Finally, consider what is especially important in such consciously contained figures — pose and scale. These define their natures, active or passive. Each of the two monk teachers is significantly larger in scale or raised in position to contrast with his pupil (nature the contrast for the solitary Dongshan). Xuefeng is seated, raised on a rock platform, but were he to stand the same increase in scale might well apply.

As to pose, there are two contrasting presentations — profiles and three-quarter views. A profile defines fixity. The person is flat and static, yielding to linear abstraction. Interest is not so much physical nature as outline, a recognizable shape, as with a head stamped on a coin. In contrast a three-quarter turn, a shift of head or shoulder, is movement in space and time. The figure becomes active, shifting toward direct physical confrontation, breaking the seal of iconic removal. Such freer action is implied in the poses of Dongshan, Fayan's teacher, and Yunmen. Fayan's profile and reverential hands indicate acceptance of Luohan Guichen's teaching. With Yunmen the situation is reversed. He is the young protagonist, only in his thirties. He is the staff-thrower, conveyer of a gesture of fear. Unless present damage, which is considerable in the lower part of the painting, has destroyed more literally relevant clues, Ma Yuan was content with subtleties of pose. Xuefeng, a seated raised profiled triangle of rustic stability, complete with motionless staff, does not deny acceptance of Yunmen's activity, or his progress, yet asserts the certainty of age and more accomplished truth. Of what use would the visibility of a thrown staff have?: ". . . It opens wide its mouth . . . like a lightening flash . . . hidden here . . . look under your own feet" and a final addition in the commentary: "repeated words are not worth enduring" (重言不當吃).

Further Confrontation

Partly to round out the Ma Yuan tradition in the depiction of Chan heroes and also to offer an important contrast, one cannot neglect the precisely defined meeting between two older contemporaries of Dongshan, the monk Yaoshan 藥山, and the Tang dynasty official Li Ao 李翱, in a painting owned by another Kyoto Temple, Nanzen-ji: *Li Ao and Yaoshan: Question — Answer* (*Wenda tu* 問答圖 — Pl. 28). It, too, is a hanging scroll painted on silk with ink and added color. Lacking the vertical extension for calligraphy, the pictorial area fills the format, but like the other scrolls the figures are placed below in a composition that echoes, with more detail, the familiar platform of land framed by emphasis on one side. Here it is the right edge that depicts parts of three trees, appearing, disappearing, and reappearing — two prominent pines and, tucked behind them, the tree-trunk that must be the source of the split plum branch emerging above among the high limbs of the full-needled overhanging pines. The scroll, in far better condition, has what the others lack, a signature. Strongly brushed in the lower right in a convincing Southern Song fashion (the family name large, the two-character given name smaller and closely knit) is the name of the artist, "Ma Gongxian," a member of the Ma family about whom we know very little. He has been ambiguously recorded, on the one hand as the uncle of Ma Yuan active in the Shaoxing era, 1131–1162,[20] but in the more recently discovered earliest surviving mention of his name as Ma Yuan's grandson.[21]

Judging by the painting alone, it is almost impossible to think of its existence without the influence of Ma Yuan. Beyond the presence of this scroll, nothing appears to have survived as possible support for the nature of painting in the Ma family tradition before Ma Yuan himself. It is unlikely that a painter flourishing in the Shaoxing era, 1131–1163, could have been influenced by a very young nephew, to say nothing of one possibly not even born. The claim of a grandson as a painter of the current masterpiece appears increasingly to be the more likely. Now the outward intensity of expression takes us well beyond the depths of Ma Yuan's restraint. Looking closely, one may indeed catch such details of Ma's style as his firm ink-black lines, including the nail-head rat-tail variety, lines often abruptly hooked and angled. Thus, technical familiarity is present, but that familiarity is subtly more stereotyped, released to serve an open obvious excitement.

Although not carrying the written commentary of imperial calligraphy, the episode was well published as early as the beginning of the eleventh

[20] Xia Wenyan, *Tuhui baojian* (1365), ch. 4 (1936 ed., p. 76).
[21] Zhuang Su, *Huaji buyi* (1298) (1963 ed., p. 14).

century in *Jingde Era Record of the Transmission of the Flame* (*Jingde chuandeng lu* 景德傳燈錄; Jingde era, 1004–1007). It is, however, of no little significance that a complete recording occurred in 1252 in chapter 5 of the *Collated Essentials of the Five Flame Records* (*Wudeng huiyuan lu* 五燈會元錄),[22] a date compatible with the effort of a Ma Yuan grandson. The texts offer slight differences in the selection of characters but do not diverge in descriptive intent. Accordingly, I have relied most exactly on the later publication. With this in mind one can trace the literal pictorialism of the artist. A wisdom, ambiguous but clear in presentation, unfolds:

> Li Ao, a Tang dynasty government official, friend of the great official-literatus Han Yu 韓愈 (768–824), having heard the fame of the monk Yaoshan, asked the monk to pay him a visit. As there was no response, Li Ao determined, rather, to go himself to see the monk. When confronted, Yaoshan, grasping a sutra, remained silent. To such conduct Li Ao, having indicated his presence, became upset and admonished him:

> Li Ao: Seeing you face-to-face is not equal to hearing your reputation ⌈waves sleeve and prepares to leave⌉.
> Yaoshan: Why do you prize the ear but demean the eye?
> Li Ao ⌈bowing with a gesture of respectful thanks⌉: What then is the True Way?
> Yaoshan ⌈silent, thrusts forward a hand-gesture of fingers up and fingers down⌉ Do you get it?
> Li Ao: No, I don't.
> Yaoshan: Cloud in the blue sky, water in the vase
> Li Ao ⌈with a poem of recognition⌉:
>> His ascetic body parched like a crane
>> Under a thousand pines two sutra boxes
>> When I came to ask the Way, no other words, only
>> "Cloud in the blue sky, water in the vase"

曰，見面不如聞名，拂袖便出。山曰，太守何得貴耳賤目？
守回拱謝問曰，如何是道？山以手指上下曰，會麼？守曰，
不會。山曰，雲在青天，水在瓶。守忻愜作禮而述偈曰，
鍊得身形似鶴形，千株松下兩函經。我來問道無餘説，
雲在青天水在瓶。

The recording of this path to truth carries with it not only the typical brevity of Chan enigma, but it can stand, too, for much of the nature of Southern Song painting. It is what is visible before you, here and now — as with Dongshan in his river wading — that conveys what is real, what you see, not what you hear. The eye is more to be trusted than the ear. Recall

22 Puji (1179–1253), *Wudeng huiyuan* (1252), *Dainippon zokuzōkyō* (1971 ed.), *juan* 5, p. 89a–b.

Dongshan's intensity: "But when sound is heard with the eye, then it is understood." That Li Ao answers with a poem both parallels Dongshan's *gāthā* of revelation and helps draw his Confucian official status closer to the skill of a literatus.

It is remarkable how exactly the painter makes visible the written account — the partially hidden sutras in his left hand, the tension of silent rejection in the spacing between, the focused instant of awakening partially blocked by the firm stone table. The monk's authority rests not only in his being seated (cf. Ma Yuan's Xuefeng), but backed as well by the firmness of two large pine trunks.

5.6

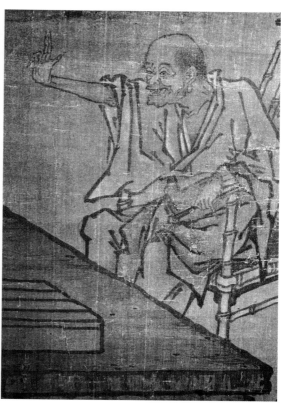

5.7

Notable is the encounter's dramatic visibility, a confrontation that appears to reflect the specific origin of the *gongan* (*kōan*) practice itself. Turn back again to the ninth century and a biography of Chen Zunsu 陳尊宿 (790–877?) as found in *Jingde Era Record of the Transmission of the Flame*. There the master judges the monk: "(Yours is) a clear-cut case but I release you

Figs. 5.6 and 5.7
Ma Gongxian
*Li Ao and Yaoshan: Question —
Answer* (detail)
Nanzen-ji, Kyoto

from the thirty blows (you deserve)" 見成公案放汝三十棒. It was a legal matter. Closer now to the time of this painting, when the Song was slipping into the Yuan, the famous Linji master Zhongfeng Mingben 中峰明本 (1263–1323) explained:

> The *Gongan* may be compared to the case records of the public law court. Whether or not the ruler succeeds in bringing order to his realm depends in essence upon the existence of law. *Gong* 公, or "public" is the single track followed by all sages and worthy men alike . . . *An* 案, or "records," are the orthodox writings which record what the sages and worthy men regard as principles.[23]

Ma Gongxian's "judge" is seated at his "bench," here a stone garden table, passing judgment on the suppliant. It is a "judgment" indeed that fills the entire painting. One is tempted to say that it explodes with the thin moment of a "great awakening" (*dawu* 大悟). These are active figures, superbly intense. Yaoshan on the edge of his bamboo armchair, turned in three-quarters pose, thrusting his right forearm from a crisply falling hanging sleeve, the hand tensely vertical, fingers frozen, thumb angled back, two fingers straight up and skyward, two fingers angled down toward Li Ao, the recipient of the forward thrust of open-mouthed words, words that issue from the old gnarled features of a tensely drawn beady-eyed face, whose arched eyebrows and touches of crows-feet are not without a hint of a smile. In turn, the "action" of the recipient, Li Ao, imitates, but in greater detail and precision, that of Ma Yuan's Fayan: the fixed standing profile, the open mouth (here somewhat hidden in his beard), and the reverential cupped hands receiving, with eye-popping intensity and the open curve of a jowl, the thrust of the crisp message. It is a Song recreation of historical Chan action at its explicit best (Figs. 5.8 and 5.9).

The intensity of meaning, however, is not confined to human action. Echoes reverberate throughout the surroundings. The major intermediary — also clearly illustrating the message — is the plum branch in its Song vase and stand (like the container illustrated earlier in the Southern Song album leaf of the *Peach Blossom Chrysanthemum* — Pl. 18). Here the stem mimics the angled pose of the monk and his hand-gesture, a down-thrusting branch carrying the message to the official. This in turn is repeated by the spear-like breaks of two fallen horizontal bars in the rustic background fence, in the two major overhanging pine limbs above, while between them a growing plum branch splits (as the monk's outstretched fingers), one branch aimed

[23] I am grateful to Robert Sharf for drawing my attention to this history and its significance for this painting. For respective quotations see: T. 51 (no. 2076), *juan* 12, p. 291b. Miura and Sasaki, *Zen Dust* (1966), p. 4. I also changed the Wade-Giles to pinyin.

5.8

5.9

Figs. 5.8 and 5.9
Ma Gongxian
Li Ao and Yaoshan: Question — Answer (detail)
Nanzen-ji, Kyoto

skyward, one angled down. The lotus stand below in all likelihood contained water, an attraction for birds (see *Pine Stream and Paired Birds*, *Songquan shuangniao* 松泉雙鳥, a Ma Yuan–style painting in Taipei's National Palace Museum, Pl. 50). Truth is above. Truth is below. Skilled as is the execution in defining an enigmatic moment, one cannot escape the exact mirror of its literal presentation. As it echoes throughout, does the drama not become too insistent, slipping from subtlety toward the limitations of a precise, literal stereotype? Although not incompatible in the hands of a great master, is there not a distinction to be drawn between illustration and visual creativity?

6

Portraits:
Confucian
and Daoist

Confucius

Among ideal historical portraits by or attributed to Ma Yuan it is of no little significance to turn to a seemingly modest effort claiming to represent no less a sage than Confucius himself. It is a figure painted in ink and slight color on silk now in the collection of Beijing's Palace Museum. The scale is in a disarmingly ordinary album-leaf size, but it carries the claim of a "Ma Yuan" signature (Pl. 29a). The figure, in a three-quarter pose, is isolated without setting or companion, but it offers the same kind of representation that effectively carries that blunt condensed statement characteristic of other Ma Yuan figures, especially his Chan heroes. Both its isolation and apparent incidental preservation on a small piece of silk suggest that the portrait might have been plucked from or inspired by a larger, more complete narrative, image, or series of images. With this in mind, it is important to return to the significant Hangzhou environment that joined China's "Three Teachings," or "Creeds" — Buddhism, Daoism, and Confucianism — a syncretistic approach touched on earlier while discussing Ma Yuan's winter *Fuel Gatherer*.

That Ma Yuan painted the three leaders in a single composition comes from that reliable recorder of the late Song scene, Zhou Mi. It is important to look at his specific account:

> In the court of Lizong there was a painting of the *Three Teachings* by Painter-in-Attendance, Ma Yuan. The "Golden-faced Old One" (Sakyamuni) sat cross-legged in the middle. The "Dragon-like Old Man" (Laozi) stood sternly imposing at one side, and "Our Master" (Confucius) was posed in ceremonial obeisance before them. All this was the result of an order from the court eunuchs, its purpose to mock the sage (Confucius).

One day a request for an encomium reached Guxin Jiang Ziyuan (Jiang Wanli 江萬里, 1191–1278) with the intent of continuing the fun. Without hesitation that gentleman wrote:

> Sakyamuni sits cross-legged
> Laozi a glance beside
> Only Our Master
> Laughing on the ground below

As a result, he was considered to have admirably fulfilled the request. His phrases might also be described as both subtle and suggestive.[1]

理宗朝，有待詔馬遠畫三教圖。黃面老子則踑趺中坐，猶龍翁儼立於旁，吾夫子乃作禮於前。此蓋內璫故令作此，以侮聖人也。一日傳旨俾古心江子遠作贊，亦故以此戲之。公即贊之曰，釋氏趺作，老聃傍睨，惟吾夫子，絕倒在地。遂大稱旨。其辭亦可謂微而婉矣。

The final line of Jiang's encomium needs further explanation. The use of the term *juedao* 絕倒 helps explain Zhou Mi's own comments. A literal translation should be more forceful: "doubled up or roaring with side-splitting laughter." I have modified this somewhat because it is impossible to believe that Confucius could assume such an outward pose. Accepting that the surviving image attributed to Ma Yuan must be close to how he painted him in his *Three Teachings*, we must conclude that a dignified pose with an open mouth and impressive robes affirming the power of antiquity should be sufficient to declare superiority over Laozi's reluctant glance or Sakyamuni's rigid, silent golden-face. The laughter is in fact internal. Perhaps the tilt of the eyes, the up-turned nose, and the lively whiskers add to an animation that is, indeed, "subtle and suggestive."[2] Given such an account, turn then to the image and its modest respectful pose. Perhaps on first glance not impressively painted, the figure is no less inactive than Ma Yuan's Chan heroes who reveal a controlled strength not because of dramatic action — as with Ma Gongxian — but because of a convincing quiet stability.

Moreover, Confucius here is not a fixed icon. The turn toward a three-quarter pose is a self-contained movement. His head with a swollen brow becomes an obvious sign of learning. Add to that the open mouth, the lively whiskers. The long robe, bordered with a leopard skin pattern, links him to a tradition of sages robed by or seated on such a symbol of primal antiquity. Thus in Liang Kai's idealized standing portrait, the great poet recluse *Tao Yuanming* (Pl. 27) is represented with a fur cape — spotted and loosely

1 Zhou Mi, *Qidong yeyu* (1291, reprint 1987), ch. 12, pp. 249–50.
2 I am indebted to Thomas Smith for steering me toward such a conclusion about Zhou Mi's account.

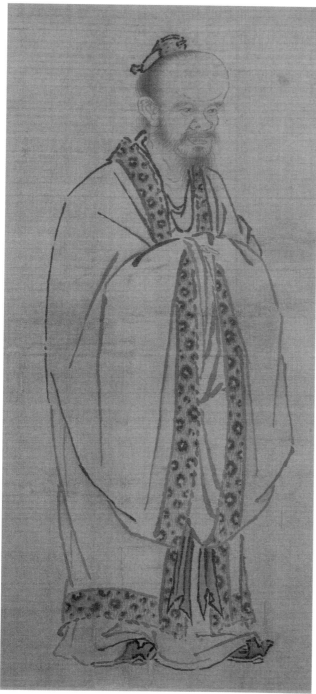

Fig. 6.1 Ma Yuan (genuine or close copy)
Confucius (detail)
Palace Museum, Beijing

6.1

Fig. 6.2 *Rong Qiqi*
from *Seven Sages of the Bamboo
Grove*
Nanjing Museum

fringed — a clear Song equivalent of the fifth-century carvings of the mats for the seated *Seven Sages* now in the Nanjing Museum (Fig. 6.2), implying again the same animal of the wild.

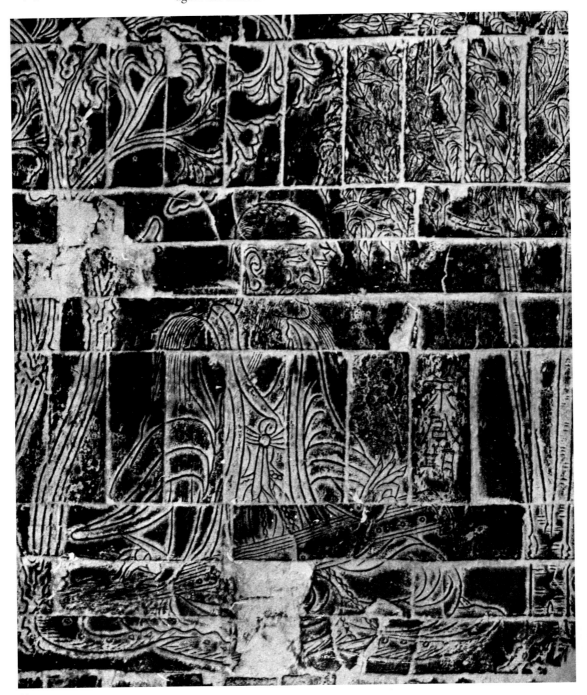

6.2

In the Ma family tradition, Ma Lin repeated this pattern for the lower robe of his near life-size *Fu Xi* 伏羲 in the Taipei National Palace Museum (Fig. 6.3, Pl. 29b). The technique for this dotting is remarkably similar to that on the Confucius image (Fig. 6.4).

6.3 6.4

This latter was the first of the series of *Thirteen Sages and Worthies* commissioned by Lizong in 1230. It is not wilderness wildness that we are asked to admire with such a noticeable article of clothing, but rather the established depths of a tradition of sages deep in ancient myth.

In addition to its quiet turning and withdrawal, the body of Ma Yuan's Confucius is under complete control. Present is a purposeful concealment which, as so often with the garment-draped figures of Chinese figure painting tradition, is the vehicle for meaning, the subtle power of the unseen. Here there is no question about the positioning of arm and hand. There is the certainty of closely joining hands — a single slender finger emerges — the implication of bowing respect, the deeper, the more dignified by virtue of the heavy weight of the sleeves. In a word, this Confucius, whether or not it is exactly what we would see were the original Three Teachings before us, does not contradict Zhou Mi's brevities of performing the rites (*zuoli* 作禮) nor the result of Jiang Wanli's commentary. Whether or not Jiang had seen Ma Yuan's painting directly, it contained, as an idea, more than superficial outward appearance, and one must consider two factors: that it was ordered by the eunuchs; and Jiang Wanli's relationship with the court.

In illuminating what he calls "political loyalty to cultural values" during the last years of the Song dynasty, Richard Davis has given us glimpses of scholarly disdain for the palace eunuchs. The conservative Ouyang Xiu 歐陽修 (1007–1072) had earlier given his stern opinion:

Fig. 6.3 Ma Lin
Fu Xi (detail)
National Palace Museum, Taiwan, Republic of China

Fig. 6.4
Ma Yuan (genuine or close copy)
Confucius (detail)
Palace Museum, Beijing

Since antiquity, the roots of eunuch havoc on the human world lay deeper even than the ravages of women. For women, it lies merely with sensuality, but the harm done by eunuchs has no single source.

Davis carries much of this attitude into the late thirteenth century and the court of Lizong:

. . . Under the sensually distracted Lizong, empresses were eclipsed by eunuchs — Dong Songchen perhaps the most hated of these illicit surrogates of the emperor. With this shift, literati grew increasingly alarmed, seeing in the ascent of eunuch power a more compelling symbol of dynastic emasculation.[3]

As to Jiang Wanli, the writer of the cryptic commentary on Ma Yuan's lost painting, there can be little question where he stood. He was a confirmed Confucianist. Spending much of his life in the capital he rose from being a student in the Imperial University to be its chancellor. He filled other significant government posts as well, becoming chief counselor briefly in 1269. For Zhou Mi, the suggestiveness of Jiang's "laughter" blunted the eunuch's request — subtle, not rigidly offensive.

Follow out the history. The University, after its reopening by Gaozong in 1142 and the reestablishment of the scholarly *jinshi* exams in the next year, had under the careful attention of this first Southern Song emperor grown to be an essential focus for traditional Confucian values. In the world of art it was the repository for his own calligraphy of the classical Confucian texts, engraved as the *Stone Classics* (*Shijing* 石經), and a subsequent series of *Confucius Instructing 72 Disciples*, datable to 1157, apparently brushed by Academy artists, but with Gaozong's own written text. These, too, were preserved in stone engravings still kept in Hangzhou's Confucian Temple, Kong Miao 孔廟 (Pl. 30a).[4]

Lizong, whose ascendancy to imperial power was the result of a palace coup in 1224, followed a similar course. The imperial commission of 1230, mentioned above, appears specifically connected to bolster the orthodoxy of his rule — all the more necessary in the shadow of the Mongol advance. It established legitimacy in terms of traditional learning, the so-called School of Dao (*Daoxue* 道學), or True Way, a conservative Confucian revival. More exactly it is described as *Daotong* 道統, the orthodox lineage of Dao.[5] The 1230 commission called for Ma Yuan's son, Ma Lin, to paint thirteen near

3 Davis, *Wind against the Mountain* (1996), pp. 160–61.
4 Fontein and Wu, *Unearthing China's Past* (1973), p. 230. Murray, "Hangzhou Portraits" (1992), pp. 3–14; also Murray, *Ma Hezhi* (1993), pp. 12–14.
5 Fong and Watt, *Possessing the Past* (1996), p. 257.

life-size images of *Confucian Sages and Worthies*, a sequence of figures from Fu Xi, deep in early myth, through Yao 堯, Shun 舜, and Yu 禹 to the first Shang emperor, Tang 湯. The Zhou kings Wen 文 and Wu 武, and the Duke of Zhou 周公 followed. It ended with Confucius and four of his disciples. Only five of the paintings survive: *Fu Xi* (Pl. 29b), Yao, Yu, Tang, and King Wu — unfortunately not Confucius himself — are currently in Taipei's National Palace Museum. Again it was the emperor, this time Lizong, who inscribed tributes for each. The set was enshrined in the imperial temple. In 1241 the Lizong tributes were also sent to the Imperial University where they were converted into a set of stone engravings. Whatever later fears the literati might express, presumably intensified by the Mongol invasion, the official commitment to Confucianism was solidly based and one can assume Jiang Wanli's terse phrases must imply his devotion to it.

However, Confucianism was by no means a fixed concept. In writing, as he asserts "to provide the political context needed for understanding the ebb and flow of intellectual tides," James T. S. Liu offers a compelling analysis of the *Daotong*, calling it "the lineage of legitimate transition of the orthodoxy," later to be given by the Jesuits the title of Neo-Confucianism. This True Way, rooted in the Northern Song — although championed earlier by Han Yu in the Tang[6] — was to reach special clarity of expression and wide acceptance in the south through the writings of the great philosopher, Zhu Xi 朱熹 (1130–1200). With an eye toward Daoism and Buddhism, for Zhu Xi and his friends the essential flaw in early Confucianism was the lack of a universal, cosmological basis to interpret the classics. Nevertheless, adherents had their critics. *Daotong* was even officially banned as false (*weixue* 偽學) from 1195 to 1202 and proscribed in state examinations. Yet in a few decades, its fortunes changed. The True Way was to become the state orthodoxy, although partly through compromise. According to James Liu, in matters of governance its acceptance was limited to intellectual ideology — matters such as rites, examinations, and official pronouncements — not featured in direct decision-making actions — military, diplomatic, and financial.

While in Liu's account a date of 1240 is offered for this transformation, it is clear from Lizong's 1230 commission to Ma Lin for paintings of heroes exactly listed by Zhu Xi, works to be graced by the emperor's own encomiums, that acceptance was well under way at that time. It was a process to be sealed in 1241 when Lizong's tributes were sent to the Imperial University where they were converted into stone engravings.

A significant feature of True Way was its inward-directed philosophy. As popularity of the school spread through the south — Zhejiang, Jiangsu, Fujian, Hunan, and Sichuan — it led to memorial halls honoring early

[6] Winston Lo, *Yeh Shih* (1974), pp. 13–14.

Confucians with local ties. It sponsored local education in private and state supported institutions. But the core of this learning was centered on a teacher or good master rather than texts, abstractions of the written word, or the building of impressive libraries. It was person-dependent and inwardly focused. This personal transmission, master to pupil, most certainly paralleled Chan Buddhist practice. As such, however different the philosophical approach, one cannot escape the relation of Ma Yuan's *Confucius* to his portraits of Chan heroes:

> A true Confucian must examine himself inwardly and understand all things — the material world, social relations, and the cosmos — through investigation. This approach did not exclude statecraft but made it secondary.[7]

How then follow out what was "subtle and suggestive" to Zhou Mi, the commentator who lived through the last years of the dynasty? Given the background outlined here, necessary speculations have firmer foundations. Confucianism locked in self-cultivation assumes a stance of greater flexibility. Despite official acceptance, it could only marginally affect affairs of state. James Liu signals this in pointing to the emperor:

> Although in his rare appearances in court the emperor listened to lectures on Neo-Confucian teachings, he paid scant attention to them; for he was interested mostly in such un-Confucian indulgences as wine, women, and song. The state orthodoxy not withstanding, state affairs made no progress.[8]

Whether plucked from a larger project — the *Three Teachings*, or a sketch somehow related to Ma Lin's line of sages, or simply standing on its own — it is a deep sense of earliest antiquity that haunts the image that here bears a "Ma Yuan" signature. So far as I am able to discover it differs from any other known early representation of the sage. In the Confucian shrine at Qufu the rubbing of a Confucius of great gravity claiming to descend from the great Tang painter, Wu Daozi 吳道子 (ca. 710–ca. 760), carries respect and weight (Fig. 6.5).

But despite an active three-quarter pose, it appears to be a later version echoing the kind of direct imperial power we know best today in the well-known early *Thirteen Emperors* handscroll now in the Boston Museum. Ma Yuan's reduced simplicities carry a different message.

Ma Yuan's uniqueness is not unrelated to what can best be seen as a general quality of directness in Song representation, a quality through which

[7] James Liu, *China Turning Inward* (1988), p. 135.
[8] James Liu, *China Turning Inward* (1988), p. 149.

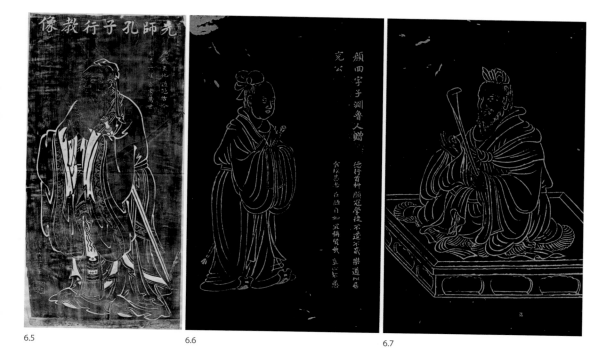

6.5

6.6

6.7

even sagely formalism shifts subtly toward a more physically acceptable likeness. This, for lack of a better word, might be described as "naturalism."

However filtered through a process of carving, copying, and reproduction in ink rubbings, the late Song seems clearly present in the images of *Confucius Instructing 72 Disciples* that preserve Gaozong's commission of 1157 preserved on stone in Hangzhou's Confucian Temple (Kong Miao 孔廟) (Pls. 30a and 30b; Figs. 6.6, 6.7). Here is a far more relaxed and expressive represention of the human figure. It begins with Confucius: position (on a raised dias), seated (disciples all standing), teaching (the active right hand), authority in debate (holding a *ruyi* 如意 staff). As a small touch of naturalism note how the open structure of the platform allows us to glimpse its continuation across the otherwise hidden back sides.

To the important presence of the staff must be added the unusual headdress here seen in the form of a lotus. Both staff and lotus are worthy of special attention. In a valuable study some years ago, Leroy Davidson defined the *ruyi* staff as a symbol of authority in debate or teaching originating in early Buddhist representation.[9] In turn, the lotus headdress, absent from other known images of Confucius, is a clear indication of Daoist representation as proven by its presence on votive images of the

Fig. 6.5 *Praising the Greatness of Ancient Master Confucius' Teaching*
Harvard College Library

Fig. 6.6 Li Gonglin, formerly attributed
Yan Hui
from engravings in the Confucius Temple, Hangzhou

Fig. 6.7 Li Gonglin, formerly attributed
Confucius
from engravings in the Confucius Temple, Hangzhou

9 Davidson, "The Origin" (1950), pp. 239–49.

deified Laozi.[10] Accepting a stylistic difference in a shift from Tang to Song, a seated Tang image of Laozi now in the Museum fur Ostasiatische Kunst in Cologne with its staff and lotus headdress offers a striking iconographic comparison (Fig. 6.8). By the time of the Tang statue (late seventh/early eighth century) the *ruyi* had found a ready place in Daoist imagery. What

Fig. 6.8 *Deified Laozi*
Museum fur Ostasiatische Kunst, Köln

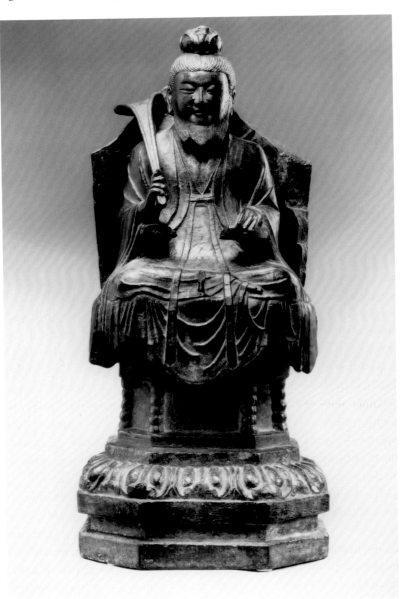

6.8

[10] Little, *Taoism* (2000), pp. 182 ff. For the special significance of the lotus cap I am indebted to Ellen Laing's personal communication.

is important for the Song image, however, is the recognition that a staff of Buddhist origin and a headdress connected to religious Daoism are both present. This cannot help but indicate a visual linking of the Three Teachings so important here in the mid-twelfth-century and extending in Hangzhou throughout Ma Yuan's career.

The style throughout carries unusual elements of freedom, and with that a claim that the ever-important Li Gonglin is somehow the master hand. There are linear touches that may be found in Li's work, but as a whole this is difficult to accept. Despite early recordings of an impresssive number of different paintings by this master there is no mention of this subject, and the earliest claim for Li's involvement appears to come from a Ming colophon dated to 1427.[11] The quality of representation, however, cannot be ignored. The lively linear treatment of so many sages gives to each a special aura. This begins with the complex, curving weave of robes that embrace Confucius himself. From such an active pattern of lines one cannot help but feel a special urgency, indeed an emotional power, that defines the teacher and his message. Despite a less imposing scale, this continues in the presentation of the disciples that follow.

In them is a comprehensive understanding of the human figure. This may be stressed, by choosing examples of posture from the long informal numerical sequence of seventy-two. Such a selection highlights the ordered completeness of possible view-points (Pl. 30b). I have arranged each in a progression beginning from a right-facing profile (upper left). Next is an opening stance of three-quarters, and then to a figure in full-face. Now for the back: First the shift to a three-quarters stance turned leftward, then a full back, followed by a further turn to a three-quarter back toward the right. Variation comes in a double portrait where two scholars are examining the rhythmic wave of a handscroll. Completion comes with a final scholar in profile, this time facing left — a closing parenthesis to answer the upper opposite-facing profile at the beginning. The totality of pose becomes, then, the basis for the insistent and skilled linear play that seals the vitality of each disciple and in a compelling sense echoes and expands the larger vitality of the teacher himself.

However, the challenge to traditional formalism with its rich variety of the linear mode is not without its own conventional manner. One is a central line in the back suggestive of a spine, a feature that has been traced to Li Gonglin (Fig. 6.9). Another has been defined as "flying lines over the shoulder" (*jianshang feiwen* 肩上飛文), lines that curve in separation from

[11] Murray, "The Hangzhou Portraits" (1992), p. 15. Throughout I have relied heavily on this carefully detailed study of these portraits and their circumstances.

neck or shoulder. They are present here in the image of Confucius (Fig. 6.7). A mannerism, exaggerated in these rubbings, is the prominence of the hat-strings that appear to frame the face, thereby suggesting a mask-like visage. When a standing disciple turns in the direction of Confucius there is the suggestion of a relationship not unlike Ma Yuan's later teacher-pupil confrontation for his Chan buddhist heroes, especially that of Xuefeng and Yunmen (Pl. 26b). This is clear at the beginning of the sequence when a favorite disciple, Yan Hui (顔回), faces him directly (Fig. 6.6). Continuing, however, is a far different sense of separation, each figure in turn claiming his own sense of individuality, able to move in continuous variation.

Fig. 6.9 Anonymous
Back-Turned Disciple
from stone engravings of *Confucius*
Instructing 72 Disciples
Confucian Temple, Hangzhou

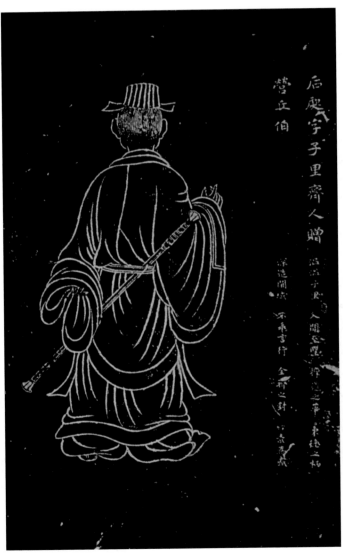

5.3

However one interprets these ideal portraits they cannot help but indicate the mind and hand of a skilled artist. A compelling suggestion points toward Ma Hezhi 馬和之 (act. mid to later twelfth century), a contemporary master of heroic figures anchored to the past.[12] However, Ma Hezhi's brush as it is now known is based on an active flaring linear mode far different from the tight, evenly controlled lines of the Hangzhou figures, and can only be supported on the hypothetical level of a different early style.[13]

More immediate in respectful naturalism is the small-scale portrait of Confucius found in a circular silk fan now in the Boston Museum. Very likely from the south in the late twelfth century, its landscape setting embraces the episode of Confucius at Mt. Tai meeting the seated recluse, Rong Qiqi 榮啟期 (Pl. 31 and Fig. 6.10). For Rong Qiqi one might point out the difference of representation between this version and his fifth-century ideal "portrait" illustrated above (Fig. 6.2). The duality in this fan is once again the teacher-pupil relation, the seated recluse by his special presence offering advice. It is worth repeating Rong Qiqi's statement of the personal contentment reflected in his isolated music: three worldly joys of a successful ninety-year life (however partially at variance with current Western ideals) are to be a human being, to be a man, and to enjoy longevity.[14] It is the immediate Song clarity of visual representation that is important — the selected limited lines of the *qin* player, an unpretentious profile bowed in isolated concentration on his music, and the active three-quarter stance of the formally respectful Confucius, who is more heavily robed while continuing a similar if more complex linear definition. Two lesser-scale

Fig. 6.10 Ma Yuan, formerly attributed *Confucius' Encounter with the Hermit Rong Qiqi* (detail) Museum of Fine Arts, Boston

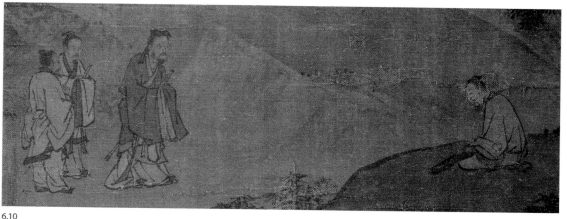

6.10

12 Fontein and Wu, *Unearthing* (1973), no. 120, p. 230.
13 Murray, *Ma Hezhi* (1993), p. 50. Here she also sums up possible relations to Li Gonglin.
14 Wu Tung, *Tales* (1997), pp. 156–57. The author notes a traditional attribution to Ma Yuan, not entirely impossible, but as he affirms, a broad link to the style of Li Tang.

disciple-attendants accompany the master, the major part of a traveling delegation that has emerged from an elegant chariot waiting patiently behind.

This anonymous inch-size Confucius differs, but by no means is completely removed, from Ma Yuan's version of the sage. There are broad parallels: the partially bearded face, the concealing expanded robes, heavy sleeves falling from horizontal forearms, the implied meeting of hands, elegant shoe-tips emerging, a figure immediately available, but by no means discarding sage-like modes.

With Ma Yuan's Confucius there may be other touches of detail that seem important to Song sensitivity. Thus the mid-eleventh-century portrait of ninety-year-old Wang Huan 王渙, now in the Freer Gallery of Art, one of the *Five Oldsters of Sui Yang* (*Sui Yang Wulao tu* 睢陽五老圖) brushed for a local shrine, shows a similar subtle emergence of finger from an otherwise hidden respectful gesture of joined hands (Fig. 6.11). Perhaps we are to think

Fig. 6.11 Unidentified artist
Five Oldsters of Sui Yang (detail)
Freer Gallery of Art, Smithsonian
Institution, Washington, D.C.

6.11

6.12

of the hidden depths of old age. The painting of all five nonagenarians, or versions of it, was well known among Song literati, including Zhu Xi.[15] The placement of figures in a hieratic configuration is particularly evident in a depiction of Su Shi in Qiao Zhongchang's 喬仲常 (act. early twelfth century) *Later Red Cliff Ode* (*Hou chibi fu tu* 後赤壁賦圖) of the twelfth century (Fig. 6.12), a scroll now in the Nelson-Atkins Gallery, Kansas City. Attention is drawn towards the poet, who is seated larger than life compared to his two flanking companions and whose top-knot differs markedly from that of his friends who have the more familiar black cloth covering.

Despite the natural setting, the group assumes the guise of a deliberate iconic trinity, with head coverings in this case apparently reinforcing the hierarchy. As Ma Yuan's Confucius embraces its own mythic implications, it does not escape its place within broader Song vision. Even the swollen cranium, more god-like than human, is remarkably close to the shape of Dongshan's "natural" head as he quietly receives the lesson of crossing calm waters (Pl. 26a and Fig. 5.5).

As to the time of execution — whether an original or a close copy — it is difficult not to accept a relation to Zhou Mi's account of Ma Yuan's *Three Teachings*. If that painting were executed under Lizong, it would place the current Beijing image toward the end of the artist's career. More likely, as Zhou Mi's account appears to indicate, by Lizong's time the *Three Teachings* was simply present in his court — in which case, for the later Confucian ascendancy, the tradition that either the painting or its hanging, or both, was eunuch-inspired must have held negative significance. A likely scenario

Fig. 6.12 Qiao Zhongchang
Illustration to the Second Prose Poem on the Red Cliff (detail)
The Nelson-Atkins Museum of Art

[15] Lawton, *Chinese Figure Painting* (1973), p. 168.

would place its creation under Ningzong when Empress Yang was such an important patron, a painting still valued under Lizong when as Dowager Empress, not dying until 1233, she still held considerable power. The request for Jiang Wanli's commentary suggests the later need for reappraisal, presumably when the True Way had gained imperial acceptance. Indeed, whatever Ma Yuan's original intention, the placing of Confucius beneath the other two leaders takes on the political aura of propaganda. How now to interpret "Our Master's" apparent inferiority when the court had accepted the True Way? Thus the subtlety of Jiang's encomium also lies in its accepting what the painting revealed while opening the door to a Confucian contrariness — the vital enactment of the rites (*zuoli*) in contrast to the aloof withdrawal of the other two leaders.

Having presented three images of Confucius that likely span the time from 1157 (late in Gaozong's rule) to 1224 (Lizong's ascendency), differences in respect to individuality must be clear. However all three are alike in their acceptance of a proximity to Daoism. It is time to turn directly there.

Daoism — Lü Dongbin

As Confucius leans toward a mythic realm, including suggestions of Daoism, all the more important to face directly that far more myth-steeped branch of Chinese thought. Although passed over earlier, hauntingly suggestive is the signed portrait of the Daoist immortal, *Lü Dongbin*, a painting published over thirty years ago (1979) as in the collection of the Chongqing Museum[16] (Pl. 32 and Fig. 6.13). As with the representation of Confucius, the figure stands alone on empty silk. Furthermore, as with Ma Yuan's Chan heroes, it is brushed in ink and light color on silk on a hanging scroll of closely similar dimensions (74.8 x 40.4 cm). The space above also presents a surface screen of calligraphy. Here it is not with the claim of an empress, but rather the signature of a contemporary known painter-official, Wang Jie 王介, who was active in the court of the Qingyuan era (1195–1200), exactly at the time when Empress Yang was coming into prominence. With a style name Yuanshi 元石 and sobriquet, Mo'an 默菴, he came from Jinhua in Zhejiang Province with apparent family connections to Wuyuan 婺源, currently in southern Anhui — doubtless more famous at the time as Zhu Xi's ancestral home. In official life he held the title of Grand Guardian in Palace Service

[16] *Yiyuan duoying*, no. 7 (Dec. 1979), p. 14. It is not, however, reproduced in *Zhongguo gudai shuhua tumu*, v. 17 (1997), which covers the Chongqing Museum holdings, an omission which, if the painting still exists, implies a rejection for lack of Ma Yuan authenticity.

(*Neiguan Taiwei* 內官太尉), suggesting close association with palace society. More important for this painting, however, is the claim that Wang Jie was a follower of Ma Yuan and Xia Gui in both landscapes and figures.[17]

During a steamy April Chongqing day in 1981 I was shown the painting through the kindness of the curator, Xu Wenbin 徐文彬. Here let me record my brief reactions:

> Thick and thin wet drapery lines with slight "natural" tremulous quality, some blunted pale nail-head strokes; fine lines for beard, face and eyebrows; facial features sensitively realized, line backed with wash, mouth line hidden by moustache; eyes exact with dotted pupils and lengthening eyelid crease; pattern of ear; two emerging dark ink tasseled belt cords (dotting to suggest texture); the head-cap also in dark lines, filled with grey; straw shoes; "flying" feeling (hat ribbon, three-quarters pose, curving lines especially proper right sleeve); angles, but softened by sensitive touch; all lines carefully selected; simple gown. It works beautifully, push and pull, holding back yet quietly forward, both stable and off balance. The background has been washed so that the figure emerges light. Seals of Ke Jiusi (1290–1343) in black, lower right — two modern seals above them; modern seal upper left.

Put this together and it becomes difficult to reject the skill of the painter and the possible significance of the scroll.

Turn next to other rare late Song and Yuan images of Lü Dongbin. First to the Song. One shows the same figure depicted on a well-known anonymous rounded silk fan in the collection of the Boston Museum of Fine Arts (Fig. 6.14). It is more consciously active than the Chongqing image, being given a brief setting of waves, with robe and ribbons openly flying, to introduce the specific narrative of a miraculous crossing of Dongting Lake. It fits the final lines of a poem attributed to Lü himself:

Three times I entered Yueyang no one aware	三入岳陽人不識
Singing a song I flew across Dongting Lake[18]	郎吟飛過洞庭湖

17 Xia Wenyan, *Tuhui baojian* (1365), p. 87. Yu Jianhua, *Zhongguo meishujia* (1981), p. 61. For the official title see Hucker, *Dictionary* (1985), no. 4203, p. 347. *Neiguan* is also a term applied to eunuchs. For Zhu Xi's connection with Wuyuan see Feng Yulan, *History* II (1953), p. 533.

18 Wu Tung, *Tales* (1997), no. 99, pp. 204–5. For the poem see Baldrian-Hussein, "Lü Tung-pin" (1986), p. 158.

In essence, however, the two show different artists presenting the same basic figure (Figs. 6.13, 6.14): the cloth cap, drapery in movement, the triangular collar gracing a curved neck-line, the same long sideburns and swinging beard, the exaggerated slant of eyes and eyebrows. The body is completely robed with dangling lines of a waist-cord or ribbons. There is also the effortless detachment of hidden hands — one with arms folded, the other's hanging down. Similar fiber shoe-tips peek from a robe-concealing hem.

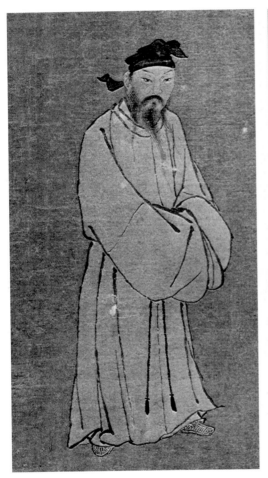

6.13

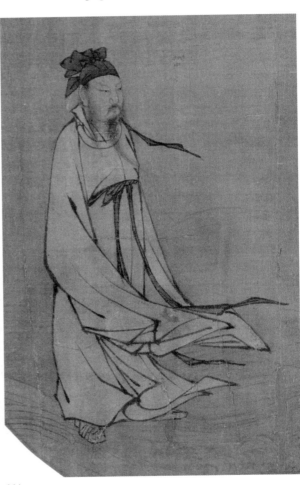

6.14

Fig. 6.13 Unidentified artist
Lü Dongbin (detail)
Three Gorges Museum, Chongqing

Fig. 6.14 Unidentified artist
The Daoist Immortal Lü Dongbin Crossing Lake Dongting (detail)
Museum of Fine Arts, Boston

Yueyang comes into direct view as the setting for a third image on another thirteenth-century rounded silk fan, now in New York's Metropolitan Museum (Pl. 33). Tiny in scale, indeed almost invisible on first glance, the sage is nevertheless the focus of attention (Fig. 6.15). The image-style is an essential repeat of the Boston representation. The whole expands to a narrative filled with surrounding detail, but it is the same Lü Dongbin, now airborne appearing high above an amazed crowd gathered in and beside what

Fig. 6.15 Unidentified artist
*The Immortal Lü Dongbin Appearing
over the Yueyang Pavilion* (detail)
The Metropolitan Museum of Art

Fig. 6.16 Unidentified artist
Lü Dongbin
Collection unknown

Fig. 6.17 Unidentified artist
The Taoist Immortal Lü Dongbin
The Nelson-Atkins Museum of Art

in a partial banner inscription is claimed to be a version of — or perhaps setting for — the exact pavilion. The sweep of the banner below amplifies the sweep of the robe above. It is the immediate availability of a simply robed human being that would seem to be a feature of this late Song representation. Yuan images shift the emphasis. In one direction they may carry with them a more fixed iconic rigidity as in a printed text datable to 1326 where movement is stilled in rigid lines and the heavy gathering of held sleeves (Fig. 6.16). There is also in the Yuan a contrary movement turning Song restraint into a more aggressive image. This is true of a large and impressive hanging scroll now in the Nelson-Atkins Museum in Kansas City (Fig. 6.17). It offers

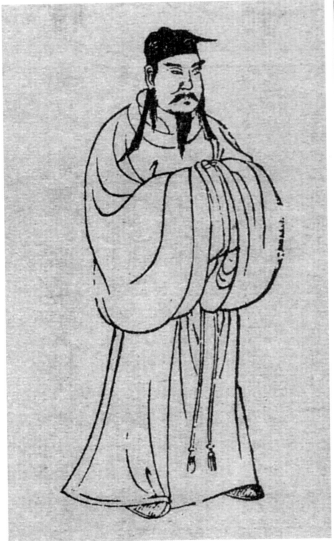

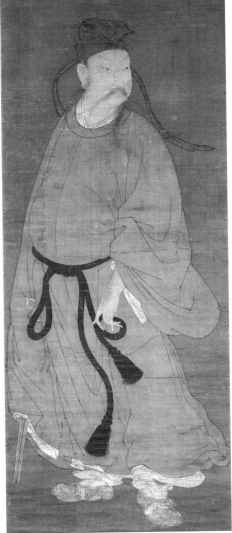

6.16

6.17

an open, martial contraposto iconography with hand and feet exposed, the hand with textured hair and long fingernails. He has both a sword (for which he was famous) and a defining gourd. Long hat-bands fly as do the loops and tassels of his black waist cord.[19]

In his detailed account of the Yuan Palace of Eternal Joy (Yongle gong 永樂宮), Paul Katz has shown the difference, within a stiff linear mold, between a strict iconic Lü Dongbin caught in repetitive narrative illustration and one partially released to a freer popular taste. The latter is found at the same temple in a non-canonical episode, *The Eight Immortals Crossing the Ocean* (Fig. 6.18). Here, while still retaining a substantial form, the artist appears to

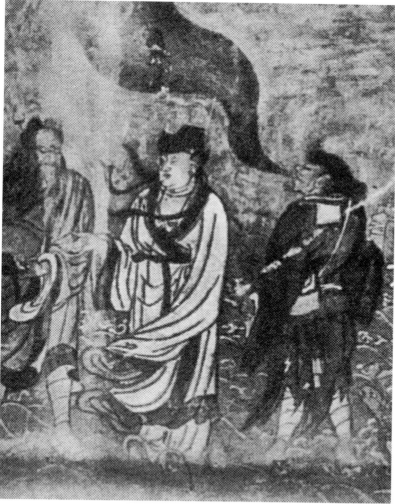

Fig. 6.18 Unidentified artist *Lü Dongbin* (section from the Palace of Eternal Joy (Yongle gong)) Ruicheng

6.18

[19] For an account of Lü Dongbin with this image as well as those in Boston and the Metropolitan see Little, *Taoism* (2000), pp. 324–27.

reach for the earlier sense of a directly independent figure. While there is a stubborn strength in this Lü Dongbin, the subtle airiness of the late Song imagery is missing.[20]

Returning then to the Song images, types of brush-touch with their impact on style have recognizable importance. The Boston painting converts long lines of nail-head rat-tail brush strokes into flat, crisply swinging movement, relating a precise windblown progress made visibly magical by the lines of water. This obvious exploitation of an established pictorial style has generally led to placing the painting late in the Southern Song tradition as the thirteenth century extended into the Yuan. Such a date appears confirmed by the Metropolitan painting. The white retaining wall may have the swiftly brushed cyclical characters, *dingsi* 丁巳, which correspond to the year 1257.[21]

The Chongqing scroll with its tiny "Ma Yuan" in the lower left corner reflects the hand of a far different artist. Like Ma Yuan's *Confucius*, the person is without setting and action is similarly contained, a restraint also apparent in Ma Yuan's Chan heroes. It is a blunter, more understated, and consequently more contemplative image in which subtleties matter. Now lines have a unique, ephemeral, moist quality, vibrantly contained rather than outwardly expressive. While the swing of the body is to our right, the head turns back toward us, almost full face. Movement is stilled. In comparison with the Boston painting the left shoe tip is more exactly turned away from the direction of the right one. The fuller face is more balanced in the centering slant of eyebrow and eye. That and the ever so slightly heavier lids draw the person inward. The pupils are not gazing at us. There is a special presence as opposed to passing vision. Yet while the brevities, the selected lines, the thoughtful understatement appear to parallel Ma Yuan's ideals as an artist, there is nothing in his surviving work that surrenders so much of his blunt, dark ink certainty to this kind of consistently light and watery presentation. At least on present knowledge, it cannot be accepted as by his own hand.

Turn now to Wang Jie's inscription. It is integral to the full composition and reveals a series of puzzling couplets brushed with an apparently easy spontaneous hand:

The iron ox plows the earth planting gold coins	鐵牛耕地種金錢
The boy stone-carver strings them together.	刻石兒童把貫穿

[20] Katz, *Images* (1999); for dated 1326 image, p. 82; for *Eight Immortals*, pp. 188–89.
[21] Little, *Taoism* (2000).

Within a single millet grain a world is hidden	一粒粟中藏世界
In a two-pint alchemical vessel mountains and rivers boil.	二升鐺內煮山川
On white whiskered Laozi the eyebrows drag the ground	白鬚老子眉垂地
A blue-eyed barbarian's hand points to heaven.	碧眼胡兒手指天
If asked about mysterious encounters in the world	若問世間玄會事
This mystery after mystery is even more no mystery	此玄玄後更無玄

Again the poetry-painting link enhances understanding. In a study of Lü Dongbin in literature, Farzeen Baldrian-Hussein has highlighted Lü's ubiquitous presence as both a calligrapher and poet, including the claim of Lü's direct relations to Song leaders such as Wang Anshi 王安石 (1021–1086) and Huizong. In a Song citation:

> The poems of the immortal Lü circulated widely among the people . . . the vocabulary of his verse is generally strange (and abstruse). Over a hundred verses are in circulation in the world and are much chanted by the people.

仙翁詩多傳人間 . . . 大抵皆詞句奇怪 . 世所傳百餘首 . 人多誦之。

It is the second couplet of Wang Jie's inscription that the author has discovered in a brief recorded poem, a poem popular enough to have reached an anecdote alleging Lü's conversion to Chan Buddhism. Indeed, as followed through, these poem couplets carry the quality of the Chan *gongan* (*kōan*) in the context of master-pupil relation. Consider this additional poem, an example of alchemical verse:

> The water-drinking sea-tortoise passes unnoticed,
> The mountain talisman burner disliked by the demons,
> Within a single millet grain a world is hidden,
> In a two-pint alchemical vessel mountains and rivers boil.[22]

飲海龜兒人不識 . 燒丹符子鬼難看 . 一粒粟中藏世界 . 二升鐺裡煮山川。

Yet another mystery is added in the first two lines, lines however that suggest a release from danger embracing both water and mountain — in other words, the whole landscape. The presence of the last two lines in Wang Jie's poem tells us that Wang Jie may be plucking couplets from various sources.

[22] Baldrian-Hussein, "Lü Tung-pin" (1986), pp. 137–38, for both citations. Translations slightly altered. The last is repeated in Little, *Taoism* (2000), p. 324.

The last couplet receives an explanation — if it can be called that — from a mid-thirteenth-century text where it is part of a confrontational lesson with the Chan monk, Huiji Chanshi 誨機禪師, at Huanglongshan 黃龍山 (Yellow Dragon Mountain) in what is now Wuchang in Hubei. The traveling Lü had just been to Huashan where he had learned the skills of alchemy (*jindan* 金丹) and the sword (*jianfa* 劍法) from his master, Zhongli Quan 鐘離權. The year was 904. It is again the classic teachings of Chan that triumph. Lü resolutely asked for an explanation of the couplet on the millet grain and alchemical vessel:

Chanshi: To preserve corpses and the spirits.	師曰、守屍鬼。
Lü: Why then do I have a pill of immortality in my bag?	洞賓曰，爭奈囊中有不死丹。
Chanshi: Even after 80,000 kalpas, one will eventually perish.	師曰，饒經八萬劫終是落空亡。

The displeased Lü then turned to his new-found sword skills.
賓不服。夜飛劍以脅之。

But the monk, with prior knowledge, seated as a temple superior, covers his head with a ceremonial robe. The sword whirls around and, as he points his finger, falls to the ground. Lü apologizes.
師已前知，以法衣蒙頭坐方丈
劍遶數匝。師手指之，即墮地。賓前謝過。

Chanshi: Let alone the problem of the content of an alchemical vessel. How can a grain of millet contain the whole world?	師詰之曰，半升鐺內即不問 如何是一粒粟中藏世界。
Lü [awakening to the truth] composed a gāthā:	賓忽有省，乃述 偈以為謝曰。
From the moment of encountering Yellow Dragon	自從一見黃龍後
The realization of all before: wrong-mindedness.[23]	始覺從前錯用心

The pattern of confrontation, misunderstanding, rejection, and final acceptance clearly follows that of the Yaoshan–Li Ao episode painted so exactly by Ma Gongxian. Again one cannot escape the commonality of

[23] Baldrian-Hussein, "Lü Tung-pin," p. 148. The text, *Fozu tongj*, is in T. 49 (no. 2035), *juan* 42, p. 390b. In the couplet "two-pint" is changed to "half-pint." The missing text from which the episode is copied is given as *Xianyuan yishi*.

the Three Teachings as they focus on the person and consequent personal enlightenment which, in the visual arts, opens the road to portraiture.

Leaving to others more qualified to excavate additional couplets, should they exist, to further illuminate Lü's poetry, contemplate directly what else Wang Jie has left us. In the first line consider "iron ox." While not an uncommon expression in early texts, this episode remains hidden. Iron, however, was in Daoism an important metal to ward off evil. The twelfth-century poet, Wang Shipeng 王十朋 (1112–1171) has the lines:

| Instruments of iron before Yueyang Pavilion | 岳陽樓前鐵為械 |
| Used by ancients to cut off the menace of *jiao* and *li* dragons.[24] | 古人欲斷蛟螭害 |

The "boy stone carver" may have significance in that Lü's poems were often preserved on stone tablets. In addition to the above confrontation, certainly the notion that a single grain or a small vessel can contain the whole world may be paralleled with the belief of the universe contained in a double gourd ("two-pint"?). The reference next to Laozi brings a more familiar focus: first to his venerable, if drooping age and implied disappearance, and then to a renewal from where he vanished. The blue-eyed barbarian is a general reference to a foreigner from the northwest. Yet here the implication is more specific — a fresh person/image, pointing toward transcendent immortality — may well refer to a new Laozi image that legend, as will be later explained, was created after Laozi's disappearance to the west. Again, might the new image also embrace Bodhidharma?

Wang Jie's final couplet, which as the others may come from Lü himself, plucks the idea of "mystery upon mystery" (*xuan xuan* 玄玄) directly from the beginning of Laozi's *Classic of the Way and Its Power* (*Daode jing* 道德經).[25] The poem ends "even more no mystery," followed by a space before Wang Jie's "respectfully" lowered signature. Could it not be that the inscription's silent withdrawal implies an open door to the image below, that mystery fades because of the clear inescapable presence of the sage himself? More broadly, however, "no mystery" cannot help but suggest that mysteries are only mysteries to the unenlightened. The whole world is full of them. It is the communality of the miraculous that is Lü's true message. In this sense it is likewise Ma Yuan's acceptance of the physical world, selected and captured by the subtleties of his brush, that lies at the heart of his painting.

Turning again to the image, it is claimed that portraits and statues of Lü were common throughout the Northern Song. Originally an unkempt ink

[24] Baldrian-Hussein, "Lü Tung-pin," p. 143.
[25] Feng Yulan, *Chinese Philosophy* I (1937), p. 178.

seller, bearded, wide-eyed, and disheveled, refinements came as early as the tenth century from the Southern Tang emperor, Li Yu, the historical time and place already related to Fayan and the painter Dong Yuan. The emperor ordered a painting made from an image transmitted by Lü himself. Now, we are told of it, there was true divinity, serenity, elegance, and purity.[26] It is certainly this refinement that is echoed in the image below Wang Jie's calligraphy. As subject and format it can be seen as a Daoist equivalent of Ma's late ninth- and tenth-century Chan heroes.

As to the painter's style, lightness or moistness of touch in its realization is hardly foreign to the late Song. It is found in a great landscape handscroll, the *Xiao and Xiang as in a Dream* (*Xiao Xiang woyou tu* 瀟湘臥遊圖, Tokyo National Museum), datable no later than 1170. In the thirteenth-century figure style, for example, it is a touch used for an alternate representation of the meeting between Yaoshan and Li Ao, a painting now in New York's Metropolitan Museum. As a recognized stylistic mode it appears to have begun in the twelfth century, acquiring in extreme examples the term "ghost" or "apparition" painting.[27]

While Wang Jie only takes credit for his writing, in a similar fashion, Empress Yang's calligraphy never mentions a painter. The couplets are signed: "Wang Jie, respectfully written," the given name in modest miniature, a late Song fashion. But "writing" with the brush was not limited to the Chinese character, especially when mentioning a light sketch. Although no works by Wang Jie appear to have survived, as noted above, he is a recorded Southern Song personality, established in the court, whose painting style followed Ma Yuan. Whoever the artist may be, the image parallels Ma Yuan's other selected religious images in that Lü Dongbin was not an imaginary disembodied sage. Whatever the "mysteries" may have been in the hagiography that surrounded him, there is at least the claim that he was a specific historical figure living in the late eighth and ninth centuries. This would make him an older contemporary of Dongshan. He was said to have passed the *jinshi* examinations of 827 and held an official post before being converted into the "way of immortals."[28]

With the mention of a "blue-eyed barbarian" in one of Wang Jie's couplets, thoughts of the Western sage, Bodhidharma, need not be entirely discarded. While Bodhidharma's arrival in China appears to have no certain connection

[26] Baldrian-Hussein, "Lü Tung-pin," p. 154. The source is Chen Shidao, *Houshan tanzong, juan* 3, pp. 2b–3a (Baoyan tang edition); also Katz, *Images of the Immortal* (1999), p. 58.

[27] For listed reproductions see Cahill, *Index* (1980), pp. 202 and 227. The Metropolitan painting (earlier at Princeton) is illustrated and discussed in Fong, *Beyond Representation* (1992), pp. 352–53 and note 38, Shimada, "Moryo-ga."

[28] Katz, *Images of the Immortals* (1999), p. 79.

with this Western description, a fresh appearance on the late Song scene reinforces the importance of rediscovering the ideal historical sage as a recognized individual and hence the need for a portrait. Its significance in Ma Yuan's time indicates, broadly speaking, a late Song phenomenon. It is therefore not surprising to find the parallel renewed image of Bodhidharma. This has been carefully explored by Charles Lachman with his focus on a reinvented Bodhidharma crossing the Yangtze on a reed, in his phrase, "The Rushleaf Bodhidharma." Although there are earlier increasing mentions of Bodhidharma, an essential textual biography appears delayed to the late eighth century. Here and in succeeding texts as late as the eleventh century there is no mention of this dramatic feat. There is similar neglect when early images are mentioned. Rather than river crossing, the focus is on the orthodoxy of transmission, as in a ninth-century text from Dunhuang (ca. 830):

> In this corridor they intended to present paintings of stories from *Lankāvātārā Sutra* together with paintings of the five eminent patriarchs transmitting the robe and the *dharma*.[29]

> 於此廊下，供養欲畫楞伽變，并畫五祖大師傳授衣法。

This subject was reinforced in Huizong's time. His *Xuanhe Catalog of Paintings* (*Xuanhe huapu*) lists such a painting attributed to Chen Hong 陳閎 (act. 713–742, d. after 756), a figure painter of the eighth century: *Portraits of Six Patriarchal Chan Masters* (*Liu zu chanshi xiang* 六祖禪師像). The style may well have been close to that — linear and richly colored — in a surviving handscroll, *Eight Noble Officials* (*Bagong tu* 八公圖), attributed to him now in the Nelson-Atkins Museum in Kansas City.[30] The same text lists another version by Li Gonglin: *Patriarchs Transmitting the Law and Receiving the Robe* (*Zushi chuanfa shouyitu* 祖師傳法授衣圖).[31] In contrast, actual surviving painted images of this "transmission Bodhidharma" are not found before the mid-twelfth century.[32] The most complete and currently best known among them is in a long handscroll of *Buddhist Images from the State of Dali* (*Dali guo fanxiang tu* 大理國梵像圖), datable to 1173–1176 by Zhang Shengwen 張勝溫 (fl. 1163–1189). It is now in Taipei's National Palace

[29] Compare with an alternate valid translation in Yampolsky, *The Platform Sutra* (1967), pp. 128–29.

[30] *Xuanhe huapu* (1964), ch. 5, p. 109. Wai-Kam Ho, *Eight Dynasties* (1980), no. 5, pp. 6–8.

[31] *Xuanhe huapu*, ch. 7, p. 133.

[32] Charles Lachman's claim of an eleventh-century image by citing a fourteenth-century stele rubbing (1308) with an eleventh-century emperor's inscription is not convincing. The text does not mention the river-crossing but rather the nine-year cliff-facing episode. Importantly the stele is essentially archaistic, a construct not truly reflecting that earlier period. Lachman, "Why Did the Patriarch Cross the River?" (1993), p. 256.

Fig. 6.19 Zhang Shengwen
*Buddhist Images from the State of Dali:
Transmission Bodhidharma* (section)
National Palace Museum, Taiwan,
Republic of China

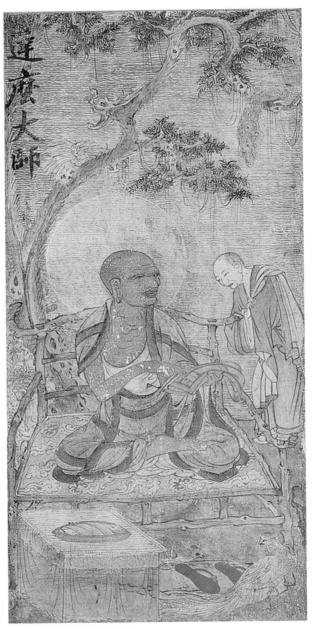

6.19

Museum (Fig. 6.19). Here the sage is a monk who is presented in the guise of a luohan, an image with devotee that bears a striking general resemblance to an image of such a luohan and small-scale devotee on the south wall of Dunhuang cave 97 (Fig. 6.20). The latter dates from the Five Dynasties period (907–960), then under the influence of the Western Xia (Xixia 西夏). Now the far more sophisticated twelfth-century image replaces the earlier rock

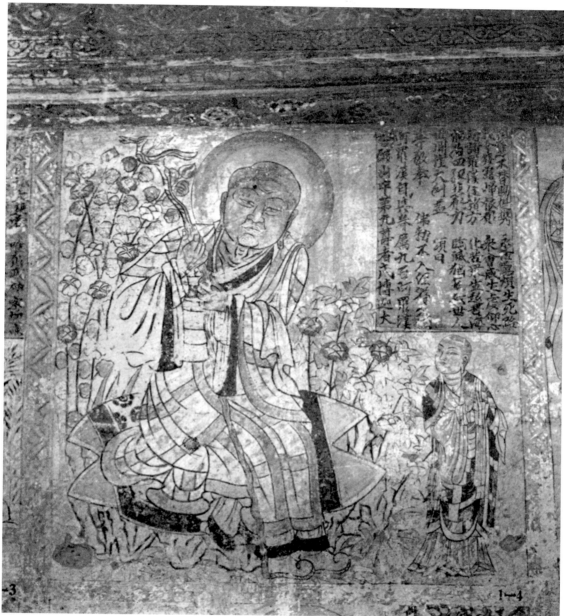

6.20

and flower setting with a raised chair of authority beneath an arching tree. Dark-skinned, his prominent features face three-quarters right. As with the earlier luohan a halo, now gold-rimmed, sanctifies his presence.[33] "Blue-

Fig. 6.20 Unidentified artist
Luohan and Devotee
Dunhuang, Cave 97

[33] Generally for the above analysis see Lachman, "Why Did the Patriarch Cross the River" (1993), p. 246 ff.

eyed," perhaps. As Basil Gray suggested of the Dunhuang painting: "The deep eyes look out from heavy brows with great intensity."[34]

As the twelfth century progressed, turned to the thirteenth and went beyond, the by now familiar image of a fierce and sometimes cowled individual took hold, an image for which the Rushleaf Bodhidharma assumes an important place (Fig. 6.21). What is especially important about his fresh appearance is the recognition of a Chan portrait change defining a move from the orthodoxy of transmission to an independent expression of individuality. This shift to the person, Lachman maintains, corresponds to a time when "the Discourse Records" (*Yulu* 語錄) of individual masters replaced the transmission histories as the dominant literary genre. While mention is made of the parallel image of Sakyamuni, the thesis can well be applied to late Song portraiture in general, including Lü Dongbin, an imagery that embraces a creative approach to individual ideal heroes of the historical past whether, as has been discussed, by Liang Kai, Ma Yuan, Ma Lin, or Ma Gongxian. In a word, we are shown new conceptions of personal presence. It is a Song immediacy, however, which also may be reinforced with suggestions of deep antiquity. Thus Liang Kai's *Sakyamuni* (Pl. 4b) retains aspects of the earliest authentic Buddha image, while Ma Yuan's *Confucius* (Pl. 29a) and Ma Lin's *Fu Xi* (Pl. 29b) relate the directness of Song presence to notions of a mythic origin. In this connection, Lachman has discovered that while his "Rushleaf Bodhidharma" is absent from early Buddhist texts, the idea of such water crossing may go back to the Confucian *Book of Poetry* in the *Odes of Wei* section:

Who says the river is wide?	誰謂河廣
a reed to cross it	一葦杭之
Who says Song is far?	誰謂宋遠
on tiptoe I see it.	跂予望之
Who says the river is wide?	誰謂河廣
it won't take a boat	曾不容刀
Who says Song is far?	誰謂宋遠
it won't take a morning.	曾不崇朝

In the moving simplicities of the poem the river is the Yellow River, not the Yangtze, but still the direction is from the north to the south — Wei is in the north, Song to the south. The line, "a reed to cross it," is exactly appropriate for Bodhidharma's passage. Need I remind that in selected "portraits" of egret, duck, and flower associated with Ma Yuan the same early classic has enhanced understanding more than once. If one wishes to take it a bit

[34] Gray, *Tun-huang* (1959), p. 78 and Pl. 70. For a color reproduction see *Dunhuang Mogao ku* (1987), v. 5, Pl. 149, and brief commentary, pp. 264–65.

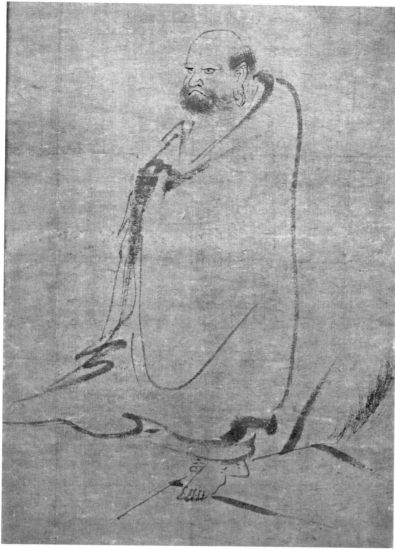

6.21

further, the immediacy of reviving a lover's meeting centuries ago extends to the close presence and promise of a freshly individual Bodhidharma.

Can we not speculate a similar renewal for Lü Dongbin in this surviving scroll, including its unusual inscription? Removed from an extended narrative, a seemingly unobtrusive presence is all the more that of an individual. Can it not also be suggested that it may be the work of Wang Jie himself, a portrait "copy" that is both an echo of and an explanation for the skill of his teacher? If the Ke Jiusi seals are accepted, it should at any rate not be later than Ke's death in 1343. But in iconography and style the mode appears to reflect the Song rather than the Yuan.

Dragon Rider (Laozi and Yin Xi)

More certain in Ma Yuan's treatment of idealized Daoist portraiture is a hitherto admired but until recently little studied painting in Taiwan's Palace Museum that has been given the title of *Dragon Rider — Chenglong tu* 乘龍圖 (Pl. 34). The format is that of a modest hanging scroll (108.1 x 52.6 cm) that falls within the dimensions of the idealized portraits already discussed. It presents, as have the scrolls of Chan subjects, a dualistic image — two figures in limited surroundings that are now elevated to a supernatural level. In style it reveals significant attributes of Ma Yuan authenticity, including a hopeful signature. The shift here is to a brooding space from which, again in its lower half, emerges a taut swiftly moving vision. As though from another planet, an ancient being mounted on a cloud-riding three-clawed dragon descends toward us with compelling immediacy. Below, and to the right, at a discreet angled distance and in contrasting profile, is a no less strongly brushed miniature attendant, an alien disproportioned dwarf whose flying scarves, heavy drapery, and swift movement echo in lesser scale the shapes of the grizzled dragon-rider. Besides a staff with loosely swinging gourd, he holds in his left arm a book or sutra case comparable to the rectangular sutra shape held by Yaoshan in his meeting with Li Ao (Pl. 28).

Ma Yuan, a master in the use of close space, creates here an ambient which, as so often in the Southern Song, is seldom empty and continues thereby to be the author of commanding physical definition. Atmospheric breath gathers and emerges in a forward thrust of powerful presence, a moment of concentration within a small area of the painting. Wash and line move from muted suggestion to jet black certainty. This tonality is linked to appearance in both shape and careful placement. The breath that pervades the whole fuses to become its own conscious complementary statement of form in subtle shapes of cloud, mist, and light. Current careful mounting screens what might have been lost from original tightness through worn, broken, and repaired areas of silk, and certainly some fading color, but the logic is not broken. In upper regions a diagonal shaft of light foretells the figural diagonals below: an ink-wash platform fronts curling clouds, offers the clawing twisting dragon, its contraposto rider and the angle of glance toward a swiftly crossing figure.

What gives the painting unique force, however, is the degree to which Ma Yuan is concerned with this positively defined vision, the sky-born presence coming directly toward us (Fig. 6.22). The dragon depiction parallels, but in more focused arrival, the clawing emerging forms in Chen Rong's 陳容 (act. first half of the thirteenth century) famous *Nine Dragons* (*Jiu long tu* 九龍圖) of 1244 (Fig. 6.23 and Pl. 24). The forward parts of Ma's dragon, in a kind of intuitive foreshortening, appear enlarged — its rough head with

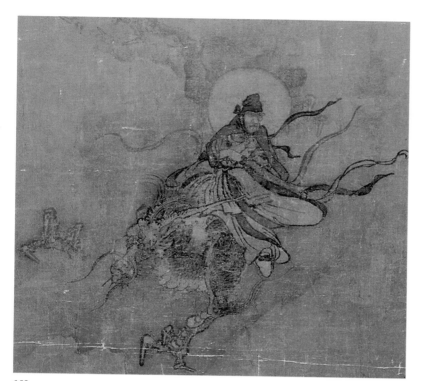

Fig. 6.22 Ma Yuan
The Dragon Rider: Laozi and Yin Xi
(detail)
National Palace Museum, Taiwan,
Republic of China

Fig. 6.23 Chen Rong
Nine Dragons (detail)
Museum of Fine Arts, Boston

eyes matching the circular intensity of those of the sage, its extended snout and enframing whiskers, a long bristling shape, a large ear. In the increasing scale of the front claws the dark ink of the proper left leg is the closest. The total is a vision, however, in its embrace of dual figural confrontation, that is not simple, but complex. The crusty large-scale rider offers a powerfully seated triangular pose which then turns contrary to the leftward path of his vehicle, toward the lower scroll-edge and the miniature attendant who in turn, while glancing upward, faces left and rushes inward. Moving with less complexity, the striding tousle-headed dwarf is stamped as a profile. His is, however, a sympathetically active pose. The vision is never static.

In this total exercise in concealment and forceful emergence robes swirl and scarves fly, a primary device, as Susan Nelson has recently suggested of this scroll, for defining divinity.[35] Shadowy curves of cloud shapes mute angled intensities, and there is consistent variant movement, as in the loop of the dragon's tail or, again, the swing of enfolding drapery. Throughout, a mastery of touch ranges from thin wisps of line to those of rough strength, deep black or muted greys. Nor should one neglect the details of portraiture: high waistline, dark cape and hood, billowing outer garments, prominent foot (where now is a small semi-circle of damage and added new silk — was there once a stirrup?) and, miniature as it is, the precision of the face: beard, moustache, heavy eyebrows, eye sockets, large nose, eyes with centered pupil dots. In a physical sense this visionary figure and his companion are "real."

So far identification of the subject remains elusive. It is usually considered to be Daoist, and apparently rightly so in its transfer of humanity to a more cosmic realm. But without certainties and at a time, as has been shown, when ideas linking the Three Teachings were in vogue it is well to take a broader view. Imagery need not be confined to a single creed.

Initially there would appear to be possibilities within the Buddhist canon. The supernatural exploits of Mulian 目連 (Maudgalyayana), one of Buddha's ten early disciples, and his dragon nature come readily to mind. He had the ability to rise to the Heaven of the Thirty-Three Gods to capture a true image of the Buddha or with equal ease to descend to the lowest of Buddhist hells to rescue his mother. This latter became a popular legend recorded in several "transformation texts" (*bianwen* 變文), defined by Fan Jinshi 樊錦詩 and Mei Lin 梅林 as "a type of narrative literature in prose and meter adopted to relate Buddhist sutras and stories to the laity." The tradition goes back to the mid-Tang and early pictorial illustrations are found from the Five Dynasties (907–960) not far from Dunhuang in the Yulin Grottoes of Anxi. The practice continued much later and can

[35] Nelson, "Tao Yuanming's Sashes" (1999), p. 11.

be found in a Japanese version of the text reflecting a thirteenth-century (1251) original. In this latter the form follows an earlier sutra layout that uses the upper half of the format for illustration, with the verbal account written below. Similarly in the fourteenth century, the Japanese priest Tenan Kaigi 天庵懷義, who died in 1361, catches the sage in the brevity of a poem-line brushed on a bamboo scroll by Ue Gukei 友慧愚溪, a painter strongly influenced by China: "Out surges the dragon of Mulian" . . . 出日連龍. The latter leaves the figural image to the imagination, but both the Yulin wall painting and the Japanese handscroll have tamed the dragon nature of Mulian to simply record a standard Buddhist monk (Fig. 6.24).[36]

Fig. 6.24 Unidentified artist
Mulian as a Priest Finding His Father in the Heavens
Yulin Grottoes, Gansu Province

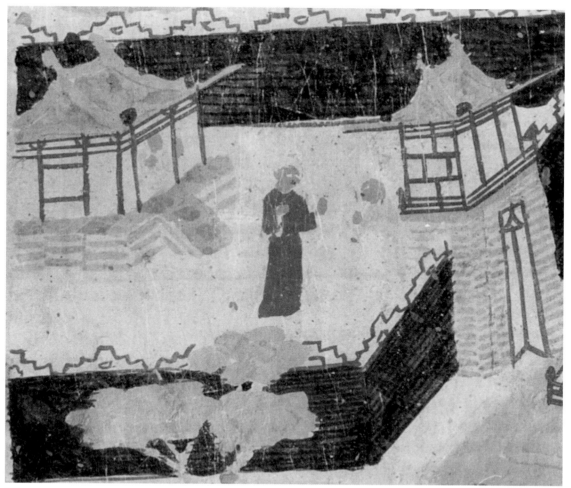

6.24

[36] See respectively, Fan and Lin, "An Interpretation" (1996), pp. 70–75. Miya, *Bijutsu Kenkyū* (1968), no. 255, pp. 155–98. Edwards, "Ue Gukei" (1968), p. 172. Shimada, *Zenrin gasan* (1987), p. 429.

Nor is the dragon absent from those often mysterious non-Chinese sages with lesser attendants in paintings depicting distantly arrived carriers of the Buddhist Law, the luohan 羅漢 (arhat, Jap. rakan), so prominent in the Song Buddhist religious scene. For them, too, the dragon might be a symbol of vigorous complementary power. However, late Song representations, especially those painted in the port city of Ningbo attributed to Ma Yuan's contemporary, Lu Xinzhong 陸信中 (fl. 1195–1277), have also markedly turned the physical presence of such foreign sages into gentler, more "civilized" types.[37] In contrast an earlier tradition maintained their craggy foreign nature. This can be most exactly connected to what remains of the great Five Dynasties painter, Guanxiu 貫休 (832–912, Fig. 6.25). It is this latter figural tradition that in part lingers within the artistry of Ma Yuan's famous contemporary in Hangzhou, Liu Songnian 劉松年, revealed in three hanging scrolls now in the Taiwan National Palace Museum (Fig. 6.26).

Such types can also be found on occasion among the extended numbers of *Five Hundred Luohan* 五百羅漢 by Zhou Jichang 周季常 and Lin Tinggui

Fig. 6.25 Guanxiu, attributed
Sixteen Arhats: Luohan no. 4
The Museum of the Imperial Collections, Sannomaru Shozokan

Fig. 6.26 Liu Songnian
Luohan Leaning against a Tree
National Palace Museum, Taiwan, Republic of China

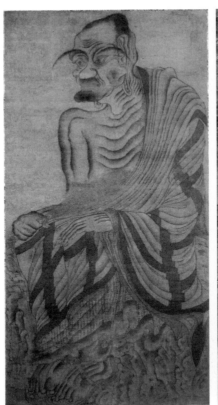

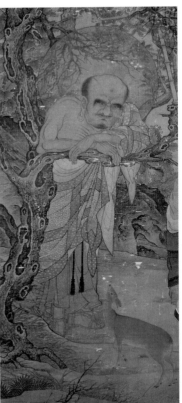

6.25

6.26

[37] For the type see Wu Tung, *Tales* (1997), pp. 174–77.

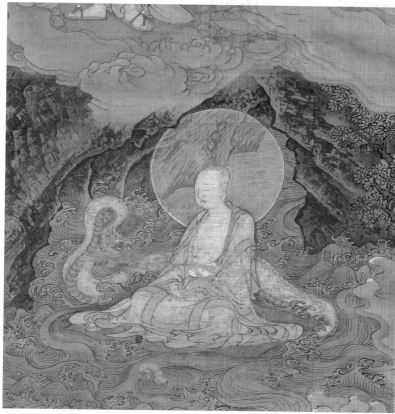

6.27

Fig. 6.27
Zhou Jichang
Lohan in Meditation Attended by a Serpent
Museum of Fine Arts, Boston

林庭珪 in the late twelfth century, now in Kyoto's Daitokuji, the Boston Museum, and the Freer Gallery. Ma Yuan is, however, far more forceful in recapturing this mythic sage-type of antiquity. If Guanxiu, born twenty-five years after Dongshan, is an acceptable source, once again there is a return to that late post-Tang period already significant in Ma Yuan's work. Indeed Guanxiu's images are said to have come from his dreams, an idea not inappropriate for Ma Yuan's image. Still, to my knowledge, there is no exact facial, or otherwise, Luohan model, and it is generally the taming or civilizing of the foreign difference that marks the late twelfth and thirteenth centuries in the genre. This may be true even when the dragon type is present as may be seen in Zhou Jichang's haloed Luohan in meditation juxtaposed to a watery dragon-snake (Fig. 6.27), a calm triumph over a restless setting rather than conformity to it. It is a water-image interestingly caught in the concluding line of a poem by the Tang Buddhist poet, Wang Wei: "The peace of meditation controls the poison dragon."[38]

[38] From "Visiting the Temple of Gathering Fragrance," Pauline Yu, *The Poetry of Wang Wei* (1980), no. 64, p. 145.

More productive is a return to a Daoist framework. One might add, for example, that the cloth head-cover of Ma Yuan's dragon-sage conceals or eliminates what might have been a Buddhist tonsured head, and even more positively may seal his Daoist nature. A head-cloth has been seen as a feature in late Song representations of Lü Dongbin.

Continue, thus, with Daoist implications. Consider the compositional placement of the figures. Three hanging scrolls in the Boston Museum, thought to be of the twelfth century, feature in great detail *Daoist Deities of Heaven, Earth and Water*. While the Water Deity rises calmly on the vehicle of an open-mouthed four-clawed dragon, it is rather the horse-riding Earth ruler with his train, cloud-born but earth-moving, who turns in contraposto fashion, as with the Ma Yuan figure, to look downward and left to a demonic presence below (Fig. 6.28). In this case demons are led by the scholarly queller of them, Zhong Kui 鐘馗. Needless to say, this Earth Deity is a dignified crowned courtly figure with a suitable crowd of attendants, all of no interest to Ma Yuan. Closer to Ma Yuan's own time is the long handscroll of the 1170s by Zhang Shengwen. Early in the scroll is a Dragon King notable for its Chinese qualities as opposed to possible direct Indian influence (Fig. 6.29). Figure, cloud, and curling open-mouthed dragon

Fig. 6.28 Wu Daozi, formerly attributed *Daoist Deity of Earth* (detail) Museum of Fine Arts, Boston

Fig. 6.29 Zhang Shengwen *Buddhist Images from the State of Dali: Dragon King* (detail) National Palace Museum, Taiwan, Republic of China

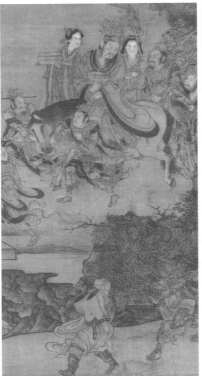

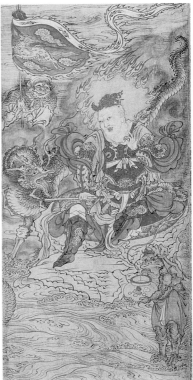

6.28

6.29

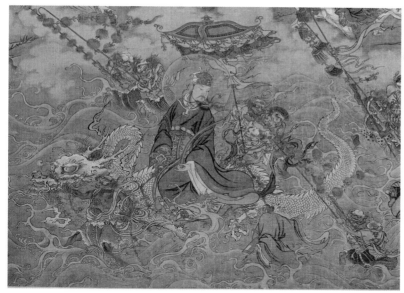

Fig. 6.30 Unidentified artist, falsely attributed to Ma Lin
Three Daoist Deities: Water Deity (detail)
National Palace Museum, Taiwan, Republic of China

6.30

are closely linked. But once again the god is "king" — crowned, elegantly robed, with pale and benign features.[39] Ma Yuan's relationship can only be suggestive, present in posture and positioning and the swirls of a robe, but Zhang Shengwen's dragon king is far too "civilized" for Ma Yuan's rough and spacious untamed image. Nevertheless a recent study of the Boston scrolls offers a valid parallel conclusion: ". . . a pictorial tendency newly formulated during the Southern Song period, a preference for the magical and mobile character of the gods rather than the static and inaccessible icons residing in their remote palaces."[40]

A civilized lordly aspect appears to have been carried on in the Ming. Both iconography and positioning are found in a single scroll depicting in vertical layering all three of the deities in the Boston scrolls. The painting, now in the Taipei National Palace Museum, carries an acknowledged false attribution to Ma Lin. This time, lowest in the scroll, it is the Water Deity riding his crusty dragon that catches our attention (Fig. 6.30). While the pose is one parallel to the picture plane, the figure is haloed and turns leftward, somewhat in Ma Yuan's contraposto fashion, down toward one of many demonic figures who carries a "book" in the form of a scroll. In contrast, however, Ma Yuan's crusty figure is uniquely isolated, not of sea, or land,

[39] Chapin and Soper, "A Long Roll of Buddhist Images" (1970), p. 198, Pl. 9 (15). See also a similarly vigorous crowned warrior Dragon King from the wall of a rediscovered twelfth-century temple, Yanshang si, in Shansi Province. Barnhart, *Along the Border of Heaven* (1983), p. 52.

[40] Huang, "Summoning the Gods" (2001), p. 47; for the Boston scrolls see Wu Tung, *Tales* (1997), pp. 63–65 and 149.

or heavenly kingdoms. Rather it projects a vision directly at home in the solitary cloud-swirling, mist-filled air.

The absence of lordly Daoist rulers in Ma Yuan's image need not distract us from Daoist intent. The Daoist idea must remain but it is individual and perhaps multiple in meaning. It is worth mentioning other elements not exclusively Daoist, thus reaching beyond confining religious boundaries. Prominent for Ma Yuan's striding attendant is a long staff. The staff ends in a stylized eye-dotted double head with an extended "beak" that may suggest a dragon. The staff, however, was also a persistent sign of Chan Buddhist authority and meaning, a vehicle to bring the realization of "true thusness" (*zhenru* 真如). Consider some selected examples drawn from App's study of Yunmen:

> When a patched-robed monk sees this staff, he just calls it a staff . . . [167]

> The Master abruptly seized his staff, drew a line on the ground, and said "All are in here" . . . [84]

> The twenty-eight Indian and six Chinese founders as well as the whole empire's teachers are all on the tip of this staff. [146]

> Yunmen held up his staff and asked, "what is this?" [174]

> The Master once held up his staff and said to the assembly "This staff has turned into a dragon and swallowed the whole universe. The mountains, the rivers, the earth, where are they to be found? [197][41]

The staff is both significant in the simplicity of its single self — its sign of authority — and its equivalence to all things. Just as the staff is symbol of universal containment, so too the gourd. That the gourd or calabash, container of heaven and earth, should swing on a flowing ribbon from that staff surely reinforces the message, but not necessarily as an exclusive sign of religious Daoism. Recall its presence on the forward donkey of Ma Yuan's mountain fuel gatherer (Pl. 1). No, Ma Yuan's enigmatic scenes may not find a ready fit within standard representation.

Much more focused in meaning and of key importance is a recently published detailed account of the Ma Yuan *Dragon Rider* by Wang Yaoting, curator of Taipei's National Palace Museum that harbors the scroll. His views fall into two major categories.

In the first place he has assembled illustrations of dragon-rider subjects from earlier historical times — late Zhou and Western Han — into the Song

[41] App, *Master Yunmen* (1994). Episode number listed after each.

and beyond. Secondly, in offering an extensive discussion of physiognomy, he has probed the portrait-like quality of the rider's face.[42]

As for the first, however, no image comes close to the strange uniqueness of Ma Yuan's rider. Period styles bring differing emphasis toward representation, but whether male or female, god or goddess, scholar or king-emperor (alone or in a dragon chariot), each hero, as has been seen with the late Song arhats and kingly figures, mirrors or suggests a recognizable repetitive Chinese type (Figs. 6.31–6.33). It is the tightness which binds Ma

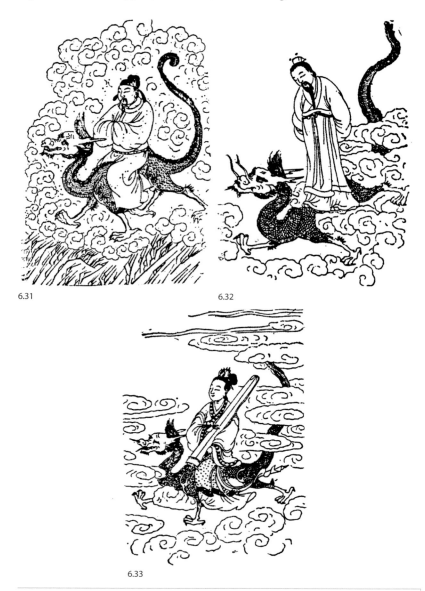

Figs. 6.31, 6.32 and 6.33
Immortal Riders of Dragons
from *Shenxian liejuan*

6.31

6.32

6.33

[42] Wang Yaoting, "Shuo Song Ma Yuan" (2000), pp. 377–89.

Fig. 6.34 *Imperial Dragon Face*
From Wang Wenjie (comp.), *Qie Wang shi michuan*

6.34

Yuan's rider to his mount, his unkempt wildness, a wildness focused on clear facial uniqueness, that sets the image apart. This applies both to the main figure and his dwarfed profiled disciple-attendant who offers his own startling protruding visage.

Thus, far more positively significant is Wang Yaoting's exploration of physiognomy and his reasoned conclusion that the face is exactly a "dragon-face." While the most convincing parallel image is a woodblock page from a late text (Fig. 6.34),[43] the entire multi-chapter volume is complex and suggests extensive traditional knowledge. That Ma Yuan's image may be thought of in terms of the woodblock idea becomes its own proof of tradition. The didactic poem printed beside the print adds verbal confirmation:

In form as in flight exactly the dragon –	體勢如飛宛若龍
Full beard, lofty brow, nose eminent	美髯頭角鼻高隆
Spirit of majesty, awe transfiguring none to compare	威靈赫變如無比
Ten thousand kingdoms cloud-gather to admire imperial omniscience	萬國雲從仰帝聰

This also confirms the significance of imperial association. But emperor-dragon or dragon-emperor is a longstanding idea. Continuing to follow

43 Wang Wenjie, *Qie Wang* (Wanli 1573–1620), ch. 7, p. 15.

Wang's thesis, consider the birth of the first Han Emperor as described in Sima Qian's *Historical Record* (*Shiji*). As Burton Watson translates it:

> Before he was born, Dame Liu (Kaozu's mother) was one day resting on the bank of a large pond when she dreamed that she encountered a god. At this time the sky grew dark and was filled with thunder and lightning. When Kaozu's father went to look for her, he saw a scaly dragon over the place where she was lying. After this she became pregnant and gave birth to Kaozu. Kaozu had a prominent nose and a dragonlike face, with beautiful whiskers on his chin and cheeks…[44]

其先劉媼嘗息大澤之陂，夢與神遇。是時雷電晦冥。太公往視，則見蛟龍於其上。已而有身，遂產高祖。高祖為人隆準而龍顏美須髯。

However, it is not just emperors who can claim close links to the dragon. Return to Zhou Mi's comments on the *Three Teachings* and his reference to Laozi as "Dragon Old Man" who stands or is placed sternly "at one side" (*yanli*). Jiang Wanli confirms this contrast to the other sages in describing a special aloofness with his cryptic "Laozi a glance beside." But the true basis of Laozi's dragon nature must derive from again turning to Sima Qian in his *Historical Record* (*Shiji*), which contains Laozi's earliest biography. In this text the imagery is far more complete.[45]

Again it is Confucius who focuses our understanding. The historian unfolds his compelling visit to see Laozi himself when the latter was librarian in the Zhou capital, Luoyang. The purpose, we are told, was to discuss the very idea later revealed in the *Three Teachings* painting, ceremonial conduct, or properly an early teacher-pupil confrontation, Laozi explains that those of whom Confucius speaks are as bones all moldering away. Only words remain. He then offers his definition of the superior man (*junzi* 君子), that ideal so deeply rooted in Confucian teaching. The superior man, intones Laozi, is one who when times are in accord mounts — hitches his chariot — and rides with them. However, when times are contrary, he acts as the tumbleweed (*peng* 蓬). Further, he explains, "I have heard the true merchant conceals his wealth within. Similarly the superior man, complete in his virtue (*de* 德), has the outward appearance of the unlearned" (*yu* 愚). Finally, dismissingly, he insists:

[44] Sima Qian, *Shiji, juan* 8, pp. 1a–2b. Watson translation, *Records* (1961), vol. I, p. 77. A later edition (1993) translates to pinyin.
[45] Sima Qian, *Shiji, juan* 61, pp. 1a–3b.

Reject your proud ways, your many desires, your deportment and stubborn will — all to no advantage to yourself. That is my advice to you!

去子之驕氣與多欲，態色與淫志，是皆無益於子之身。吾所以告子，若是而已。

Returning to his disciples from this stern rejection Confucius tells them:

I know that birds can fly; I know fish can swim; animals, I know, are able to walk and run. However, what runs may be trapped, what swims can be hooked, what flies the threaded arrow can retrieve. It is the dragon alone I cannot know. It rides on the wind and clouds, ascending to heaven. Today I have seen Laozi. Is he not as the dragon?

鳥吾知其能飛，魚吾知其能游，獸吾知其能走。走者可以為罔，游者可以為綸，飛者可以為矰。至於龍，吾不能知其乘風雲而上天。吾今日見老子，其猶龍耶。

Lacking a satisfactory alternative, or perhaps not even needing any other, can we not think of this startling image as the creation of Ma Yuan reinventing for his time the spirit of Sima Qian's Laozi — the compelling concreteness of this mythic character? Sima Qian continues to add general reinforcement to Laozi as one removed from normal expectation:

Laozi cultivated the Way and its Virtue (*Daode*). His learning concentrated on self-concealment, not name or fame (*ming*). He lived a long time under the Zhou dynasty, but when he saw its collapse, he made his way to the border barrier gate. There the gate commander, Yin Xi, spoke out: "You are about to go into hiding; I urge you to author a book for me." Laozi did author the book — two volumes (*shang, xia*) declaring the meaning of the Way and its Virtue (*Daode*), over 5000 words, and departed. No one knows to what end.

老子脩道德，其學以自隱，無名為務。居周久之，見周之衰，迺遂去。至關，關令尹喜曰，子將隱矣，彊為我著書。於是老子迺著書上下篇，言道德之意五千餘言而去。莫知其所終。

It is Laozi's self-concealment in life and his disappearance to "no one knows what end" that defines the earliest accounts. For Zhuangzi in the fourth century B.C., even though the text itself may be considered of Han date, it is quite simple:

The Master came, because it was his time to be born; he went because it was his time to die.

適來，夫子時也。適去，夫子順也。安時而處順。

The section of the chapter in which this is found, 'The Principle Nourishing Life" (*Yangsheng zhu* 養生主), concludes in the same vein but with the assurance of continuity:

Though the grease burns out of the torch, the fire passes on, and no one knows where it ends.

指窮於為薪，火傳也。不知其盡也。

This is the triumph of essential life-force beyond personal embrace, or as Laozi has been further defined in the final chapter of Zhuangzi's expanded text, "The World" (*tianxia* 天下):

Others all grasp what is in front; he alone grasps what is behind.[46]

人皆取先，己獨取後。

It is this intangibility, what cannot be grasped, the "behind" of physical form, disappearance itself, that in the development of Daoism as an organized religion, challenged the image. Wu Hung, as part of a recent ground-breaking exhibition of Daoist art, has offered a significant explanation of the sage's presence in the late Han, especially in Sichuan.[47] Pointing to surviving tomb reliefs he finds a presence retained by indirection: a throne, a sheltering umbrella, a tree that centered worshiping admirers. This appears to be no less than the earlier Indian Buddhist experience in the disappearance of its sage with the attainment of nirvana. This was so there, as historical legend would have it, until most prominently the so-called Udayana image exactly shaped the Buddha's appearance, a likeness as he appeared in the Heaven of the Thirty-Three Gods. Returned to earth, the likeness became tangible proof of a teaching with the specific directional purpose of carrying Buddhist truth to the East. Thus the seat, or slab, or throne embracing the invisible at such early sites as Barhut and Sanchi was filled, and a version crafted in Northwest India found its way into late Han tombs in China. Especially in Sichuan its form has appeared convincingly on tomb lintels and included as well at the base of sacred Daoist trees with apparent transfer of meaning to indigenous cults.

[46] For these quotations from *Zhuangzi*, see Watson, trans., *Chuang Tzu* (1968), pp. 50, 372.
[47] In Little, *Taoism* (2000), pp. 77–93.

This tentative introduction may not at first have taken firm hold as Wu Hung relates in an early statement about the famous Daoist stronghold of Maoshan: "In Buddhist halls were sacred statues which the Daoists did not have." But the pressure came, and allegedly it was from the West: "The barbarians do not believe in emptiness and non-being." When Laozi emigrated to the West he made statues of his form — thus converting the barbarians (*huahu* 化胡).[48] In China the significance of a divine image was to follow.

In history, religious images are never a fixed absolute. Each is shaped by the vision of its time. Never is this clearer from what we know so far of Laozi's physical return in visual media. A stele from the Forest of Stelae (*Beilin* 碑林) in Xi'an reflects this exactly (Fig. 6.35). Dated to 517 in the Six Dynasties period it is remarkable in showing Sakyamuni Buddha on one side and the deified Laozi on the other. There may be subtle shifts in iconography but in

Fig. 6.35 Unidentified artist
Laozi and Sakyamuni
Beilin Bowuguan, Xi'an, Shaanxi
Province

6.35

[48] Little, *Taoism* (2000), pp. 87 and 91. See also Zurcher, *Buddhist Conquest* (1972), vol. 1, p. 291.

its niche style, central figure, attendants, and donors, each serves a differing religious tradition fixed in the stereotypes of the other. They both display that marvelously other-worldly drawn-out rigidity in formal abstractions that combine sculptural solidity with unique proportions and surface linear invention that so often signals the sixth-century style during the Six Dynasties period. Once again we have visual consistency between what is Buddhist and what is Daoist.

Much of the same continues in the Tang. The deified sage, adopted now as an ancestor of the royal family, assumes the ideal qualities that mark figural sculpture of that era — sensitive selected surfaces, flexible rationally balanced order, and careful placement anchored to and reinforcing a strong physical presence. Whether the subject is Buddhist, Confucian, Daoist, or courtly secular the same broad aesthetic applies. There is now a sense of weight and mass that brings the image down to earth. Here it may be seen in a quiet centrally seated limestone statue of *Laozi* now in the Shanghai Museum juxtaposed to a corresponding Buddhist image from The Art Institute of Chicago (Figs. 6.36, 6.37).

Fig. 6.36 *Mi-le Buddha*
The Art Institute of Chicago

Fig. 6.37 Unidentified artist
Laozi
Shanghai Museum

6.36

6.37

In a recent article Liu Yang has pursued the Tang dynasty Laozi image in enviable detail. It becomes clear that images large and small appear locked in the web of institutional worship, extending from grand complexes to smaller, more private shrines. Balanced frontality commands and controls a central focus, the seated figure often secured behind the frame of a low armrest, or *yinji* 隱几, on which may rest a hand, an apparent mark of special, if somewhat withdrawn, authority. In imposing temples he was certainly backed or flanked by attending statues and now lost painted wall images expanding power into a world of gods and goddesses sometimes including landscapes, mountains, immortal isles, and even cloud-born transcendents: an entire setting that echoed, as with Buddhist paradises, a kind of imperial power raised to cosmic spiritual glory. It is Liu Yang's belief that the figural style in such lost paintings must have been closely allied to the style of a sculptor's chisel, modeling, or mold.[49]

Consider the origins of one such image in the reign of Emperor Xuanzong (713–756):

> The Emperor (Xuanzong) had a dream that the August Thearch of the Mysterious Prime (Laozi) told him: "I have an image at more than 100 *li* southwest of the capital. If you send someone to find it, I will then meet with you at the Xingqing Temple." The Emperor sent envoys who found it between Zhouzhi and Mt. Louguan. In the summer in the intercalary fourth month, it was welcomed and placed in Xingqing Temple. In the fifth month, (the Emperor) ordered that this true image of Laozi (The August Prime) be painted and (copies) be distributed to the Kaiyuan Temples of all prefectures.[50]
>
> 上夢玄元皇帝告日，吾有像，在京城西南百餘里。汝遣人求之，吾當與汝興慶宮相見。上遣使求，得之於盩庢，樓觀山間。夏閏四月，迎置興慶宮。五月，命畫玄元真容分置諸州開元觀。

While preserved statues appear to define a consistent sculptural image, and one must expect that image to harmonize with now-lost painting surroundings, one cannot assume a single style in either painting or calligraphy. While the words of texts can only hint at the physical presence of the painting, these texts imply variation both by grading artistic achievement and in drawing us within the scope of what we might actually have experienced. The result, at the very least, is to preserve the effect of a given artist's creative powers.

49 Liu Yang, "Images for the Temple" (2001), p. 233.
50 Sima Guang (1019–1086), *Zizhi tongjian* (*Comprehensive Mirror to Aid in Government*), *juan* 214, p. 26a–b. I am indebted to Thomas Smith for the reference and basic translation.

Excursus. An Aesthetic Preserved: Wu Daozi and Du Fu

With this in mind, among the painters who served Emperor Xuanzong in the first half of the eighth century, none rises higher in textual approbation than the divinely inspired Wu Daozi 吳道子 (act. ca. 710–760). The main writers closest to Wu's time are two compilers: Zhu Jingxuan 朱景玄, *Record of Renowned Paintings of the Tang Dynasty* (*Tang chao minghua lu* 唐朝名畫錄; ca. 840) and Zhang Yanyuan 張彥遠, *Record of Renowned Paintings through the Ages* (*Lidai minghua ji*; ca. 847).[51] From these authors we learn that when Wu was drawn to the court he changed his name from Daozi to Daoxuan 道玄, and he was given the official title of Doctor of Instruction within the Palace (*Neijiao boshi* 內教博士). While it is declared that he could only paint on official command, no command could tell him *how* to paint. Nowhere is this more clear than in Xuanzong's order that sent him to Sichuan to bring back a record of the scenery there. He returned, we are told, without a single sketch. The scenery, it turned out, was completely absorbed in the mind, and only revealed by transferring mind to brush, a painting of more than three hundred *li* of the Jialing River accomplished in a single day. It is this spontaneous creation of something previously unseen and hence unknown that haunts what is told of the artist. Major influences extended beyond painting, but in the same vein. On the one hand was the swift "draft" or "grass" calligraphy (*caoshu* 草書) of Zhang Xu 張旭 (act. 713–756) with whom he had studied, and the other, the martial vigor of the sword dance practiced by General Pei Min 裴旻 in which "uncanny things appear and disappear." (Zhang Xu had experienced a similar influence from a performance by a woman, Dame Gongsun 公孫大娘). Wu's accomplishments relate to a total aesthetic, linked to calligraphy, music, and the dance, that appear to be encapsuled in the brief phrase, "When the brush is lowered, divinity is present" 下筆有神.[52]

Wu's special importance to Daoism itself is captured by Zhu Jingxuan in mentioning his painting of *Five Sages and a Thousand Officials* (*Wusheng qianguan* 五聖千官) in a Temple of the Mysterious Prime (*Xuanyuan miao* 玄元廟). The Five Sages are no less than Xuanzong's claim of ancestral line which he traced back to Laozi himself, here with Zhu's expected praise:

> The palaces and halls, the caps and gowns, all seem to aspire to clouds and dragons, the mind returning to creation itself.[53]

宮殿冠冕，勢傾雲龍，心歸造化。

[51] For English translations see Soper, "*Tang chao*" (1958), pp. 204–30; and Acker, *Some Tang and Pre-Tang Texts* (1974), vol. II, 1, pp. 232–33; Chinese text in II, 2, pp. 108–9.

[52] Acker, *Some Tang and Pre-Tang Texts* (1974), p. 232. Chinese text, *juan* 9, p. 109.

[53] Zhu Jingxuan, *Tang chao* (1985 reprint), p. 2.

It is exactly such parallel powers that, now on an individual basis, one cannot help but realize in viewing Ma Yuan's *Dragon Rider*. Of course generalities can be dismissed. But in view of creative accomplishment, it remains important not to neglect the broader presence of Wu Daozi that was alive in the late Song. As seen in both Zhu Jingxuan and Zhang Yanyuan, Du Fu also plays a part in understanding the Tang Daoist aesthetic. As such he continues to be an important later conduit, and it is worth looking more closely at him especially as it concerns two poems, one early in the poet's career, one toward its close, both preserved in his collected works.

On a winter day in the early 740s when the poet was living in the area of Luoyang he went to the northern section of the city to visit Laozi's Temple of the Mysterious Prime. There, as the poem tells us, landscapes graced the doors; sun and moon were carved on temple beams; the immortal plum, great twisted roots; pliant orchid leaves in bright abundance. Both the plum, *li* 李, the Tang imperial surname, and orchid are shown by the commentators to have generational significance. Then we come closer to Daoism itself.

> The noble house ⌈of Laozi⌉ omitted by past history
> His *Way and Virtue* conferred by the Emperor today.

世家遺舊史，道德付今王。

And painting:

> The painter's hand shows generations past 畫手看前輩
> Master Wu so far beyond the field — 吳生遠擅場
> All things revealed, earth's axis trembles 森羅移地軸
>
> Marvelous perfection, temple walls in motion 妙絕動宮牆
> Five sages linked in dragon robes 五聖聯龍袞
> Officials thousands lined like geese 千官列雁行
> Tasseled head-caps spreading splendor 冕旒俱秀發
> Each banner, pennon flies unfurled.[54] 旌旆盡飛揚

Du Fu's late poem, *On Seeing a Pupil of Dame Gongsun Dance the Sword Dance* (*Guan Gongsun daniang dizi wu jianqi xing* 觀公孫大娘弟子舞劍器行), turns to a performance so influential in Wu Daozi's aesthetic. Both Zhu and Zhang bring the dance into their descriptions of the painter. Du Fu's ballad on the other hand makes no mention of him. Rather it is the calligrapher, Zhang Xu, whom the poet praises at the close of a long introductory passage: "His grass writing improved and he was enormously grateful, from which one can precisely know (the dancer) Gongsun." 自此草書長進，濠蕩感激，即公孫可知矣。

[54] Du Fu's poem is entitled, "In Winter, Visiting the Temple of Mysterious Prime North of Luoyang." I have consulted William Hung, *Tu Fu* (1952), pp. 32–33. For a convenient Chinese text of the entire poem see Wang Shijin, *Du Fu* (1986), p. 70.

However there are clear verbal passages in the poem's dance imagery that fit not only the calligrapher but also the great painter as we are able to imagine him:

Spectators amassed like mountains – bewilderment	觀者如山色沮喪
Heaven and earth ever dipping, ever rising	天地為之久低昂.
Flashing as nine suns shot down by Archer Yi	爜如羿射九日落
Soaring as hosts of emperors dragon-hitched	矯如群帝驂龍翔
Forth then as thunder-gathering rage	來如雷霆收震怒
She stopped: river and sea freeze clear light.	罷如江海凝清光

Significant is the further thrust of emotion that the aesthetic moment evokes, the passage of time and the memory of lost glory. Du Fu has now experienced, in the fall of 767 at Kuizhou on the Yangtze River, an echo of what he witnessed as a child fifty-two years ago in 715 when he had seen Li's teacher Gongsun performing the very same dance, a dance that apparently came from the western regions, its forceful freedoms that so greatly influenced calligraphy and by inference Wu Daozi himself. Now even the pupil was old, and the whole experience stirs a tragic aftermath beginning with Xuanzong's tomb, where:

South of the hill of golden grain tree boughs already interlaced	金粟堆南木已拱
On rock walled Qutang gorge grasses sough forlornly	瞿唐石城草蕭瑟
At the glittering feast shrill flutes once more have ended.	玳筵急管曲復終
With pleasure so high sorrow must follow The moon comes out eastward	樂極哀來月東出
this old man directionless	老夫不知其所往
Calloused feet, wild mountains turn anxious haste.[55]	足繭荒山轉愁疾

The mood would not have been lost on loyalists in later Hangzhou's diminished China.

In the Song, the Tang dynasty painting of Wu continues to be present in recorded life. It is described by no less a poet than Su Shi. This was early in his career when from 1062 to 1065 he held an official post at Fengxiang, some 150 kilometers west of Xi'an. There he visited the nearby Kaiyuan Monastery, which contained paintings of Sakyamuni's final sermon, one by Wu Daozi, one in another room by Wang Wei. To center on Wu's image:

[55] On the latter poem I have relied on the scholarly work of William Hung, *Tu Fu* (1952), p. 251; David Hawkes, *A Little Primer* (1967), pp. 188–99; also an unpublished translation by Thomas Smith. Hawkes, p. 192, suggests the dance source is from the West. For the Chinese text see Wang Shijin, *Du Fu* (1986), pp. 1275–77.

Daozi releases true martial vigor	道子實雄放
Vast as the waves of a churning sea	浩如海波翻
A hand descending, the speed of wind and rain	當其下手風雨快
What the brush has not reached the spirit holds	筆所未到氣已吞
Majestic amid paired trees	亭亭雙林間
Radiant as the sun-rising Fu Sang tree	彩暈扶桑暾
Centered, the perfect one lectures nirvana	中有至人談寂滅
For the enlightened compassionate tears the lost clutch hearts	悟者悲涕迷者手自捫
Barbarians and demons thousands upon ten thousands	蠻君鬼伯千萬萬
Push and shove forward heads like sea-turtles.	相排競進頭如黿

In this pairing Su's apparent preference for Wang Wei as a literatus suggesting ideas beyond the painting need not steer us from Wu's own revelations of life forces that "push and shove": the crowds, the enlightened, the demonic, the foreign. Clearly the flat wall comes to special and immediate life.[56]

Painting texts, sometimes with links to Du Fu, kept the fame of Wu Daozi alive as the Song progressed. One need only search Guo Ruoxu's 郭若虛 famous *Experiences in Painting* (*Tuhua jianwen zhi* 圖畫見聞志, ca. 1080), to find his presence there. Mi Fu, in his well-known *History of Painting* (*Huashi* 畫史), here and there also turns his careful and perhaps self-serving eye to what might remain of the master, mentioning his own rescue and possession of Wu's *Two Monks* as genuine, but otherwise showering little praise and even contempt on followers or later imitators. Still, it is proof that the name and style were clearly alive.

A few decades later Emperor Huizong's imperial catalog *Xuanhe huapu* (ca. 1220) includes a substantial account of Wu from earlier sources along with the claim of some ninety-three paintings. In it is the repeated summary drawn from Su Shi that links Wu Daozi and Du Fu: the Tang dynasty's greatest painter and greatest poet along with Han Yu for prose and Yan Zhenqing 顏真卿 (709–785) in calligraphy — a finality in Peter Sturman's felicitous translation: "All that could be done was done."[57] Du Fu's influence spread to other painters. Elsewhere in the same text is the assertion: "Li Gonglin had a deep understanding of the fundamentals of Du Fu's poetry and transferred them to his paintings." Again it relates to another poem, this time Du Fu's "Song of the Tied Up Chicken" (*Fuji xing* 縛雞行).[58] Moving on to Ma Yuan's

[56] Egan, *Word, Image, and Deed* (1994), p. 297. Some changes in translation. For other translations, whole or in part, and some evaluation see Siren, I (1956), p. 127. Egan, *Word, Image, and Deed* (1994), p. 297, and note 111.

[57] Vandier-Nicolas, *Le Houa-che de Mi Fou* (1964), pp. 58–59, 64 — nos. 62, 54, 55; *Xuanhe huapu*, pp. 46–48; Su Shi, *Su Shi lun shuhua shiliao* (1988), p. 46; Sturman, *Mi Fu* (1997), p. 22.

[58] Edwards, "Li Gonglin's Copy" (1993), p. 176. *Xuanhe huapu, juan* 7, p. 131.

time, the twelfth century turning into the thirteenth, the clearest established artist's connection with Wu Daozi comes from the brush of Ma Hezhi. Both Zhuang Su (1298) and, later in the Yuan, Tang Hou (ca. 1328) associate his painting with that of the famous Tang master. It is both a quality of archaism and a conscious expressive deviation from the norm that appear to anchor this debt.[59] On a parallel connection with Du Fu, it is difficult to believe that when Liang Kai shifted from his compelling version of the troubled, chilled Sakyamuni to his ideal depiction of *Li Bo Passing Chanting* (李白吟行 — Pl. 35) he was unaware of that poet's own search for his older friend and lines beginning one such poem, *Dreaming of Li Bo* (*Meng Li Bo* 夢李白):

> All day the floating clouds move on 　　　浮雲終日行
> Your ever traveling not arriving 　　　　遊子久不至
> Three nights on end I dream of you . . .[60] 三夜頻夢君

Indeed it is not just subject matter but the tight formal order of a poem that may be significant. Thus in his study of the poet Jiang Kui 姜夔 (ca. 1155–ca. 1221) and the lyric tradition Shuen-fu Lin has presented a detailed structural analysis of another of Du Fu's late poems now written in the spring of 768 when he was sailing down the Yangtze after leaving Kuizhou — "Thoughts Written While Traveling at Night" (*Lüye shuhuai* 旅夜書懷). Du Fu here becomes a kind of entry "to an understanding of the lyric song's structure."[61]

The Song Daoist Image

What then of actual surviving Song painting, our main concern? The claim may be made that at least in part Wu Daozi has again come to life in a surviving handscroll, *Homage to the Primordial* (*Chaoyuan xianzhang tu* 朝元仙仗圖), by Wu Zongyuan 武宗元 (d. ca. 1050), a painter of religious figures during the first half of the eleventh century (Pl. 36 and Fig. 6.38). While Mi Fu viewed the artist with contempt when compared to the great Tang original, we still can be grateful for this rare survival now in the family collection of Wang Chi-chien in New York. Unrolling what is apparently the sketch of a wall painting now in ink on silk, a substantial though incomplete view (58 x 777.5 cm), one faces a crowded procession of Daoist immortals and attendants. Fronted by a low and open irregularly curving balustrade, they file forward, male and female, in tight representation. One

[59] Murray, *Ma Hezhi* (1993), pp. 33–34.
[60] Hawkes, *A Little Primer* (1967), p. 93 ff. Translation altered.
[61] Li, *The Transformation* (1978), p. 106.

cannot help but be reminded of Su Shi's crowded "push and shove." Heads, varied only with a rare front or profile pose, are turned three-quarters left. Faces emerge as repeated lighter accents caught in ritual conformity as they top a sea of stately movement dominated by their form-concealing linear drapery. The weight and mass of clothing surely draw on Tang precedent. There are musical instruments and elegant held offerings. Caps, crowns, and towering headdresses startle the imagination and further ceremonial richness mounts high on elegant staffs and swaying streamers. Labels are found throughout. Only two, presumably the major figures, are classified as "Celestial Emperors" (*Tiandijun* 天帝君): the Celestial Emperor of the Southern Pole and the Eastern Floriate Celestial Emperor (*Nanji tiandijun* 南極天帝君 and *Donghua tiandijun* 東華天帝君). They are distinguished also as the only heavenly beings with halos. This inclusion of circular divine light may well echo, in more measured thin line control, the early bravado of Wu Daozi who, when he created a halo, did so not with a compass, but a single unaided sweep of arm and brush. The emperors' robes and proportions, somewhat concealed in successive waves of surrounding clothing, also help define a subtle massiveness as distinct from attendants who crowd in shapes of lesser bulk.

Below, only the tips of plants, flowering lotus and leaf, a single lily, and a few reed-spikes are all that affirm the unseen open unsubstantial foundation of a lotus pond (Fig. 6.38). Both above and below are selected stylized cornucopias of rising mist. Earthly splendor, however repeating the weight of imperial Tang forms, claims a visionary presence.

While it is possible, as Suzuki Kei has suggested,[62] to consider the three Boston scrolls of Daoist deities (Fig. 6.28) as a continuation of the Wu style, in painting, Laozi himself continues to be absent. Indeed visual presence in this medium along with an exact verbal confirmation appears only certain in its rarity. All the more unique, then, is the fine handscroll, *The Transformations of Lord Lao* (*Laojun biehao shishi tu* 老君別號事實圖) now in the Nelson-Atkins Museum in Kansas City (Pl. 37 and Figs. 6.41 and 6.42). The painter, Wang Liyong 王利用 (act. 1120–after 1145), lived in the century after Wu Zongyuan, his lifetime bridging the political transition to the south. Each figure, or "transformation," floats in ink and color on undefined silk. Each appearance is introduced to the right by a full explanatory inscription. Each differs but is generally standardized, wearing rich low-flowing robes — the outer garment grey or blue featuring (with one exception) a heavily banded border. The inner garments are in warm tones of violet, red, tan and orange. For all but two, shoes reveal elaborate up-curving tips that help anchor

[62] Suzuki Kei, *Chūgoku kaigashi* (1984), *chu no ichi*, p. 200.

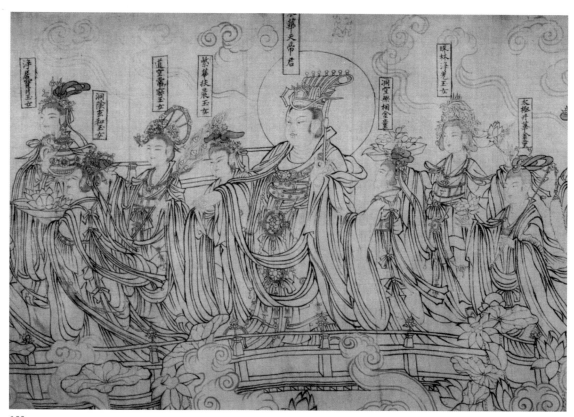

6.38

individuals in lingering formal aristocratic pose, rather than being released to easy common movement. While all ten figures are posed in three-quarters stance and face rightward toward an appropriate explanatory text, three turn heads back in contraposto leftward glances. Whether such shifts carry implications of character definition is difficult to determine. For example, the second transformation is grandly entitled "Imperial Lord of the Golden Tower" (*Jinchue dijun* 金闕帝君) and appears with the discovery of fire. He is the only one with a towering head-cap and only one of two with his shoe tips painted red (the other red-footed lord [no. 6] is tied to the casting of magical tripods, a feat not unconnected with fire). More important in differentiation may be the hands. In all portraiture, hands become an important sign of a subject's character. Here, hands vary in each, either in gesture or by virtue of holding some differing object.

Be that as it may, the importance of these transformations, Laozi's appearance or, more exactly, personal visible reemergence into Song consciousness, is most significant in claim to an historical pattern of metaphysical scope extending from earliest civilization to the more historically exact presence in the Shang dynasty. This continuum that begins

Fig. 6.38 Wu Zongyuan
Homage to the Primordial
Private Collection

deep among the legendary Three Emperors (*Sanhuang* 三皇), when he was named "Sir Ancient" (*Gu xiansheng* 古先生), extends through a familiar sequence: fire's discovery, Fuxi's creation of the Eight Trigrams, agriculture under Shen Nong, the Yellow Emperor's metal-casting, accomplishments for each of the emperors Yao, Shun, and Yu, before reaching the Shang.

The notion of Laozi as an everlasting teacher can be traced to around AD 165–166 in the later Han with the recorded assertion: "From the times of [Fu] Xi and [Shen] Nong onward [Laozi] has been active as a teacher for the sages."[63] While there are subsequent other extant textual versions of Laozi's transformations, none appears precisely consistent with Wang Liyong's selection. Shawn Eichman has pointed to the significant Northern Song *Biography of One Like a Dragon* (*Youlong zhuan* 猶龍傳), in which the first six correspond to Wang Liyong's painting. Variants appear for the others.[64] The artist's signature preceded by the character *chen* 臣 (servitor) indicates an official intent, which makes it highly unlikely that he was inventing his own sequence.

However, the connection with *Biography of One Like a Dragon* gives the painting with its sequence of Laozi transformations special significance. Dated to 1086, the text takes its place in Song historiography beside the better known history of the same date, Sima Guang's *Comprehensive Mirror to Aid in Government* (*Zizhi tongjian* 資治通鑑). The title of the Daoist text reaffirms Laozi's dragon nature, but more important is the clarity, based on earlier material, with which it presents a developed hagiography, or as Livia Kohn describes it:

> The Youlongzhuan, while presenting an extensive hagiography of Lord Lao, also functions as a universal account of the Dao, proposing a Daoist view of how and why the world came into being . . . a chronological account of the divine presence and relevance of the Dao in Chinese history and culture.[65]

A subsequent text by Xie Shouhao 謝守灝 (1134–1212), dated to 1191, carries the sequence on into the reign of Emperor Zhenzong in the Northern Song (998–1022) too late, apparently, to shape Wang Liyong's brush.[66]

While the painting follows tradition in presenting each portrait in the dignity of formal isolation, conformity is not rigidly imposed. Indeed, transformations are subtly varied. No longer surrounded by units of

[63] Zurcher, *Buddhist Conquest* (1972), p. 293.

[64] Little, *Taoism* (2000), p. 176; Wai-Kam Ho, *Eight Dynasties* (1980), p. 32. No clear textual source for the painting appears to have survived.

[65] Kohn, *God of the Dao* (1998), p. 172.

[66] For Xie Shouhao's text, *Sage Record of Chaos Prime* (*Hunyuan shengji*, DZ 1191), see also Kohn, *God of the Dao* (1998), pp. 31–32.

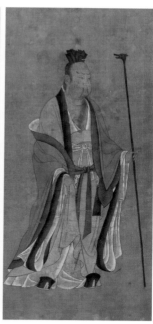

6.39 6.40 6.41 6.42

adoring triumphant processions, nor shaped in the quiet balance of the centered devotional image handed down in surviving sculpture, there is now a release. Each is successively defined in clear Song terms, not only in "active" three-quarters pose but with a minimizing of grandeur in their slender proportions along with a special precision in detail and color. These images are not weighted by heavy formal drapery. Elegant as is their clothing, they are left free to physically move in a new-found space. That they have slender proportions, and are thus part of a wider Song aesthetic traceable toward the end of the eleventh century, may be emphasized by juxtaposition to the beautifully conceived standing clay sculptures of court ladies, attendants at the Shrine of the Holy Mother some twenty-five miles to the southwest of Taiyuan city in Shansi Province. In proportion, pose, and color the contrasting medium appears similarly touched with elegant human understanding (Figs. 6.39–6.40). The sculpture is datable to 1087, a time conveniently comparable to the *Biography of One Like a Dragon* text of 1086.[67]

Of special significance is how the metaphysical extension of these transformations conforms to the philosophical direction found in the other two of the so-called "Three Teachings" so popular in late Song times. While Buddhism grew out of a civilization that readily allied itself to repeated

Figs. 6.39 and 6.40
Unidentified artist
Two Court Ladies
Jin Memorial Hall, Shrine of the Holy Mother (Shengmu), Taiyuan, Shanxi Province

Figs. 6.41 and 6.42
Wang Liyong
The Transformations of Lord Lao
(detail)
The Nelson-Atkins Museum of Art

[67] For further reproductions and discussion of these figures see *Zhongguo meishu* (1987), vol. 5, *Sculpture*.

kalpas of deep time, Song Confucianism, as has been shown, needed to establish such depths, finding the answer in Zhu Xi's historical alignment and the concrete imaging of Ma Yuan's son, Ma Lin, who in his imperial commission created direct and still surviving portraits of Fu Xi, Yao, Yu, Tang, and Wu, the last three taking us to the Xia, Shang and Zhou dynasties. An essential difference in these later Ma Lin representations rests in their extensive historical quality. His heroes continued on to reach Confucius and four disciples, a complete set of thirteen. In contrast Wang Liyong's "persons" all claim to be versions of the mythic Laozi himself who was significantly present to enlighten and guide the ancients, but no later in his case than the early Shang. Further, the two series are separated by close to a century in time. Ma Lin's 1230 commission contrasts with the work of Wang Liyong, whose life bridged the political transition from Huizong in the north, when he was a *jinshi* of 1120, to Gaozong in the south, where in 1134 he became a secretary in the Imperial Library. The scroll, signed with the designation of "servitor," bears two of Gaozong's seals, strongly implying a date from around that time, and likely no later than the emperor's retirement in 1162.

One should note as well a clear stylistic difference. While there is a tremendous contrast in scale and format — Ma Lin's portraits being hanging scrolls close to life size — this does not obscure the fact that the earlier Daoist sequence, while recognizable as "Song," is by far the more conservative in its figural presentation. Ma Lin appears personally free to reach a new level of inventive portraiture, especially in the grandeur of the seated Fu Xi (Pl. 29b). It is this quality, the freedom and desire, if you will, to realize a unique creation of compelling individual presence that increasingly appears as a feature of the finest late Song portraits, real or ideal, that have survived.

As mentioned earlier, Liang Kai's Buddhist founder is historically followed, or perhaps paralleled by a series of ink paintings of the subject that extend into the late Song and Yuan. Strongly related to Chan or Chan-inspired ideals, we owe their preservation to Japan's embrace of this Buddhism under its more familiar name of Zen. Late Song evidence of such a reconstructed Laozi appears not to have been so fortunate. However, there is at least one surviving portrait that suggests a parallel development. This, too, is preserved in Japan, now in the Okayama Prefectural Museum of Art. The hanging scroll (Fig. 6.43) is without signature, but bears two important seals: one in the upper left that claims the painter as Muqi, and one in the lower left of the Ashikaga shogun, Yoshimitsu, indicating its presence in Japan in the late fourteenth century. A half-length portrait, it bears little direct relation to Ma Yuan except for a speculative idea that it might once have served as part of a triptych embracing the *Three Teachings*.

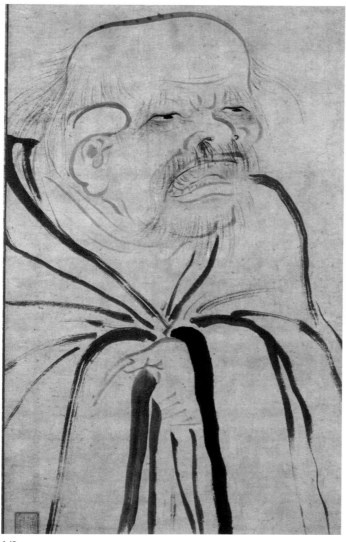

Fig. 6.43 Muqi
Portrait of Laozi (detail)
Okayama Prefectural Museum of Art

6.43

What is significant, however, is the way in which it supports the nature of the portrait subject for the generation close to and following Ma Yuan — a vision contemporary with that of Ma Lin. Emerging here is a Laozi of hoary age, a physical portrait characterized by Stephen Little as "one of the earliest and most powerful painted portraits of Laozi known."[68] Finer and lighter lines for the head and facial definition contrast with broad dark brushstrokes for a heavy embracing robe. The down-turned mouth is open, speech most certainly audible. The eye pupils are piercing black dots. Ear is outlined with a swift "S" curve. The brow furrowed. A three-quarters pose, along with

[68] Little, *Taoism* (2000), p. 117.

the partial emergence of a hand (here with an ancient long fingernail) are consistent, however, with Ma Yuan's more stable *Confucius* (Pl. 29a). One thinks, too, of Zhou Mi's description of Ma Yuan's *Three Teachings* where not only was a cooperative Confucius in "a pose of ceremonial obeisance" but Laozi was not, an image of contrast even if the Muqi style may well have raised the level of its intensity. That Laozi as a defiant standing monk continued into the Yuan is confirmed by a rare printed image from a 1326 text (Fig. 6.44).[69]

Fig. 6.44 Unidentified artist
Laozi
Reprinted from Kohn, *God of the Dao: Lord Lao in History and Myth*

6.44

[69] See Kohn, *God of the Dao* (1998), p. 34.

However, at this point one can only speculate as to why, in contrast to Buddhism, more such independent Laozi images were either not created or did not survive. Perhaps, in addition to the Japanese connection, it rests in the fact that institutional Buddhism in its Chan aspects was such a powerful force in stressing individual enlightenment that sympathetic images naturally followed. In contrast, Daoism, while returning to a repeated reincarnation of its leader, was unable in any important degree to let go of the complex ritual focus so evident in descriptions of Tang wall painting and surviving statuary. While Ma Yuan in Zhou Mi's description reveals the "Dragon Old Man" as "at one side" or simply, "a glance beside," few seem to have suggested, paralleling Chan, that in meeting the hagiography of the traditional Laozi and his host of followers you should slay them in favor of a more directly isolated "person."

Returning then to an individual, Ma Yuan's *Dragon Rider* is not alone. Too important is the smaller but equally intense attendant that accompanies the stern rider. The dwarf-like form, continuing the theme of unique presence, strides his airy world from a lower corner entrance, moving right to left, deliberate in clear profile, an angled contrary direction to the oncoming rider, yet one who remains in certain flying harmony with the central sage, in composition inseparable from the whole (Fig. 6.45).

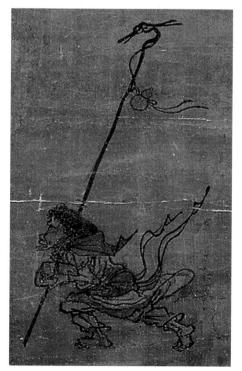

Fig. 6.45 Ma Yuan
The Dragon Rider: Laozi and Yin Xi
(detail)
National Palace Museum, Taiwan, Republic of China

6.45

The notion that this might be a shaman calling an immortal into visibility seems hardly adequate.[70] Not only is the figure completely in the air himself, with no suggestion of earth's foundation, he is not separately stationed to call forth. An integral part of the main image, he is present to echo the master's uncommon presence: dwarf-like, disproportioned, shaggy hair capping protruding features. Contrast him with a person who most surely does act as a shaman for the earth-conscious late Song, a scholar type emerging through the clouds (Fig. 6.46) who is bringing to us the "Great Unity, the Sovereign of the East" in a dragon-propelled heavenly chariot.

The scene is the opening of a late thirteenth-century handscroll depicting Qu Yuan's *Nine Songs* (*Jiu ge* 九歌), now in the Boston Museum of Fine Arts.[71] The idea of a disciple to accompany the main image also parallels the Buddhist world where so often the western-arrived arhat has his supporting disciple, a youthful harmonious acolyte.

Fig. 6.46 Formerly attributed to Zhang Dunli
The Nine Songs of Qu Yuan (detail)
Museum of Fine Arts, Boston

6.46

[70] Wang Yaoting, "Shuo Song Ma Yuan" (2000), p. 384.
[71] Wu Tung, *Tales* (1997), no. 91.

Surely, the dragon rider's attendant is no less than one of those persistent "transcendents," *xianren* 仙人 (or simply *xian*), so common in Daoist representation of its sages. Indeed, it is the Han again that clarifies this representation. At the late Han dynasty site of Yinan in Shandong province one can find an imagery that parallels Ma Yuan's iconography. Among many figures carved on an octagonal pillar from the tomb's inner chamber, in what so often at that time was the cryptic, separated language of carefully isolated forms, one can extract a clear sequence of god-figure, transcendent, and dragon (Fig. 6.47). In this case the "god" is a Buddha-inspired figure as shown in its seated pose and *Abhaya mudrā* or gesture of raised hand. Other god-figures add a halo. As Wu Hung has shown, this Buddha type was readily absorbed into the Daoist world not only in the north of China but in many examples found in the southeast, especially on portable bronze mirrors and ceramic vessels. The companion Han transcendent may also be seen in a beautiful small bronze with gold inlay from an excavation in the eastern outskirts of Luoyang (Fig. 6.48). Grasping a stand for the insertion of

Fig. 6.47 Unidentified artist
God-figure, Transcendent, and Dragon
Yinan County, Shandong Province

Fig. 6.48 Unidentified artist
Han Transcendent
Provenance: Eastern outskirts of Luoyang

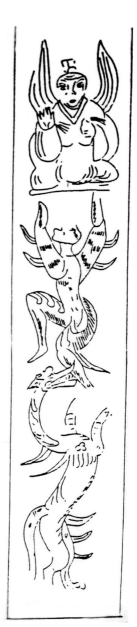

6.48

6.47

some object, he too is clearly an attendant.[72] The whole was a Buddha-Laozi connection that found textual affirmation thru the cryptic phrase: "Laozi went to the barbarian lands and became the Buddha."[73] Or more simply stated: "Laozi entered the Pass and thereby created the transformation of an image."[74]

Even though we cannot immediately confirm exactly what may have filtered through history's time to sophisticated Song Hangzhou, both texts and the comparison of Ma Yuan's image with recent archaeological finds are striking enough to suggest that it was not made of whole cloth. Other Daoist elements are not to be neglected. The presence of the gourd goes without saying. The staff, already mentioned in the wider context of Chan Buddhism, can also be specifically appropriated to Laozi. The use of a dragon-head as the ending of a staff or finial receives archaeological support from the discovery of them in the northwest regions (Fig. 6.49).[75] In Wang Liyong's *Transformations of Lord Lao* two figures carry a staff (Pl. 37). The ninth transformation, Laozi as Wuchengzi 務成子 during the time of Yu in the Xia dynasty, stands erect holding a staff in his left hand (Fig. 6.42). The staff is also dragon-headed. The text expounded bears the suggestive title of *The Scripture of Opening the Heavens* (*Kaitian Jing* 開天經), certainly appropriate for Ma Yuan's earth-removed setting. The tenth transformation, Laozi as Chuanyuzi 傳預子 in the time of Tang of the Yin-Shang dynasty, also bears a staff in his left hand, but now shouldered and with a bundle of scrolls suspended from it. These presumably contain the text he is illuminating, *The Scripture of the Numinous Treasure* (*Ling bao jing* 靈寶經).

So it is with Ma Yuan's attending transcendent. Of key importance is not only the holding of a complex dragon-headed staff but that, as mentioned earlier, the other arm grasps in a forward position what in all likelihood is a sutra or scripture case. Again compare this with Ma Gongxian's depiction of Yaoshan Weiyuan holding a sutra in his left hand (Pl. 28). Here, if a Laozi identification is accepted, the scripture must be *The Way and Its Virtue*, the "book" of Sima Qian's account.

The hagiography of Laozi was vastly expanded in the post-Han period and most certainly so by the time of Ma Yuan. The text to which the conversion of the barbarians was anchored, *Scripture on the Conversion of the Barbarians* (*Huahu jing* 化胡經) had a checkered history. According to

[72] Little, *Taoism* (2000), no. 21.
[73] Among other sources, Fan Ye, *Hou Han shu*, *juan* 30, p. 1082; Wu Hung, "Buddhist Elements" (1986), p. 301 (the Han date for Yinan has been pushed by some to the Jin; ibid., p. 268, n. 22); Zurcher, *Buddhist Conquest* (1972), p. 291, n. 13.
[74] *Hongming ji*, T. 52 (no. 2102), *juan* 8, p. 52b.
[75] Juliano and Lerner, *Monks and Merchants* (2001), p. 96.

6.49

Kohn, it was often attacked, and emerged again in the Tang under the rule of Xuanzong, when it was rewritten for the third time. We are told that Laozi then becomes the magical traveler centered in Khotan. In India he is a precursor of Sakyamuni; he is then off to Penglai, the eastern isle of immortality; westward again, he orders Yin Xi to become Buddha; back east, he is the teacher of Confucius; for a few centuries at Kunlun he deals with religious Daoists; west, again, he becomes Mani (216–276), expanding his universality to Manichaeism. In the end, all religions will be as one, the goal an earthly harmony. This gives us a god, to use Kohn's words:

Who never seems to stand still, always moving either up or down between heaven and earth or east and west between China and the barbarian countries. The conversion originally developed as a supplement to Laozi's biography in the *Shiji*, here has grown to a full mythical statement, showing in narrative form the celestial powers and universal impact of the deity.[76]

Important for Ma Yuan's image is the increasingly prominent role of Yin Xi, the frontier guard to whom Laozi entrusted his text. Laozi does not always wander as a solitary figure, for Yin Xi follows him from the Pass. The Han dynasty *Biographies of Eminent Transcendents* (*Liexian zhuan* 列仙傳) — at least in its eleventh-century form — asserts that after Yin Xi receives the double book, he "together with Laozi roamed the regions of the moving sands converting the barbarians."[77] Once again Kohn, in pointing to the universal mythic quest of the hero, offers a strong summation:

Lord Lao as the Dao is not alone, but interacts and joins with Yin Xi, his primary disciple and most active follower. The quest of Lord Lao is thus the quest of Yin Xi, and through him of all humanity.[78]

As discussed above, each age sees its gods in conformity to acceptable perception. Especially is this so with organized religion. The closeness of the Sakyamuni-Laozi imagery is not surprising within the ordered shrines of Han, Six Dynasties, and Tang. For painters in late Song Hangzhou, however, the parallel must yield to an emerging sense of specific individuality. This is exactly what Liang Kai has accomplished in a transformation of Sakyamuni that respected both his early history in the wilderness and the anchor of the Udayana image. The historical Laozi is different. Yet even in early stages the individual figure is not neglected, nor his connections with the West. While humanized "persons" continue to be present in Wang Liyong's mythic reincarnations, individuality is obscured in the hagiography of repetitive religious myth. Unlike the Buddha, Laozi was not originally a Western import carrying an established form. Laozi was Chinese with a particular enigmatic disappearing place in Chinese history. With the fall of the Zhou he went, "No one knows to what end." Thus, if we are to see him reappear, the notion of visionary non-conformity

[76] Kohn, *God of the Dao* (1998), p. 26.
[77] Zurcher, *Buddhist Conquest* (1972), p. 291. Zurcher points out that the phrase "converting the barbarians," missing from early versions, was added by the time this text entered the Daoist canon in the eleventh century. It was thus certainly available for Ma Yuan in late Song Hangzhou.
[78] Kohn, *God of the Dao* (1998), p. 287.

would seem to be integral to his redefinition, treasured both in the portrait itself, its setting, cloud-borne from an otherworldly reality, not unlike — as Tang history claimed but without description — an insistent dream, a dream coming to us, perhaps not incidentally, in the eleventh-century text of Sima Guang. There can be little doubt that Ma Yuan's *Dragon Rider* is most successfully aligned with Laozi by returning him to a basic foundation in the Han and the possibility of subsequent but still early developments. The result of the overwhelmingly detailed and convincing account of the hagiographies of "Lord Lao" by Livia Kohn, is to leave the clear impression that through the passage of history Laozi accrued too much additional baggage to preserve the isolated focus of easy stability. Still, the core of a dragon nature persists. While Sima Qian is the first to clearly define it, the dragon continues and is significantly preserved as in the title of the Song *Biography of One Like a Dragon*. The date, incidentally, is close to the projected time of the birth of Ma Yuan's great grandfather, Ma Fen. Later, however, one must seek it in a votive image, and the dragon nature attached by Zhou Mi must somehow have been present in Ma Yuan's lost painting of *The Three Teachings*.

Kohn's expansion of early texts into the logic of "eight major mythical episodes" adds as well a relation to other religious traditions, both East and West, a maturing into a "mythological corpus" marking Daoism as a developed religion. However, this cosmic undertaking occurs "only *after* the key features of the religion have been produced." [79] Curiously, as a sign of the complex variety of the Hangzhou environment, even Liang Kai appears to have accepted an institutional approach to religious truth. How otherwise accept a beautifully detailed handscroll of Lord Lao, *Liberating the Soul from the Netherworld*, now in the collection of Wan-go H. C. Weng (Pl. 38a)? [80] Here Laozi is clearly the captive of later hagiography which, as it were, stands guard over a series of miniature episodes revealing his power to liberate souls from the nether world. The painting bears a tiny Liang Kai signature prefixed with the character, *chen* (servitor), indicating an imperial commission and very likely an early work when he was closely connected to the Academy.

However, for the art historian, acceptance of authenticity rests not so much on the commanding presence of a calmly sanitized larger-than-life official god surrounded by a celestial entourage as on the episodic details of the rest of the scroll that often convey in linear miniature Liang Kai's ink-revealed

[79] Kohn, *God of the Dao* (1998), p. 191.
[80] The painting is also discussed in Little, *Taoism* (2000), pp. 178–79. The Chinese title under which this handscroll is frequently recorded is in error.

6.50

Fig. 6.50 Liang Kai
*Liberating the Soul from the
Netherworld* (detail)
Wan-go H. C. Weng Collection

sense of contemporary life, both sacred and secular (Fig. 6.50). Inventiveness, however, is also present in the main image, its angled three-quarter, right-left view, and even extends to the bowing worshiper (defined by Kohn as Zhang Daoling), whose main form is shaped by the thin outline of an expanded swollen circle-garb, imperfect but not out of visual harmony with the halo-wrapped god. Also, despite the crowding of celestial attendants, there is an echo of Han iconography. To left and right one can discover the dragon and the tiger. Now they are elevated to kingly personifications, but they remain the appropriate symbols that originally flanked the Queen Mother of the West (*Xiwangmu* 西王母) in a late Han representation from Sichuan, distant but with a much used passage to the east on the long stretch of the Yangtze River[81] (Pl. 38b).

Leaving aside commentary with other possible images that gloss the *Historical Record* (*Shiji*) rendition — including riding on a dark, perhaps blue (*qing* 青) ox, and purple air over the pass — it is recalling again both the clarity and implications of Sima Qian's basic account, a verbal parallel to Ma Yuan's unique image that matters: the setting of non-attachment as of wind and cloud and the power of the proud rider coming toward us in this brooding air. The dragon here is no abstract added symbol. Rather the

[81] For the growth of hagiographies see Kohn, *God of the Dao* (1998), p. 10 ff. For the significance of *Biography of One Like a Dragon*, see p. 171 ff.

mythic beast is the most forward element, a surging larger presence to which the human form is inseparably bound. There can be no division. What more convincing certainty of dragon-man and odd disciple — dragon staff and triumphant swinging cosmic gourd — so far beyond the trap, the hook or the threaded arrow. It is also as the tumbleweed that captures rootless flight in the open spaces of a treeless, now politically unobtainable non-Chinese steppe, and when brought into the ecumenical world of the Three Teachings must "stand aside," rejecting earth-bound Confucian propriety or calm Buddhist piety. Here also is a visionary presence bringing flat silk to life in a manner consistent with the laudatory encomiums that echo Wu Daozi's lost Tang brush, a dual figuring of unique defiance, what god-man might or here must be when times are out of joint. Is it not then imperative to see Ma Yuan's fertile imagination returning to us — from "No one knows what end" — the original, vital enigmatic sage and his converted disciple, the accrued reality of Laozi and Yin Xi?

7

The Wider Environment and into Landscape

Extended Vision

While this is not the time for a full survey, in concluding the effort to piece together the fragments of what history has left of Ma Yuan as a painter of China's religious heroes — Chan, Confucian, and Daoist — it is important to realize his contributions not only as unique in themselves but as part of a broader vision of painterly expression when to discover the human figure was to respect the importance of a person, not only in physical recognizability but, in the finest images, as convincing psychological presence. In recognizing individuality an overwhelming challenge, perhaps not always met, appears to have been offered in the repetitive Buddhist theme of five hundred arhats or *luohan*. The most complete surviving painting set, briefly mentioned earlier, is found in the famous hanging scrolls by two otherwise unknown masters, Zhou Jichang (act. ca. 1160–1188) and Lin Tinggui (act. ca. 1160–1180), realized over several years in the latter half of the twelfth century (ca. 1178–1188). They were painted for the Huianyuan 惠安院, a temple near the flourishing seaport town of Ningbo not far from Hangzhou. In the thirteenth century they made their way to Japan, eventually reaching the temple collection of Kyoto's Daitoku-ji. Late in the nineteenth century twelve were sold in this country, two to the Freer Gallery in Washington and ten to the Boston Museum of Fine Arts.

One of the paintings, a scroll from the Boston set, is particularly important for revealing the challenge of individuality. It is a carefully wrought visionary mock drama, *Luohan Manifesting Himself as an Eleven-Headed Guanyin* (*Yingshen guanyin tu* 應身觀音圖; Pl. 39). Combined in one painting is the religious image itself, the imagined ideal of the Western-derived *luohan*, and the likenesses of contemporary Chinese along with that of an equally contemporary visiting foreigner. Crafted in the best academic

Fig. 7.1 Zhou Jichang
*Lohan Manifesting Himself as an
Eleven-Headed Guanyin* (detail)
Museum of Fine Arts, Boston

Fig. 7.2 Zhou Jichang
Dedication of Five Hundred Luohan
(detail)
Daitoku-ji temple, Kyoto

tradition, an enthroned dark-skinned luohan is completing his adjustment to a devotional image. With one hand contriving to apply a light-skinned many-headed mask, the illusion of a miraculous transformation, with the other offering a welcoming gesture toward a kneeling worshipper. Each of the other four luohan is distinct in feature, pose, and dress. From these colorful ideal forms the direction shifts downward and lower left, where the ordinary late Song world of organized religion and art is displayed in a steep compositional triangle of contemporary portraits (Fig. 7.1): at the top a dark-robed monk whose gesture of praying hands continues the theme of piety; two lay figures below, one with a paper revealing an outline sketch, the other with a slender writing brush that might well have been used for such a drawing (now abraded but distinctly a full face or head); at the lowest point a young acolyte holding a black plate (lacquer, with possible materials of the craft?) swivels his profile head sharply back as though awaiting the next command, a kind of hyphen between creators and image.

This shift to the contemporary world is often interpreted as representing a monk, a donor, an artist, and an assistant. The monk, it has been

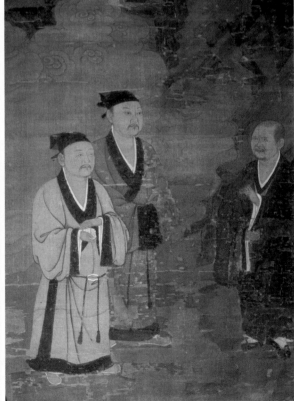

7.1

7.2

suggested, is the Abbot of the Temple Yishao 義紹, a proven writer of some of the project's dedicatory inscriptions. It is possible, however to offer a different interpretation. Turn to an important parallel representation of real-life figures in another of the paintings still remaining in the Kyoto temple Daitoku-ji (Fig. 7.2). Along with a parallel representation of five *luohan* the scroll also portrays contemporary figures, this time in a scene representing the dedication that defines the entire complex project. Featured as the most prominent clerical figure is an elderly priest who, as is generally recognized, can only be the project's chief mentor and supporter, the Temple Abbot. If this is the case, the portrait hardly matches that of the young monk in the *Guanyin* painting. However, the two forward lay figures in this second scene offer a general parallel to the same two in the Boston painting. A standard interpretation identifies them as donors.

However the absence of such forward donor representation throughout this complex series would hardly support such a conclusion. Wen Fong, who brings to this project a long history of scholarship, has clarified the complexity of donor involvement as one of varied personalities extending over a ten-year period. Indeed, while there are often lay figures inserted into a given scene, there seems to be no clear way to identify which of them might be donors as opposed to being significant actors supporting the drama of a given scene. Furthermore, the question also arises as to who gained credit for paintings that are entirely without a lay figure? Were they covered by inscriptions? Be that as it may, the two scrolls under consideration here are unique in presenting personalities who carry clear signs of the creative process itself: the tools of art, brush and paper, or the open presentation of calligraphy embracing the project as a whole.

Compare again these two scenes. In general the dedication scene reveals figures of stubbier proportions and fuller faces than the Boston group, for each scroll is not under the exactness of the same camera lens. The indication is thus of different designers, or at least paintings done at different times. However parallels remain striking. Compare the two secular figures at the left. In one, both hold proof of their profession, brush and paper. In the other, while there is an echo of this twin pair, they are without such emblems of craft. If the scene is of the project's completion, one might even suggest that now their work is done, their tools laid aside. The youthful monk behind the main figures in each painting presents a far closer match. He can be easily taken for the same person. In one instance he is seen in reverential worship, perhaps blessing a single project; in the other, while in a like secondary position, he now has the honor of holding the calligraphy of its completed dedicatory plaque, a title generally to be translated: "The Making of the Five Hundred Luohan." Whether a calligrapher in his own

right or a valued assistant he takes his place with what I would suggest must be the two known major artists. While in one the artists hold proof of their craft, the realization of a single magical event, it is now appropriate that they appear again in symbolic praise of an entire enterprise: its organizer and sponsor, Abbot Yishao, and those most responsible for its creation.

While the vision in the dedication scroll is directly clear, presenting as it does the necessary number of five *luohan* who appear above in a comfortable cloud-based garden, understanding the Boston scroll is more complex. What, indeed, have its artists created as they stand aside in the lower corner of the scroll? A miracle unfolds not, it must be admitted, without a sense of dramatic irony. Visionary clouds intrude from top, bottom right, and sides. In turn, the bright blue-green garden rock holds a distant timelessness that no earthbound setting could claim. However, no *luohan* offers Guanyin direct attention. The two highest look away. A third gives only a white-eyed glance. The one most concerned stands at the lower right. His profiled head gazes upward while active hands and open mouth proclaim an audible purpose — chanting and gesturing not in direct worship but apparently calling forth a compelling audio environment. Ideally no *luohan* needs an icon. Each carries the Buddha Law within. The *luohans'* duty is to preserve. Thus, to whom is the haloed mock image directed? It is to the only remaining figure, a single worshipper, the heavily bearded, sharp-featured, tall-hatted devotee, certainly a foreigner of Western origin. The perfume of his reverently held censer rises and the Guanyin image leans to him with a welcoming gesture of assurance. One can assume that the devotee was easily drawn from the busy international port surroundings of Ningbo.

For the dramatic subject, Wu Tung has suggested a source as early as the sixth century when a Buddhist priest of magical powers, Baozhi 寶誌 (d. 514), scratched his face to produce a twelve-headed Guanyin. More than the genre, however, is the significance of worship itself. In the light of the long history of religious imagery in China, images, as have been discussed, were early interwoven with the West. Given that background, this curious miracle appears to reenact the long-held belief that surrounded Laozi and the appearance of his image of disappearing beyond the pass. Here, of course, it is not the idea that when Laozi went to the West he actually became Buddha — although in China the match between images of Sakyamuni and Laozi tend to support it — but rather that in those distant regions worship required the presence of an image. A Buddhist text is specific:

The Barbarians do not believe in emptiness and non-being. Therefore when Laozi went through the pass he had to create an image for conversion.[1]

論云，胡人不信虛無。老子入關故作形像之化也。

Five *luohans*, with their Buddhist intent, and not without a satirical touch, are happy to oblige for a foreign guest.

Turn then to a detailed portrait of a known individual. There is no finer such painting in the late Song than the anonymous portrait, dated to 1238, of the priest, Wuzhun Shifan 無準師範 (1178–1249). Wuzhun is known in the world of visual art as the teacher of Muqi, and he was close enough to Ma Yuan's imperial connections to have been summoned to the court after the death of Empress Yang in 1233 to offer an official eulogy.[2] In his portrait the cleric appears to us wrapped in elegant robes spilling over the withdrawn legs on a throne-like chair that seals a commanding authority (Pl. 40). Yet it is the face itself that truly matters (Fig. 7.3). Its subtleties go well beyond the

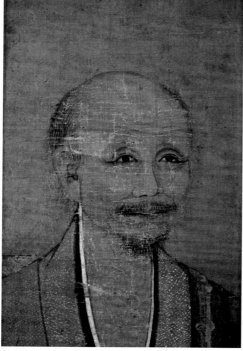

Fig. 7.3 Unidentified artist *Portrait of Wuzhun Shifan* (detail) Tōfuku-ji, Kyoto

7.3

[1] Sengshun, *Shi sanpo lun*, in *Hongming ji*, T. 52 (no. 2102), p. 52b. See an alternate translation by Wu Hung in Little, *Taoism* (2000), p. 91. For broader discussions of the *luohan* paintings see Wu Tung, *Tales* (1997), pp. 160–67; Fong, *Beyond Representation* (1992), pp. 343–45. The full set is reproduced in Suzuki Kei, *CICCP*, vol. 4, pp. 44–48. The Baozhi episode is found in Nianchang, *Fozu tongzai* (1341), reprint 1993, *juan* 10, p. 127.

[2] Lee, "The Domain of Empress Yang" (1994), pp. 242–43.

recognizable — the shading about the eyes, even the hairs within the ear. Present is an open-eyed assurance of both control and gentleness, a modest strength that carries qualities of internal wisdom. In large part this is because the sensitivity of the brush — the lines of its tip, its color, its ink — does not allow external rigidity of specific light.

Of the greatest known artists, once again it is Liang Kai who must be mentioned. What lifts his Sakyamuni far above the ordinary is the congealed tension of chilled doubt (Pl. 4b). What makes his differently conceived image, *Li Bo*, so compelling is a deliberate psychological shift (Pl. 35). Now brief marks of brush, ink and wash on the emptiness of clear paper capture a different *person*. The cloudlike Tang poet, defined above in Du Fu's poetry, gazer at moon and moon's reflection, who on another occasion, when asked about the life of withdrawal replied with his own brief poem, "Question and Answer in the Mountains" (*Shanzhong wenda* 山中問答), with the closing line:

> There is a different heaven and earth not among men.
> 別有天地非人間 。

While stable religious figural traditions must linger, it is creative difference that marks the finest painting of a time, and in turn becomes a mark of authenticity. Too much has been destroyed, but a lingering contrast may be found in a rare surviving depiction of the *Three Teachings*. It is on a stele from the Shaolin temple at Mount Song in Henan province, here reproduced as a rubbing (Fig. 7.4).[3] The carving is datable to 1209 and hence corresponds to a time when Ma Yuan must have been well into his maturity as a painter. While favoring the central Buddha, present is a solid dignity as old as the traditional Tang. Sakyamuni is wrapped in stylized repeated drapery loops recalling Chinese versions of the Udayana image, while robes on Confucius and Laozi anchor them to similarly early traditions of even greater weight. Ma Yuan's different vision of Confucius (Pl. 29a) must be apparent. The Laozi contrast must be imagined. However, no description of the rubbing could visually allow one to write, as did Zhou Mi, of a Confucius with personal dignity while being placed below, along with the dragon aloofness of Laozi.

Once again it is Ma Yuan's break from expectation that must be affirmed: a different Confucius and, I am suggesting, a different Laozi. As Liang Kai rediscovered Sakyamuni, so also with Ma Yuan and his Laozi — two personalized narrative images that challenge the rigid institutional norm. Both do so, however, through a deep-seated reevaluation of historical roots. Neither gives his subject a verbal label. Signatures (an extended one in the

[3] See Fong, *Beyond Representation* (1992), p. 327; Little, *Taoism* (2000), p.27.

case of Liang Kai) are their only surviving words. This appears to have come from accepted necessity. The verbal doors of the socially elite and the literati were not open to the craft world of the Academy. Visual understanding must thus play a special role, uniqueness its special strength. Is it not possible, as when unexpectedly meeting an initially unrecognized acquaintance in a foreign land, to let the image declare its own identity?

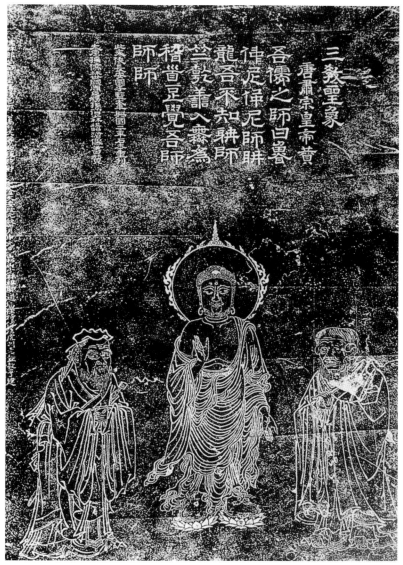

Fig. 7.4 Unidentified artist, Jin dynasty
The Three Teachings (detail)
Shaolin Temple, Mount Song, Henan Province

7.4

Landscape

Night Banquet

It is time now to turn to those few surviving paintings that move Ma Yuan's vision closer to the landscape itself. There is no more convincing introduction than a hanging scroll in Taiwan's National Palace Museum, *Night Banquet*, to condense the more elaborate Chinese title, *Attending a Banquet by Lantern Light* (*Huadeng shiyan* 華燈侍宴; Pl. 41a — not to be confused with a later copy in the same collection Pl. 41b). Opening before us is a kind of close garden view that surrounds a scene of palatial night-time banqueting extending beyond toward a wider natural setting. Although lacking a signature, it is now generally accepted as revealing Ma Yuan's own hand.

Broadly speaking, the proportions of the silk — although slightly enlarged (111.9 x 53.5 cm) — along with the arrangement of forms, including calligraphy placed upon it, follow the compositional order present in other Ma Yuan hanging scrolls. The calligraphy is a neat block of seven characters in each of eight ordered lines, by or close to the hand of Empress Yang.[4] It hangs, not unlike the lingering edge of a rolled-up bamboo curtain, far above the earthly scene below. In deference to the fuller landscape, the writing is far less intrusive than in the painter's Buddhist portraits.

Out of an otherwise open sky, definition is increasingly gathered into the lower half of the scroll and its tipped level land. While dependence on a one-sided, or one-corner, composition is muted by the horizontal extension of architecture, its open platform, and the rectangular framing of forward plum tree plantings, the setting refuses to discard an angular mode. Thus the plum trees fade toward a leftward dark. The architecture is not full-face but angled to reveal its right wall and part of a covered corridor extending to that same side. Finally, in the further rise toward vertical tree and mountain peak the significance of an oblique anchoring is all the more apparent. A single pine towers high yet gestures down in benediction, the mountain an echoing right-hand shape to carry the message both higher and toward dark distance.

Now, in contrast to Ma Yuan's other figural subjects, the figures, which are numerous, sixteen on the open stage and ten within, are minuscule (Fig. 7.5). They must defer to the grandeur of a towering palace and the surrounding presence of flowering plum and thickets of bamboo. Beyond is the even greater loftiness of rising land and extending distance, nature's implied embrace.

[4] Lee, "The Emperor Lady's Ghostwriters" (2004), p. 91.

Fig. 7.5 Ma Yuan
Night Banquet (detail)
National Palace Museum, Taiwan,
Republic of China

7.5

Fig. 7.6 Unidentified artist, attributed
to Guo Zhongshu
Emperor Minghuang's Flight to Shu
(Sichuan) (detail)
National Palace Museum, Taiwan,
Republic of China

7.6

The exaggerated miniature of these figures, however, has deeper roots. On the contemporary level it brings us to another beautifully crafted architectural study, also in Taipei, somewhat erroneously, even ironically, titled, *Palace Pleasures* (*Gongzhong xingle* 宮中行樂; Fig. 7.6 and Pl. 42). Unsigned, it must be considered to be an anonymous painting by a late

Song Academy artist not too far from Ma Yuan's own time. Precisely detailed palace architecture both surrounds and towers over pigmented miniature human activity placed, not unlike Ma Yuan, on a smoothly tipped-up courtyard platform before an extensive horizontal stretch of building. It is also a scene of night as two yellow circles of lantern that guide the action suggest, along with a broader conventional glowing brightness emanating from the palace interior. While it has an ambitious attribution to the tenth-century painter Guo Zhongshu 郭忠恕 (910–977), famous for his detailed architectural studies classed as "boundary painting" (*jiehua* 界畫), the identification of Guo's hand is historically untenable. The name, however has the value of suggesting an important tradition. As with Ma Yuan's brushing of water or the depiction of ideal portraits, it helps link the late Song to an earlier time. In this case the tradition can be more exactly related to the painter Dong Yuan and the same Nanjing environment and time experienced by Ma Yuan's Chan hero Fayan. At least an important segment of Dong Yuan's style has currently survived, and from this it appears that it was one of the qualities of the style to place such miniature pigmented figures, active but dwarfed, upon an expansive landscape (Fig. 7.7). This can be best explained as a retention of the carefully drawn and precisely colored men and women so important in Tang court painting, this early not to be rejected, despite growing interest in the landscape, but to be directly transferred, along with narrative implications, to grace open expanses of mountain and water. There they inevitably acquired a scale appropriate to such natural grandeur. The next step, of course, was to fuse their depiction more harmoniously within the increasing desire for direct, spatial extension.

The subject of this carefully detailed fan painting adds credence to this hypothesis since it is, indeed, as revealed some years ago by Li Lin-tsan of the museum staff, a courtly narrative. The tiny pigmented figures on the artificially bright night stage act out the famous Tang dynasty event in 756 with Emperor Xuanzong 唐玄宗 (r. 712–756)'s favorite beauty, Yang Guifei 楊貴妃 (719–756), shown mounting a horse to ride with the emperor on his flight to Shu (Sichuan). Two lines from a poem by the Tang scholar Su Lingzhi 蘇靈芝 (act. ca. 739) that once accompanied a now lost painting of the subject accurately describe the scene before the imperial palace. In Li's translation: "The court ladies help the Precious Consort mount the horse / The Emperor still turns back once more to glance at her jade face."[5] 侍兒扶起跨金鞍，聖主頻頻顧玉顏。

This scene not only told of a surrender of empire but was the tragic prelude to her own execution. While one can speculate as to its meaning for

5 Li, "A Study of the Masterpiece" (1961), p. 320.

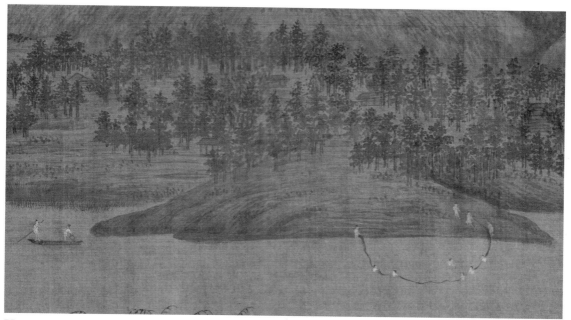

7.7

Fig. 7.7 Dong Yuan, attributed
Xiao and Xiang Rivers
Palace Museum, Beijing

a Song China that had similarly surrendered power to northern barbarians, it is a painting that like Ma Yuan's scroll makes architecture (here in a more specifically garden nature, and with no far distance, and with the definition of seemingly endless detail) a visual symbol of power and imperial continuity, adding as well for late Song viewers a touch of prophecy. Indeed, the Tang dynasty did renew itself for a span of 150 years.

Ma Yuan's *Night Banquet* must in part be considered in the light of this tradition, but at the same time a clear transformation has occurred. Color is present, particularly in its repetition as a seemingly conventional red on the women, on hangings, columns, and what appear to be other textiles. Perhaps it was more evident in an earlier condition, but it is no longer a major component. Color now simply enlivens the scene with bright and welcome accents, not, as will be shown, without important content but allowing brush and ink, line and wash to become the major technical source of expression, reflections of Ma Yuan's unique vitality. Accordingly, appropriate to the musical scene behind them, hasty linear plum trees dance. Bamboo, its leaves — brief dotting — fan gracefully into the night. Pines, reduced to two, their needles fused to a kind of scumbling of rough brush, slant down toward the celebration. Selected wash outlines of mountain peak echo such gestures. Even the architecture, although lofty in scale, is reduced to linear repetition. Forget the intricacies of extensive bracket supports.

Parallel lines suffice for roof-tiles and foundation masonry, while flat squares of latticework complement the generous invitation of a thin façade, its easy openness in which there is still one more linear detail — a thread-fine pattern of crossing lines that indicate the building's tile floor. Finally, sensitive washes infuse Ma Yuan's characteristic spaces with their brooding message of night.

Yet a narrative, concealed as it may be in lofty architecture and night's embrace, is important — as in a traditional view of Dong Yuan or an attribution recalling Guo Zhongshu. Partially screened by branches of the flowering plum, sixteen tiny slender women offer reciprocal poses of dance and music on the forward terrace (Fig. 7.5). Within are additional figures, six in the center space and two in each of two open wings. The latter are placed left and right, a tiny but significant figural order not unlike a framing balance often found in rare surviving Tang handscroll compositions. Indeed the ordering of interior space provides a contrast to Ma Yuan's dominant angularity. This order is not only set by the flanking attendants but begins with the two balancing three-step stairways that present access to the interior. The stairways lead to furniture, tables, and screens. On each side these are consciously angled so as to define a parallel receding perspective aimed not toward a single point but toward a centered unseen focus somewhere deep within. This, too, is an echo of Tang forms as they may be seen in the arrangement of palace architecture in Buddhist paradises of that time, as in Cave 172 at Dunhuang (Fig. 7.8). Thus an intrusion of architectural stability, an ordered central arrangement, implies balance and control toward all around it. In paradise scenes it is the Buddha who presides at such a focal point. Here the emperor is implied. That this stability runs counter to the painting's dominant impact of shifting angularity, including the rightward-facing and bowing guests, only affirms Ma Yuan's skill at complexity. He conceals an implied statement of traditional stability — imperial order — within the surrounding depiction of what can only be described as a scene infused with temporal vitality. The moment is far more than a moment.

In her analysis of the painting's content, Lee Hui-shu has convincingly suggested a direct connection to Ningzong's Empress Yang and her adopted family, her brother and nephews: Yang Cishan and his two sons, Yang Gu and Yang Shi, a relationship outlined above in the discussion of Ma Yuan's *Twelve Views of Water*. She broadens the validity of this argument by pointing to similar situations in the courts of the earlier Hangzhou emperors, a pattern in Southern Song imperial art: "Confirmation of the imperial honor that is specifically directed toward the clan of the empress."[6]

[6] Lee, "The Domain of Empress Yang" (1994), p. 251.

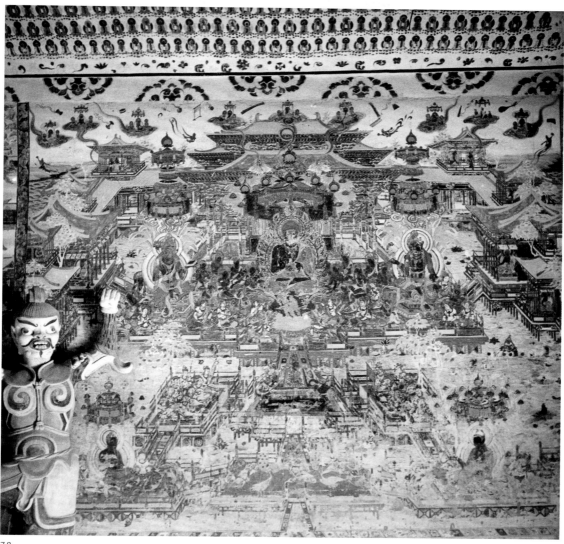

7.8

Their identification in the painting begins with its inscription, attributable to Empress Yang, or at least her writing style. Its presence once again appears to grace — not without a touch of bombast — the art of her favorite painter:

Fig. 7.8 Unidentified artist
Paradise Scene, Amitāyus Dhyana Sutra
Dunhuang, Cave 172

Back from his dawn audience the Imperial Commissioner proclaims official summons:	朝回中使傳宣命
Honor to father and sons to attend an imperial banquet.	父子同班侍宴榮
Wine cups raised — prayers for great blessings	酒捧倪觴祈景福
Music heard in Han halls — joyfully animated sounds	樂聞漢殿動驊聲

The budding plum in precious vases, 寶瓶梅蕊千枝綻
 a thousand branches bloom
Carved balustrades, floriate lanterns, 玉柵華燈萬盞明
 ten-thousand brightly lit.
They say to urge a poem 人道催詩須待雨
 one must await the rain
A line of cloud, the great hall in the rain, 片雲閣雨果詩成
 the poetry complete.

Enough of the poet's imagery is paralleled by the painting to draw word and image together. Thus dark lines of wash suggest cloud and mist, although the open-air music and dance deny the actual presence of rain. Rather it is the warm embracing damp of Hangzhou's spring night, the kind of air you can touch, still so characteristic of southern China, that carries the inevitable promise of the poem's completion. Similarly, within the hall the straightforward narrative is both clear and suggestive. Three men, the foremost larger than the other two, bow in reverent gesture toward long banquet tables and beyond. Behind them are three women dressed in auspicious red (Figs. 7.5 and 7.9). Thus we see father and sons outlined in imperial favor before a physical presence yet to be revealed. The emperor's bounty and power, as with the immanence of promised rain, the more powerful, the more sure from what takes place around him, from what is about to be. As James Cahill has neatly suggested, "From the periphery of an event we infer the event itself."[7] Anchored to a moment in space and time, meaning extends into the enduring world of idea.

The personal identification for this scene helps also in our understanding of history. It is logical to place the painting within the time of the political ascendancy of Yang Cishan as well as his two sons. Thus it must fall between 1207 and 1219, years that bracket Yang Cishan's life from the time when both he and his sons received significant official promotions until the father's death in 1219. For example, Yang Cishan received the title of Grand Guardian (*taibao* 太保), in 1210.[8] This dating leaves little doubt that the scroll coincides with Ma Yuan's maturity as an artist and his recognized importance for the Yang family. Remember that his water studies of 1222 were directed to the elder son, Yang Gu. In them are similar effects of sensitive atmospheric wash combined with forward linear play (Pls. 22a–l).

Somewhat hidden in Ma Yuan's integration of pictorial elements into a physically believable architecture, festival, and night is the fact that plantings gracing the scene are specifically selective. In order of their appearance, from foreground into depth, is the precise presentation of plum, pine,

7.9

Fig. 7.9 Ma Yuan
Night Banquet (detail)
National Palace Museum, Taiwan,
Republic of China

7 Cahill, *Lyric Journey* (1996), p. 36. For the poem translation of the first two characters of the sixth line (*Yuzha*) see *Hanyu dacidian* (1986), vol. 4, p. 487.
8 Lee, "The Domain of Empress Yang" (1994), p. 246.

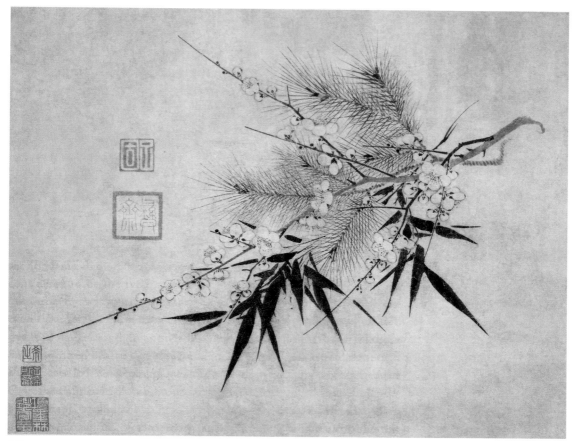

7.10

and bamboo. The pine is the most obvious, appearing to carry out Guo Xi's late eleventh-century instructions for its symbolic meaning: "A tall pine stands erect . . . a noble man dazzling in his time, all lesser men in service, no insolence or oppression."[9] To recognize the three, however, is to realize further depths of auspiciousness that pervade the whole. These are no less than the "Three Friends of the Cold Season" (*Suihan sanyou* 歲寒三友), here opening into spring. To mention the theme in late Song art is to recall the beauty of its isolated selection on an album-leaf format by the late Song artist Zhao Mengjian 趙孟堅 (1199–1267). The painting is in the same Taipei Museum (Fig. 7.10). Zhao was a *jinshi* graduate of 1226 who filled official posts as well as being intimate with prominent intellectuals in the Hangzhou area. His lifetime thus overlapped that of Ma Yuan, and he can be considered a close contemporary of Ma's son, Ma Lin. Zhao, however,

Fig. 7.10 Zhao Mengjian
Three Friends of the Cold Season
National Palace Museum, Taiwan, Republic of China

9 Guo Xi, *Zaochun tu* (1979), p. 9 ff. For a slightly alternate translation, Bush and Shih, *Early Chinese Texts* (1985), p. 153.

was an aristocrat carrying the name of the Song royal house along with the social status of a literatus. Here one need not dwell on stylistic difference, but it should be noted that both artists, each in his own way, depend on the subtleties of brush, of line and wash. Yet there is a clear reversal of traditionally accepted roles. Maggie Bickford has described the jewel-like album painting: "Its monochrome, linearity, and significant stylization notwithstanding, the polished presentation and impeccable execution of Zhao's work here exhibits deep affinities with and affection for the courtly art of flower painting . . . the same self-possessed, now-and-forever pictorial finality that characterizes the finest work in the Academy tradition of poetic realism."[10] In contrast, the brush of Ma Yuan is here the one that is animated with suggestive touches that carry intention well beyond "pictorial finality." Yet, as subject, the meaning of plum, pine, and bamboo is a constant, and popular, the theme having been found woven into contemporary textiles. Bickford speculates on Zhao's offering: an emblem of virtue, a token for the New Year or a birthday, for a scholar's retirement, a favorite lady, a statesman. The last, along with the promise of seasonal return, anchors Ma Yuan's vision, but there are enough good wishes to imagine wider blessings, all stemming from imperial bounty.

With all its complex weight of seasonal auspiciousness and imperial benevolence, its narrative, its symbols, Ma Yuan's larger intention will not allow such content to overbalance the embracing significance of a landscape. It is possible that he had in mind a specific view. Lee Hui-shu suggests a pavilion in the Rear Garden where some thousand plum trees were to be found as well as two pavilions called Plum Ridge (*Meigang* 梅崗) and Ice Flower (*Binghua* 冰花).[11] If so, the painting is hardly a photograph, which brings us to view-points.

By Ma Yuan's time it was clear in the literature, from writings by Guo Xi and Han Zhuo, that the Chinese passion for order had attempted to define the complexities of visual perspective in terms of six so-called "distances" (*yuan* 遠). While these have already been touched upon in my preface, they bear repeating here. Three, from the later eleventh century, were described as "high" (*gao* 高), "deep" (*shen* 深), and "level" (*ping* 平). In the early twelfth century three more were added: "broad" (*kuo* 闊), "hidden" (*mi* 迷), and "obscure" (*you* 幽). The first trilogy can be described as essentially psychological in moving the observer as on a shifting mental elevator: high, the better to see mountain peaks; mid-level, the better to see directly into the scene; and level, the ability to look down upon flat land or water and

10 Bickford, in Hearn and Smith, *Arts of the Sung and Yuan* (1996), pp. 298–99.
11 Lee, "The Domain of Empress Yang" (1994), p. 255.

to examine such surfaces. In Ma Yuan's *Banquet* landscape all three are evident. We look down upon the terrace and the floor of the pavilion. We look directly at plum trees, façade, human figures, bamboo. Pine top and mountain crests require, in turn, a raised vision, a clearing away of anything close that might obscure them. The other three "distances" are significant because they do not rely on such adjustments but on what it is possible to see from a stable position in the physical world. In such an experience, "broad" is conceived as what is visible from a foreground position in a spacious sweep toward far distance, perhaps hills and mountains. "Hidden" is when in such a view there may be interfering foreground objects, but more significantly, mists, cloud, and fog, a tangible atmosphere that conceals what might otherwise be seen. "Obscure" designates objects that, though still visible, are reduced to atmospheric suggestiveness.[12]

In effect, dependence on the physical eye creates its own limitation. Observation of what is near suggests surrender of what is far. The mind must take over. In this, however, there is no contradiction. The eye's surrender it is not. What happens is simply continuation of physical fact. Now it is the observed facts of atmosphere and distance, obscurity and concealment, that must be shown.

What happens when we return to the *Banquet*? First there is compression of the psychological distances. We catch all three, but they are relaxed. They easily run together. Most effective is the lowering of the implied horizon line, releasing the top of the scroll to a high sky. Mountain peaks slip down to enfold the pine. The sense of a coherent direct view is also caught below. Architecture conceals much of what is behind it. The foreground plum branches partially screen the view of dance and music. The look into the palace interior is generous, even if not complete. The rightward anchoring of visible forms then allows the atmospheric damp and dark of leftward night to hide what clear day might have revealed. The corollary to this focused space is focused time, the setting for a specific narrative about to unfold.

Here it is necessary to return to the poem calligraphy of Empress Yang and its somewhat puzzling last lines:

> They say to urge a poem one must await the rain
> A line of cloud, the great hall in the rain, the poetry complete.

These are a direct play on the ending of the first of two poems, spilling over to the second, written by the poet Du Fu — eight lines of regulated verse, but in five-character lines as opposed to the empress's seven-character

[12] Yu Jianhua, *Zhongguo hualun leibian* (1956), pp. 639–40, 662. Bush and Shi, *Early Chinese Texts* (1985), p. 170.

extension.[13] Once again this great Tang poet brings life to the art of the late Song. Du Fu was inspired by an experience in his early years, also at the capital, then Chang'an (the present Xi'an). The actual site was some fifteen Chinese miles (*li* 里) to the south, a summer outing on the Zhangba Canal 丈八溝. It, too, had its own aura of elegance, an evening in summer with "young aristocrats and courtesans," an evening ending abruptly in a rainstorm:

With setting sun delights of the untied boat	落日放船好
The light breeze stirs lazy waves	輕風生浪遲
Deep in bamboo a place for guests to linger	竹深留客處
Pure lotuses the time now fresh and cool.	荷淨納涼時
Dandies stir iced drinks	公子調冰水
Beauties shred the lotus roots	佳人雪藕絲
A line of cloud black above our heads	片雲頭上黑
Surely the rain is hastening a poem	應是雨催詩

From what has survived, Du Fu's poem had special significance for another late Song painting. The middle lines, "Deep in bamboo a place for guests to linger / Pure lotuses the time now fresh and cool," have been captured in a handscroll now in the Shanghai Museum (Fig. 7.11). The painting was brushed by a military official of the time, Zhao Kui 趙葵 (1185– 1266), like his contemporary, Zhao Mengjian, a member of the royal clan, also holder of official posts with literati tastes and abilities, but little known as a painter. Zhao Kui's interpretation of the outing is that of an individual, no longer young, who is hidden in a rustic retreat. He is waited upon by a fan-waving servant as he contemplates, perhaps as a poet, the lotus-dotted waters before him. In a rightward extension of the painting, two "guests" leading their mounts approach distantly on a bright path through sheltering bamboo groves.[14] Empress Yang and Ma Yuan had other purposes. The flavor of assembled aristocracy is, of course, closer to Du Fu's original experience. Now, however, it is raised to the highest social level. Curious the nature of the resulting poetry — for one, a quiet solitary retreat, for another imperial pleasure, an emperor's benevolent reward.

Once again, enough of the poet's imagery — now both Du Fu's and Empress Yang's — is paralleled by Ma Yuan's painting to draw word and image together. While not of summer, bamboo groves behind the palace are important for its setting, and the ink washes of night do not neglect the dark cloud overhead. It is, however, knowledge of Du Fu's second poem that completes the experience, a poem most certainly known to both the empress

[13] Both poems in Wang Shijin, *Du shi bianlan* (1986), pp. 129–30. For an alternate translation see Hung, *Tu Fu* (1952), p. 55.

[14] For a full reproduction of the painting see Xu Senyu, *Huayuan duoying* (1955), 2: 5. Also *Zhongguo meishu quanji*, 4, pp. 116–17. For the painter see Barnhart, "Three Song Landscape Paintings" (1998), pp. 58–60.

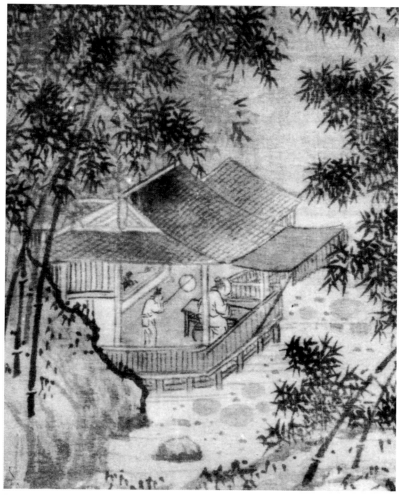

Fig 7.11 Zhao Kui
Deep in Bamboo (detail)
Shanghai Museum

7.11

and Ma Yuan. Anyone concerned with the first must also be aware of the second.

Rain arrives, seating mats are drenched	雨來沾席上
A sudden wind then strikes boat's bow	風急打船頭
The beauties of Yue, their red skirts soaked	越女紅裙濕
The courtesans of Yan, their penciled brows weep	燕姬翠黛愁
Mooring ropes tangled in willows	纜侵堤柳系
Curtains sprayed by the curling foam	幔卷浪花浮
The way home faces the soughing of the wind	歸路翻蕭颯
Embankments in a fifth-month autumn.	陂塘五月秋

Thus is the summer of the first poem transformed into an unexpected other season.

At first reading the second poem may appear to have little importance for Ma Yuan's painting, especially as one must substitute a welcoming palace for Du Fu's struggling chilled pleasure boat. That, however, is exactly what the empress does by placing "the great hall in the rain." More exact, however, is the clarification of one specific point. The three tiny figures dressed in red and placed behind the three honored guests clearly become identified from the second poem as the red-skirted "beauties of Yue," the ancient Yue meaning the south and specifically Zhejiang, now with its focus on Hangzhou itself. Yan is the contrasting north.

Naturally, Ma Yuan's auspicious painting is not one to suggest Du Fu's troubled outcome. But in a less specific sense, his poem has further reverberations. Du Fu takes us to another season. Such extension is paralleled in Ma Yuan's painting. An auspicious spring evening must grow to other times. It is the very nature of Ma Yuan's corner or one-sided compositions to open such a path. By limiting what the eye may surely grasp he is asking us to view what it cannot. The search at hand is linked to the search without. It joins a long-established painting tradition in which the human figure is important not because of a looming presence but because of a close relation to a far wider world. The near view becomes the far view. Ma Yuan thus presents an invitation to the mind, a mind not separate from but continually joined to physical experience. The moment extends. What is completed in Empress Yang's "great hall in the rain" is spring's welcome nurturing in the presence, no less, of plum, pine, and bamboo. It cannot help but augur continuing blessings — all seasons, an embracing imperial gift. As enfolding night extends, it is appropriate to suggest yet another line from Du Fu, whose poetry was noted for going beyond pure description. Written from Chengdu in China's southwest, this line relates to another, though differing, festival time, the ninth of the ninth lunar month, when it was the custom to climb to high places, in this case a city wall: "Across distances, seasons run together"[15] (望遠歲時同).

[15] Hinton, *Selected Poems* (1989), p. 66. For Chinese text, Wang Shijin, *Du shi bianlan* (1986), p. 641. Note as well other linking of seasons in this Ma Yuan study: Ningzong's calligraphy for Ma Lin's painting in Boston, and the anonymous *Peach-Blossom Chrysanthemum*.

Bare Willows and Distant Mountains

For Ma Yuan the significance of a controlled direct view in the landscape genre is uniquely revealed in his well-known *Bare Willows and Distant Mountains* (*Liuan yuanshan tu* 柳岸遠山圖; Pl. 43) now in the Boston Museum of Fine Arts. The painting is, in the Western world, one of the most familiar images associated with the late Song as a whole and thus more than any other Ma Yuan painting one establishing a close connection to his time. Concurrently, it is not without the assurance of an especially gifted hand. The landscape, while not perfect in preservation, is a marvelously condensed and yet complete view of spring, even more specifically of a spring morning. The sureness of selected, somewhat blunt detail, the spare flavoring of dots of color, the sensitive laying on of washes and a reticence that allows empty areas to speak for themselves combine to create its magic. By completeness is meant not only the inclusion of sufficient detail to relate a theme, but rather more the arrangement of those details or parts to reveal a harmonious interlocking whole.

Although part of this may be the result of the format's geometry, the limitation of an enclosing rounded fan, its focused perception rests far more in the composition itself. In contrast to the limits of a palace-garden setting, *Bare Willows* becomes a wonderfully open, direct prospect well beyond such city or palace walls. No need now to markedly tip up the level foreground nor lift high the mountain peaks to understand its elements. From an only slightly raised viewpoint, low forward land, a modest rustic bridge spanning river or inlet, the other bank with simple architecture, misted trees, and disappearing shore fall easily into place, as does behind them the misted flanks of sharply rising hill, cliff, and mountain peak — triangular, rounded, or forming a horizontal extended ridge. It is an unbroken progression, despite shifting direction, that carries even to the farthest disappearing distance. Yet this availability is most exactly controlled by the closeness of two willow trees with their selective bowing branches and to a lesser degree the lower contrasting angles of two flowering plums. We must look through them to see what is beyond.

Willow and plum, as subject, lead us back to what has already been explored, especially to the ten-leaf album of *Flowering Plum* and *Strolling on a Path in Spring* (Pls. 14, 17), representing as they do the spring willow that flourishes only slightly later in seasonal time than the early plum. The fact that one of the ten album views embraces both enforces the validity of viewing these two harbingers of spring together. While *On a Path in Spring* paints the close view of a strolling aristocrat and his servant, thus emphasizing human action, even in this feature *Bare Willows* may once have contained a similar, if less intrusive presence. In the lower right corner is

a tiny foot traveler (Fig. 7.13). It is puzzling that one so close should present such a huge discrepancy in scale when compared to his surroundings. Just in front of him, however, is a large spot of damage and repair. According to the museum curators, this may once have contained an additional image (colors in the chemicals of a painted backing having eaten away the original silk). The suggestion is that originally there was a traveler on horse or donkey pausing to contemplate the view before continuing the journey. A possible parallel may be found in such a tiny foreground detail on an impeccable album leaf presenting a traditional late Song subject, *Mountain Market in Clearing Mist* (*Shanshi qinglan* 山市晴嵐) by the twelfth-century artist, Yan Ciyu 闇次于 (act. ca. 1164–1187), now in Washington's Freer Gallery (Fig. 7.12).[16] Here it must be mentioned as well that damage along the lower right edge of *Bare Willows* has left only a partial "Ma" character to indicate the painter's original signature, this perhaps related to removal from the original border frame needed to hold taut such a fan.

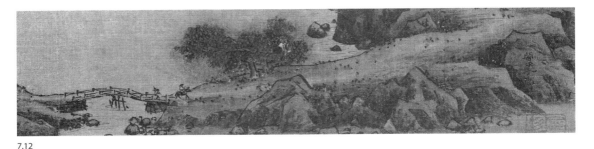

7.12

Fig. 7.12 Yan Ciyu
Mountain Market in Clearing Mist
(detail)
Freer Gallery of Art, Smithsonian
Institution, Washington, D.C.

In judging a painting that differs both in composition and breadth from what has been examined so far, a close look is needed to discern the sensitivity of touch embracing qualities of skill that have much to do with both selectivity and restraint — ideals guided, especially in the Song, by physical observation and yet demanding a holding back so that one is not overwhelmed by the endless variety that nature inevitably presents. It is the mark of Ma Yuan's art that he is able to realize this with consummate skill. In the close-up of Ma Yuan's miniature *Plum* album one sees the willow fronds as uniquely marked by the dotting of its buds, apparent short-hand for its blossoms. It is rather the broader album leaf of *On a Path in Spring* that presents a more valid opportunity for comparison with *Bare Willows*. Because *On a Path in Spring* is essentially a foreground painting, it includes more detail. Also, willow tips are more active since the idea of movement is key to the subject. In both, however, there is a spontaneity of touch, including variants of light and dark, and occasional lines that need not always be connected. For *Bare Willows* quiet is the intention (Fig. 7.13).

[16] Wu Tung, *Tales* (1997), no. 68, p. 180.

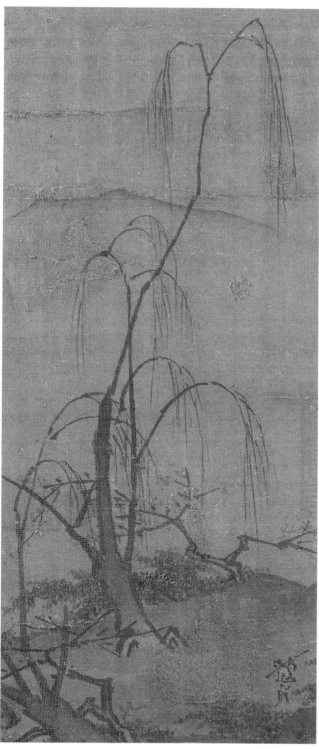

Fig. 7.13 Ma Yuan
Bare Willows and Distant Mountains
(detail)
Museum of Fine Arts, Boston

7.13

Tensions of angularity are muted by curves and softening wash. Check the line of arching willow fronds motionless in the stilled air not, it must be added, without the possibility of a nail-head beginning. If speculation takes us to a mounted traveler, he too must have been at rest, in contrast to the striding aristocrat. The shapes of the plums are a fitting foil to the willows, but their angularity is unobtrusive, not dramatic, low-level and subdued. Looking more generally, the "rightness" of isolated detail, however, rests strongly on the painting's conscious compositional order already described. However, the ease of the whole conceals further invention. For example, if one takes the two points of the most forward land at the right, raises them slightly and slips them leftward, they fit rather like two pieces of a jigsaw puzzle into inlets framed by the farther bank. Similarly, in a reversal of direction, the single triangular peak and its neighboring rounded summit echo the thin lines of forward-leaning willow branches. Continuing background heights reach a point not far from the physical center of the fan where atmospheric concealment and eventual disappearance take over. It is to penetrate this space for which forking willow branches politely stand aside. The interweave of what is close and what is far is finally confirmed by the surface height of the tallest willow, which like a spraying fountain sends, as lofty as any peak, twin arcs of fronds into the empty sky. They crown the last blue and distant line of hills, becoming a stretched, subtlely angled statement of heights (erase from your mind the upper intrusive line, a slash in the silk). In these angles, the two are as well a deliberate contrasting shape to the tree's lower willow arcs that offer calm and crowning circular perfection over the earth below.

Concern is, thus, not just for the visibility of objects but how those objects weave complexities of space. Once space is made concrete, as is true of the physical world, one must recognize time. It is a special quality of late Song painting to insist on this cohesion. In *Bare Willows* time as season is unmistakably early spring. But movement signaled by the single tiny figure — all the more the possibility of a second — speaks of travel through these surroundings. At which point we return to the painting's stillness. There is no restless breeze. The mists hold over the mid-distance, concealing and yet revealing the simple hamlet and its setting — a "distance" defined by the Song as "obscure" (*you*). The mountains wait. Depth holds, leading finally to what is "hidden" (*mi*). However, set by the presence of plum and willow this all-important spring is early. A traveler has just entered. Much is ahead. The painting is a painting of promise, of beginnings. Given other harmonies, time, too, must join them. We are left with something more precise, the beginning of day. Life may be still. It is

never static. Morning mists are at the point of rising, distance clearing. *Bare Willows and Distant Mountains* is a landscape, small in dimensions, but perhaps the most perfect of its kind. South China, a spring morning alive toward what is about to be.

Grasping the Wine Cup

Turn to another album leaf, this time a square of silk in the Tianjin Museum, *Grasping the Wine Cup* (*Yuexia babei* 月下把盃; Pl. 44a). Now the season has shifted to autumn. Characteristically pressing major definition to the lower part of the format, its formal stage-like foreground may recall Boston's *Scholars Conversing Beneath a Blossoming Plum Tree* (Pl. 16). Again in a high place, it features two such figures. Now, however, distance becomes the simplicity of a high flat night sky, empty silk accented by a yellow gold-rimmed moon. There are further differences. Restrained in its representation of objects and its almost doll-like human figures, it is spread before us from the left with only a brief selection of bamboo, principally two stalks, and two slants of land-rock, as well as two fence posts to suggest a leaning, or corner composition. Ink dominates but there are also touches of color. It is a painting, although unsigned, that betrays aspects of Ma Yuan's unique approach to a recognizable theme. There is a subdued control in the necessary miniature scale of figures and objects. Further, the theme draws special attention because of the calligraphy couplet by Ma's royal patron, Empress Yang, high in the upper right corner, affirmed both by the familiar writing and her small signature *kun* seal:

> Good fortune this meeting in seasonal celebration
> Under the moon, fronting flowers, lifting the cup.

> 相逢幸遇佳時節
> 月下花前且把盃

It is possible, perhaps necessary, to expand the significance of these two lines. According to Lee Hui-shu, they touch ". . . on a theme that barely emerges in the brief couplet."[17] There are other such festival poems. One of these is a fan with poem and painting, no longer in the original, but preserved in the fourteenth-century writings of Wu Shidao (1283–1344). Again it offers the Ma Yuan–Empress Yang relationship in a parallel, though different moon festival. This time, the empress wrote a quatrain by the

[17] For her complete discussion, drawn on here, see Lee, "The Domain of Empress Yang" (1994), pp. 211–20.

famous Tang poet, Bo Juyi 白居易 (772–846), but with a single character modified:

People tell the wonders of a bright Mid-Autumn moon	人道中秋明月好
May I not invite you to enjoy it with me?	欲邀同賞意如何
In Huayang Cave, on the immortal altar	華陽洞裡仙壇上
Tonight, pure light, this place – so full.[18]	今夜清光此處多

With this poem dated to 805, Lee dwells on the particular lure of its feminine qualities. It is about a woman, and Wu Shidao extends his commentary to imagine the fan as being gently waved by the emperor. While the original Huayang was a specific place at the Daoist mountain, Maoshan, here it is transferred to include a princess and a building in the Tang capital, Chang'an. Now by implication, the invitation, as with Du Fu in *Night Banquet*, the scene has shifted to another capital, Hangzhou in the Song, where Empress Yang changes only a single character. For her the terrace is "immortal" (*xian* 仙). The Tang original in a more earthy touch penned "autumn" (*qiu* 秋) altar.[19]

In understanding *Grasping the Wine Cup* it is tempting to add yet another quatrain by the empress. Not only has the original been preserved, it has been brushed on a square of silk with dimensions matching those of the painting, and even appears to fall naturally into place by being in the same Tianjin Museum collection. The pairing seems inevitable (Pl. 44b).[20] Again it approaches the theme with enrichment of idea:

Released from attachment, anxiety no more	人能無著便無愁
Ten thousand aspects mingle, off with a laugh	萬境相侵一笑休
But why alone Mid-Autumn feasting and delight?	豈但中秋堪宴賞
A cool day, a fine moon, that's Mid-Autumn!	涼天佳月即中秋

This poem also draws extensively on earlier poetic tradition. The first two lines may well have had in mind a poem by another Tang poet, Du Mu 杜牧 (803–853), with the line: "In this dusty world difficult to meet an open-mouth laugh" 塵世難逢開口笑. The last line, "A cool day, a fine moon, that's Mid-Autumn!", is a direct borrowing from the Song genius, Su Shi:

[18] The Huayang cave and altar was a specific place at the Daoist mountain, Maoshan. See Schafer, *The Snow of Maoshan* (1985–1986).

[19] Wu Shidao, *Wu Zhengchuan xiansheng wenji*, Taipei facsimile (1970), *juan* 5, pp. 93–94. For the original poem see Bai Juyi, *Bai Juyi ji jian jiao*, *juan* 13, pp. 733–34. For Huayang explanation see p. 726. (The poem there also used the term *xian*.)

[20] See Lee, "The Domain of Empress Yang" (1994), p. 212 ff.

When chrysanthemums flower, that's the Double Ninth. 　　　菊花開時即重陽

A cool day, a fine moon, that's Mid-Autumn.[21] 　　　涼天佳月即中秋

Despite the empress' recurring treatment of the theme, it is doubtful, as has been claimed, that this calligraphy leaf should in fact be paired with the painting. It is the clear visual directness of *Grasping the Wine Cup* that demands rejection, that and the fact that it carries its own crisp inscription, one that exactly fits the painter's grasp of a fortunate (unexpected?) meeting between two men at a precise seasonal moment.

The moon, the flower (certainly the season-defining chrysanthemum), and the high place emphasized by the climbing attendant and his music are too specifically of the Double Ninth to move comfortably to the quatrain's generalized festival. The painting demands a separate identity. Despite the echoing format, its Su Shi conclusion unnecessarily expands the tight-knit painting/inscription focus. However poetically possible, further words create an unwelcome distraction. Nor does it seem common for the empress to offer two inscriptions for a single painting. The lost Ma Yuan work recorded by Wu Shidao makes no mention of an additional one. It might be added as well that Su Shi's famous line relates directly to the differing circumstances of the deep south where the warm climate does not fit either the cool needed for the calendar eighth month nor the chill when the chrysanthemum blooms on the ninth. In a word, the quatrain album leaf is best understood in separation.

It becomes all the more necessary to concentrate again on the painting and its concrete visual selection. Just as its inscribed couplet is verbally condensed, so the painter has reduced imagery to the disarming simplicities of a composition that offers an open stage of unusually balanced order. Rising rocks and bamboo on the left are countered by the smooth land platform rising at the right to meet the corner of a fenced parapet (answering the suggestion of a fence to the left). Enclosing lines and wash of hillcrests limit the foreground stage while allowing the open sky with its assurance of the festival's height. Two crossed stalks of arcing bamboo are indeed a suggestion of left-anchoring emphasis, but they quickly divide in counter directions in deference to the empty silk above, an opening toward the moon and the twin lines of calligraphy.

It is often difficult to determine whether a given inscription comes before or after the execution of the painting. Here it seems clear, however, that both in placement and content the painting was done with an exact knowledge of, or at least an invitation to, its writing. With figures and objects a

[21] For the two poems: Du Mu, "Jiuri Qishan denggao," *Fanchuan wenji* (1978), *juan* 3, p. 46. Su Shi, see Chen Yuanjing, *Sui shi guangji*, *juan* 34, pp. 375–76.

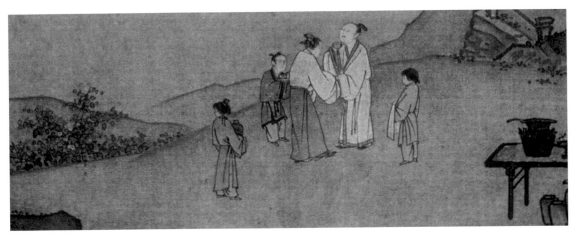

7.14

meaningful illustration unfolds (Fig. 7.14): an ordered knot of off-center figures; meeting in an embrace of full-gowned arms; the cup raised toward the lips of an open-faced upward-looking aristocrat; the strategic placing of servants holding appropriate signs of service — towel for cleansing, tray for cups, jug for refilling — and ample more in the containers cut by the lower right corner. A fourth attendant just emerging from an upward climb holds a stringed instrument, visible enough to show its circular shape identifying it as a *ruan* 阮, a close relative of the *yueqin* 月琴 (moon-lute), thus a form complementing the image in the sky.[22] In turn the musician's upward climb helps accent the quality of height. Touches of color play their part: flowers in the low foliage, ink bamboo echoed by similar leaves of green; mineral green filling other leaves, a towel touched with red, a blue plate again with red, a cool blue-grey wine jug, a yellow wine cup.

As with other Ma Yuan paintings this condensed narrative is of a moment: the *ruan*-bearing servant emerging, the brief face of another attendant looking toward him, the bowing of one friend, the moment of grasping hand or arm, however hidden by ample sleeves, the raised cup, a tilted head. While it is a painting without the easy flowing elegance of *On a Path in Spring*, there are hints of the same intention. These include the significant placing of an emerging music-bearing servant showing only the top of his instrument, and perhaps the selected curving bamboo, which like the willow branches cannot bend without an occasional subtle angle. While placement differs, the painting and its narrative carry a special sense of sophistication that gives visual realization to the couplet in the empty sky,

[22] For an early representation of the *ruan* see the representation of Ruan Xian 阮咸 among the early fifth-century bricks from Nanjing, *The Seven Sages of the Bamboo Grove. Inter alia*, Laing, "Neo-Daoism," Fig. 9.

its "seasonal celebration," its "fortune" hinting the unexpected. There is no attempt at excessive elaboration either visually or verbally.

The poetry couplet leaves the specific festival to the painter. It is the landscape of a high place that defines it, for the climbing of heights, as the instrument-bearing servant must, was a tradition too directly joined to the Double Ninth to be denied. One cannot help but realize that the quatrain now paired with it in the Tianjin Museum is a doubtful contemporary fit. *Grasping the Wine Cup* is too specifically focused. What the couplet does not specify, the painting completes. We have seen before how accurate Ma Yuan might be when it came to his filtered details. Here, in addition to the heights, is a special gold-rimmed moon high in the empty sky. Note, however, that it is not purely round as the full Mid-Autumn moon must be, but ever so clearly off-round, an oval and thus more appropriate to the ninth day of another month. Even more important, there is a broad aesthetic harmony between the brevities of the couplet and the brevities of the painting — meeting, moon, flowers, cup, good fortune. Authenticity must rest in its convincing cohesion of visual and verbal expression captured in the clarity of a single leaf. It stands by itself.

On strict matters of authenticity one cannot avoid a cautionary word. The album leaf's painterly execution appears unique for what has survived of Ma Yuan's finest work. Given his spontaneous sensitivity, he would not normally require an obtrusive guiding line to define a wash for the crest of the far hills. Nor would he embrace the rigidity of outline and inner drapery definition that gives too frozen a stance to the stage's miniature actors. The fixity of line is made more acute on light fabrics by the clinging addition of parallel white (now somewhat abraded but still visible). This slipping into a different aesthetic, while acceptable within a late Song time, suggests another hand, one close to but different from the painter himself. It is to examine such possible transformations of the painter's style that the heart of Ma Yuan must now turn.

8

Transformations

Album Leaves: Gazing

Since words, contemporary words — other than parallel poetry and the occasional presence of an early seal — are largely absent in exploring Ma Yuan as an artist, he must be judged by the only medium through which we can know him directly, the visible forms of his brush, their presence or absence. Such has been the process in careful viewing of *Grasping the Wine Cup*, with a conclusion that a great deal of Ma Yuan can continue in the hand of another. In this case it is subtle pictorial rigidity not perhaps ineffective in its own right that shifts a mode into another kind of expression. Also, as discussed above, a differing direction is embraced in the moist light touch displayed for the ideal portrait of *Lü Dongbin*, a painting possibly by the hand of a known Ma Yuan contemporary follower, Wang Jie (Pl. 32). That one must be sensitive to such transformations is clearest, however, when there are surviving examples that duplicate a given subject, twin versions of what is substantially the same painting — others will emerge, either actual or implied, as the story unfolds. For now, fortunately, there are two well-known examples. The two also show a range of difference extending from a juxtaposition in which the authenticity gap seems only too obvious to the presence of far more subtle differences where the copy is refined enough to be easily accepted as genuine were the opportune proof of precise comparison not present.

The first duplication is a second painting of *Night Banquet*, also housed in Taipei's National Palace Museum (Pl. 41b). James Cahill has succinctly summed up the difference in pointing to the copy:

> The palace building is enlarged, and another building has been
> added behind it. The distant hills at the upper right have been
> made larger and heavier, and at the upper left, where in the

original an area of mist absorbed the viewer's gaze into limitless depths, there appears now a second, worked-over area of palace buildings, trees, and peaks, which blocks off this opening.[1]

Gone is the visual restraint and compactness that have been analyzed earlier in discussing what is surely the original (Pl. 41a). In the foreground change is clearest in the way the tiny dancing figures are lifted above forward plum branches, a platform disturbingly exposed in contrast to Ma Yuan's sensitive visual screening. The copyist was apparently meeting the needs of later taste, a rejection of clear Song vision no earlier than the fourteenth century. Here, too, it is well to remember that the inclusion of Ma Yuan's signature (present in the copy, but not the original) is no guarantee of authenticity. Further, one can generally state a rule of thumb in judging late Song landscapes. With the exception of winter scenes, which in the Song may be tightly enclosed, views of the twelfth and thirteenth centuries almost universally leave an open space among the distant hills, a sign of significant depths which later post-Song paintings imitating the style tend to neglect.

The second clear example of repetitive painting is much different. It is discovered in the painting of miniature album leaves depicting the *Flowering Plum*. Already discussed in chapter 3, a group of ten and a group of six return here as precise examples of the other end of the authenticity scale. Comparison between the two sets reveals a qualitative distinction that might otherwise go unnoticed. While both sets appear incomplete, it is the group of six on measured silk of slightly different proportions that betray the imitator. Four of these repeat original designs either closely or in mirror reverse. In them, as noted earlier, are found the hasty circling of a moon, the rigidity of a cloud-streak, less precise dotting and a fixity of outline along with axe-strokes of the brush that, however tiny, have sacrificed the touch of spontaneity to rigid repetition (Pls. 14, 15).

With these rare examples in mind, consider some works that, while far from copies of each other, carry out a consistent theme, the scholar or aristocrat in a limited landscape setting. Two examples of the genre have already been discussed in some detail with the resulting claim for Ma Yuan's creative skills. One is the rounded fan of Boston's *Scholars Conversing beneath a Blossoming Plum Tree*, the other a rectangular album leaf, Taipei's *Strolling on a Path in Spring* (Pls. 16 and 17). These help set a standard against which others must be matched.

Turn to a closely connected pair of album leaves that were once together in the collection of the eminent New York connoisseur and painter, Wang

[1] Fong and Watt, *Possessing the Past* (1996), p. 185.

Chi-chien (C. C. Wang). Now they have been divided, one, *Watching the Deer by a Pine-Shaded Stream* (*Songxi guanlu tu* 松溪觀鹿圖) to the Cleveland Museum of Art, the other, *Scholar Viewing a Waterfall* (*Guan pu tu* 觀瀑圖), moving nearby to New York's Metropolitan Museum of Art (Pls. 45, 46a). However, their consistent subject is best understood as a continuing pair, a complementary relationship far more significant than if each should stand alone. One is signed (*Waterfall*), the other (*Deer*) is not. The connecting theme is one specially consistent with the late Song: the idea of gazing, or more appropriately, the quiet contemplation of the natural scene by a scholar-aristocrat.

First view Cleveland's deer painting and its low-level open landscape. The setting is that of an appealing garden-park. A right-anchored corner composition and angular approach to both overall arrangement and definition of tree, stream, rock, and ink-washed distance argue well for a broad application of Ma Yuan's style. Representation is such that focus immediately turns to the right of center foreground and its white-robed, back-turned scholar (Fig. 8.1). Seated in contraposto fashion he gazes out and away toward mist-filled spaces. To the left, a statement of undisturbed quiet, even a traditional note of fading day, is an antlered male deer bending to drink. While there are damages and repair throughout the lower edge of the silk — particularly beside the deer — this appears to have little effect on the artist's major definition.

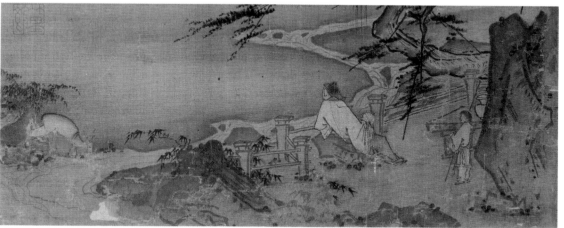

8.1

Fig. 8.1 Ma Yuan, attributed
Watching the Deer by a Pine-Shaded Stream (detail)
The Cleveland Museum of Art

However, without seeking perfection, disturbing formal inconsistencies are evident. The scholar, angled in outline shape and leaning pose, flat of back and sleeve, is placed — rather than meaningfully seated — against the shadowed rock. Nor does his relation to the fence convey restful "leaning." The placement of the boy attendant is similarly uninspired. He is of course traditionally "there," holding the scholar's staff. But he is almost bumped by the heavy protruding line of the steep corner rock and in turn almost beheaded by the top line of the stone table behind him. This space is further confused by a fence-post intruding on the entering loop of the large pine trunk. Nor do brief stream-lines convey the urgency of flowing and pooling water, however miniature, that we might expect from a master of this genre. It is possible, too, that awkwardness of foreground representation has its effect on the whole where other aspects are more skilled and consistent: imposing expressive pine, touches of bamboo, mist-shrouded deciduous foliage, gentle washes of distance, all clearly related to acceptable Song taste rather than being specific to Ma Yuan himself. The scholar's pose and gaze are turned away toward empty distance — lofty thoughts, or too obvious a cliché?

However, the purposes of the Cleveland picture become clearer on examining the figure-landscape in New York. The two views create a sympathetic balance: contemplation on the plains, contemplation into a steep mountain gorge. *Scholar Viewing a Waterfall* also carries clear marks of Ma Yuan's angled approach, now from the left rather than the right. It, too, has scars of damage and repair near the lower edge. Again, however, main definition is apparently unaffected. They are a comparable pair. Now, raised above the plain, instead of low distance cut by the brightness of a level angling stream, distance is the negative of a flat wash of mist blanketing an implied steep mountain flank. The vertical emphasis is sealed by a complementary curve of falling water, a tense bright band defined by a few inked lines but mostly by the negative of untouched silk. To left and right at the lower edges are pale cotton shapes, faint outlines of empty clouds that help frame the foreground scene and stress its height.

Again, the main forward focus is on a white-gowned scholar figure (Fig. 8.2). Now he is standing, his pose an arced parenthesis, a gentle bow that parallels the waterfall's fixed curved descent. Gaze, however, is not to the fall, but to fall's result, the stream below. Look back again to the Cleveland painting where the deer is similarly not important for what the scholar sees but is also a key sign — in this case open quiet — in defining figural meaning. However, just as the figures in the Cleveland painting appear flawed, so it is with the figures in the waterfall scene. Fragile definition has

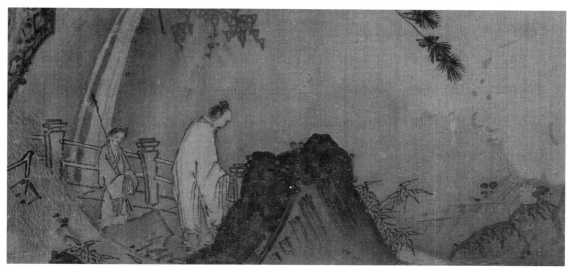

8.2

Fig. 8.2 Ma Yuan
Scholar Viewing a Waterfall (detail)
The Metropolitan Museum of Art

hardly been seen as a mark of Ma Yuan's depiction of the human form. The scholar's tall proportions are the more ephemeral by virtue of the delicate and slightly tremulous lines that define his presence. In turn, the thin shape of the staff-holding attendant and his curiously triangular face assume only a doll-like addition for the master.

However, the more one looks at both paintings, the more one realizes the intention of a comparative harmony. A crowning forward pine in each is backed by faint deciduous shapes. Two scholars, one seated, one standing. One turned away, formally flat and deliberately angled, responds to an angled stream. The other, a thin fragile profile, echoes the shallow arc of the waterfall. However, this does not mean that each imitates the other. The standing figure also differs in its delicacy and its contrasting looseness. To point to a tiny detail, the back outline does not meet the collar, and the collar itself is a separate wedge independent of the neck. This appears deliberate and might be considered as a valid angled transformation of a device already discovered in the image of Confucius in *Confucius and His 72 Disciples* as "flying lines over the shoulder" (*jianshang feiwen* 肩上飛文).[2] Similar fencing tells that these scenes are hardly wilderness experiences. What this means to the history of a shadowy personality, most often defined outside his painting by only a name, is not easily resolved. The Metropolitan painting is somewhat freely signed "Servitor, Ma Yuan" in the lower left corner. This gives an official status. The Cleveland landscape is unsigned.

[2] Murray, *Ma Hezhi* (1993), p. 50.

Such pairing, however, is not unusual judging by the duo of Ma Yuan's *Apricot* and *Peach* (Pls. 20, 21): one signed, one not signed.

That these are paintings of considerable appeal cannot be denied. They are clearly of the Southern Song. However, they lack an acceptable consistency that would place them as by the master himself. There is a subtle shift away from Ma Yuan's debt to natural reality and toward a deliberate manipulation of nature's forms. This can be found in both paintings, but while some of the visual uncertainties in the Cleveland work have been suggested, consider the waterfall scene more closely: the powerful heavy overhanging pine with its angled branches and sharp needles, the dark intrusive triangle of the foreground rock and its flat carefully placed axe-stroke brushmarks. Both present a deliberate, perhaps disturbing contrast to the fragile human figures. The fixed streak of waterfall in turn denies a natural strength, and after we imagine its unseen flow below — the object of the scholar's contemplation — it emerges in the lower right corner not as convincing natural foam but as arcs of conscious decor playing with circles of mist. To this manipulation of objective power note the mountain scene's far lower right corner at the pointing tip of the overhanging pine (Fig. 8.2). There are brushed pale touches of design describing circles of cloud. Prominent is a shadowy profile: a forehead, two eyes, a bulbous nose, mouth, and chin. It is a curious anthropomorphic touch that once detected is hard to erase. A date has been suggested of ca. 1220.[3] If so, it is not easy to relate its style to works discussed above that are datable close to that time, *Water* and *Night Banquet* (Pls. 22 and 41a). Even if, for expressiveness, you point to the lively upright dance of the tiny forward plum trees in *Night Banquet*, there is a subtle controlled difference between compliance there to a musical scene and movement now toward a differing, independent aesthetic.

Proof of the communality of repeated versions has recently emerged in Japan with what appears to be a Yuan version of the Metropolitan painting. This time it is an album leaf with similar ink and color on silk but in the shape of a rounded fan — 22.7 x 24.8 cm (Pl. 46b). A somewhat oddly angled seal carries the legend, *Yefu* 野夫, which thereby indicates the painter as Ding Yefu 丁野夫 of the fourteenth century, a recorded follower of the style of Ma Yuan. A second seal, *Zijing zhenbi* 子京珍祕, further offers the claim of ownership by the sixteenth-century collector, Xiang Yuanbian, yet another mark of his extensive holdings, several, as we have seen, related to Ma Yuan's brush. Stylistically, however, this new discovery signals the change that often embraces Ma Yuan's style as it slips from late Song sensitivity

[3] Fong, *Beyond Representation* (1992), p. 273.

to a less spacious, more congealed Yuan image. Thus, the flat confusion of forward axe-strokes, the inflexibility of rigid outlines, or rightward open spaciousness transformed from a sensitive mist-wash to the smooth flat side of an overhanging cliff rigidly edged at its base by downward spears of foliage. In turn lesser details such as the play of river foam, the triangular mask-like face of the attendant, or even the white bordered lines of the scholar's bent pose have lost the art of convincing description. The contrast clearly supports the Song significance of the Metropolitan painting, whether one stretches it to Ma Yuan himself or accepts subtle changes to a gifted follower.[4]

This stylistic shift can be seen far more exactly in a second well-known "gazing" painting in the Metropolitan Museum of Art, *Viewing Plum Blossoms by Moonlight* (*Yuexia guanmei tu* 月下觀梅圖). Now the form is that of a rounded fan offering an angled and somewhat squeezed Ma Yuan signature at its lower left edge. It returns us to what for him was a familiar theme, the flowering plum (Pl. 47). Again the broad elements are undeniably his. The left-leaning composition opens to a delicately washed night sky responding to the firm circle of a yellow full moon. Eliminating the security of a railing, the profiled scholar sits on a land-edge, now closer to pure "wilderness." A high rusticity is further emphasized by the tip of a roof of thatch just appearing in the lower right. This time the gazer holds his staff, while the attentive stance of the companion has the task of sheltering a well-wrapped musical instrument, the *qin* of independent, perhaps Daoist retreat. Consistent with the high perch and the higher sky, "gaze" is outward and upward.

If there is any music, however, it is carried by a crescendo of shapes. They are extended both as verticals, urgent outward leanings, and downward slants. To a degree, purposes also are intensified by alternating rhythms: the sharp rise of foreground rocks, a paler slice of grey background peaks surging outward, and a light distant layer of pale blue crests slanting downward. Fronting this is the inevitable linear play of plum with its ink-black forward lines and muted echoes behind, an extension challenging gravity to its utmost limits. The artist's brush clings to deliberate rigidity. Rare is the occasion of a curve. Most shifts of direction employ the angle. A carved formal flatness rules the human figures, often exaggerated by

[4] For the painting see Nezu Institute of Fine Arts, *Southern Song Paintings* (2004), Pl. 28 and p. 151. For Ding Yefu, see Xia Wenyan, *Tuhui baojian* (1365), ch. 5. Howard Rogers has further noted the existence, also in Japan, of a quality copy (with additions) of the Cleveland fan. Again the attribution is to a Ma Yuan follower, Ye Xiaoyan, active in Hangzhou after the mid-thirteenth century. But without the original, or a clear reproduction, a detailed analysis remains to be carried out. See Wai-Kam Ho et al., *Eight Dynasties* (1980), no. 52, p. 70.

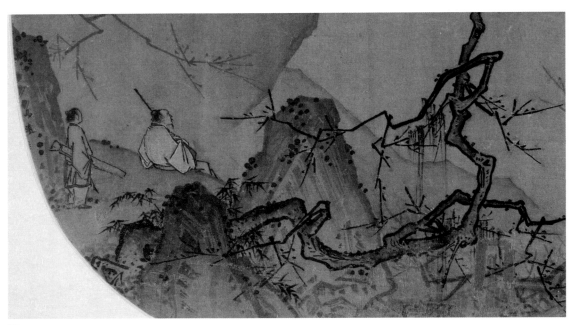

8.3

Fig. 8.3 Ma Yuan
Viewing Plum Blossoms by Moonlight
(detail)
The Metropolitan Museum of Art

bordering even lines of white (Fig. 8.3). This passion for straight lines invades, even dehumanizes the depiction of the human face, a small but significant detail. The profile of the boy attendant's features is reduced to three crisp, angled dashes. For the scholar, a straight line cuts across nose, mouth, and chin, also erasing the human profile. These recall the imprecise profile of the scholar gazing into the waterfall's gorge, but differing in its sharpness.

Ma Yuan's love for the plum and its angled branches is, as has been shown, firmly anchored in his finest painting. But never does its definition so clearly depart from a respect for organic cohesion. Here the brittleness of branch or extended twig is made patently clear. It is especially so in those darts of the brush that are separated from or cross over nature's supporting branch. Such touches hang dramatically in air, or perhaps on silk's surface. There is a peculiar confusion that infects the definition of the left foreground rock. The thin passage of a hesitantly angled plum branch cuts across rock's surface, apparently severing the dark top from its lighter, wider base. Indeed, the rock itself offers flat and often harsh placement of varied axe-stroke texturing. One suspects this passage may have been retouched. In its own right, the painting as a whole offers valid, even brilliant expression to which one might add the scattering of "moss" dots that play with sharp spear-pointed accents of bamboo. However, for history and its transformations of vision, can we accept Ma Yuan as turning in this direction within his projected life span?

Undeniably the theme of the flowering plum remains strong in late Song taste. Both for poetry and painting, in gardens and in the wild its presence is secure. But how far can we stretch its representation? How acrobatic can those branches and surroundings become and still lay serious claim to the personal hand of Ma Yuan? Such extensions have survived, but can they not rather be seen as signs of a new expressiveness based on Ma family traditions but realized by differing hands and minds? Perhaps such painting is also a sign of a *fin-de-siècle* mentality that may have pervaded much of Hangzhou both before and shortly after the Yuan conquest — some even later forgeries.

Consider another example from the Wang Chi-chien collection, *Enjoying Plum Blossoms* (*Guanmei tu* 觀梅圖; Pl. 48). It shows a scholar and his boy attendant boating in a shallop, now seemingly caught in the overhanging tangle of the ever-present plum. The companion is no longer the calm symbolic attendant, but the active boatman keeping his craft — its thin length like a stretch limousine — at sufficient distance so that the seated scholar may be undisturbed in calm contemplation. Such a tangle and its human response appear to be an obvious reference to plums blooming in the wild. Richard Barnhart follows an acceptable logic in pairing this fan with the Metropolitan's *Plum Blossoms by Moonlight*.[5] Certainly in general setting the two repeat a dual relationship established by the Metropolitan's *Scholar Viewing a Waterfall* (mountain heights) and Cleveland's *By a Pine-Shaded Stream* (lowland plain and water). Now it is rustic mountains and unkempt shores. To complete the comparison, in each case, one has a signature and one does not. The plum pair shows similar handling of the ever expressive tree. Each, for example, reveals on that tree the similar detail of a clump of hanging moss.

Another fan, *A Gentleman in His Garden* (*Yuanli guanmei tu* 園裡觀梅圖) in the Honolulu Academy of Arts, plays again with the theme of the extended plum (Pl. 49). It is a painting that has also been grouped with the above. Now two plum trees from opposite banks of a bridged stream contend and tangle with each other toward the center of the composition. A small, thin profiled scholar with staff stands below. Gustav Ecke's sensitive eye for artistic quality long ago retreated from its authenticity: "Ma-Hsia style, Southern Sung tradition . . . of a kind which seems obvious to the more fastidious viewer."[6]

The shift under discussion may be further illustrated from an introductory presentation of work associated with Ma Yuan by Gao Hui-yang. The author illustrates two details from album leaves presenting the scholar in a brief landscape. In them the focus is narrowed to tree roots,

[5] Barnhart, *Along the Border* (1983), p. 84. Bickford, *Bones of Jade* (1985), p. 50.
[6] Ecke, *Chinese Paintings in Hawaii* (1965), v. 1, p. 177. Also, Bickford, *Bones of Jade* (1985), p. 51.

8.4

8.5

Fig. 8.4 Ma Yuan, attributed
Pine Stream and Paired Birds (detail)
National Palace Museum, Taiwan,
Republic of China

Fig. 8.5 Ma Yuan
Strolling on a Path in Spring (detail)
National Palace Museum, Taiwan,
Republic of China

the kind that rise out of the earth beside the base of a massive trunk (a motif very likely derived from Li Tang). One is from a willow, the other a pine. The author picturesquely describes them as a "great boa rising from hibernation" 如巨蟒之蟄 or "a fiercely entrenched dragon" 如猛龍之盤踞 (Figs. 8.4, 8.5).[7] The two highlight the importance of brush expression, an artist's touch, and ultimately intent. The paintings from which these telling details are drawn are *Strolling on a Path*, earlier discussed in some detail (Pl. 17), and another similar subject now introduced, *Pine Stream and Paired Birds* (*Songquan shuangniao tu* 松泉雙鳥圖, Pl. 50). Both are now in Taipei's National Palace Museum.

The first detail (right) appears clearly contained within the tree's lower structure. The second surges out of it, related not so much to its tree as creating a convenient foot-stool for the extended scholar's perch. Still, *Pine Stream and Paired Birds* continues the established theme with a similar left-sided composition. While pine is now substituted for willow, and the aristocrat with his attendant (now holding a staff) is seated and holding a feathered fan, parallels continue with the presence of two magpies, one perched, the other in flight. Not only the tree roots but the twin trees themselves echo each other. The result has one tree looping out of the picture with returning branch, the other spreading an open canopy over the scene. Now magpie-like in form, the two birds come into the picture — rather than fly away — lured by a stone birdbath, or perhaps feeding station. One cannot here escape the subtle touch of human control with auspicious avian symbolism.

However, the proportionate narrow height and extended length of the *Pine Stream* appears to set the tone for additional transformations of form

7 Gao Huiyang, *Ma Yuan* (1978), p. 36, fig. p. 178.

whether in the drawn-out shape of the seated figure, the extension of an axe-stroke texturing, the long pointed lines of bamboo leaf-tips, or a stiff pine branch over-slender for the visual weight of its strong needles. Note, at the right, the sloping lines of the low rock-land answered above by the reverse pointing of the water passage above it, the two offering a formal lively embrace of the stone bath that draws twin birds.

As with other line-controlled representation of figures, here the scholar is not so much seated on his pine perch as placed against it, and again straight lines and angles are stiffened by a rim of white (upper robe and loose trousers are of a different tone, as in the Cleveland painting). Consistent with an emphasis on brush design, the scene is presented stage-like. Empty silk becomes a flat background rather than one conveying illusions of depth. Finally, one cannot escape a different sense of man's relation to nature, as with the cloud in *Scholar Viewing a Waterfall*. Now the birds are lured to man's garden, not startled by him as in *Strolling on a Path* where:

> Spurning man reclusive birds
> cut short a song.

Album Leaves: Further Transformations

Of all surviving paintings that feature the overhanging tree — especially the plum — and help extend Ma Yuan foundations toward a differing view of art, an art that stresses the open consciousness of art's play, a rhythmically laid out more expressive mode, none is more forthcoming, perhaps exactly realized and secure in such expression than another album leaf in the Cleveland Museum. It is cataloged there with the title, *Drinking in the Moonlight* (*Jubei yaoyue tu* 舉杯邀月圖; Pl. 51). The lower part in particular seems to have captured a blunt Ma Yuan touch. The scholar is pressed into the lower left corner. Although the figure is partially damaged and his attendant almost eliminated behind a patch of repair, the intention is clear — a backward leaning form with standard companion. Face is lifted, wine-cup raised in the direction of an imposing cliff landscape the sharp forms of which split dramatically to reveal the precarious anchoring of two plum trees, a cave-like angled path and the sliced arc of a full moon emerging from a brief "V" of sky. Pale warm and cool color tones help organize and at the same time mute the sharp certainty of the brush. This latter is carried not only in the angularity of cliff, rock, land, and progress of extending plum, but also in its detail: split flat axe-strokes, drawn-out bamboo leaves, linear strength in the conscious patterning of plum, root, trunk, and branch. This includes both the straight and the slightly tremulous.

What is happening here — as implicit in paintings already discussed — is an historical shift that in the West we would call "Mannerism." It occurs when a classic natural stability turns from nature's implied order to a conscious display of artifact, creating an overlay of the inventions of art. One moves from nature's object to personal superposition that features the skilled play of mind and hand. As defined by John Shearman, an early explorer of the mode, it is a term at once significant to Italy — the word *maniera* — in the specific time of the late Renaissance, but is also applicable to style in other historical times. It carries connotations of "effortless accomplishment" yet cannot escape the negative possibilities of "stylization." At its best it "should, by tradition, speak a silver-tongued language of articulate, if unnatural beauty . . . it is, in a phrase, the stylish style." He also claims for it a generally close connection with the "aesthetic convictions of the artist's environment . . . (where) the swing had gone beyond the mean."[8] It is not difficult to appropriate such ideas for late Song Hangzhou.

The "stylish style" presented in this scene of moonlight drinking contains a great deal of such transformed skill, yet remains within what can be considered to be a Song "tightness," a formal confidence still linked to physical detail. Consider the partial platform and stone table in the lower right with its effort to convey all the signs of a calligrapher (Fig. 8.6). Ink, brush, brush-holder, inkstone (popular in the Song as a "hoof inkstone")[9] and the brief spread of paper with touches of writing, clearly recognizable as revealing a swift cursive style. This gives the painting a special focus, indeed a specific narrative intent. It is as though the scholar, calligrapher, poet had just laid down his brush to catch the looming moon and raise his cup in solitary companionship with it. This thus adds further specific revelation of art to what is displayed throughout. At the same time it creates a curious

Fig. 8.6 Ma Yuan, attributed *Drinking in the Moonlight* (detail) The Cleveland Museum of Art

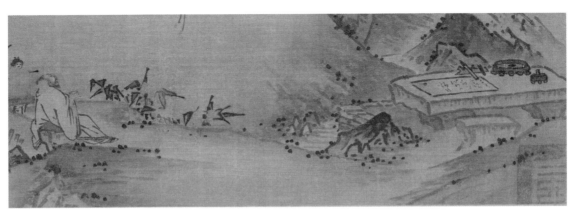

8.6

8 Selected from Shearman, *Mannerism* (1967), pp. 17–19, 42.
9 Fontein and Wu, *Unearthing* (1973), p. 220.

8.7

Fig. 8.7 Li Bo, attributed
On Yang Terrace
Palace Museum, Beijing

disjunction in which literati skills are placed in the heart of an academic style.

Indeed it is the subject itself, combined so well with the painting's style, that gives this album leaf special importance. An expressive style, the scholar raising his wine cup at the moment of an appearing moon, and a brush laid down beside its free calligraphy, the rustic seat momentarily empty cannot help but point toward recognizing an ideal portrait-landscape of the Tang poet, Li Bo, Du Fu's contemporary. Once again the Tang dynasty is brought into the late Song. While it does not appear possible to actually read the pattern of strokes revealed by the outspread rectangle of calligraphy, its four lines and apparent signature indicate the flow of a brief poem. It is not difficult to tie this to Li Bo himself. A rare example alleged to be his has survived and is currently in the Palace Museum in Beijing. Although authenticity is in great doubt, it too is of four lines and adds a signature. It carries the title referring to part of the imperial palace at Chang'an (Xi'an), "On Yang Terrace" (*Shang Yangtai* 上陽臺), written in the style of Emperor Huizong's golden wire calligraphy (Fig. 8.7). More significant for the Ma Yuan tradition, however, is the presence of a seal of Zhao Mengjian (*Zigu* 子固). If not spurious, it would place this brief fragment (recalling earlier imperial capitals) in the environment of late Song Hangzhou, certainly within the lifetime of Ma Yuan's son, Ma Lin. With the calligraphy in the painting, one

of the few ink touches that might be read is the final character. It suggests a hasty rendering of "Bo" (白).

Be that as it may, more important is the portrayal of a kind of calligraphy with which Li Bo is intimately connected. He knew the great writer of a free-spirit brush, Huaisu 懷素 (b. 737). In fact Li Bo honored the younger calligrapher with a poem, "Song for Cursive Writing" (*Caoshu gexing* 草書歌行), including the comprehensive line: "In cursive writing all the world claims he walks alone"[10] (草書天下稱獨步). As with Li Bo, both were considered free spirits. Inspiration came through wine. Du Fu placed Li Bo and another eighth-century free calligrapher, Zhang Xu, Huaisu's elder, together in his poem, "Song of the Eight Immortals of the Wine Cup" (*Yinzhong ba xian ge* 飲中八仙歌). In it is Li Bo's self-described phrase to the emperor, "Your Majesty's servitor is a wine-steeped immortal" 臣是酒中仙.[11] However, the subject in the painting is so specifically related not only to wine and calligraphy but more exactly to the viewing of a moon that it cannot be readily diverted to other such calligraphers.

Returning to it, *Drinking in the Moonlight* reveals the same free spirit of Li Bo himself as a legendary lover of wine, free expression, and the moon that is sealed in the lines of some of his most famous poems. Here, confronting this Ma-style painting, consider his "Under the Moon Drinking Alone" (*Yuexia duzhen* 月下獨斟):

Among the blossoms a jug of wine	花間一壺酒
pouring alone facing none	獨酌無相見
raising the cup to toast the moon	舉盃邀明月
shadow beside and there are three.	對影成三人
For moon no knowledge of drink	月既不解飲
and shadow's moves must follow me.	影徒隨我身
A moment: moon companion clinging shadow,	暫伴月將影
joy — springtime's reach.	行樂須及春
I sing, moon back and forth	我歌月徘徊
I dance, shadow confused.	我舞影凌亂
Waking is together pleasure	醒時同交歡
Drunk and each a way his own.	醉後各分散
Yet ever linked through idle wander	永結無情遊
far off we'll meet in the river of stars.	相期邈雲漢

The far distance of that starry river streaming across the sky leaves a marvelously suggestive and enduring image, the future of the poet's earth-

[10] Li Bo, *Li Bo quanji* (1996), ch. 7, p. 1237.
[11] Wang Shijin, *Du shi bianlan* (1986), p. 65. Hung, *Tu Fu* (1952), p. 52.

released feelings which for now, as in this painting, remain in Du Fu's description written to him: "Completely drunk, singing wild songs, passing empty days" 痛飲狂歌空度日.[12]

Most consistently poems connected with paintings of the twelfth and thirteenth centuries suggest images that repeat or parallel the painted vision. This also holds here with the lower part capturing something of the bluntness of a true Ma style. Either the word or the image might guide us through the other. Now almost faded away are flowering dots of rose and green on plum branches. Precise is the cup-raising scholar leaning back to view and toast the moon. "Shadow" is more subtle. It holds in a triangle of surface wash beside the poet that in its shape echoes Li Bo's angled pose. "I sing" is in the open mouth. "Back and forth," "Shadow confused" are surrendered to the painter's crisp brush: the spirited "dance" of plum in line and form, the contending cliffs that rise to partially block the moon. Expected moonlight serenity is not present except in its interrupted roundness. The last of the poem takes us toward a yet-to-be-realized conclusion, here visually emerging in contending shapes as promise, the high, small but positive wedge of silk-sky, space far above the tight entering "wander" of the earth-path below.

One might contrast this lively narrative of nighttime drinking and moonlight with the sober *Grasping the Wine Cup* in the Tianjin Museum as to which has absorbed more of Ma Yuan's intentions. The suggestion has also been made that *Drinking in the Moonlight* might relate to a specific Hangzhou scene: Moon Cliff (*Yueyan* 月岩) in the hills behind the imperial precincts.[13] If so, it would only affirm a continuing reliance on physical experience that marks Hangzhou's Late Song art.

The sense of a familiar autocratic place, however transformed or idealized, is present in another very different beautifully crafted album leaf now in the Boston Museum of Fine Arts: *Viewing Sunset from a Palace Terrace* (*Diaotai wangyun tu* 雕臺望雲圖; Pl. 52). This is also a painting that has traditionally carried the suggestive aura of Ma Yuan. Now visual transformations appear more subtle. With unique attention to sky, we turn to the importance of a space that dominates a compressed architectural base. Unusual is the specific light silk cloud-streak (somewhat worn and damaged) that suggests high cirrus cloud formations on fading blue wash. There are lingering touches of gold and red implying day's end. The architecture below is in unwavering miniature detail: careful roofs, a dizzying steep

[12] For the poem see Li Bo, *Li Bo quanji* (1996), p. 3268. The "river of stars" in the last line refers to the Milky Way. For the poem see Li Bo, *Li Bo quanji* (1996), p. 3268. For other translations see Obata, *The Works* (1965), p. 85. Hinton, *Selected Poems* (1989), p. 5. For the Du Fu line and the whole poem, see Owen, *The Great Age* (1981), p. 189.

[13] Lee, *Exquisite Moments* (2001), p. 31.

staircase, precise dotting of treetops, three tiny inhabitants, brackets, lattice work, a broad paved platform carefully furnished — screen, table, stools, flowerpots — in a word, a complex structure of elegant heights helping to seal the ease of the far view, the privileged figural gaze (Fig. 8.8).

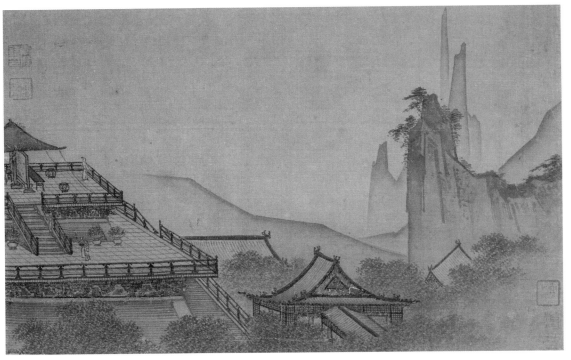

8.8

Fig. 8.8 Ma Yuan, attributed
Viewing Sunset from a Palace Terrace
Museum of Fine Arts, Boston

However, there are differences from the familiar nature-directed view, and it is architecture that appears to engineer them. The platform is carefully tipped, the better to see what is on it. While near roofs are gravely stable, the one to the right is consciously slanted, its ridge a directional line to cliff and mountain crest. It is the latter with their deliberate shapes that seal this elegantly crafted painting. Rather than the ease of nature's distances, sharp outlining of angled or gloriously vertical summits of hill and mountain take on the quality of rulered architectural drawings. It is architecture — whether in the fabulous building itself or its echo in hill, hill-crest and mountain — that, however tiny the figures, bring them closer to the even higher sky, indeed makes possible the painting's purpose which is to praise, by making it openly available, the far view. It is a purpose made the grander by the scale of the tiny thin aristocrat standing at the platform railing. Exactly before him a hillcrest line vanishes, surrendering to calm mist intrusion, an entrance to the spaces above. Far to the right magical needle peaks also point out the heights, the clouds that crown the fading evening

sky, all now in the range of his gaze. Finally, it is a gaze of broad viewing that because of an unobtrusive personal presence becomes more exactly ours. To be truly effective, the repetition of a quietly contemplating figure, so important in the twelfth and thirteenth centuries, must draw us across the line from looking *at* to looking *with* and thereby truly understanding what the painter has revealed. In this case it may bring us to a time, and the time may well be the Double Ninth. Certainly it is high enough. The flowerpots are suitable for chrysanthemums. There are two empty stools and the two servants waiting below can indicate the expected arrival of a guest. As with Ma Yuan's *Night Banquet*, it may be an event about to be.

This collection of miniature paintings all generally recognized as carrying the aura of the painter, Ma Yuan, can represent only a very tiny fraction of what were certainly thousands of such efforts by or reflecting the work of skillfully recognized artists and their followers trained in the Academy or copied outside it during and after Ma Yuan's lifetime. Xia Wenyan's *Precious Mirror for Painting* (*Tuhui baojian* 圖繪寶鑑) helps us recognize the poverty of what has survived. He lists countless names for whom we have no existing paintings, among them followers of Ma Yuan, by my count half a dozen outside of the Ma family, including the already discussed Wang Jie. Even granting his accepted popularity, there is no reason to think that the number of his surviving works should greatly exceed other famously recognized masters, most notably Li Tang, Xia Gui, Liu Songnian, or the favored Chan artists so embraced by Japan.

The implied variety of what has been selected here as transformations makes it doubtful that a single hand created them all, much less Ma Yuan himself. What seems to be involved, beginning toward the end of the Song, was a recognition of Ma Yuan as one of soaring popularity and importance, buoyed no less by his close imperial patronage. It was important to have a "Ma Yuan," the most believable by close followers or clever contemporary copyists. This brings us to what at first glance is a strikingly beautiful multiplication of not just one or two landscapes related to Ma Yuan but an entire album of such scenes that have recently come to light and published as owned by an anonymous New York collector. Assembled are twenty leaves in ink and color on silk: ten of landscapes, ten of calligraphy (*Shihua ce, ershi kai* 詩畫冊, 二十開; Pls. 53a–j). Half of the paintings are signed with the name of Ma Yuan preceded by the character *chen* (servitor), thus giving them official academic recognition). That five are unsigned merely carries out a practice already discovered in other Ma Yuan–related pairs. The declared calligrapher is no less than Emperor Ningzong who ruled parallel to Ma Yuan's maturity from 1194 to 1224. Further, bright twin rectangular seals reading "imperial calligraphy" (*yushu* 御書) claim proof of Ningzong's hand. A small fragment of a seal remains in the upper corners of most of the

leaves, enough apparently to be deciphered as that of the Jixi Palace which was constructed in 1236, twelve years after the death of Ningzong in 1224.

Lee Hui-shu has successfully explored the content of the calligraphy concluding that the poems have little to do with Ningzong himself but are a kind of collage plucked in part or in whole from a variety of poets (in the order of her presentation): Li Shi 李石 (b. 1108), Wang Anshi, Chen Yuyi 陳與義 (1091–1138), Yang Wanli, Emperor Huizong (r. 1101–1126), Fan Chengda, Shao Yong 邵雍 (1011–1077). She offers the further conclusion that putting such poems together would require wide learning, a special literary knowledge beyond the recognized character of Emperor Ningzong's abilities. The selection therefore must have been the work of a literati official within the court. The learned Li Bi 李璧 (1159–1222) is suggested, especially since he was the editor of an annotated collection of Wang Anshi's poems.[14]

As for the calligraphy itself, while the general form may be there, the writing often shows a curious lack of spontaneous even strength. Instead of a constancy from top to bottom in each of the seven-character lines that fill the album one can often detect a disarming shift from rich dark ink to light thin definition in a subsequent character as in the last two lines of the poem for "Gazing at Spring Mountains" (*Guan chunshan* 觀春山) by the much older contemporary of Ma Yuan, Yang Wanli (Fig. 8.9), or the full scope of Huizong's poem for *Spring Gazing from the High Terrace* (*Loutai guanchun* 樓臺觀春; Pl. 53f). Of course one expects some variation due to the ink flow in the brush and its necessary replenishment. But how often is this needed in the spontaneous brushing of a brief poem? Then there is the question of a signature. Generally speaking, an album leaf or fan filled with southern Song imperial calligraphy is "signed" with a seal denoting "imperial calligraphy" (*yushu*). For Ningzong, however, surviving examples are rare. All the more significant are two dated examples. *Celebrating the Birthday of Empress Yang*, (*Shu Kunning shengchen shi* 書坤寧生辰詩), an album square of silk now in the Art Museum, the Chinese University of Hong Kong (Pl. 54), offers four lines of a seven-character poem beginning (upper right) with a dark strong character. This carries over in essentially undiminished value down the whole line (even allowing a thinner brush-tip required of a complex form). Indeed such strength marks the entire composition. At the same time Emperor Ningzong is not reluctant to impress the vigor of bold seals, here the twin squares of a date, *bing zi* 丙子 (1216), and filling the lower left corner, a traditional large gourd seal for "Imperial writing" (*yushu*). Also on silk, a second example dated three years later, is currently in New York's Metropolitan Museum of Art (Pl. 55). Now in the form of a rounded fan its

[14] Lee, *Exquisite Moments* (2001), for publication of the album, pp. 86–93.

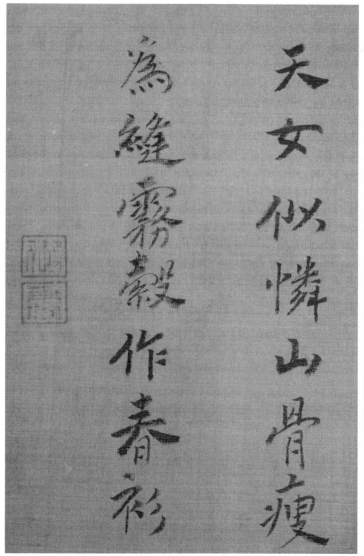

8.9 8.10

somewhat abraded surface also presents four lines, a *Quatrain on Immortality* (*Qingliang jingjie qijue* 清涼境界七絕). Again, despite damage, there is a consistency of touch and it is similarly stamped with strong seals of its date, *ji mao* 己卯 (1219), and a large gourd shape form carrying its assertion of "Imperial calligraphy" (Fig. 8.10).

Of course, the birthday writing in particular carried a focused, personal meaning. However, given the ambitious undertaking of an entire double ten-leaf album featuring the important Late Song theme of contemplating the natural world, brushed in turn by a favorite and famous imperial artist,

Fig. 8.9 Ma Yuan, after
Landscape Album Paired with Imperial Poetry Inscriptions (leaf d, detail: *Gazing at Spring Mountains*)
Private Collection

Fig. 8.10 Yang Meizi
Quatrain on Immortality (detail)
The Metropolitan Museum of Art

8.11

Fig. 8.11 Ma Yuan, after
Landscape Album Paired with Imperial Poetry Inscriptions
Private Collection

Fig. 8.12 Ma Yuan, after
Landscape Album Paired with Imperial Poetry Inscriptions (detail of leaf b: *Listening to the Bamboo in the Water Pavilion*)
Private Collection

carrying the implication of an imperial nature tour, its literati credentials established by a complex knowledge of historical poets, with all this, are the simple exactly repeated square *yushu* seals (one is tempted to say, "delicate and monotonous") a worthy signature for Ningzong's involved imperial presence? It is a seal (Fig. 8.11) that pales beside the strength of signature on both the separate calligraphy album leaves.

In returning to the paintings, this failure of convincing strength also haunts their execution. While the preservation of freshness should by no means disqualify the hand of a famous master so many centuries in the past, the quality of that representation must be a determining factor establishing, in a word, authenticity. The subject-content is certainly consistent with expectations of painting in the thirteenth century. Some of those subjects have already been discussed. It is, rather, the execution that matters. There is a lack of what might best be described as "depth." This is often blocked by an over-refinement of detail. By this I mean the substance of an object, the quality of an outline, the life of a figure, the subtleties of extensions into space.

Look closely at the foreground of the leaf *Listening to the Bamboo in the Water Pavilion* (*Shuiting ting zhu* 水亭聽竹; Fig. 8.12), drawing on a poem by Wang Anshi. It is not just that precision is established in the pavilion architecture, which would be expected, but that it extends to other aspects

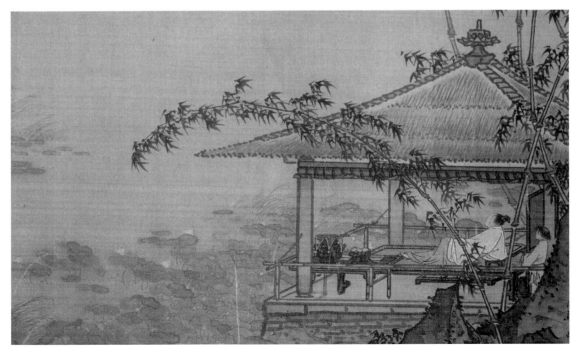

8.12

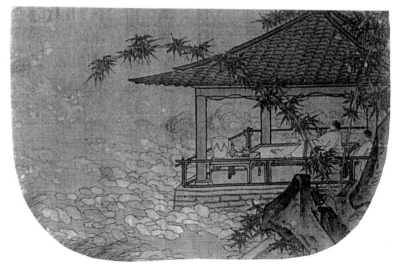

8.13

of the foreground as well, including bamboo leaf, rock, and human figures. Indeed, it is not so much the architecture itself that invades the style, but an exaggerated rigidity of its representation that destroys its significance. Thus for the roof there are careful bands of separation between the thatching and the dark-tiled ridges that anchor it. Moreover, the thick lines of post and railing are too ruler-intrusive in their black surety to allow substance within. This extends to the mannered crisp shape of the foreground rock, and in another fashion to the thin extension of a pointed eave that stretches the pavilion roof outward beyond visible support, a spear-point, where it is then given a too-deliberate blessing by an additional single arc of bamboo. Nor do the thin careful lines of drapery, reinforced by white banding and capped by featureless outlined faces, convey a true sense of relaxed ease.

As has been already shown of several paintings by or attributed to Ma Yuan — *Fitting Plum Branches, Night Banquet, Lü Dongbin,* and *Scholar Viewing a Waterfall* — the world of copy or imitation hovers readily around the fame of Ma Yuan. It is not surprising, then, to discover a second painting of *Listening to the Bamboo*. This time the album leaf is shaped with curiously rounded corners. It was at least formerly in the Far Eastern collection of J. D. Chen (Pl. 56a and Fig. 8.13). As with previous comparisons, such versions continue to avoid exact repetition. Most notable in this second rendering is the pavilion roof as it shifts from a deliberate pattern of tile and separate thatch to one that is completely tiled, and while the same sharp eave extension holds, the painter now conceived it necessary to curve it subtly upward and offer physical support with bracing circles of beam-ends. More significantly, when two such versions occur, both of differing quality, is the

implication that behind them must be a more accurate template carrying the certainty of a master hand.

Return, then, to further selections from this remarkable group of ten paintings. I will limit my analysis to two of them deliberately chosen for their contrasting approaches. On the one hand there may be so much detail that the relaxing breath of easy space is stifled by its rigid presence; on the other, openness yields to an exaggeration of flat silk leaving foreground brevities that have too deliberately surrendered qualities of natural substance in tree, rock, or man so valued in the finest of Song definition during Ma

Fig. 8.14 Ma Yuan, after *Landscape Album Paired with Imperial Poetry Inscriptions* (detail of leaf a: *Whiling Away the Summer by the Lotus Pond*) Private Collection

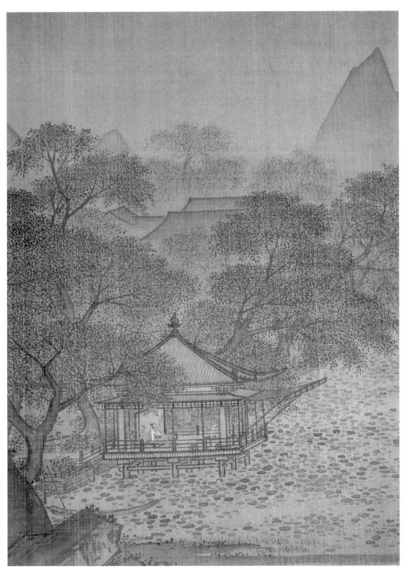

8.14

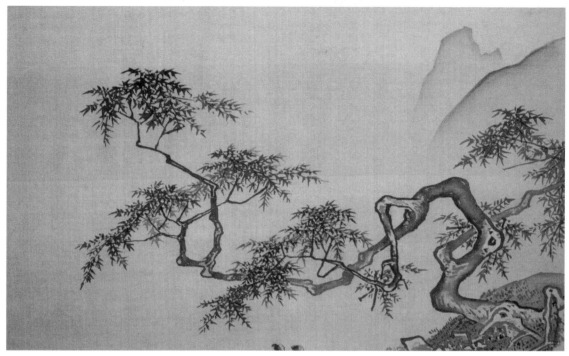

8.15

Yuan's time. They carry the English titles of *Whiling Away the Summer by the Lotus Pond*, and *The Long-Lived Locust Tree*.

In *Summer* (Pl. 57a) all the elements are there: the corner composition at the lower left, the rock, the empty anchored skiff, the open architecture extending over water, the lotus leaves below, massed shading of deciduous trees above that reach to lofty roof-tops and then beyond to rounded hills followed by a layer of mountain peaks. The problem — rather like the previous *Listening to Bamboo in the Water Pavilion* — is that each element appears too deliberately rendered and carefully placed. The light side of the introductory rock becomes abruptly a flat dark wash. Each stroke of foreground water-reed or daub of lotus leaf is conceived in separate isolation. In turn the painstaking dots that offer tree-shading foliage are massed into careful clumps separated by fixed alleys of narrow space, the whole sealed by the flatness of a mountain screen with crests of ruled sharpness (somewhat recalling Boston's *Viewing Sunset*) (Fig. 8.8). In sum, this deliberate triumph of design — perhaps appealing in its own right — is not enough to grasp the breath of nature's summer presence.

With *Locust Tree* (Pl. 57i) the shift is to heights where spareness in earth's richness isolates the wonder of an ancient tree. Surely the tree extends as Ma Yuan might well agree, but where is that blunt strength to characterize what is represented and make wide space more than just flat silk? (Fig. 8.15). Where is

Fig. 8.15 Ma Yuan, after *Landscape Album Paired with Imperial Poetry Inscriptions* (detail of leaf i: *The Long-Lived Locust Tree*)
Private Collection

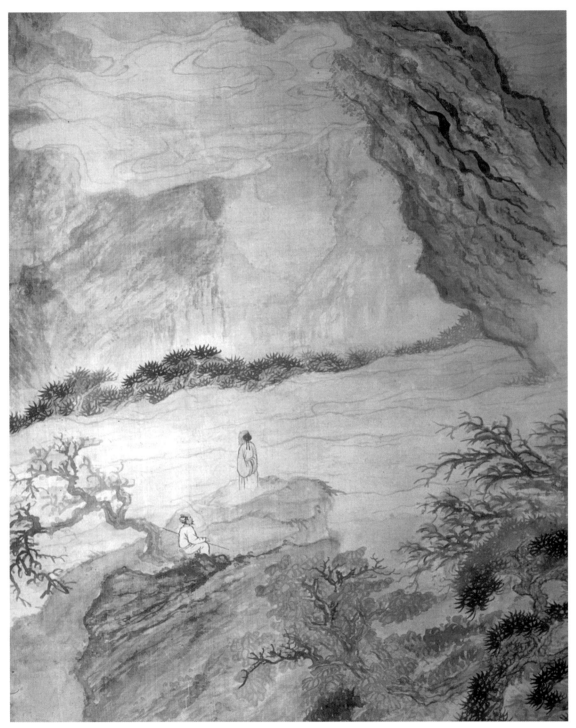

Fig. 8.16 Shitao
The Waterfall at Mount Lu (detail)
Sen-Oku Hakuko Kan

the sense of substance in rock, root, or tree? For the benefit of an aristocratic staff-carrying companion, a leafy garbed figure (certainly of Daoist intent) points in explanation toward the angled tree base where the first form encountered is outlined like a rock but within which is a wash suggesting a connection with the land behind. Is it then an errant tree root? Strange transparency. Indeed, does the tree really grow with its mannered roots, its ink-washed trunk and dagger-like compound leafage isolated against flat silk?

One calligraphy-painting pair, *Gazing at Spring Mountains* (Pl. 57d), is worthy of special comment. The calligraphy of Wang Yangli's poem reveals the lack of constant strength already noted. But the painting is exceptional in defying expectations created by the other leaves. It presents an unusual composition in that the mountain forms hover over a band of foreground mist. Not only in what this album presents but what has survived broadly in late Song painting — other than some subsequent ink splashes and washes often associated with Chan Buddhism — is a view introduced in this floating manner. An open band of entry universally suggests the tangibility of water or perhaps empty flat land. The effect of this unusual motif is to create a floating removal from immediate availability, a kind of withdrawal which is far more suitable for post-Song painting, especially that associated with personal expression. Even then it is not common. It is, however, an accepted device in late seventeenth-century painting connected with the fall of Ming power and the rise of Manchu control, a kind of personal retreat most notably a feature of the great individualist, Shitao 石濤 (1642–1707), as seen in the lower section of one of his most famous paintings, *The Waterfall at Mount Lu* where the landscape's floating stance is echoed in the standing gazer (Fig. 8.16).

This might rest as an incidental curiosity for *Gazing at Spring Mountains* were it not for the unusual nature of the mountains themselves. The prominent overhanging mid-distance peak is clearly related to the similar overhang in the more convincing Ma-style painting, *Viewing Plum Blossoms by Moonlight* (Pl. 47; Fig. 8.17). Now, rising out of mist, the form is textured by unusual tiny "pepper dots" (*hujiao dian* 胡椒點), an unexpected visionary contrast to the Ma Yuan axe-strokes (*fupi cun* 斧劈皴) in the foreground, to say nothing of his usual simplicities in mountain wash. In turn the next distant mountain draws out the dots to vertical strokes, a miniature form of so-called "nails drawn from mud" (*nili bading* 泥裡拔釘) that can be associated with the eleventh-century artist Guo Xi. Finally, distant thin mountain spires continue to present what is traditionally not found in leading Ma Yuan works, although they can be found, with a different touch,

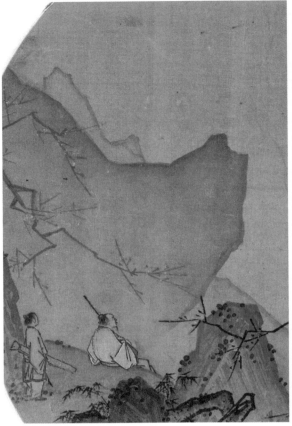

8.17 8.18

Fig. 8.17 Ma Yuan
Viewing Plum Blossoms by Moonlight
(detail)
The Metropolitan Museum of Art

Fig. 8.18 Ma Yuan, after
*Landscape Album Paired with Imperial
Poetry Inscriptions* (detail of leaf d:
Gazing at Spring Mountains)
Private Collection

in rare paintings by or attributed to Li Tang.[15] It is a painting, too, that does not neglect the inevitable extended tree, now a pine gracing the right foreground. The extension is vertical but no less contrived, an accordion-shaped zigzag that is in turn echoed below by roots mysteriously fronting the massed grass of the corner slope (Fig. 8.19). There is a skill, the skill of a trained craftsman, but it is surface, not substance that results. In comparison again one can suggest antecedents, for example, a pine tree drawn from an album leaf by Ma Lin in New York's Metropolitan Museum of Art, *Landscape with Great Pine* (*Da song tu* 大松圖): large foreground rock, steep right-hand cliff and the clinging angled vertical pine. There are touches that the father would not have made, but the natural physical strength remains true to the family tradition (Fig. 8.20).

Indeed, one of the reasons why these selected transformations, however carefully ordered, do not fit with expectations of Ma Yuan himself is the

[15] Cahill, *Index* (1980) under "Li Tang," pp. 122–23, in Taipei Palace Museum listed as SV64; VA16b.

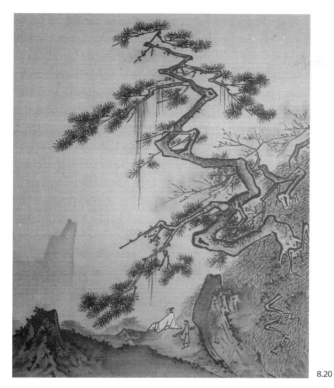

Fig. 8.19 Ma Yuan, after
Landscape Album Paired with Imperial Poetry Inscriptions (detail of leaf d: *Gazing at Spring Mountains*)
Private Collection

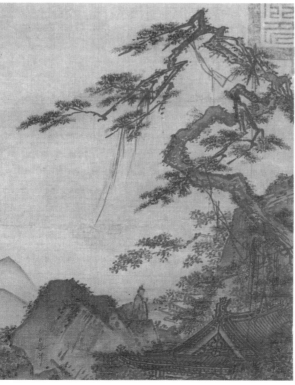

Fig. 8.20 Ma Lin
Landscape with Great Pine (detail)
The Metropolitan Museum of Art

fact that they are foreign to the family traditions carried on by his son, Ma Lin. Whatever the value of the claim that in younger days the father ghost-painted for his son, the finest work associated with Ma Lin clings persistently to a blunt family dignity that continues to differ from ordinary academic elegance. It is the wonder of Ma Lin that as he develops he stretches the manner of the father both in physical form and spatial extension to the thin edge of denial without letting go. Thus, his famous *Fragrant Spring* (*Fangchun yuji tu* 芳春雨霽圖), in Taipei's National Palace Museum (Pl. 59), fills the Ma family style with expressive delight whether it be the jaggedness of a rock, the extended horizontal of the blossoming plum, the dancing left-over of last year's reeds, the tiny reality of swimming ducks (again Su Shi: "When spring river water warms the duck is first to know"), the active play of mists, or the deliberate off-center centering of the tallest trees so that there is a gateway (partially blocked) to the embracing reality of direct distance — all this infusing a view with the special strength of non-static magic, nature's irregular undeniable hold on the freshness of renewing life, a life not overly trimmed by man.

Whether the calligraphy that gives the title is by Ningzong or his empress, one must date the painting no later than either the death of the former in 1224 or the latter in 1233, and Ma Yuan could well have been alive during some of this time. However, two of Ma Lin's most significant surviving fan-album leaf paintings carry, on accompanying silk, elegant dated calligraphy of the next emperor, Lizong (r. 1225–1264). One, *Evening*, in Tokyo's Nezu Institute of Fine Arts (Pl. 23), was mentioned briefly above in connection with Ma Yuan's paintings of *Water*. It illustrates the couplet, "Mountains hold autumn colors close / Swallows cross the evening sun late," characterized by Max Loehr as ". . . a marvel of terse economy and tidy elegance."[16] It was an imperial presentation to his ten-year-old princess daughter, a daughter, alas, who saw her last evening sun at the age of twenty-two. The other, *Watching the Clouds Arise*, illustrates Wang Wei's famous Tang period couplet, "Walking to where the waters end / Sitting to watch the time the clouds arise" 行到水窮處，坐看雲起時. With inscriptions of 1254 and 1256, there is no wavering in the richness of their imperial calligraphy nor the certainty of seals and dates, the years are well beyond the believable life span of Ma Yuan. The work of 1256 returns us to the gazing theme (Pl. 60b).

In its brevities and suggestive power an artist is both respecting a tradition into which he was born and creating a style of his own. Firm selective strokes draw entry to the lower left — water, rock, foliage, man — with a condensed restraint that anchors immediate understanding. The angle of a strongly seated figure and his laid-aside staff gives exact contemplative

[16] Loehr, "Chinese Paintings" (1961), p. 274.

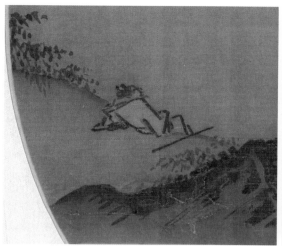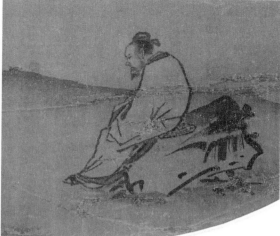

8.21 8.22

direction toward a goal that is the briefest of ink touches, touches that seal
a point when a rising vision conceals and yet reveals a mountain's presence.
Something ordinary becomes extra-ordinary. It is a moment when physical
fact reveals across tangible distance the reality, indeed the mystery, of fragile
existence.

The nature of the imagery is in special harmony with its calligraphy. Just
as the painting reduces a complex natural scene to a few strokes of the brush,
the two lines of calligraphy are culled from an eight-line poem, "Zhongnan
Retreat" (*Zhongnan bieye* 終南別業), that expresses Wang Wei's maturing
progress toward enlightenment.[17] That the poet was a devout Buddhist
cannot be separated from the intentions of both the calligrapher and painter.
Indeed, the same two lines can be found in a Chan Buddhist text, *Gathering
the Sources of the Five Lamps* (*Wudeng huiyuan* 五燈會元) printed three years
earlier in 1253.[18] It is not surprising that in expressing Chan ideals the
son appears to follow the father. Robert Harrist and Ellen Laing have even
suggested that the image here might be considered a portrait of Wang Wei
himself.[19] If so, we could place it among the variety of such images that
appear to help define Ma Yuan. In style a relationship can be even more
exactly expressed by pairing Ma Lin's gazing figure to one realized by the
father in his fan of *Scholars Conversing beneath Blossoming Plum Tree* (Pl.
16). The two contemplative figures, differently realized, are yet alike in their
strength of selected linear presence (Figs. 8.21, 8.22).

Fig. 8.21 Ma Lin
*Sitting to Watch the Time the Clouds
Arise* (detail)
The Cleveland Museum of Art

Fig. 8.22 Ma Yuan
*Scholars Conversing beneath
Blossoming Plum Tree* (detail)
Museum of Fine Arts, Boston

[17] Pauline Yu, *Poetry of Wang Wei* (1980), pp. 157 and 171.
[18] Compiled by Puji, *Wudeng huiyuan* (1252), *juan* 10, p. 183 lower right. For further discussion
of both poem and painting see Edwards, "Painting and Poetry" (1991), pp. 424–27. Harrist,
"Watching Clouds Rise" (1991), pp. 301–23.
[19] Harrist, "Watching Clouds Rise" (1991), p. 304.

Continuing proof that an understandable Ma family style may extend for yet another generation, doubtless overlapping Ma Lin's lifetime, has been suggested in discussing the famous hanging scroll signed with the name, Ma Gongxian, the meeting between Yaoshan and Li Ao (Pl. 28). While adopting many aspects of Ma Yuan's art, the painter — most convincingly Ma Yuan's grandson — differs in introducing an unusual and contrasting intensity. A single tradition gives way to individual expressions of it. To highlight its personal integrity it need not only be compared to the subtle "transformations" selected here, but by contrasting two details showing Ma Gongxian's Yaoshan (Fig. 8.24) and a painting now in New York's Metropolitan Museum of Art of the same Yaoshan episode (Fig. 8.23). The latter, realized by a different artist with the lightest of ink touches, is an example of "apparition" painting (*wangliang hua* 魍魎畫), the painting that is almost not there. It is datable from its inscription by the monk Yanxi Guangwen 偃谿廣聞 (1189–1263), when he was abbot of Hangzhou's famous Lingyin temple between 1254 and 1256, dates so significant for Ma Lin's work, and certainly possible as well to include the projected life of a Ma Yuan grandson. The two are significant and contrasting ways in which painters might answer the more ordinary mainstream of academic art.

Fig. 8.23 Zhiweng, attributed
Meeting between Yaoshan and Li Ao
The Metropolitan Museum of Art

Fig. 8.24 Ma Gongxian
*Li Ao and Yaoshan: Question —
Answer* (detail)
Nanzen-ji, Kyoto

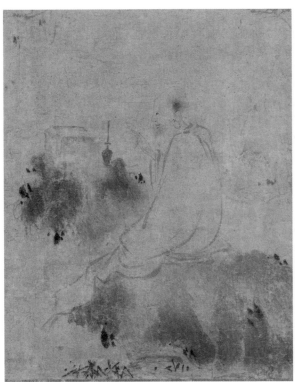

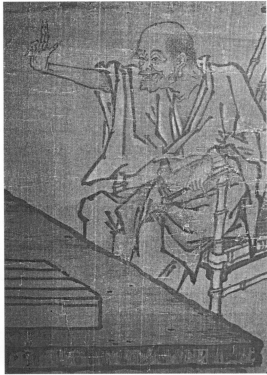

8.23

8.24

Handscroll: Ink on Paper

The anonymous ideal representation of the poet Li Bo in *Drinking in the Moonlight*, where the insertion of calligraphy into the scene offers such a significant clue to meaning, perhaps brings our account to another aspect of the Ma Yuan style. This rides on the lurking suspicion, suggested by a few surviving paintings, that the Ma Yuan who comes to us mostly in paintings on silk, often with imperial connections, must also have turned his skill to a more consciously personal mode, the play of ink as it reacts to the sympathetic surfaces of paper. In Ma Yuan's lifetime this might have followed two possible directions. One would turn him toward the literati tradition and the spontaneity of scholar painting ideals that were by now well at hand, established by such earlier luminaries as Su Shi, Li Gonglin, and Huang Tingjian. The other was the free ink tradition most evident among painters identified with Chan Buddhism and its subjects.

Ma Yuan's relationship with the wealthy poet-aesthete Zhang Zi affirms that he was not limited to painting and patronage within the palace. Moreover, having painted ideal portraits of Chan heroes, he was certainly involved with Chan Buddhism. Is this not exactly what his younger contemporary Liang Kai reveals as he moved from an imperial commission with his painting of *Sakyamuni Emerging from the Mountain* — a work with a suggestive relationship to Ma Yuan's wintry *Fuel Gatherer* — to his famous free ink dream-like rendering of the chanting poet, *Li Bo*, now in the Tokyo National Museum, as well as crisper Chan heroes? However, there is little evidence in his painting of past sages that Ma Yuan was interested in such a stylistic shift, and Liang Kai's transformations must rather be considered as reminders of the richness and complexities of Hangzhou aesthetics as they appear to have extended beyond the main lifetime of Ma Yuan and his classic definitions of form. Li Bo's *Drinking in the Moonlight* from the Cleveland collection is a clear indication that expressiveness in the family tradition was on a different path. Furthermore, Liang Kai's shift appears to have been related to a direct rejection of his connections with the Academy, a path not acceptable to Ma Yuan. As to literati aspirations, his social status within the Academy would hardly have allowed him that option. For example, calligraphy, so much a part of scholarly aesthetics, only entered the Academy world as practiced by the imperial family. Gaozong, for example, whose brush set a calligraphic standard, was a great admirer of Mi Fu. Consider the ambiguous position of Ma Hezhi, whose art, often praised for intellectual and implied "scholarly" archaism, must yield its written counterpart to the calligraphy of imperial hands.[20] Ma Yuan, in a very different manner, would

[20] For a complete discussion of images and text see Murray, *Ma Hezhi* (1993).

have been subject to the same pattern. Indeed, traces of his style were to cast their extending shadow on similar successive illustrations, including, as well, imperial-style calligraphy. This is particularly evident in a version of the *Ladies' Classic of Filial Piety* (*Nu xiaojing* 女孝經) currently in Taipei's National Palace Museum (Fig. 8.25).[21]

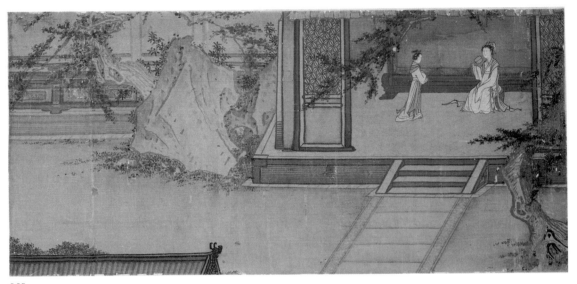

8.25

Fig. 8.25 Unidentified artist *Ladies' Classic of Filial Piety: Noble Ladies* (section 1) National Palace Museum, Taiwan, Republic of China

What then does the "ink-play" attributed to Ma Yuan yield? The collection of the Shanghai Museum claims three possible such works. However, none of them, either in the quality of motifs that might suggest Ma Yuan or the absence of them in different designs, embrace the master's touch. Quality-wise the most promising is an interesting group of four separate winter landscapes that suggest a very late Song ink manner. Published earlier as by the artist, they have since, more justly, been described as "anonymous."[22]

Far more interesting is a handscroll in the Cincinnati Art Museum, *The Four Sages of Shang Shan* (*Shang shan sihao tu* 商山四皓圖). Mentioned earlier in connection with a recorded subject of chess playing under plum blossoms, it is worthy now of careful analysis. Painted in ink on paper with touches of color (33.6 x 3073 cm, Pl. 58), it carries the added weight of some thirty-seven colophons. Several of them, both by name and/or rhyme scheme, also

[21] For a complete discussion of the subject see Murray, "Ladies' Classic of Filial Piety" (1988), pp. 95–129. Also the same author in Weidner, *Latter Days of the Law* (1994), pp. 27–53.

[22] For the earlier attribution see Xu Senyu, *Huayuan duoying* (1955), vol. ii, p. 4, and for the changed attribution, *Zhongguo gudai shuhua tumu* (1987), vol. ii, p. 62 for the handscroll. Also p. 37 for three other individual attributed works, nos. 0062–4 whose attribution seems similarly questionable.

refer to another poem by Yang Zai 楊載 (1271–1323), its absence noted by Emperor Qianlong's recording in the eighteenth century. It is believed to be preserved in Yang's collected writings. To add uncertainties, however, it is listed there as written for a screen.[23] All writings, to which must be added the calligraphy of Qianlong dated to 1754 and 1765 on the painting itself, create an extended web of commentary. All relate only to the subject, with the occasional nod to a painting, but none admit the artist. In Qianlong's writing it is the publication title, not the writing itself, that identifies Ma Yuan as the painter. At any rate, the first two colophons, if written at a time of maturity, can be no earlier than the fourteenth century. Compare the writers' life-spans: Yang Zai (1271–1323), Yang Weizhen 楊維楨 (1296–1370). Several of the succeeding colophons, including that of Ni Zan 倪瓚 (1301–1374), the twenty-first in the original list of writers, claim to follow the rhyme scheme of the first writing.

The fame of the Four Sages rested on their refusal to accept what they considered to be the tyranny of the Qin dynasty (221–207 B.C.) in its overthrow of the Zhou. Writers here place them in the context of both the earlier Bo Yi 伯夷 and Shu Qi 叔齊, who in refusal to support the Zhou dynasty similarly withdrew, and the famous legend of the Peach Blossom Spring, written by Tao Quan (Yuanming), that told of a later discovery at Wuling of a hidden community whose forefathers had similarly rejected the Qin. The Four lived on mushrooms and herbs. They played chess under the pines. They were also said to have returned to influence the succeeding Han dynasty and to place it on a proper moral course. Among the colophons it is the significance of this return that is sometimes debated. In a word, were they true recluses? For our purposes, however, the strength of reclusion is what the scroll relates. Turning to Ni Zan's poetic colophon, dated to 1371, three years before his death, the return is only made important because of established reclusion, a power emphasized the more by the Peach Blossom's more positive withdrawal:

The white-haired are the Mount Shang ancients	白髮商山老
fanning pure breezes — all eight directions	清風扇八垠
and peace to Han's foundations	能安漢基業
debt owed to the *yimin* of Qin.	賴此秦遺民
High rank they did not covet	好爵非愛慕
guests alone to hosting great pines —	長松相主賓
also there were planters of peach trees	亦有種桃者
on the banks of Wuling's stream.[24]	武陵溪水濱

[23] Yang Zai, *Hanglin yang* (1929), *juan* 1, p. 11b.

[24] Translation with a debt to Achilles Fang. See his version in Avril, *Chinese Art* (1997), p. 58. Ni Zan writes that his poem follows the rhyme scheme of the first colophon by Yang Zai. I have been unable so far to find Ni Zan's poem in his collected writing. *Yimin*, the term for loyal survivors of a previous dynasty.

Since none of the numerous colophons, including Qianlong's writing, make mention of the painter, we are essentially left with the painting itself along with a final "Chen Ma Yuan" signature and the attribution to him by the compilers of Qianlong's catalog. Despite wear and possible retouching, there is little doubt that it presents what in many ways is a spirited vision of the Four Sages. The difficulty comes with the attempt to relate it closely to Ma Yuan himself. The frequent darkness of the ink, the axe-strokes, and brisk lines of nail-head rat-tail drapery definition, tree angularity, and surging water all approach his recognized brush. Even reflecting Ma Yuan is the compositional device of a concentrated group (chess players and a pine-trunk leaning companion) spaced in contrapuntal "balance" by a separated individual (the standing sage with attendant) as shown in his hanging scrolls of *Egrets* and *Mandarin Ducks*, or with fewer numbers in the separation of *Two Scholars* in the Boston Museum of Fine Arts fan painting.

However, what happens among the *Four Sages* is that these signs of Ma Yuan representation assume very different qualities. Present and undeniable is the effort to embody nature with an open emotional intensity, even a conscious wildness: a dramatic sweep of rushing water, foaming dots, looming rock, crisp angled branch, circular explosion of pine needles, often hasty additional foliage, and more generally, sharp contrasts of black ink and bright paper. In turn this achievement carries with it an aura of self-consciousness. Brush and ink, paper and form in their open aim for expressiveness too readily deny the representational values on which their freedoms continue to depend. Subtly, but exactly, brush and ink become something in their own right. They pick up what has already been defined as *maniera*, an effort to slip "beyond the mean."

Such mannerisms are evident throughout. The axe-strokes are either brief dashes (opening section) or powerful split-brush movements on flat paper (closing section). Ink-wash is found in dark passages consciously contrasted with empty paper. The bursting stars of pine needles haloed by circles of dots are apparently unique among surviving Ma Yuan attributions. Outlines are often broken, too restless for convincing continuity. Much of this is contained in the surroundings of the four heroes and their lone attendant. The figures, warmed by slight touches of color, are executed with considerable care, but it is the angled tensions of their expressive nail-head rat-tail configurations of drapery, however electric and vital, that tell of crossing the thin line from the way drapery in nature may fall, fold, and embrace the human figure into transformations of dramatic touches of brush and ink well beyond Ma Yuan's more stable touch. Once again, *maniera*.

Perhaps least impressive of all is the artist's treatment of surging water. Ellen Avril, in an admirable detailed account of the painting, suggests a date for the painting as close to 1225. The subject would thus offer logical support for Emperor Lizong, who had come to power as the result of a palace coup sponsored by Ma Yuan's great patron, former Empress Yang. Surely Ma Yuan would have been a logical choice as the artist. However, if a hypothetical date is to be close to 1225 it brings us within range of Ma Yuan's painting of *Water* so well documented by Empress Yang's inscriptions and seals as datable to 1222. Already carefully described and illustrated (Pls. 22a–l), the album (now a handscroll) admittedly is not signed, but the attribution is backed not only by its high quality but also by leading Ming connoisseurs who emphasize, with some surprise, Ma Yuan's unique creativity.

The documented contrast is marked. While among the host of colophon writers attached to the Cincinnati scroll there may be scattered references to a painting, or even the unrolling of a scroll, none make mention of the painter. As with the *Water* album leaves, identifiable commentators on the *Four Sages*, in large part, appear eminently suited not only to discuss the ever-present subject, which they have, but the signed painting itself. While many of the writers have escaped identification, in dealing with selected calligraphy Avril has clarified the importance not only of Ni Zan but also of several others, especially a group in the Songjiang area: Yang Weizhen 楊維楨 (1296–1370), historian and painter, poet and calligrapher, leader of the Songjiang school of poetry; Lu Juren 陸居仁 (fourteenth century), retired scholar-poet and Yang's close friend in Songjiang; Wang Feng 王逢 (1319–1388), again a poet with relations to the same region. Of this group only Lu Juren mentions, in one of four poems, the fact that he unrolled a scroll. Speaking generally, colophons, especially poems written on a painting, may not feel the necessity of mentioning the artist, but complete absence in this extensive parade is more than curious.

An interesting suggestion has been made that equates the Cincinnati scroll with the artistic process of a *gaoben* 稿本, a sketch made for approval before carrying out a finished work. This appears to have been an accepted practice within the Song Academy extending broadly from landscapes to figures and on to the category of birds and flowers.[25] If so, and if the signature is genuine, it could only be the brush of a student carrying out a general plan by the master. Why also did none of the clearly knowledgeable fourteenth-century commentators raise this possibility? A conclusion might well be that, excepting Qianlong and the famous sixteenth-century collector Xiang Yuanbian whose seals proclaim ownership, a majority of

[25] See Li E, *Nan Song yuan hualu*, Meishu (1721), vol. 17, I, p. 14.

the commentators, including many who are still unidentified, were not looking at this painting. It must be added that there is an important recording found in a letter by Wen Peng 文彭 (1498–1573), Wen Zhengming's 文徵明 (1470–1559) elder son, who advised Xiang Yuanbian in his collecting. In it he comments on the rarity of Ma Yuan's paintings on paper and that his brushwork on silk is far stronger:

> Ma Yuan's paintings on paper are extremely few. If this painting were on silk a more powerful brush-strength would be visible. The figure-style is also beyond the ability of the fourteenth century Ma Yuan follower Zhang Keguan (Zhang Guan 張觀). At the end is the three-character signature, "servitor Ma Yuan" (*chen Ma Yuan*). The writing is of high quality, not possible for a forger. Moreover the colophons are numerous indeed, all by famous men and to be treasured. Only, for some unknown reason, the poem by Yang Zhonghong (Yang Zai) is missing.[26]

> 馬遠紙上者絕少。此幅若在絹上當更見筆力。其人物似亦非張可觀所能到。後臣馬遠三字寫得甚好。若偽物不敢如此寫也。且題識甚多而皆名人，可愛。惟楊仲弘詩不見，不知何故。

It is clear from this valuable comment that the painting in Xiang Yuanbian's possession is substantially the same as that inherited by Qianlong. One can still raise the question as to why other famous writers all ignored the painter. Is this a comment on literati taste in the fourteenth century as opposed to the sixteenth? Was the signature, so central to Wen Peng's evaluation, not on the painting they saw? Zhang Guan is an interesting name to bring forward. His paintings seem not to have survived today, but he was from Songjiang, which would connect him to many of the colophon writers. He spent time in Suzhou and was noted not only as a landscape follower of Ma Yuan and Xia Gui but for his special skill as a copyist. Because of early association with Wu Zhen 吳鎮 (1280–1354), the additional claim is for a strong brush, one without weakness.[27] Clearly Wen Peng did not agree, although his praise of the figure style, while not easy to connect directly to Ma Yuan, does point to a skillful aspect of the Cincinnati scroll. From this letter, the painting appears to have already been acquired. Yet another letter thanks Xiang for sending money. Was his judgment, then, truly impartial? The connoisseur Zhan Jingfeng 詹景鳳 (1520–1602), who visited Xiang in 1576 is less compliant. He complained that the collection was full of forgeries.[28] On the other hand the much-

[26] A partial translation in Avril, *Chinese Art* (1997), p. 55, citing Wong, "Hsiang Yuan-pien" (1989), p. 156.

[27] Yu Jianhua, *Zhongguo meishujia* (1981), p. 889.

[28] See Wong, "Hsiang Yuan-pien" (1989), pp. 155 and 156.

traveled and prolific observer, Xie Zhaozhi 謝肇淛 (1567–1624) gives a far more positive assessment. His well-known *Five Miscellanies* (*Wu Zazu* 五雜俎*) records boundless admiration both for the collection's numerical richness and specific priceless masterpieces. He noted as well its current dispersal.[29]

Wen Peng's statement is suggestive, but not beyond question. One wonders how much he knew about Ma Yuan. He certainly would have at least heard of the *Water* album, since it had been viewed by famous Suzhou connoisseurs in both the fifteenth and sixteenth centuries. Both his cousin Wen Boren and his brother Wen Jia added colophons to it that are dated respectively to 1568 and 1577. Wen Jia writes that he had heard the painting highly praised by Chen Daofu 陳道復 (Chen Chun 陳淳; 1485–1544) over forty years earlier.[30] Clearly paintings were not always open for easy viewing. Further, one suspects that seeing a Ma Yuan painting may not have been high on a literati's mental want-list. Accepting the fact that early Chinese connoisseurs had remarkable visual memories, today, despite the limited number of paintings that have survived, we have certain advantages. Collections are more open and with the aid of careful photography we are often able to make more exact visual comparisons. For Song Hangzhou there is also the advantage of works preserved early in Japan.

Return then to the painting, our most secure means of judgment (Pl. 58). It remains compositionally impressive. The single broad sweep of water, partly hidden, partly revealed, until at the very right it crashes in breaking foam against rocky shoals, creates an inventive tension countering the traditional leftward unrolling of the scroll. Granting the liveliness of this tense movement, when water as an initial sweep of white paper emerges from the fixed line that cuts the land behind it, the flow loses its impetus, appearing as a series of marginally connected exercises of the brush. In the mid-distance are thin lines: a curl, triangles, rounded crests. More forward, implied strength collapses in broken outlines and clustered dotting representing foam. Whether deliberate or accidental, the left-most surge of wave, isolated by gray ink, faces a linear definition that curiously suggests a paper-pale human profile (forehead, dot for eye, large nose, brief dash for a mouth). However, the breakers are essentially a flat design presenting a loss of palpable substance that differs so markedly from expectations of Ma Yuan's uniqueness. A Rembrandt pen and ink drawing is still Rembrandt, no matter how it differs from a finished oil painting. How could the hand that created the true power of *Clouds Unfurling, a Wave Breaking* around 1222 — however the shift to paper —

[29] Oertling, *Painting and Calligraphy* (1997), pp. 132 and 189.
[30] For reproduction see *Ma Yuan shuitu* (1958).

Fig. 8.26 Ma Yuan, attributed
The Four Sages of Shang Shan (detail)
Cincinnati Art Museum

Fig. 8.27 Ma Yuan
Water (detail of leaf g: *Clouds Unfurling, a Wave Breaking*)
Palace Museum, Beijing

be responsible for this lack of conviction in a wilderness setting needed to nurture the strength of these mythic heroes (Figs. 8.26, 8.27)?

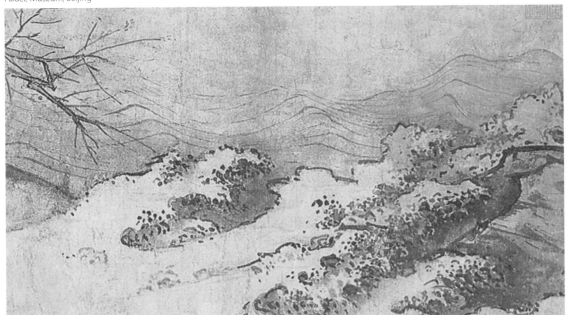

8.26

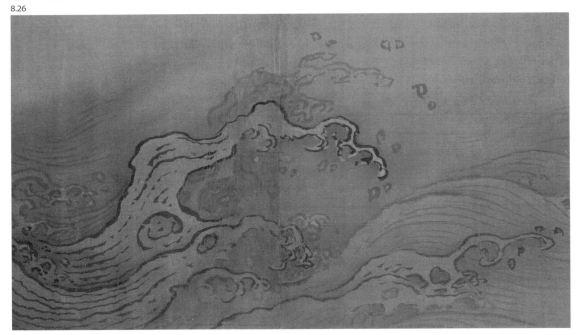

8.27

Handscroll: Ink on Silk

Continuing with the handscroll format, return it now to Ma Yuan's more familiar surface of silk. This can be found in a well-known scroll now in the Nelson-Atkins Gallery in Kansas City. Activity is such as to offer a modest scholarly story for which its current title, *Composing Poetry on a Spring Outing* (*Chunyou fushi* 春遊賦詩), appears appropriate (Pl. 62). It is an appealing work somewhat brief in measured length (29.3 x 302.3 cm) but with narrow proportions that emphasize an extension in which a variety of human figures approach toward or withdraw from a significant gathering placed in the final third of the scroll. Focus is stage-like, arbitrarily limited both below, where we abruptly enter, and above, where any upward extension is clipped by silk's ruled edge. There is no descriptive far distance. We are thus faced with an immediacy of people and things, nature and humanity. While one might imagine extension both before and after what is shown, barring possible trimming, there is a significant sense of visual completion in its current form.

This is secured by a logical formal division. Two evenly placed vertical accents or screens divide the scroll into three major sections. The first, the most open, presents a calm, unblemished natural approach, open water and a dike-like earthen path crossing and bordering it (accented by rustic travelers). There is no aristocratic pretension in the stooped common humanity, carriers of goods or guiders of transport by land and water: three empty-saddled animals and three figures (upper right) and three more (lower left). A boatman poles an empty skiff that apparently has just deposited two passengers at a simple earthen ferry-landing. There is a neat contrapuntal balance between movement that is somewhat distant and movement that is close, a land-water completion.

This brings, however, an abrupt stop in the form of a barrier of rising rock and screening tree. Except for two curving strands of bamboo, neither base nor summit is visible. Abruptly there is a new beginning, a second opening. Its setting picks up the twin themes of water and flat land, but now there is a pavilion floor, a balustraded, arching wooden bridge, servants, and the progress of a tall aristocratic scholar. The surroundings now feature the sweep of thin budding willow fronds, angled flowering plums and, to parallel the aristocratic presence, the towering majesty of a vine-wrapped, root-dancing pine. Willow with brief green dots and plum with similar touches of green and red set the scene in early spring.

The pine trunks and lower foliage — again no summits — become the second compositional barrier. Now it is a partially open screen through which the bridge-crossing scholar has implied access to what certainly is the

main focus of the painting — the gathering of pine-shaded scholars and their entourage that crowds a garden table. One of the members has risen from his seat to write. The lightly held brush has already half-filled an open stretch of paper. In turn the scholarly group opens to a scattering of three selected aristocrats along a brightly open extended "Y" of land. While each is individually absorbed, all face rightward in the direction of the gathering. On the upper branch is one strolling and one in seated contemplation. On the lower path a single strolling scholar and trailing boy attendant emerge from a barrier of foreground rock toward the lofty benediction of a towering pine. As a final touch, the closing rocky ground rises to reveal the vertical trunk and exposed roots of an ancient tree that, with its partial branches, helps shelter a somewhat mysterious grotto where three servants are preparing food and wine by a stone table furnished with antique vessels.

Even a cursory look at this three-part composition offers selected motifs familiar from the Ma Yuan paintings already discussed. Thus the opening passage of travelers with their twin donkeys reflects those of the fuel gatherer's progress in *Thru Snow Mountains at Dawn* (Pl. 1). The boatman may be considered an alternate for the solitary fisherman in *Fisherman on a Winter River* (Pl. 5). The early curving spring bamboo recalls the isolated stalks on Cleveland's *Ducks* (Pl. 7). The progress of the first staff-bearing aristocrat with an attendant carrying music in the form of a *qin* (zither) parallels Ma Yuan's *Strolling on a Path in Spring* (Pl. 17), as might, as well, the two strollers at the handscroll's conclusion. Willow fronds combined with lower crackling plum are key to the purposes exposed in *Bare Willows and Distant Mountains* (Pl. 43). The drawing of many of the figures around the calligrapher's table carry some of the linear structure and poses found in Ma Yuan's isolated heroes, while lines of water — some in surging arcs — indicate another special interest (Pls. 22a–l).

The late eminent painter-scholar, Xie Zhiliu, earlier published the scroll as *The Elegant Gathering in the Western Garden* (*Xiyuan Yaji* 西園雅集), that traditionally famous scholarly meeting alleged to have taken place in the estate of Wang Shen 王詵 (ca. 1036–after 1100) at Kaifeng in the year 1087. However, that collection of scholarly paragons included a far more complex and exact arrangement of characters, at least in tradition if not in historical fact: Su Shi writing at a table, Li Gonglin painting his famous *Return of Tao Yuanming* (Tao Qian), Chen Jingyuan 陳景元 playing the *qin*, Mi Fu inscribing a rock, and a Buddhist monk discoursing on nirvana. However differing the presentation, as it was repeated and doubtless altered over the course of time — Ellen Laing claims eighty-eight known or recorded versions — to have reduced the activities of the scene to the writing alone

can only indicate an unconvincing hint of complexities inherent in the garden meeting.

While logically rejecting the Western Garden idea, Marc Wilson, whose museum houses the scroll, claims a closer identification. He points significantly to the quality of informality that indicates an actual event. In doing so he offers the compelling suggestion that it is taking place in a famous garden of Ma Yuan's wealthy patron, Zhang Zi. This is the patron already introduced both as the wealthy poet who spoke of Ma Yuan's painting paralleling his own poetry and as a garden designer with an obsession for the flowering plum. In his introduction to the poem Zhang explicitly states that he was deeply moved by the result of the painter fulfilling his commission to paint a "forest grove scene" (*linxia jing* 林下景), presumably his own Cassia Garden. Just as the scroll opens with open water, so too Zhang Zi's garden was located by a lagoon extending southwest from Hangzhou's West Lake. Furthermore, it was a garden known for willows and plums, as well as the presence of four ancient pine trees. Finally, the cliff background of the writing scene, including a cloud, may be related to yet another feature of the garden, a twenty-foot high "Hanging Cloud Stone." If all this is correct, the writer of course would be Zhang Zi himself. The specific association of person and setting would thus present the whole, following Richard Vinograd's definition of such views, as an early example of a "landscape of property."[31]

Still, one cannot entirely escape other suggestions. The presence of a seasonal early spring, a gathering of scholars, a pavilion (however cut and removed), flowing water, a single calligrapher, the curious closing grotto for wine preparation — all these cannot help but return us to the famous poetry gathering of Wang Xizhi and his friends at his garden site, the Lanting Pavilion, in 353 under the Eastern Jin dynasty. While the presence of wine or tea can be found in paintings of other related themes, that the closing grotto was lifted from this thematic source is difficult to escape. Two relatively early versions of the Lanting show us the motif. One (Fig. 8.28), openly relying on archaistic sources, is falsely attributed to the tenth-century painter Guo Zhongshu (with a further claim to antiquity as being after Gu Kaizhi 顧愷之 (ca. 344–ca. 406), which would bring it far closer to the time of the Lanting event). The other is by the fourteenth-century painter Zhao Zhong 趙衷, who writes after it that it is a copy (*lin* 臨) after Li Gonglin. Both paintings are in the Taipei National Palace Museum.

[31] For sources of the above, see Xie Zhiliu, *Tang Wudai* (1957), pp. 87–90; Laing, "Real or Ideal" (1968), pp. 419–35; Wilson in Wai-Kam Ho et al., *Eight Dynasties* (1980), pp. 66–69; Vinograd, "Family Properties" (1982), pp. 11–12.

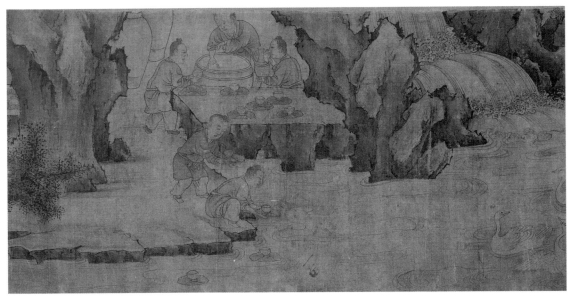

8.28

Fig. 8.28 Unidentified artist
Lanting Pavilion: Grotto Wine Serving
(handscroll section)
National Palace Museum, Taiwan,
Republic of China

In both, directly facing the calligrapher in his pavilion is such a cave showing servants preparing wine. That both extend the opening to a double cave, as opposed to the single one squeezed into the end of *Composing Poetry*, can hardly eliminate the significance of repetition. In a discussion of the Lanting scroll, Stephen Owyoung has even suggested figural poses in the Kansas City scroll that also parallel what tradition has handed down of the famous early gathering: the extended gesturing arm in the group around the calligraphy table or the waterside seated figure toward scroll's end.[32]

This brings us to another figural source, depictions of the famous poet-recluse Tao Yuanming (Tao Qian). The strolling figures would suggest parallels to the Tao of Ma Yuan's contemporary, Liang Kai, and his carefully constructed pine-sheltered portrait of the great early poet (Pl. 27). His person in a narrative context is found in scrolls that pictorially revived Tao Yuanming's extended rhapsody of *Returning Home* (*Guiqu lai* 歸去來), dated to the eleventh month, or winter, of 405. As Elizabeth Brotherton has shown, it was a popular subject in the late Song with reverberations once again of Li Gonglin, who in a recorded but now lost scroll appears to have been the originator of its then pictorial mode. In turn, Martin Powers quotes the late Song critic, Hong Mai 洪邁 (1123–1202), commenting in his time on the popularity of the subject as a painting theme. Each painter in turn, we are told, "Regarded his own version as an original masterpiece."

[32] Owyoung, "The *Lan-t'ing*" (1977).

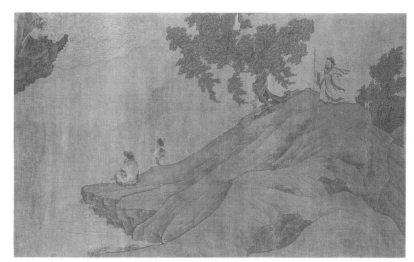

Fig. 8.29 Unidentified artist
Tao Yuanming Returning Home
(handscroll section 7: "Climbing East Hill")
Freer Gallery of Art, Smithsonian Institution, Washington, D.C.

Fig. 8.30 Ma Yuan
Composing Poetry on a Spring Outing
(handscroll section, detail)
The Nelson-Atkins Museum of Art

8.29

8.30

Apparently the earliest surviving painting in this tradition is now in the Freer Gallery of Art. While the painter is not known, the calligraphy connected with it by the poet, Li Peng 李彭 (d. before 1146), a younger acquaintance of both Huang Tingjian and Su Shi, is signed and dated to 1110.[33] It is divided into seven sections, of which the last appears to have suggestive importance for the scroll attributed to Ma Yuan. In both paintings (Figs. 8.29, 8.30), the ending combination of a strolling upright figure and one seated at water's edge — although now facing the other way and cramped

[33] Powers, "Love and Marriage" (1998), p. 51; for full account of the scroll see Brotherton, "Li Kung-lin" (1992), for Li Peng 李彭, pp. 103–14 ff.

into a tighter space — cannot help but suggest a consistent thematic idea which clearly visualizes Tao Yuanming's closing lines of the *Return*:

> Or climbing the east hill and whistling long
> Or composing verses beside the clear stream:
> So I manage to accept my lot until the ultimate homecoming.
> Rejoicing in Heaven's command, what is there to doubt?[34]

登東皋以舒嘯。臨清流而賦詩。聊乘化以歸盡。樂夫天命復奚疑。

It might be added that part of the gaze across water in the Freer scroll includes a stylized cloud. The cloud, although differently placed, and for apparently different reasons, is also a feature of *Composing Poetry*. Indeed, the reversed physical direction in the later painting may be a conscious gesture toward the Hanging Cloud Stone.

Both the long arm of tradition and a clear Ma Yuan manner are woven into the fabric of *Composing Poetry*'s narration. The question, however, shifts both to the quality of execution and how effectively the different parts are combined. While a narrative scroll by definition may require a swifter, less carefully ordered brush, the mature Song in the hands of its skilled painters cannot let go of the gravity or precision founded upon a respect for formal physicality that anchors the most compelling painting of the time. It is this logic of form and its related certainty of spatial extension that distinguish that time from other historical periods of early Chinese art — Huizong's precision in small things, Li Tang's "axe-cut" rocks, Xia Gui's deliberate spaces. Even in swifter ink renderings, as with Liang Kai's famous *Li Bo*, a physical presence is not erased. Both in detail and in combination, *Composing Poetry on a Spring Outing* is not entirely comfortable with these ideals.

Still, the scroll continues to hold importance. Two carefully researched recent studies have stressed its significance within a broader frame. Masaaki Itakura, citing a series of paintings with related subjects from the late Northern Song down to Ma Yuan's own time, places it in an enlarged environment of literati ideals with special reference to Li Gonglin. In them may be compelling parallel elements of subject matter. For example, the surviving copy versions of Li's *Mountain Villa* contain the scene described by Robert Harrist as "Surpassing Gold Cliff" (Fig. 8.31), which, in a vastly different style, offers the familiar elements of sharp cliff, cloud, and servants preparing refreshment, all part of a scholarly meeting.[35] The sum of the argument is to suggest that the Kansas City scroll has transformed the literati ideal into the late Song vision of Ma Yuan. In turn, Alfreda Murck

[34] Hightower, *Poetry* (1970), p. 270.
[35] Harrist, *Painting and Private Life* (1998), Ill. 1.7; Maasaki (1999), p. 73, fig. 10.

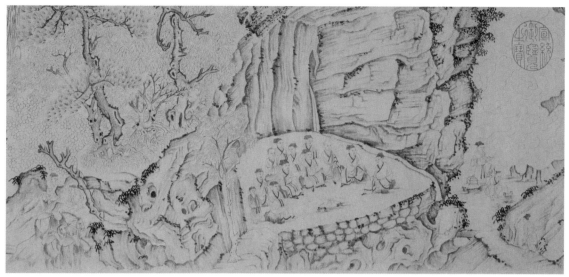

8.31

offers a compelling and penetrating study of political dissent hidden in literary allusions of poetry and parallel paintings, in which *Composing Poetry* also finds a careful niche. Relying on the close connection between Zhang Zi, the poet, and Ma Yuan, the painter, the setting becomes logically the former's Cassia Garden. However, noting that the major event, the poetry writing, and its crowd of admirers appear oblivious to what is going on around them, she suggests the painter's aim in presenting the detached presence of other scholarly types was to bring to the scene poets of the past. Offered for selection are Su Shi, Wang Wei, Du Fu, Tao Yuanming, Li Bo, Bo Juyi, or even the tea connoisseur, Lu Yu 陸羽 (733–804). The result is thus an intensified "numinous moment," combining the richness of a physical present with the culture of the past, a possibility certainly within reach of the high culture of sophisticated Hangzhou.[36]

However, in coming to grips with understanding Ma Yuan the painter, the nature of his "heart," the recognition of a subject and the relation of that subject, in this case, to the literati taste of the time is only a partial fulfillment. Beyond a sometime signature, Ma Yuan left us no words. His brush was not the brush of a writer but of a painter. It is what we see, rather than what we hear, that must be respected and at least partially grasped in the translation of words. Return, then, to the valid observation of a visual separation between the genre-like calligraphy scene and the remoteness of the painting's other scholarly types. In discussing Ma Yuan's ability to create ideal portraits of the past, whether Chan, Confucian, or Daoist, it has been

Fig. 8.31 Li Gonglin, copy after *Mountain Villa: Surpassing Gold Cliff* (handscroll section) Palace Museum, Beijing

[36] Murck, *Poetry and Painting* (2000), pp. 238–39.

shown that there is a clear recognition of individuality. Importantly this may be aided by contemporary inscription, but even when that is lacking the logic of person is still present. Why then in painting for a close patron and admiring friend would Ma Yuan reduce lofty scholars with clear traditional roots, perhaps poets of the past, to unimpressive deflated types? Most obvious in the reduction to anonymity is the Tao Yuanming connection — strolling and seated. Tao Yuanming was readily identifiable in both the Freer *Return* scroll and Liang Kai's portrait (Pl. 27) — a leopard skin, an open scroll, a wine cup, a willow tree, a head scarf (used to strain wine), a chrysanthemum.[37]

The one individual scholar who does differ from the others is the bridge-crossing aristocrat in the central portion of the scroll (Fig. 8.32). Since he wears a so-called Su Shi hat, this might be a clue to the person. However,

Fig. 8.32 Ma Yuan
Composing Poetry on a Spring Outing
(handscroll detail)
The Nelson-Atkins Museum of Art

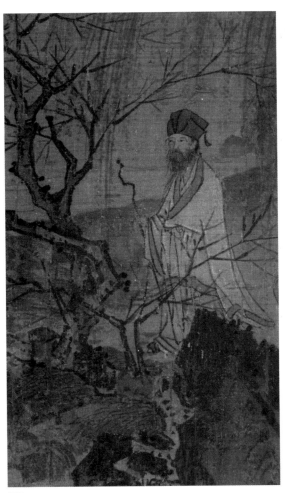

8.32

[37] Nelson, "What I Do Today Is Right" (1998), pp. 61–90.

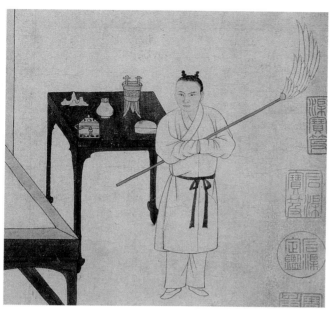

Fig. 8.33 Unidentified artist
Portrait of Ni Zan (handscroll detail)
National Palace Museum, Taiwan,
Republic of China

8.33

the rendering of the figure and his immediate surroundings both carry visibility an unacceptable distance from Ma Yuan's recognizable hand. Much is at variance from either established or close assimilations of his style. Rather than the sufficiency of a single disciple or servant there are two — one with the standard well-wrapped musical instrument, the *qin*, the other carrying an unusual long-poled feathered fan or duster. This latter is unique among what has survived of Ma Yuan and is apparently rare for the period. However, a comparable example can be found in a well-known anonymous fourteenth-century portrait of that esthete of cleanliness, Ni Zan (Fig. 8.33). The angled plum with its tangle of thin, rigid, brittle lines completely denies a repeated love for this flora, certainly not to be excused on its miniature scale. If this scroll is to be directly related to Zhang Zi's *Cassia Garden*, why is there not a closer connection between these forms and Ma Yuan's miniature plum paintings, which also can claim a close connection to his patron's gardening (Pl. 15), or more generally the plum tree hovering over Boston's two scholars (Pl. 16)? Likewise the willow tree. Now the selection and strength of spring's separate willow fronds, as in Taipei's *Strolling on a Path in Spring* (Pl. 17), and *Bare Willows* (Pl. 43), are replaced by soft linear repetition blending to a wash-and-color effect. Even less acceptable is the awkwardness of rock, root, grass, and water that front the figure. But what might be called the deflation of the scholar himself is most pertinent for this scroll — thin sloping shoulders ending in a swallow-tail gown, unkempt beard, slender drapery for which each fixed black line is repeated in rigid surface white. Add the uncertain crooks of the staff (Fig. 8.32).

Nor do the wider surroundings of this central section offer stable confidence with its pale land and cut-off architecture limited to steps and the edge of a platform (Fig. 8.34). A discrete huddled servant is bowed in sleep, hair curiously humped, seeming to suggest two heads. Architecture offers the blunt dark of furniture. There are flat rocks and the extended screen of the dotted willow fronds. Included is a partially revealed table loaded with antique vessels and the heating of wine or tea beside. This detail implies a curious disconnectedness since it is repeated in a different form, with figures added, at the very end of the scroll (Pl. 62, section 9, Fig. 8.30).

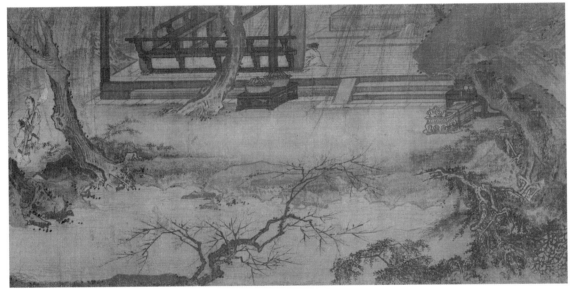

8.34

Fig. 8.34 Ma Yuan
Composing Poetry on a Spring Outing
(handscroll detail)
The Nelson-Atkins Museum of Art

Furthermore, the central scholar type does not carry over to the final and most important scene of the scroll, the writing of calligraphy and the attendant crowd (Fig. 8.35). Style, however, does return to mirror a Ma Yuan mode, and there is a special effort to capture a variety of types and poses, both those that press toward the table with its single calligrapher and what might be described as "hangers-on," including a back-turned scholar and two women bothered by a child tugging for attention. Another child is distracted by something outside the main event, apparently the writhing shape of an emerging tree root. As for the others, there are scholars robed in dark banded gowns, two dark robed monks, women definable by double hair loops. Faces and poses generally fit a three-quarters view, thereby suggesting an active turning. There is a lone profiled head (extreme right) and a particularly effective full-face bearded onlooker peering between a knot of other heads.

Variety is also in the male headdresses: cloth, gauze covered, and one prominent onlooker with a Su Shi hat (differing, however, from the earlier

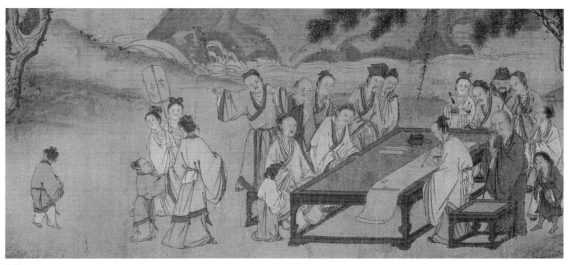

8.35

scholar at the bridge). Both the variety of persons and the implications of detail in a gathering consciously informal in its grouping do bring us to a significant interest — a Song interest — in the everyday world. These are not figures isolated in iconic splendor. The finest figure is the prominent back-turned aristocrat placed forward to the left of the table. While other figures are somewhat loosely conceived, he is brushed with a certainty that bears comparison with Ma Yuan's authority in the single aristocrat in the Taipei National Palace Museum painting, *Strolling on a Path in Spring*. Juxtaposed, the Kansas City figure might well have followed such a model (Figs. 8.36, 8.37). The differences are subtle. Yet in artistic performance, it is

Fig. 8.35 Ma Yuan
Composing Poetry on a Spring Outing (handscroll detail)
The Nelson-Atkins Museum of Art

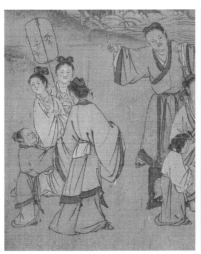

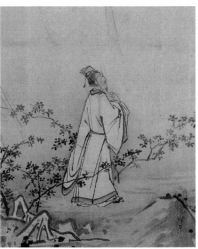

Fig. 8.36 Ma Yuan
Composing Poetry on a Spring Outing (handscroll detail)
The Nelson-Atkins Museum of Art

Fig. 8.37 Ma Yuan
Strolling on a Path in Spring (detail)
National Palace Museum, Taiwan, Republic of China

8.36 8.37

the subtle differences that are the most important in separating copy from original. In terms of linear skill, the Taipei version draws more out of less. The line selection is both more certain in placement and in offering minuscule variations: for example, the confident sweep of the outer gown to the lower hem, just a touch of what is beneath, and the ink placing of both feet. The result is the exact strength of a secure, stable figure. Also the clarity of its facial profile contrasts with the uncertain lines that attempt description of the other's head with its three-quarters backward turn.

However if the skill in this one figure were carried to other forms, indeed present throughout *Composing Poetry* as a whole, one would doubtless be justified in placing the scroll much closer to and perhaps within the surviving work of Ma Yuan. There are simply too many additional visual doubts. No other scholar figure carries this authority. What ends the scroll are forms too weak to justify the sources from which they appear to be plucked or to counteract the lack of conviction in earlier passages.

Going back to the whole, while there are moments of welcome appeal, there is a "continuous disconnectedness." Given the possibilities of either a convincing contemporary scene or the broader impact of a compelling literati idea, it is highly unlikely that an artist of Ma Yuan's alleged skills would have emerged with this kind of broken account. One thinks more of a collage than the continuity of an unfolding narration. The three parts that mark the compositional arrangement are not convincingly joined. Start again with the opening passage where an abruptly differing spatial ambient and the small scale of the commoners and their vehicles of transport offer no clear relation to the space and figure-scale that follows. Compare them, for example, to the situation in Li Gonglin's *Surpassing Gold Cliff* section of the *Mountain Villa*, noted above as an earlier equivalent of this Ma-style handscroll (Fig. 8.31). There a similar cliff barrier separates inner and outer representation, but it is a composition where horses and servants outside are more believably related in scale and ambient to that of the figures within. As has been shown, the central section of *Composing Poetry* presents a more serious stylistic disconnection from the quality of Ma Yuan's brush, leaving only the final scene to reestablish the mode and its appeal, but still without the expected authority of the master's hand.

Hanging Scroll: Two Landscapes

Given the clear comparison of genuine and imitation between two versions of *Night Banquet*, the authenticity of the hanging scroll featuring a landscape related to Ma Yuan must be approached with caution. Here consider two such examples. Both appear clearly based on the master, but disparity takes a divided path. One can be described as over-refined in an attention to craft; the other, while more exactly adhering to original motifs, is rather too heavy in what may be described as quality of execution, thereby robbing the whole of the vital breath of creativity.

The first is found in a stilled, elegant scene that has been given the title of *Landscape in Wind and Rain* (*Fengyu shanshui* 風雨山水) (Pl. 61). Painted in ink on silk with light color, it is now in Japan's well-known Seikadō collection. For comparative purposes, the dimensions (111.2 x 56 cm) approximate those of Ma Gongxian's *Yaoshan and Li Ao*. Indeed it is a painting that has never been considered as anything more than a landscape in the Ma tradition. However, in dealing with "transformations" it is well to look closely if for no other reason than to emphasize the skilled variety that the mode can embrace. Generally speaking, accepted compositional elements are present. The entire view is approached from one side, the left, with strong forward definition that rises upward to a tight middle distance and then ultimately to a far high distance of hazed peaks and space, which takes us beyond what the eye may detect. Unusual are the verticality of close, flat-washed, unassailable mountains and the imaginative soaring of the needle-peak. Dominating the whole is a remarkable care with which each element fits into the whole: a complex dark foreground rock setting off a tight empty path leading into a heavy screen of foliage, each needle and leaf carefully described, its crest leaning rightward enough to reveal a complex mountain temple. Now the inevitable noble pine rises, as it should, to challenge screening mists that in turn become the hovering foundation of a tightly receding screen. Again there is an opening, this time to the right, a hazed space but one clearly defined by a shaft of descending light slanting toward the pines and thereby directing us back to the scene below. Note the care with which boat, landspit, and emerging rock are handled. The land is embraced above by the upward curving skiff and answered below by an echoing stretch of downward curving rock. They are embraced by lightly lapping waves.

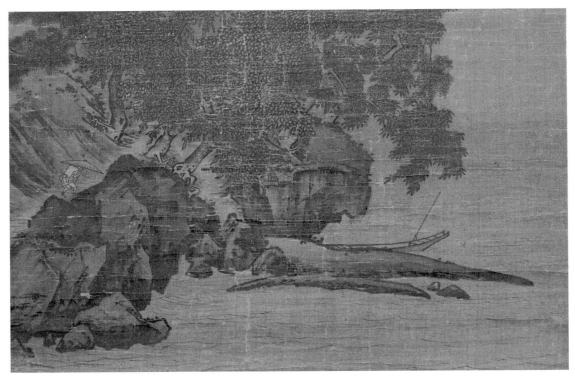

8.38

Fig. 8.38 Unidentified artist
Landscape in Wind and Rain (detail)
Seikadō Bunko Art Museum, Tokyo

Reconsider the foreground for its harmonious, understated human presence (Fig. 8.38): the empty anchored boat, the single unhurried angled traveler, half hidden by an oversized umbrella. Rain it may well be, but only as a thin, invisible mist-filled slanting descent. Wind, in turn, is exactly a carefully controlled and gentle reminder of the life-movement that ever anchors nature's world.

The second painting, *Streamside Plum and Wild Ducks* (*Meixi futu* 梅溪凫圖), is from the Ching Yuan Chai collection at the University of California at Berkeley (Pl. 63). Again brushed in ink and slight color on silk, the hanging scroll is, however, of lesser dimensions (79 x 47.3 cm). While the clarity of definition is not helped by the exaggerated darkening of age, there is little doubt, even in a cursory glance, that its more open compositional order and the motifs within it offer a debt to Ma Yuan that is direct rather than implied or deliberately transformed — a forward rock with selected axe-stroke texturing, the root-dancing angular plum, its dotted blossoms, the mist-filled background as an approach to mountain distance with firm looming washes of their crests, here placed right/left in complementary juxtaposition to the left/right of the foreground, the presence of ducks in reed-growing shoals and in the left corner a touch of

linear flowing water — all this is specific in a continuation of an accepted style, including the assurance of a "Ma Yuan" signature on the forward rock.

It is rather with close inspection that doubts arise (Fig. 8.39). Start with the sharply pointed rock, a form even more intense in the tree's emerging root and the split-brush axe-strokes that ride rocks' lower surfaces. While the upper branches of the plum capture a Ma Yuan touch, the trunk itself is curiously heavy. Strong black outlines too firmly bind a softly washed interior grading from light to dark with a smooth three-dimensional intrusion that fights with linear borders. The foreground, dominated by its sharp rock and heavy tree trunk, crowds space right and left leaving listless ducks — apparently two pairs — blending into shadows and monotonous, carefully repeated vertical reeds. Dots of eyes stare outward. At the lower left corner there is a tangle of angled plum twigs and fixed loops of a tumbling stream. Upward, the ordered space relieves the crowding but in turn evolves into its own tangible cloud-weight until high peaks, however strategically placed, answer the foreground with their own dark angles. A curious heaviness dominates the whole.

The presence of ducks in this hanging scroll returns us to that theme in Ma Yuan's repertoire. Its stolid nature here is a far cry from the lively

Fig. 8.39 Ma Yuan
Streamside Plum and Wild Ducks
(detail)
University of California, Berkeley Art Museum and Pacific Film Archive

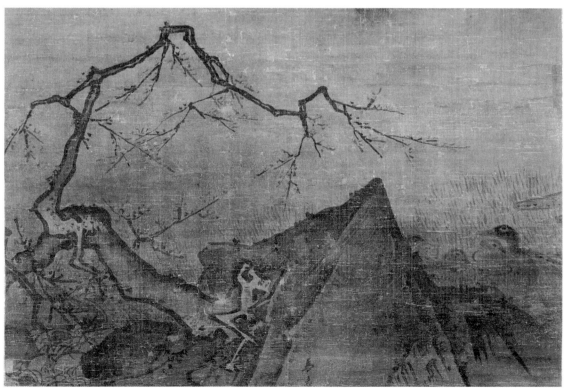

8.39

expression of wild Mandarin ducks that carried that species to their natural early spring behavior in the Cleveland painting, *Mandarin Ducks by a Bamboo Stream* (Pl. 7). It also differs from the lighter touch of another representation of ducks in a well-known album leaf in Beijing's Palace Museum, *Plum, Rocks and Wild Ducks on a Stream* (*Meishi xifu tu* 梅石谿凫圖; Pl. 64). The squared dimensions (26.7 x 28.6 cm) are painted in ink and color on silk. In this miniature world a dozen ducks, young and old, activate the gently swirling waters of a foreground stage. Framed by a left-hand overhanging rocky cliff with a brittle surface of extended axe-stroke texturing and struggling signs of clinging plum, the shift is to a cave-like grotto and a flat wash that grades rightward to an undefined distance. The painting's upper edge cuts any further vertical rise as well as the origin of a dramatically foreshortened plum branch whose sprayed ends direct us partially right but mostly down and left, back to the foreground and the active swimmers below. A Ma Yuan signature is added to the rock-cliff at its lower left edge.

Again a quick comparison with the Cleveland hanging scroll (Pl. 7) outlines the difference. Elements there so dramatically presented convey not only very early spring with its openness and surging mountain waters, but a scene directed toward understanding a way of life essential to the Mandarin duck, one so different from the tame symbolic serenely present in secure domestic pools. To a degree the album leaf echoes that life. Although now in calmer waters, it appears to be still a wilderness niche where only the plum that is wild may live.

Somewhat in contrast, the ducks have now found a comfortable surface where adults minding the young and ducklings of particular appeal act, well, like ducklings, exploring water surfaces, attempting scooting flight on undeveloped wings, or getting a free ride on the back of an adult (Fig. 8.40). The shadows of webbed feet beneath the surface convincingly suggest their method of locomotion. However, when compared with the Cleveland scroll the album leaf becomes both an echo of the setting and a realignment of an aesthetic ideal. Nor, whatever the significance, are the brief signatures a close match. The forward rock-cliff is consciously brittle in the pointed triangulation of its shape and extended axe-strokes of its surface. A white root dances in the air. The tongue of land shaping the grotto is reduced to a flat, somewhat hesitant wash. The mature ducks in a more generalized interpretation have lost much of their certain Mandarin identity, although the more centered one appears to be crested which would identify a drake. Moreover there is no other natural species that more clearly fits the general group. An exception is the right-hand flying duck apparently just alighting

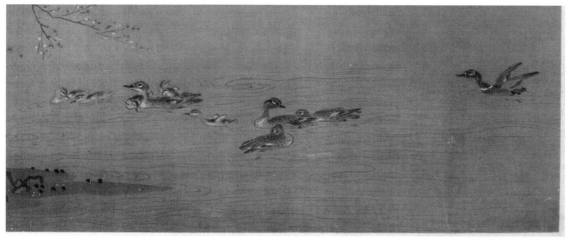

8.40

on pond's surface. A prominent white ring below the dark neck may define it as an intruding mallard.

The foreshortened angled plum branch is its own successful invention, a manipulation compatible with the white airborne root, the brittle rock, and flat wash of the bordering bank. With such a special frame, one cannot somehow escape the sense of a double picture. The forward lines of water stop abruptly once they have created a suitable platform for the avian actors. The rest of the pond becomes a sheet of undefined silk. The shift is to different purposes. One way to put it is to affirm that "art," as in the stretched-out land shapes and the flat silk, has been substituted for "nature," which still rules on the foreground stage. Is this not what has already been described as *maniera*? At the very least the result rests on a fragile line between Ma Yuan's own recognized skill toward the ducks themselves and a shift toward a wilderness of brush expression that contrasts with it.

Fig. 8.40 Ma Yuan, attributed *Plum, Rocks and Wild Ducks on a Stream* (detail) Palace Museum, Beijing

Peasants Dance and Sing

Turn next to a third and especially impressive hanging scroll, *Peasants Dance and Sing: The Stomping Song* (*Tage tu* 踏歌圖; Pl. 65) now in the Beijing Palace Museum. It is a forceful painting rendered in ink and slight color on silk and measuring, in height to width, 192.5 × 111 cm, larger than any painting so far discussed. Because of such dimensions it was necessary to join two vertical bands of silk. It has a "Ma Yuan" signature in the lower right corner. While generally accepted as genuine in China, Western scholarship

has usually placed this impressive scroll in the altered character of a well-crafted copy.[38] Even as a copy, however, the painting has considerable value in clarifying Ma Yuan's creativity as it spread to others. Floating above its needle peaks it carries, what also may be considered a copy, imperial calligraphy in running standard script, four lines of poetry and a presentation inscription to an as yet unidentified Wang Du 王都 (also to be read as Supervisor-in-Chief Wang (Wang Dutiju 王都提舉)). Two seals have been affixed, one affirming its imperial writing and another with the cyclical date, *geng chen* 庚辰, that fixes the year as 1220, late in Ningzong's reign. Both the date, the relation to Ma Yuan, and perhaps also the style of the calligraphy, identify the emperor whose rule extended from 1195 to 1225. Such historical focus can then be considered in an evaluation of the style.[39]

The painting itself is compositionally somewhat unusual in concealing a sharp right- or left-leaning angularity. It offers more of a centralized balance between willow and bamboo on the right and rock and land intrusion on the left. This results in parallel lines of foreground and mid-distance definition separated by emptiness which we read as mist below and mist-sky above. It is a change, however, that appears to be a layered version of a quality often seen in late Song landscapes that often create a clear balance between what is left open as space and what is visible as concrete form. It is the definition itself that defines the copy. While the strength of line and the presence of axe-strokes, large and small, can fall within Ma Yuan and his family tradition, the careful rigidity that often describes it is a denial of the expected more natural and spontaneous source. Ma Yuan is ever present, but only as an echo. This is true of the arc of the willow, its smooth curving outlines, continuing in branches sprouting from earlier cuttings, perhaps, too, in the spur-like point of a bamboo leaf, the tangled flow of water right and left coming forward to unite in the current under the slab-like bridge that, as with the earthen path, is similarly outlined. It is also in the figure-style, firmly linear but now explosively angular in its evocation of the active commoners on the raised earthen path. It is rather an imposed exactness that detracts. In axe-strokes it is an overuse which creates not rock but patterned surface. This carries to the excessive prominence of crystallized needle-peaks. Note especially the most forward such image rising as it does in mannered fashion from a deeply undercut base to end in a heavily darkened summit

[38] Cahill, *Index* (1980), p. 152; Lee, "The Domain of Empress Yang" (1994), p. 163. There are at least four other extant versions of the painting: another in Beijing; in the Beishan Tang collection, Hong Kong, attributed to Dai Jin; in the Art Museum of the Chinese University, Hong Kong, also given to Dai Jin; and one on loan to the Stanford University Museum attributed to Xia Gui.

[39] I have relied in significant part on two important studies of the subject, including the painting and its copies: Hartman, "Stomping Songs" (1995), pp. 1–42; and Wen-chien Cheng, "Images of Happy Farmers" (2003), pp. 194–213.

embellished by a thick "nails-drawn-from-mud" convention on the peak, a device elsewhere described as more appropriately derived from the eleventh-century painter, Guo Xi. It is precision and overuse of conventions that destroy spontaneous freshness. Conscious deliberateness of execution is particularly clear in the way both foreground willow tree and rock have accepted a precise band of a contrasting empty bright border to release its form from what lies behind (Fig. 8.41). Not without such deliberate invention, however, the painting has its own special strength. Perhaps one can also catch this by equating the formal balance of the powerful undercut needle peak on such a narrow base as an expanded abstraction of one of the dancers thinly supported by a single leg. There is an exposed logic to the whole,

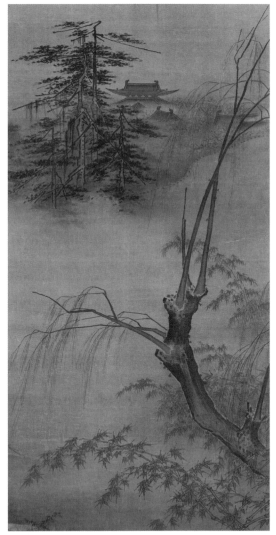

Fig. 8.41 Ma Yuan, attributed *Peasants Dance and Sing: The Stomping Song* (detail) Palace Museum, Beijing

8.41

however, that might well lay claim to having been executed within the very late Song.

That the painting exists in four additional surviving examples, all accepted as copies,[40] adds further proof to the continuing popularity of Ma Yuan's repeated designs already discovered of *Night Banquet*, album leaves of *Plum*, *Scholar Viewing a Waterfall*, and *Listening to Bamboo in the Water Pavilion*. What is apparently another version of the Beijing *Stomping Song* was known in the sixteenth century and received an accurate description in the text, *Dongtu xuanlan bian* 東圖玄覽編, compiled by the painter-connoisseur, Zhan Jingfeng. The preface is dated to 1591:

> Ma Yuan's doubled-joined fine silk Stomping Song (*Tage*) painting, a large scroll with a sharply rising mountain peak. At mid-point are clouds and mists. Among the covering clouds images of towers and terraces emerge. Below are several figures, old and young, arms joined in rhythmical stamping and singing. There are also two women standing and watching. One is old. One not so old is embracing a grandchild. All are as though alive, yet impossible to describe.

> 馬遠雙幅細絹踏歌圖一大幅，中一高峰直聳，半為雲煙暈。雲中間影出樓臺，下作老稚數人，連臂踏歌。 又作二婦立看。婦一老，一未老，一未老抱孫，皆如生，但不能言耳。

The account, while generally close to what the Beijing scroll contains, differs from it in significant respects. Most curious is the fact that there is no mention of the imperial inscription — hardly a feature to overlook. In addition, the existing scroll has only one watching woman, the figure placed far to the left embracing the child. The unquestioned acceptance of authenticity also suggests that Zhan Jingfeng may have been looking at a different scroll. Judging by another recording, he could be carefully critical of Ma Yuan attributions. This is revealed in the entry of two small Ma Yuan paintings, treasures owned by "Jingmei Fengchang" 敬美奉常, Wang Shimao 王世懋 (1536–1588), the younger brother of Wang Shizhen 王世貞 (1526–1590), for which he rejects the attribution:

> Although very refined, there is no wrist-strength, the brush not that old. While by someone of antiquity, it is not by Ma Yuan himself. After the political transfer to the south, the number of those who studied Yuan's brush were certainly no less than ten. It must have been by one of them.[41]

[40] See notes 38 and 39.

[41] For the two above entries see Zhan Jingfeng, *Dong tu xuanlan bian* (1591), p. 5, *juan* 2, pp. 93 and 71.

雖雅無腕力，筆不蒼。雖舊人畫，然非遠真筆。蓋南渡後學馬遠者不下
數十家，殆諸人擬為之。

In the same critical world that with Wang Shizhen's ownership embraced Ma Yuan's *Water* album, it is a sensitivity that also must be applied to the understanding of Ma Yuan in our own time.

Return, then, to the Beijing scroll where the inscription is a feature of the whole (Fig. 8.42). A recognizable weakness in the characters themselves appears exaggerated by the spacing between them. For this there may be some justification because of the large scale of the painting, but it nevertheless interferes with the more appropriate cohesion implicit in a brief quatrain. The same extends to the thin rigidity of the imperial seals, especially the large *Yushu zhi bao* (Treasure of Imperial calligraphy). However there is importance in the other seal's defining date of 1220, when Ningzong was 53 *sui*, and even more in the poem's meaning, for which Xu Bangda claims the poetry of Wang Anshi (1021–1086):

> A night rain clears the emperor's domain
> on eastern slope the morning sun adorns a royal city.
> A year of plenty all joyful in their callings —
> along field paths they dance the *Tage* ballad.[42]

宿雨清畿甸，朝陽麗帝城，豐年人樂業，壠上踏歌行。

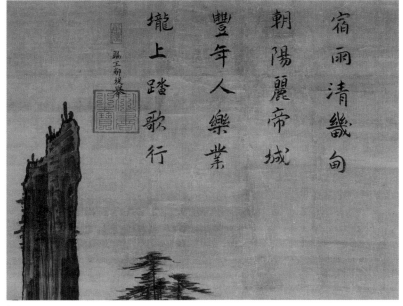

Fig. 8.42 Ma Yuan, attributed *Peasants Dance and Sing: The Stomping Song* (detail) Palace Museum, Beijing

8.42

[42] Xu Bangda, "Nan Song" (1981), p. 55; for *xing* translated as "ballad" see Hawkes, *A Little Primer* (1967), p. 9.

Whoever the writer, or indeed the painter, the poem serves as an effective commentary. At this general time it must certainly indicate Hangzhou itself. In the second line, *zhaoyang* 朝陽 carries not only the literal sense of morning sun but also the connotation of "eastern slope."[43] Following the geography of imperial Hangzhou, it is toward the east of West Lake that the city lies and above it is its highest point, Phoenix Mountain (*Fenghuang shan* 鳳凰山) where the imperial precincts presented a stunning architectural array including soaring roofs, covered corridors, and winding arcades.[44] Pines also played an important part. However idealized, this Ma-style painting has caught such architectural hints of these towering eaves and mounting corridors. They become the more magically powerful by virtue of limited exposure, distant in height and all but concealed by embracing pines.

It is such architecture among the pines that helps define the site. Its significance finds proof in a far more romantic version of the palace in a richly colored handscroll of its setting attributed to the twelfth-century painter, Zhao Bosu 趙伯驌 (1124–1182). The painting (Pl. 66) is not signed, but both the painting's title, *Palace in the Pines* — precisely, *Painting of Ten Thousand Pines and the Golden Palace* (*Wansong jinque tu* 萬松金闕圖) — and the attribution to Zhao Bosu are found in attached colophons by the important Yuan painters, Zhao Mengfu and Ni Zan. Here the pines quickly shift to thick daubs of ink and green color with golden palace roofs emerging. Again it is concealment that increases the power of our expectations (Fig. 8.43). Given the artist and the time, the imperial palace in Zhao Bosu's mind can only be that on Hangzhou's Phoenix Mountain and what was known as the Hill of Ten Thousand Pines (Wansong ling 萬松嶺).[45] The experience is exactly sealed in a poem-colophon by the fourteenth-century poet Gao Qi 高啟 (1336–1374) written for such a painting by Zhao. It again carries the same title including the addition that it is of the Song capital, Hangzhou. The poet must have been looking at this scroll or one very like it, so descriptive are its opening lines:

Tall pines lifting beards, a company of dragons	長松掀髯若群龍
Below, palace gates encircled, a thousand layers of cloud	下繞宮闕雲千重
The crest of Phoenix Mountain faces forward halls	鳳凰山頭望前殿
Waves of kingfisher blue buoy the golden lotus;	翠濤正涌金芙蓉
Sunrise, the tide begins to rise, white cranes	日出潮初上白鶴
Come flying	飛來……[46]

[43] *Hanyu da cidian* (1986), vol. 6, p. 1323.

[44] Lee, *Exquisite Moments* (2001), p. 29 ff.

[45] Gernet, *Daily Life* (1962), p. 32. For a colored reproduction of the painting as well as an important discussion by Xu Bangda see Xu Bangda, "Cong qinglu shanshui chuantong," (1980), pp. 1–8. For a full discussion of painter and painting see Edwards, "Search for Zhao Bosu" (2005), pp. 57–82.

[46] Gao Qi, *Qingqiu shiji zhu, juan* 9, pp. 17b–18a. The commentary locates the *Hill of Ten Thousand Pines* by Phoenix Mountain.

Interestingly, Gao Qi shifts what has usually been considered moonlight to a sun-rising dawn, a change easy to accept of the painting since its colored style holds so clearly the fantasy of jewel-like magic, and the activity of numerous cranes at both beginning and end support the wakening dawn rather than the sleep of night.

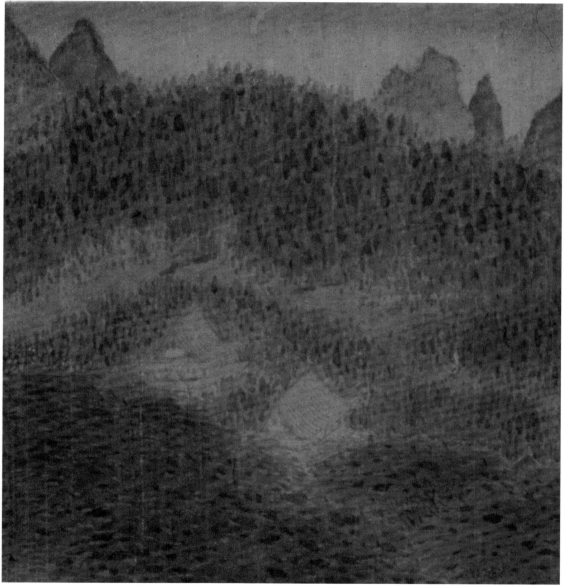

8.43

Fig. 8.43 Zhao Bosu, attributed
Palace in the Pines (detail)
Palace Museum, Beijing

Similarly with the impressive Ma-style hanging scroll — copy as it appears to be — its attribution, inscription, and date guide us to a world filled with lofty imperial rectitude centered in Hangzhou: the freshness of a newly washed world, all supported by the flowing waters, the spring time suggestions of a blossoming plum, spare willow fronds and the enduring pine and bamboo. Splendid palace architecture emerges from disappearing mists and the clarity of a newly washed eastern slope — imperial power above, dancing joy below.

However, it is still necessary to carry the implications of Wang Anshi's poem a bit further. The published text includes a title, "Feelings Inspired by Autumn" (*Qiuxing yougan* 秋興有感).[47] Thus the clearing and bright sun after the rain are linked to the traditionally open autumn view, the joy of seeing the golden city and its extended domain in the special clarity of that season. One is tempted to think of T. S. Eliot: "What is the late November doing / With the disturbance of the spring."[48] Importantly, if the poetic commentary written on it is taken seriously, the painting also embraces extended time, the endurance of continuity.

Ideals of universal peace and harmony, however, are keyed to the figures in the foreground and their enactment of the Stomping Song. The dance carries a significant history.[49] It was considered in the Song to have had its roots in the Han dynasty, but it also carried with it ideals of political perfection back to the golden age of Emperor Yao. Stomping could be presented individually or in groups. It is not incidental to its importance that its presence in a Ma Yuan–style painting is paralleled as a single stomper among Li Gonglin's archaic figures that illustrate the Han dynasty *Classic of Filial Piety* (*Xiaojing* 孝經). While the painting has only one early colophon, and that by an unidentified calligrapher, the writing is in Song style on Song paper and carries a seal dated *gengyin* 庚寅 thought to indicate either 1230 or 1290.[50] The Li Gonglin dance (Fig. 8.44) is a key element in the illustration of chapter 7. Various separated individuals are presented in poses suggesting harmonious relations among young and old. They are backed by orchestral music and the dance of the single stomper (Pl. 67). The text starts with an opening theme of universal merit attributed to Confucius himself, namely that filial piety embraces heaven and earth and the duty of man, adding in summation: "Heaven and earth inevitably pursue their course and the people take it as their pattern" 天地之經而民是則之. There is continued praise

[47] Li Bi, *Wang Jinggong shi zhu*, *juan* 40, p. 10a.

[48] T. S. Eliot, "East Coker," *Four Quartets* (1943), p. 2.

[49] Hartman, "Stomping Songs" (1995). For an extensive discussion of both spring and autumn festivals see pp. 25–34.

[50] Barnhart, *Li Kung-lin's Classic of Filial Piety* (1993), p. 156.

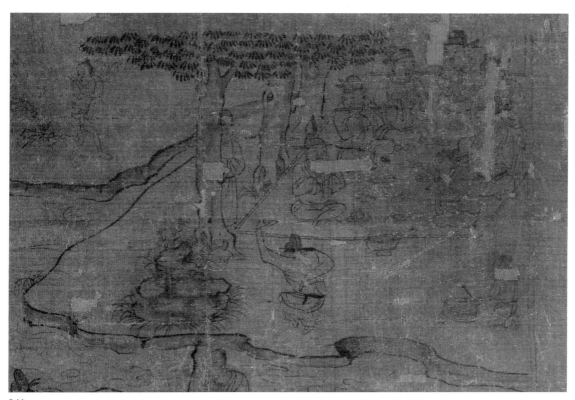

8.44

for ancient rulers who, under rules of propriety and music, created an enduring world, harmonious and benign.[51]

The significance of roots both thought to be in the Han and extending back to ancient time are ideals that have helped frame Ma Yuan's work on other occasions. Hartman, however, brings verbal proof of the dance to Ma Yuan's own time with descriptions of it from the writings of two famous older contemporaries, Fan Chengda and the poet Lu Yu. They were able to directly observe stomping, though enacted now by aboriginal tribes, Fan among the Yao in the Guilin area, and Lu in Western Hunan. Such recording reemphasizes Song dynasty importance of observing the physical world. As already suggested of the painting itself, the dance was carried out in both spring and autumn festivals.[52]

The figures in the Beijing scroll, a kind of foreground narrative, may well add an open generational significance that appears to transform the archaic Li Gonglin classic into the open grandeur of the present, its place

Fig. 8.44 Li Gonglin
The Classic of Filial Piety, chapter 7, "Filial Piety in Relation to the Three Powers (Heaven, Earth and Man)" (detail)
The Metropolitan Museum of Art

[51] Barnhart, *Li Kung-lin's Classic of Filial Piety* (1993), pp. 105–8. It is an example to be added to Hartman's discoveries.

[52] For discussion of both spring and autumn festivals see again Hartman, "Stomping Songs" (1995).

in an idealized Hangzhou landscape. Those at the right bow to the old man across the bridge (Fig. 8.46). To complete the extended family, to the far left is a mother and child, the child somewhat in imitation of the elders (Fig. 8.45). Perhaps one can see in this kind of figural separation a Ma Yuan trait, whether it be of two scholars, egrets, or Mandarin ducks. Moreover, whatever the stylistic change, one cannot help but recall Ma Yuan's *Night Banquet*, datable somewhat earlier, but no later than 1219, thus within range of 1220 as claimed of this present scene. Plum, pine, and bamboo are

Fig. 8.45 Ma Yuan, attributed *Peasants Dance and Sing: The Stomping Song* (detail) Palace Museum, Beijing

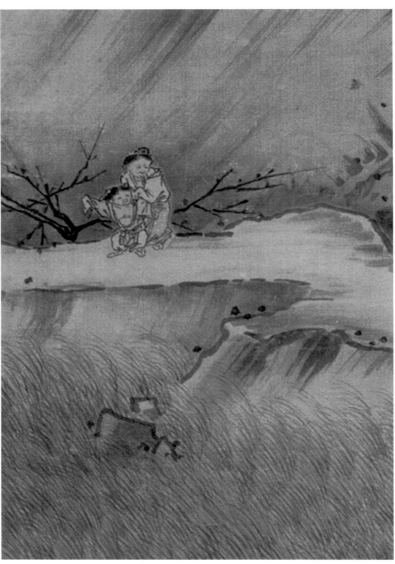

8.45

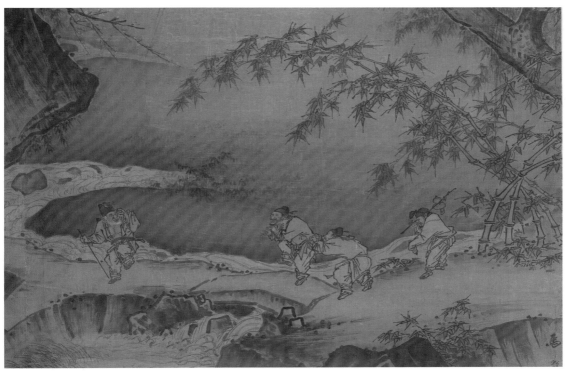

8.46

similarly present there in an evocation of imperial magnitude. Then, honor was bestowed on high officials — also a foreground "drama." Now the Ma Yuan mode, however crystallized as a close copy, extends that power and benevolence to embrace the common man.

Fig. 8.46 Ma Yuan, attributed *Peasants Dance and Sing: The Stomping Song* (detail) Palace Museum, Beijing

Postface

There is little more to say, only a brief summing up. For now it is finished. In many ways my view of Ma Yuan may appear to be a personal view. But is that not what confronts every observer of the work of art: the person attempting to understand what the artist has presented? This must always be considered, however, with the acceptance of flexibility. The person who sees, reads, hears, even touches, walks through, or perhaps wears the result of an artist's expression may have a different understanding in morning as opposed to evening, in bright light as opposed to dim, in countless differing circumstances, even youth as opposed to age. Neither the person viewing nor the work of art itself exists in a vacuum.

This is especially true of the non-verbal arts. They depend in large part not on the wonder of words but on actual physical experience. They cling to presence, music to the ear, visual arts to the eye. Still, words remain a necessary bridge, but in doing so we must accept limitation. As with a foreign language, we need translation. However, also as with that language, the translation is seldom if ever considered equal to the original.

Perhaps Zhuangzi had it right:

> Words exist because of meaning. Once you've got the meaning you can forget the words. Where can I find someone who has forgotten the words so I can have a word with him?
>
> 言者所以在意 。得意而忘言。吾安得夫忘言之人而與之言哉。[1]

It is with this in mind that I leave you a view of Ma Yuan. The words I use should not be considered as absolute. However they must be recognized as establishing a foundation for authenticity. Without that how can one write history, especially with an art carrying the uniqueness of a physical

[1] From "External Things." Translation based on Watson, *Complete Works* (1968), p. 302.

presence? It is on such a foundation that the visual arts offer a special place in history. Without question there are plenty of gaps staring at us. Only a fraction of Ma Yuan's works have survived. Others may differ as to how one connects the dots to emerge with a coherent presentation. Such views I remain open to accept.

One view difficult to accept, however, is the notion that a great artist's creativity may be held hostage to complex arguments of social deconstruction that appear to fascinate so many. A great deal is being written — I believe the operative word is "discourse" — as to how we must redefine the history of art along such lines. Perhaps this is clearest as it involves the ever-present East-West duality. No one can deny environmental differences. What is not so clear, however, is the fact that an artist's creativity can close the gap. A direct example of this comes from Peter Hessler in his popular *River Town*, recording experiences of teaching English literature in distant Fulin on the western edge of the Yangtze River. The focus was on a Shakespeare sonnet. To quote him directly:

> Four centuries ago, Shakespeare loved a woman and wrote a poem about her. He said it would make her beauty live forever — that was his promise. Today the year is 1996, and we are in China, in Sichuan, next to the Yangtze River. Shakepeare never came to Fulin. None of you have ever been to England, and you have not seen the woman Shakespeare loved four hundred years ago. But right now every one of you is thinking about her.

He was faced with silence, a silence in which he shared their respect and awe. He admits to having read or heard the poem countless times ". . . but I never heard it truly until I stood in front of my class in Fulin."[2]

Quite simply, there is nothing wrong in being aware of environment. Indeed borrowing from other disciplines may be stimulating and revealing. After all deconstruction is an attempt to do much of what I am doing, using words to define the ever-flexible gap between the wordless and the observer. (Does the discourse have to be cloaked in such a difficult vocabulary?) No matter, an artist's creativity is not the same as the setting. Far from being reflective mirrors, artists define the world in which they live. That is why we must pay special attention to them whether as in the collective quality of a craft or as a recognized individual. A skilled artist opens up a world that others have been unable to realize, and in doing so has the ability to reach beyond time-certain and speak directly to the human condition.

[2] Hessler, *River Town* (2001), pp. 42–43.

Picasso, whose creativity would be difficult to deny, was also not embarrassed to use words. "To me," he once said, "there is no past or future in art. The art of the great painters who lived in other times is not an art of the past; perhaps it is more alive today than it ever was."[3]

Not as direct as Picasso, I have approached Ma Yuan with an effort to explore his artistic surroundings, a situation more widely exposed but ending at the same point — the timeless triumph of an artist's creativity.

This is perhaps not too different from China's traditional grasp of historical time. There, too, time was anchored to a deep sense of return. This is expressed in the dating system of ten "stems" and twelve "branches" whose differing combinations end after sixty years, and begin again. To reach the age of sixty is to return to the year of one's birth. This is not to be seen as simple mathematical maneuvering, certainly not exact repetition. A spiral might be a more appropriate image. The stems are *tiangan* 天干, "heaven-stems," and the branches are *dizhi* 地支, "earth branches," thus declaring a cosmic authority. The reality of heaven and earth cannot just let go of the past. Time's wholeness demands the rejection of a single line. Once again Leo Bronstein has offered me a compelling idea: "The past is what we are within it."[4] If I may turn back to the West with yet another artist who outlives his time, as T. S. Eliot brings his expansive *Four Quartets* to a close, he echoes a similar return:

> We shall not cease from exploration
> And the end of all our exploring
> Will be to arrive where we started
> And know the place for the first time.[5]

[3] *The New Yorker* (March 26, 2007), p. 41.
[4] Edwards, "Introduction" (1969), p. xiii.
[5] Eliot, *Four Quartets* (1943), p. 39.

Bibliography

Chinese and Japanese Sources

Bai Juyi 白居易. *Bai Juyi ji jian jiao* 白居易集箋校. Annotated by Zhu Jincheng 朱金城. Shanghai: Shanghai guji chubanshe, n.d.

Cen Anqing 岑安卿. *Kaolao shanren shiji* 栲栳山人詩集. Taipei: National Central Library, 1971, microfilm.

Changsheng di shijie: Daojiao huihua tulu 長生的世界：道教繪畫圖錄 (Realm of the Immortals: Special Exhibition of Taoist Painting). Taipei: National Palace Museum, 1996.

Chen Gaohua 陳高華, comp. *Song Liao Jin huajia shiliao* 宋遼金畫家史料. Beijing: Wenwu chubanshe, 1984.

Chen Shidao 陳師道 (1053–1102). *Houshan tancong* 後山談叢. Rpt. Beijing: Zhonghua shuju, 2007.

Chen Yuanjing 陳元靚. *Sui shi guangji* 歲時廣記. In *Congshu jicheng chu bian* 叢書集成初編, Vols. 179–81. Changsha: Shangwu yinshuguan, 1939.

Cihai 辭海. Taipei: Zhonghua shuju, 1962.

Deng Chun 鄧椿. *Hua ji* 畫繼. Preface dated 1167. Rpt. Shanghai: Renmin meishu chubanshe, 1982.

Du Fu 杜甫. *Du shi bianlan* 杜詩便覽. Compiled by Wang Shijing 王士菁. Chengdu: Sichuan wenyi chubanshe, 1986.

Du Mu 杜牧. *Fanquan wenji* 樊川文集. Shanghai: Guji chubanshe, 1978.

Dunhuang wenwu yanjiusuo 敦煌文物研究所, ed. *Dunhuang Mogao ku* 敦煌莫高窟. 5 vols. Beijing: Wenwu chubanshe, 1982–1987.

Fan Chengda 范成大. *Fancun meipu* 范村梅譜. In *Baibu congshu jicheng* 百部叢書集成 as *Shihu meipu* 石湖梅譜. Taipei: Yiwen yinshuguan, 1965.

Fan Ye 范曄. *Hou Han shu* 後漢書. 12 vols. Rpt. Beijing: Zhonghua shuju, 1973.

Gao Huiyang 高輝陽. *Ma Yuan huihua yanjiu* 馬遠繪畫研究. Taipei: Wenshizhe chubanshe, 1978.

Gao Qi 高啟. *Qingqiu shiji zhu* 青邱詩集注. Taipei: Zhonghua shuju, 1966.

Gugong bowuyuan (Palace Museum, Beijing). *Zhongguo lidai huihua: Gugong bowuyuan canghua ji* 中國歷代繪畫：故宮博物院藏畫集. 8 vols. Beijing: Renmin meishu chubanshe, 1978–1991.

Guo Xi (Kuo Hsi) 郭熙. *Zaochun tu (Tsao-ch'un t'u)* 早春圖. Taipei: National Palace Museum, 1979.

Guoli gugong bowuyuan 國立故宮博物院. *Gugong minghua sanbai zhong* 故宮名畫三百種. 3 vols. Taichung: National Palace Museum, 1959.

———. *Gugong shuhua lu* 故宮書畫錄 (*zengding ben* 增訂本). 4 vols. Taipei: Guoli gugong bowuyuan, 1965.

Hanyu dacidian 漢語大詞典 (Dictionary of Chinese Terms). Edited by Luo Zhufeng 羅竹風. 12 vols. Shanghai: Shanghai cishu chubanshe, 1986.

Hongming ji 弘明集. In *Taishō shinshū daizōkyō* T. 52, no. 2102.

Huang Yongquan 黃湧泉. *Li Gonglin shengxian tu shike* 李公麟聖賢圖石刻. Beijing: Renmin meishu chubanshe, 1963.

Itakura Masaaki 板倉聖哲. "Ba En 'Seien gashū zu kan' (Neruson-Atokinzu Bijutsukan) no shi teki ichi–kyokō to shite no 'Seien gashū' to so no kaigaka o megutte" (The historical position of Ma Yuan's elegant gathering in the Western Garden [The Nelson-Atkins Museum of Art]: Concerning the pictorialization of this theme as fiction). 馬遠〈西園雅集図巻〉(ネルソン-アトキンズ美術館)の史的位置—虛構としての〈西園雅集〉とその絵画化をめぐって. *Bijutsushi ronsō* 美術史論叢 (Studies in Art History) 16 (1999), pp. 49–78.

Jiang Zhaoshen (Chiang Chao-shen) 江兆申. "Yang Meizi 楊妹子." In Jiang Zhaoshen, *Shuangxi duhua suibi* 雙谿讀畫隨筆, pp. 10–38. Taipei: Guoli gugong bowuguan, 1977.

Jingde chuandeng 景德傳燈. In *Taishō shinshū daizōkyō* T. 49, no. 2035.

Li Bi 李壁. *Wang Jinggong shi zhu* 王荊公詩註. In *Siku quanshu zhenben liu ji* 四庫全書珍本六集. Vols. 249–52. Taipei: Shangwu yinshuguan, 1976.

Li Bo 李白. *Li Bo quanji jiaozhu huishi jiping* 李白全集校注彙釋集評. Compiled by Zhan Ying 詹鍈. 8 vols. Tianjing: Baihua wenyi chubanshe, 1996.

Li E 厲鶚. *Nan Song yuan hualu* 南宋院畫錄 (1721), 8 *juan*, supplement 1 *juan*. In *Meishu congshu* 美術叢書 VI, vol. 17, compiled by Deng Shi 鄧實, 1947. Rpt. Taipei: Yiwen chubanshe, 1975.

Li Lincan (Li Lin-tsan). *Long zai gugong* 龍在故宮 (Dragons in the Palace Museum). Taipei: Guoli gugong bowuyuan, 1978.

Li Rihua 李日華. *Liuyan zhai biji* 六研齋筆記 and *erbi* 二筆, *sanbi* 三筆. In *Guoxue zhenben wenku* 國學珍本文庫. Shanghai: n.p., 1935–1936.

Ma Yuan shuitu 馬遠水圖 (Ma Yuan's Painting of Water). Reproduction with colophons. Beijing: n.p., 1958.

Miya Tsugiō 宮次男. "Mokuren Kyubo Setsuwa to sono Kaiga: Mokuren Kyubo Kyō-e no Shutsugen ni Chinande" 目連救母説話とその絵画―目連救母経絵の出現に因んで (Illustrated scripture of the story of Mokuren's salvation of his mother). *Bijutsu Kenkyū* 美術研究 (Journal of Art Studies) 255 (January 1968), pp. 155–78.

Nianchang 念常. *Fozu tongzai* 佛祖通載. Yangzhou: Jiangsu Guangling guji keyinshe, 1993.

Puji 普濟. *Wudeng huiyuan* (J. Goto egen) 五燈會元 (Gathering the Sources of the Five Lamps), 1252. Rpt. Tokyo: Dainippon zokuzokyo, 1971.

Ruizhou Dongshan liangjie chanshi yulu 瑞州洞山良价禪師語錄. *Taishō shinshū daizōkyō* T. 47, no. 1986B.

Sengshun 僧順. *Shi sanpo lun* 釋三破論. In *Hongming ji*, T. 52, no. 2102.

Shih Shou-chien 石守謙. "Nan Song di liangzhong guijian hua" 南宋的兩種規鑒畫. *Yishu xue* 藝術學 (Study of the Arts) 1 (1987), pp. 7–39.

Shimada Shūjirō 島田修二郎. *Zenrin gasan: chūsei suibokuga o yomu* 禅林画賛：中世水墨画を読む. Tokyo: Mainichi shinbunsha, 1987.

Sima Guang 司馬光. *Zizhi tongjian* 資治通鑑. In *Sibu congkan*. Shanghai: Shangwu yinshuguan, 1919.

Sima Qian 司馬遷. *Shiji* 史記. In *Bainaben ershisi shi: si bu cong kan shi bu* 百衲本二十四史：四部叢刊史部. Shanghai: Shangwu yinshu guan, 1930–1937.

Song Boren 宋伯仁 (Xueyan 雪岩). *Meihua xishen pu* 梅花喜神譜, ca. 1238. Facsimile. Rpt. Shanghai: Zhonghua shuju, 1928.

Song Shi 宋史. 40 Vols. Rpt. Shanghai: Zhonghua shuju, 1979.

Su Shi 蘇軾. *Su Shi lun shuhua shiliao* 蘇軾論書畫史料. Compiled by Li Fushun 李福順. Shanghai: Renmin meishu chubanshe, 1988.

———. *Su Shi shiji hezhu* 蘇軾詩集合注. Annotated by Feng Yingliu 馮應榴. Shanghai: Shanghai guji chubanshe, 2001.

Suzuki Kei 鈴木敬. *Chūgoku Kaigashi* 中國繪畫史, vol. 2, pt. 1, *Southern Song, Liao, Jin*. Tokyo: Yoshikawa Kobunkan, 1984.

Takakusu Junjirō 高楠順次郎 and Watanabe Kaigyoku 渡邊海旭都, eds. *Taishō shinshū daizōkyō* 大正新修大藏經. 85 vols. Tokyo: Taishō Issaikyō Kankōkai, 1924–1932.

Tang Hou 湯垕. *Huajian* 畫鑑, ca. 1320. Rpt. Beijing: Renmin meishu chubanshe, 1959.

Tianjinshi yishu bowuguan 天津市藝術博物館. *Zhonguo lidai huihua: Tianjin yishu bowuguan canghua ji* 中國歷代繪畫：天津藝術博物館藏畫集. Tianjin: Renmin meishu chubanshe, 1985.

Toda Teisuke 戶田禎佑. *Mokkei Gyokkan* 牧谿玉澗. In *Suiboku bijutsu taikei* 水墨美術大系, vol. 3. Tokyo: Kodansha, 1973.

Tokyo National Museum, ed. *Sogen no kaiga* 宋元の繪畫 (Song and Yuan painting). Kyoto: Benrido, 1962.

Wang Shijin 王士菁. *Du shi bianlan* 杜詩便覽. Chengdu: Sichuan wenyi chubanshe, 1986.

Wang Wenjie 王文潔, ed. *Qie Wang shi michuan zhiren fengjian yuanli xiangfa quanshu* 鍥王氏秘傳知人風鑑源理相法全書. Microfilm copy. Taipei: National Palace Museum, 1599.

Wang Yaoting 王耀庭. "Shuo Song Ma Yuan chenglong tu" 說宋馬遠乘龍圖. In *Qian xinian Songdai wenwu dazhan* 千禧年宋代文物大展 (China at the Inception of the Second Millennium: Art and Culture of the Sung Dynasty, 960–1279), edited by Guoli gugong bowuyuan bianji weiyuanhui 國立故宮博物院編輯委員會, pp. 377–89. Taipei: National Palace Museum, 2000. For English translation, see *National Palace Museum Bulletin* 35, nos. 5, 6 (Nov–Dec 2000, Jan–Feb 2001).

Wu deng huiyuan 五燈會元. See Puji.

Wu Shidao 吳師道 (thirteenth century). *Wu Zhengchuan xiansheng wenji* 吳正傳先生文集. Rpt. Taipei: Zhongyang tushuguan, 1970.

Wu Zimu 吳自牧. *Mengliang lu* 夢粱錄. Preface 1274. In Meng Yuanlao 孟元老 et al., *Dongjing menghua lu wai sizhong* 東京夢華錄外四種, pp. 129–328. Rpt. Shanghai: Zhonghua shuju, 1962.

Wuzhun Shifan 無準師範 (1178–1249). *Wuzhun Shifan chanshi yulu* 無準師範禪師語錄. In *Xu zangjing* 續藏經, vol. 70, no. 1382. Taipei: Xin wenfeng chubanshe, 1993–1994.

Xia Wenyan 夏文彥. *Tuhui baojian* 圖繪寶鑑. Preface 1365. Rpt. Shanghai: Shangwu yinshuguan, 1936.

Xie Shouhao 謝守灝 (1134–1212). *Hunyuan shengji* 混元聖紀 (Sage Record of Chaos Prime). In *Zhengtong Daozang* 正統道藏 (DZ 770), Vol. 30. Taipei: Xin wenfeng, 1985.

Xie Zhiliu 謝稚柳. *Tang Wudai Song Yuan mingji* 唐五代宋元名跡. Shanghai: Gudian wenxue chubanshe, 1957.

Xu Bangda 徐邦達. "Cong qinglu shanshui chuantong tan Zhao Bosu *Wansong Jinque tu*" 從青綠山水傳統談趙伯驌萬松金闕圖. *Zhongguo wenwu* 中國文物 4 (1980), pp. 1–8.

———. *Gu shuhua weie kaobian* 古書畫偽訛考辨. Nanjing: Jiangsu guji, 1984.

———. "Nan Song dihou tihua shu kaobian" 南宋帝后題畫書考辨 (Examining of Southern Song imperial calligraphy on paintings). *Wenwu* 文物 6 (1981), pp. 52–64.

Xu Senyu 徐森玉. *Huayuan duoying* 畫苑掇英 (Gems of Chinese Painting). 3 vols. Shanghai: n.p., 1955.

Xuanhe huapu 宣和畫譜 (Imperial Painting Catalogue of the Xuanhe Era). Preface 1123. In *Zhongguo hualun congshu* 中國畫論叢書, edited by Yu Jianhua 俞劍華. Beijing: Renmin meishu chubanshe, 1964.

Yang Wanli 楊萬里 (1127–1206). *Chengzhai shiji* 誠齋詩集. In *Sibu beiyao*. Shanghai: Zhonghua shuju, 1927–1936.

Yang Zai 楊戴 (1271–1323). *Hanlin Yang Zhonghong shiji* 翰林楊仲弘詩集. In *Sibu congkan*. Shanghai: Shangwu yinshuguan, 1929.

Yiyuan duoying 藝苑掇英. No. 7. Shanghai: Renmin meishu chubanshe, 1979.

Yonezawa Yoshiho 米澤嘉圃. "Den Ba En hitsu Unmon Hogen Sotō soshi zu" 伝馬遠筆雲門、法眼、曹洞祖師図 (Paintings of the patriarchs Yunmen, Fayan and Caodong attributed to Ma Yuan). *Kokka* 國華 838 (1962), pp. 36–43.

———. "Enkei Kōmon san Yakusan Rio zen-e-zu" 偃溪広聞賛薬山李翱禅會図 (Chan meeting between Yaoshan and Li Ao with encomium by Yanqi Guangwen). *Kokka* 859 (October 1963), pp. 20–26.

Yu Jianhua 俞劍華. *Zhongguo hualun leibian* 中國畫論類編. 2 vols. Beijing: Zhongguo gudian yishu chubanshe, 1956.

———, ed. *Zhongguo meishujia renming cidian* 中國美術家人名辭典. Shanghai: Renmin meishu chubanshe, 1981.

Yunzhou Dongshan wuben chanshi yulu 筠州洞山悟本禪師語錄. In *Taishō shinshū daizōkyō*, T. 47, no. 1986A.

Zhan Jingfeng 詹景鳳. *Dong tu xuanlan bian* 東圖玄覽編. Preface 1591. In *Meishu congshu V:1* 美術叢書5集第1輯, edited by Yan Yiping 嚴一萍. Taipei: Yiwen yinshuguan, 1975, vol. 21.

Zhang Zi 張鎡 (b. 1153). *Nanhu ji* 南湖集. In *Siku quanshu* 四庫全書. Rpt. Taipei: Shangwu yishuguan, 1983 (vol. 1164).

Zheng Zhenduo 鄭振鐸 et al., ed. *Songren huace* 宋人畫冊. Beijing: Wenwu chubanshe, 1957.

Zhongguo gudai shuhua tumu 中國古代書畫圖目. 23 vols. Beijing: Wenwu chubanshe, 1986–2000.

Zhongguo meishu quanji 中國美術全集, *huihua* 繪畫 (Painting), Liang Song 兩宋, vols. 3 and 4. *diaosu* 雕塑 (Sculpture), Wudai Song 五代宋, vol. 5. Shanghai: Renmin meishu chubanshe, 1987.

Zhongguo shehui kexueyuan wenxue yanjiusuo 中國社會科學院文學研究所, ed. *Tang Song cixuan* 唐宋詞選. Beijing: Renmin wenxue chubanshe, 1981.

Zhou Mi 周密 (1232–1298). *Qidong yeyu jiaozhu* 齊東野語校注 (Eastern Qi Jottings). Annotated by Zhu Juru 朱菊如. 1291. Rpt. Shanghai: Huadong shifan daxue chubanshe, 1987.

———. "Wulin jiushi" 武林舊事 (Old things of Hangzhou). In *Dongjing menghua lu wai sizhong* 東京夢華錄外四種. Shanghai: Zhonghua shuju, 1962.

Zhu Jingxuan 朱景玄. *Tang chao minghua lu* 唐朝名畫錄 (ca. 840). Annotated by Wen Zhaotong 温肇桐. Chengdu: Sichuan meishu chubanshe, 1985.

Zhuang Su 莊肅. *Huaji buyi* 畫繼補遺. 1298. Rpt. Beijing: Renmin meishu chubanshe, 1963.

Western Sources

Acker, William R. B., trans. *Some Tang and Pre-Tang Texts on Chinese Painting* (translated and annotated; original texts included). Leiden: E. J. Brill, I, 1954; II, 1974.

App, Urs, trans., ed. *Master Yunmen: From the Record of the Chan Master "Gate of the Clouds."* New York, Tokyo: Kodansha, 1994.

Avril, Ellen B., with contributions from Lora Ling-yun Shih. *Chinese Art in the Cincinnati Art Museum.* Cincinnati: Cincinnati Art Museum, 1997.

Baldrian-Hussein, Farzeen. "Lü Tung-pin in Northern Sung Literature." *Cahiers d'Extrême-Asie* 2 (1986), pp. 133–69.

Barnhart, Richard M. *Along the Border of Heaven: Sung and Yuan Paintings from the C. C. Wang Family Collection.* New York: Metropolitan Museum of Art, 1983.

———. "Huang Ch'uan." In *Sung Biographies: Painters*, edited by Herbert Franke (1976), pp. 50–55.

———. *Peach Blossom Spring: Gardens and Flowers in Chinese Paintings.* New York: Metropolitan Museum of Art, 1983.

————. "Three Song Landscape Paintings." *Orientations* 29.2 (Feb 1998), pp. 54–61.

————, et al. *The Jade Studio: Masterpieces of Ming and Qing Painting and Calligraphy from the Wong Nan-p'ing Collection*. New Haven: Yale University Art Gallery, 1994.

————, with essays by Robert E. Harrist, Jr. and Hui-liang J. Chu. *Li Kung-lin's Classic of Filial Piety*. New York: Metropolitan Museum of Art, 1993.

Bickford, Maggie, et al. *Bones of Jade, Soul of Ice: The Flowering Plum in Chinese Art*. New Haven: Yale University Art Gallery, 1985.

————. *Ink Plum: The Making of a Chinese Scholar-Painting Genre*. Cambridge: Cambridge University Press, 1996.

Brinker, Helmut. *Shussan Shaka: Darstellungen in der Malerei Ostasiens: Untersuchungen zu einem Bildthema der buddhistischen Figurenmalerei*. Bern, New York: Peter Lang, 1983.

————. "Shussan Shaka in Sung and Yüan Painting." *Ars Orientalis* 9 (1973), pp. 21–40.

————. *Zen in the Art of Painting*. Translated by George Campbell. London, New York: Arkana, 1987.

Brinker, Helmut and Hiroshi Kanazawa. *Zen Masters of Meditation in Images and Writings*. Translated by Andreas Leisinger (*Artibus Asiae* supplementum, 40). Zurich, 1996.

Brotherton, Elizabeth Chapman. "Li Kung-lin and Long Handscroll Illustrations of T'ao Ch'ien's Returning Home." Ph.D. dissertation, Princeton University, 1992.

Bush, Susan and Hsio-yen Shih, trans., ed. *Early Chinese Texts on Painting*. Cambridge, MA: Harvard University Press, 1985.

Cahill, James. *The Art of Southern Sung China*. New York: The Asia Society, 1962.

————. *An Index of Early Chinese Painters and Paintings: Tang, Sung and Yuan*. Berkeley: University of California Press, 1980.

————. *The Lyric Journey: Poetic Painting in China and Japan*. Cambridge, MA: Harvard University Press, 1996.

Chapin, Hellen and Alexander Soper. "A Long Roll of Buddhist Images." *Artibus Asiae* 32, no. 2/3 (1970), pp. 157–99.

Chaves, Jonathan, trans. *Heaven My Blanket, Earth My Pillow: Poems by Yang Wan-li*. New York: Weatherhill, 1975.

Cheng Wen-chien. "Images of Happy Farmers in Song China (960–1279): Drunks, Politics, and Social Identity." Ph.D. dissertation, University of Michigan, 2003.

Chiang Chao-shen (Jiang Zhaoshen). "The Identity of Yang Mei-tzu and the Paintings of Ma Yuan." *The National Palace Museum Bulletin*, vol. 2, nos. 2 and 3 (1967).

Chinese Calligrapy and Painting in the Collection of John M. Crawford, Jr. New York: Pierpoint Morgan Library, 1962.

Chu Hui-liang (Zhu Huiliang). "Imperial Calligraphy in the Southern Sung." In *Words and Images*, edited by Alfreda Murck and Wen C. Fong (1991), pp. 289–312.

Cleary, Thomas and J. C. Cleary, trans. *The Blue Cliff Record*. Boston and London: Shambhala Publications, 1977, reprint 1992.

Davidson, J. Leroy. "The Origin and Early Use of the Ju-i." *Artibus Asiae* 13.4 (1950), pp. 239–49.

Davis, A. R. *Tao Yuan-ming (AD 365–427) His Works and Their Meaning; vol. I Translation and Commentary*, vol. II *Additional Commentary, Notes and Bibliography*. Hong Kong: Hong Kong University Press, 1983.

Davis, Richard. *Wind against the Mountain: The Crisis of Politics and Culture in Thirteenth Century China*. Cambridge, MA: Harvard University Press, 1996.

Ecke, Gustav. *Chinese Painting in Hawaii in the Honolulu Academy of Arts and in Private Collections*. 3 vols. Honolulu: The University Academy of Arts, 1965.

Edwards, Richard. "Emperor Ningzong's *Night Banquet*." *Ars Orientalis* 29 (1999), pp. 55–67.

———. "Introduction." In Leo Bronstein, *Five Variations on the Theme of Japanese Painting*, pp. xiii–xvi. For Brandeis University. Freeport, Maine: Bond Wheelwright, 1969.

———. "Li Gonglin's Copy of Wei Yan's *Pasturing Horses*." *Artibus Asiae* 53, no. 3/4 (1993), pp. 168–93.

———. *Li Ti*. The Freer Gallery of Art Occasional Papers, vol. 3, no. 3. Washington D.C.: Smithsonian Institution, 1967.

———. "Ma Yuan." In *Sung Biographies: Painters*, edited by Herbert Franke (1976), pp. 109–15.

———. "Painting and Poetry in the Late Sung." In *Words and Images*, edited by Alfreda Murck and Wen C. Fong (1991), pp. 405–30.

———. "Pu-tai-Maitreya and a Reintroduction to Hangchou's Fei-lai-feng." *Ars Orientalis* 14 (1984), pp. 5–50.

———. "The Search for Zhao Bosu." In *Tradition and Transformation*, edited by Judith G. Smith (2005), pp. 57–82.

_____. "Thru Snow Mountains at Dawn: Ma Yuan's Exceptional Fuel Gatherer." *Kaikodo Journal* 12 (Autumn 1999), pp. 21–32.

————. "Ue Gukei: Fourteenth Century Ink-Painter." *Ars Orientalis* 7 (1968), pp. 169–78.

Egan, Ronald. "Poems on Paintings: Su Shih and Huang T'ing-chien." *HJAS* 43, no. 2 (1983), pp. 413–51.

————. *Word, Image, and Deed in the Life of Su Shi*. Cambridge, MA: Harvard University, Harvard-Yenching Institute Monograph Series, 1994.

Eliot, T. S. *Four Quartets*. New York: Harcourt, Brace and Co., 1943.

Fan Jinshi and Mei Lin. "An Interpretation of the Maudgalyayana Murals in Cave 19 at Yulin." *Orientations* 27.10 (Nov 1996), pp. 70–75.

Feng Yu-lan. *A History of Chinese Philosophy: The Period of the Chinese Philosophers*, translated by Dirk Bodde. Peipei: Henri Vetch, 1937.

————. *A History of Chinese Philosophy, Vol. 2: The Period of Classical Learning*. Princeton: Princeton University Press, 1953.

Fong, Wen C. *Beyond Representation: Chinese Painting and Calligraphy, 8th–14th Century*. New York: Metropolitan Museum of Art, 1992.

————. *Images of the Mind: Selections from the Edward L. Elliot Family and John B. Elliot Collection of Calligraphy and Painting at the Art Museum*. Princeton: The Art Museum, Princeton University, 1984.

————. *Sung and Yuan Paintings. With Catalogue by Marilyn Fu*. New York: The Metropolitan Museum of Art, 1973.

———— and James C. Y. Watt, et al. *Possessing the Past: Treasures from the National Palace Museum, Taipei*. New York: Metropolitan Museum of Art, 1996.

Fontein, Jan and Money L. Hickman. *Zen Painting and Calligraphy*. Boston: Museum of Fine Arts, 1970.

Fontein, Jan and Tung Wu. *Unearthing China's Past*. Boston: Museum of Fine Arts, 1973.

Foster, Nelson and Jack Shoemaker, eds. *The Roaring Stream: A New Zen Reader*. Hopewell, NJ: The Ecco Press, 1996.

Foulk, T. Griffith and Robert H. Sharf. "On the Ritual Use of Ch'an Portraiture in Medieval China." *Cahiers d'Extrême-Asie* 7 (1993–1994), pp. 149–219.

Franke, Herbert, ed. *Sung Biographies*. 4 vols. Wiesbaden: Franz Steiner, 1978.

Frankel, Hans H. *The Flowering Plum and the Palace Lady: Interpretations of Chinese Poetry*. New Haven: Yale Univerity Press, 1976.

————. "The Plum Tree in Chinese Poetry." *Asiatische Studien* 6 (1952), pp. 88–115.

Gernet, Jacques. *Daily Life in China: On the Eve of the Mongol Invasion 1250–1276*, translated by H. M. Wright. New York: Macmillan, 1962.

———. *A History of Chinese Civilization*, translated by J. R. Foster. Cambridge: Cambridge University Press, 1982.

Goodrich, L. Carrington, ed. *Dictionary of Ming Biography, 1368–1644*. 2 vols. New York: Columbia Universitry Press, 1976.

Harrist, Robert E. Jr. *Painting and Private Life in Eleventh-Century China: Mountain Villa by Li Gonglin*. Princeton: Princeton University Press, 1998.

———. "Watching Clouds Rise: A Tang Dynasty Couplet and Its Illustration in Song Painting." *Bulletin of the Cleveland Museum of Art* 78 (Nov 1991), pp. 301–23.

Hartman, Charles. "Literary and Visual Interactions in Lo Chih-ch'uan's *Crows in Old Trees*." *Metropolitan Museum Journal* 28 (1993), pp. 129–67.

———. "Stomping Songs: Word and Image." *Chinese Literature: Essays, Articles, Reviews* 17 (Dec 1995), pp. 1–49.

Hawkes, David. *A Little Primer of Tu Fu*. Oxford: Oxford University Press, 1967.

Hearn, Maxwell K. and Judith G. Smith, eds. *Arts of the Sung and Yuan: Papers Prepared for an International Symposium Organized by the Metropolitan Museum of Art in Conjunction with the Exhibition Splendors of Imperial China: Treasures from the National Palace Museum, Taipei*. New York: Metropolitan Museum of Art, 1996.

Henderson, Gregory and Leon Hurvitz. "The Buddha of Seiryoji: New Finds and New Theory." *Artibus Asiae* 19, no. 1 (1956), pp. 4–55.

Hessler, Peter. *River Town: Two Years on the Yangtze*. New York: Harper Collins, 2001.

Hightower, James Robert, trans. *The Poetry of T'ao Ch'ien*. Oxford: Oxford University Press, 1970.

Hinton, David, trans. *The Selected Poems of Li Po*. New York: New Directions, 1995.

———. *The Selected Poems of Tu Fu*. New York: New Directions, 1989.

Ho, Wai-Kam et al. *Eight Dynasties of Chinese Painting: The Collections of the Nelson Gallery-Atkins Museum, Kansas City, and the Cleveland Museum of Art*. Cleveland: Cleveland Museum of Art, 1980.

Hoyo, Josep del, Andrew Elliott, and Jordi Sargatal, eds. *Handbook of the Birds of the World*. Vol. 1. Barcelona: Lynx Edicions, 1992.

Huang Shih-shan Susan. "Summoning the Gods: Paintings of Three Officials of Heaven, Earth and Water and Their Association with Daoist Ritual

Performance in the Southern Song Period (1127–1279)." *Artibus Asiae* 61, no. 2 (2001), pp. 5–52.

Hucker, Charles O. *A Dictionary of Official Titles in Imperial China.* Stanford: Stanford University Press, 1985.

Hung, William. *Tu Fu: China's Greatest Poet.* Cambridge, MA: Harvard University Press, 1952.

Ingholt, Harald. *Gandharan Art in Pakistan.* New York: Pantheon Books, 1957.

Jang, Scarlett Ju-Yu. "Ox-Herding Painting in the Sung Dynasty." *Artibus Asiae* Vol. 52, 1/2 (1992).

Juliano, Annette L. and Judith A. Lerner, et al. *Monks and Merchants: Silk Road Treasures from Northwest China, Gansu and Ningxia 4th–7th Century.* New York: Harry N. Abrams with the Asia Society, 2001.

Katz, Paul R. *Images of the Immortal: The Cult of Lü Dongbin at the Palace of Eternal Joy.* Honolulu: University of Hawaii Press, 1999.

Kohn, Livia. *God of the Dao: Lord Lao in History and Myth.* Ann Arbor: Center for Chinese Studies, University of Michigan, 1998.

Lachman, Charles. "Why Did the Patriarch Cross the River? The Rushleaf Bodhidharma Reconsidered." *Asia Major*, 3rd series, 6.2 (1993), pp. 237–68.

Laing, Ellen J. "Neo-Daoism and the 'Seven Sages of the Bamboo Grove' in Chinese Painting." *Artibus Asiae* 36, 1/2 (1974), pp. 5–54.

———. "Real or Ideal: The Problem of the 'Elegant Gathering in the Western Garden' in Chinese Historical and Art Historical Records." *Journal of the American Oriental Society* 88, no. 3 (July–Sept 1968), pp. 419–35.

Lau, D. C., trans. *Tao Te Ching.* Baltimore: Penguin, 1963.

Lawton, Thomas. *Chinese Figure Painting.* Freer Gallery of Art Fiftieth Anniversary Exhibition, Vol. 2. Washington, D.C.: Smithsonian Institution, 1973.

Lee Hui-shu. "The Domain of Empress Yang (1162–1233): Art, Gender and Politics at the Southern Sung Court." Ph.D. diss., Yale University, 1994.

———. "The Emperor's Lady Ghostwriters in Song Dynasty China." *Artibus Asiae* 64, no. 1 (2004), pp. 61–101.

———. *Exquisite Moments: West Lake and Southern Song Art.* New York: China Institute Gallery, 2001.

Lee, Sherman. "Ma Yuan." In *Encyclopedia of World Art*, vol. 9, pp. 590–94. New York: McGraw Hill, 1959–1968.

Legge, James. *The Chinese Classics, Vol. 1: Confucian Analects*, pp. 137–354. Hong Kong: Hong Kong University Press, 1960 (1970).

———. *The Chinese Classics, Vol. 4: The She King*. Hong Kong: Hong Kong University Press, 1960 (1970).

Li Lin-tsan. "A Study of the Masterpiece 'T'ang Ming-huang's Journey to Shu'." *Ars Orientalis* 4 (1961), pp. 315–21.

Lin Po-ting. "The Relationship between Intimate Scenery and Shoal-and-Waterfowl Paintings in the Sung Dynasty." In *Arts of Sung and Yuan*, Symposium volume, edited by Maxwell K. Hearn and Judith G. Smith, pp. 87–107. New York: Metropolitan Museum of Art, 1996.

Lin Shuen-Fu. *The Transformation of the Chinese Lyrical Tradition: Chiang K'uei and Southern Sung Tz'u Poetry*. Princeton: Princeton University Press, 1978.

Little, Stephen, with Shawn Eichman, et al. *Taoism and the Arts of China*. Chicago: The Art Institute of Chicago and University of California Press, 2000.

Liu, James T. C. *China Turning Inward: Intellectual-Political Changes in the Early Twelfth Century. East Asia Monograph Series*. Cambridge, MA: Council on East Asian Studies, Harvard University, 1988.

Liu Yang. "Images for the Temple: Imperial Patronage in the Development of Tang Daoist Art." *Artibus Asiae* 61, no. 2 (2001), pp. 189–261.

Lo, Winston. *The Life and Thought of Yeh Shih*. Gainesville: University Presses of Florida, 1974.

Loehr, Max. "Chinese Paintings with Sung Dated Inscriptions." *Ars Orientalis* 4 (1961), pp. 219–84.

Lovell, Hin-cheung. *An Annotated Bibliography of Chinese Painting Catalogues and Related Texts*. Michigan Papers in Chinese Studies, no. 16. Ann Arbor: Center for Chinese Studies, University of Michigan, 1973.

MacKinnon, John and Karen Phillipps. *A Field Guide to the Birds of China*. Oxford: Oxford University Press, 2000.

Maeda, Robert J. "The Chao Ta-nien Tradition." *Ars Orientalis* 8 (1970), pp. 243–53.

———. "Ma Lin." In *Sung Biographies: Painters*, edited by Herbert Franke (1976), pp. 105–9.

———. *Two Twelfth Century Texts on Chinese Painting: Translations of the Shan-shui ch'un-ch'uan chi by Han Cho and Chapters Nine and Ten of Hua-chi by Teng Ch'un*. Michigan Papers in Chinese Studies, no. 8. Ann Arbor: Center for Chinese Studies, University of Michigan, 1970.

————. "The 'Water' Theme in Chinese Painting." *Artibus Asiae* 33, no. 4 (1971), pp. 247–90.

Meyer de Shauensee, Rudolfe. *The Birds of China*. Washington, D.C.: Smithsonian Institution Press, 1984.

Miura, Isshu and Ruth Fuller Sasaki. *Zen Dust: The History of the Koan and Koan Study in Rinzai (Lin-chi) Zen*. New York: Harcourt Brace & World, 1966.

Murck, Alfreda. *Poetry and Painting in Song China: The Subtle Art of Dissent*. Cambridge, MA: Harvard University Asia Center for the Harvard-Yenching Institute, 2000.

Murck, Alfreda and Wen C. Fong, eds. *Words and Images: Chinese Poetry, Calligraphy, and Painting*. New York and Princeton: Metropolitan Museum of Art and Princeton University Press, 1991.

Murray, Julia K. "The Hangzhou *Portraits of Confucius and Seventy-Two Disciples (Sheng xian tu)*: Art in the Service of Politics." *The Art Bulletin* 74, no. 1 (Mar. 1992), pp. 7–18.

————. *Ma Hezhi and the Illustration of the Book of Odes*. Cambridge and New York: Cambridge University Press, 1993.

————. "The *Ladies' Classic of Filial Piety* in Sung Textual Illustrations: Problems of Reconstruction and Artistic Context." *Ars Orientalis* 18 (1988), pp. 95–129.

————. "The Role of Art in Southern Sung Dynastic Revival." *Bulletin of Sung-Yuan Studies* 18 (1986), pp. 41–59.

Nelson, Susan E. "Tao Yuanming's Sashes: Or, the Gendering of Immortality." *Ars Orientalis* 29 (1999), pp. 1–27.

————. "What I Do Today Is Right: Picturing Tao Yuanming's Return." *Journal of Song and Yuan Studies* 28 (1998), pp. 61–90.

Nezu Institute of Fine Arts. *Southern Song Paintings: Elegant and Noble in Soul*. (Japanese text with English sub-titles). Tokyo: Nezu Institute of Fine Arts, 2004.

Obata, Shigeyoshi. *The Works of Li Po, the Chinese Poet*. New York: Paragon, 1965.

Oertling, Sewall. *Painting and Calligraphy in the* Wu-tsa-tsu: *Conservative Aesthetics in Seventeenth-Century China*. Michigan Monographs in Chinese Studies, no. 68. Ann Arbor: Center for Chinese Studies, University of Michigan, 1997.

Owen, Stephen. *The Great Age of Chinese Poetry: The High T'ang*. New Haven and London: Yale University Press, 1981.

Owyoung, Steven David. "The *Lan-t'ing hsiu-hsi t'u* by Sheng Mao-yeh: A Study of the Artist, the Painting and the Lan-t'ing Tradition in Painting." M.A. thesis, University of Michigan, 1977.

Poppe, Nicholas. *The Twelve Deeds of Buddha: A Mongolian Version of the Lalitavistara. Mongolian Text, Notes, and English Translation.* Seattle: University of Washington Press, 1968.

Powell, William F., trans. *The Record of Tung-shan.* Honolulu: University of Hawaii Press, 1986.

Powers, Martin J. "Love and Marriage in Song China: Tao Yuanming Comes Home." *Ars Orientalis* 28 (1998), pp. 50–62.

Rogers, Howard. "The Reluctant Messiah: 'Sakyamuni Emerging from the Mountains'." *Sophia International Review* 5 (1983), pp. 16–33.

———. "In Search of Enlightenment." *Kaikodo Journal* 11 (Spring 1999), pp. 8–23.

Rosenfield, John M. "The Unity of the Three Creeds: A Theme in Japanese Ink Painting of the Fifteenth Century." In *Japan in the Muromachi Age*, edited by John W. Hall and Toyoda Takeshi, pp. 205–25. Berkeley: University of California Press, 1977.

Rowland, Benjamin Jr. *The Evolution of the Buddha Image.* New York: The Asia Society, 1963.

———. "A Note on the Invention of the Buddha Image." *Harvard Journal of Asiatic Studies* 11, no. 1/2 (1948), pp. 181–86.

Sakanishi, Shio, trans. *An Essay on Landscape Painting by Kuo Hsi.* London: John Murray, 1935.

Schafer, Edward H. *The Empire of Min: A South China Kingdom of the Tenth Century.* Rutland, VT: C. E. Tuttle Co., 1985.

———. *Mirages on the Sea of Time: The Taoist Poetry of Ts'ao T'ang.* Berkeley: University of California Press, 1985.

———. "The Snow of Mao Shan: A Cluster of Taoist Images." *Journal of Chinese Religions* 13–14 (Fall 1985–86), pp. 107–26.

Seckel, Dietrich. "Shakyamuni's Rückkehr aus den Bergen." In *Asiatische Studien/ Études Asiatiques* 16–19 (1965), pp. 35–72.

Shearman, John K. G. *Mannerism.* Harmonsworth: Penguin, 1967.

Shurtleff, Lawton L. and Christopher Savage. *The Wood Duck and the Mandarin.* Berkeley: University of California Press, 1996.

Sirén, Osvald. *Chinese Painting: Leading Masters and Principles.* 7 vols. New York: Ronald Press Co., 1956–1958.

Smith, Judith G., ed. *Tradition and Transformation: Studies in Chinese Art in Honor of Chu-tsing Li*. Lawrence, KS: Spencer Museum of Art, University of Kansas, 2005.

Soothill, William Edward and Lewis Hodous, ed. *A Dictionary of Chinese Buddhist Terms with Sanskrit and English Equivalents*. 1904 and 1937. Rpt. Taipei: Buddhist Culture Service, n.d.

Soper, Alexander. "Literary Evidence for Early Buddhist Art in China." *Artibus Asiae*, Supplementum 19. Ascona, Switzerland, 1959.

———. "*T'ang chao ming hua lu*: Celebrated Painters of the T'ang Dynasty by Chu Chung-hsuan of T'ang." *Artibus Asiae* 21, nos. 3/4 (1958), pp. 204–30.

Sturman, Peter Charles. *Mi Fu: Style and the Art of Calligraphy in Northern Song China*. New Haven: Yale University Press, 1997.

Vandier-Nicolas, Nicole. *Le Houa-che de Mi Fou (1051–1107): ou, Le carnet d'un connaisseur à l'époque des Song du Nord*. Paris: Presses Universitaires de France, 1964.

Vinograd, Richard. "Family Properties: Personal Context and Cultural Pattern in Wang Meng's *Pien Mountains* of 1366." *Ars Orientalis* 13 (1982), pp. 1–29.

Wang Yaoting. "From 'Spring Fragrance, Clearing After Rain' to Listening to the Wind in the Pines': Some Proposals for the Courtly Context of Painting by Ma Lin in the Collection of the National Palace Museum, Taipei." In *Arts of Sung and Yuan*, edited by Maxwell K. Hearn and Judith G. Smith, pp. 271–91. New York: Metropolitan Museum of Art, 1996.

Watson, Burton, trans. *The Complete Works of Chuang Tzu*. New York: Columbia University Press, 1968.

———. *Records of the Grand Historian of China: Translated from the Shih chi of Ssu-ma Ch'ien. Volume I: Early Years of the Han Dynasty, 209–141 B.C.* New York: Columbia University Press, 1961.

Weidner, Marsha Smith, ed. *Flowering in the Shadows: Women in the History of Chinese and Japanese Painting*. Honolulu: University of Hawaii Press, 1990.

———. *Latter Days of the Law: Images of Chinese Buddhism 850–1850*. Lawrence, KS and Honolulu: Spencer Museum of Art, University of Kansas and University of Hawaii Press, 1994.

Weitz, Ankeney. *Zhou Mi's Record of Clouds and Mists Passing Before One's Eyes: An Annotated Translation*. Sinica Leidensia, 54. Leiden: Brill, 2002.

Wong, Kwan S. "Hsiang Yuan-pien and Suchou Artists." In *Artists and Patrons: Some Social and Economic Aspects of Chinese Painting*, edited by Chu-tsing Li, pp. 155–60. Seattle: University of Washington Press, 1989.

Wu Hung. "Buddhist Elements in Early Chinese Art (2nd and 3rd Centuries A.D.)." *Artibus Asiae* 47, nos. 3/4, pp. 263–352.

———. "Mapping Early Taoist Art: The Visual Culture of Wudoumi Dao." In Stephen Little, *Taoism and the Arts of China* (2000), pp. 77–93.

Wu Tung. *Tales from the Land of Dragons: 1000 Years of Chinese Painting*. Boston: Museum of Fine Arts, 1997.

Yampolsky, Philip B. *The Platform Sutra of the Sixth Patriarch: The Text of the Tun-huang Manuscript with Translation, Introduction, and Notes*. New York: Columbia University Press, 1967.

Yu, Pauline. *The Poetry of Wang Wei: New Translations and Commentary*. Bloomington: Indiana University Press, 1980.

Zürcher, Erik. *The Buddhist Conquest of China: The Spread and Adaptation of Buddhism in Early Medieval China*. 2 vols. Leiden: E. J. Brill, 1959. Revised reprint, 1972.

Index